Flammarion
26, rue Racine
75006 Paris

ISBN: 2-08010-618-X (paperback)
Numéro d'édition: FA0618

Originally published to accompany the exhibition
Matisse and Picasso: A Gentle Rivalry
(Kimbell Art Museum, Fort Worth, Texas, 1999)

Illustration page 4:
Pablo Picasso in his studio
at 7, rue des Grands Augustins, Paris 1948
Behind him, his work *The Kitchen*
(November 1948, oil on canvas, 175 x 252 cm)
Photograph by Herbert List
© Magnum Photos, Paris

Illustration page 6:
Henri Matisse © Succession H. Matisse
Photo Archives Matisse

Illustrations cover:
top:
Henri Matisse
The Dream
January–October 4, 1940
Oil on canvas
31 $^7/_8$ x 25 $^5/_8$ in. (81 x 65 cm)
Private collection

bottom:
Pablo Picasso
Woman with Yellow Hair
December 27, 1931
Oil on canvas
39 $^3/_8$ x 31 $^7/_8$ in. (100 x 81 cm)
The Solomon R. Guggenheim Museum, New York;
Thannhauser Collection, Gift, Justin K. Thannhauser, 1978

Printed in Italy

Matisse
and
Picasso

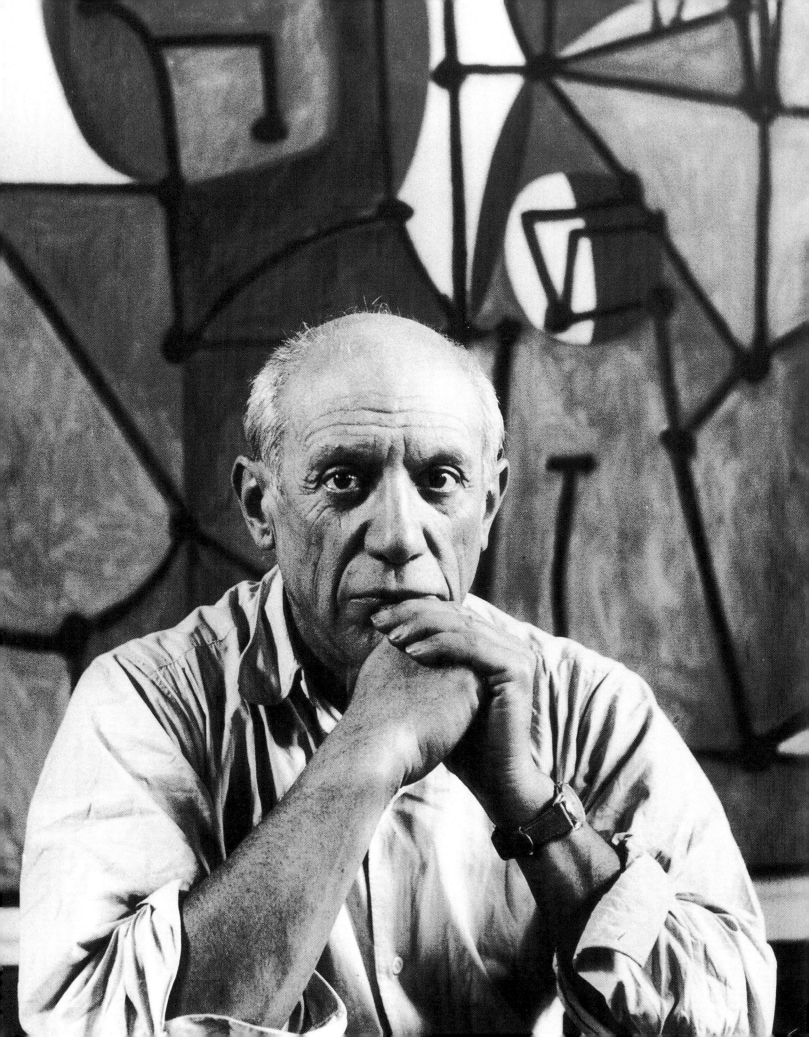

Matisse *and* Picasso

YVE-ALAIN BOIS

Flammarion

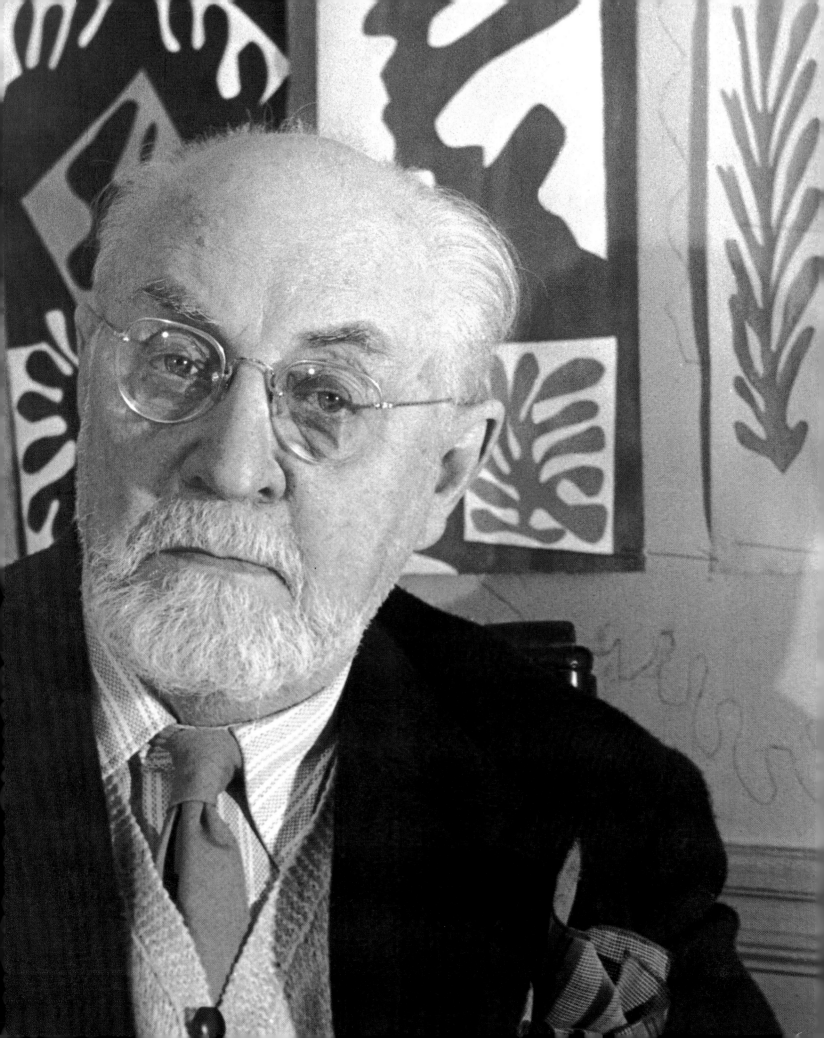

To my parents

CONTENTS

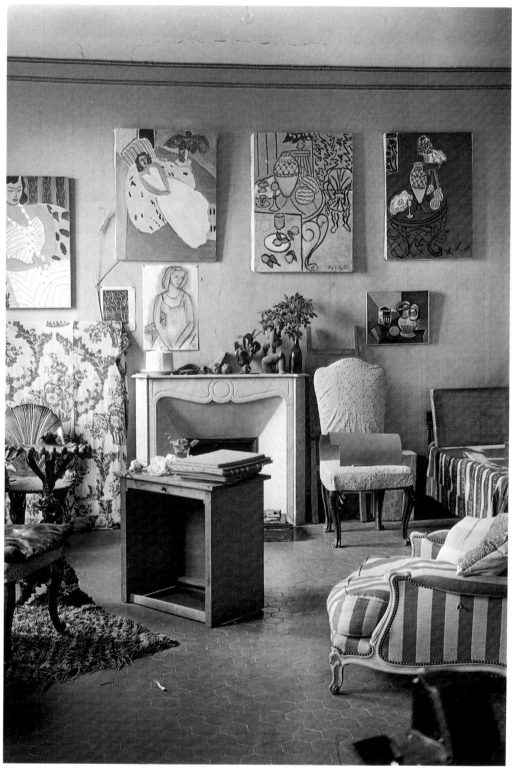

BRASSAÏ

1 The interior of Matisse's villa *Le Rêve* in Vence, 1946
On the wall among Matisse's paintings is Picasso's
Still Life with Pitcher, Glass, and Orange (1944)

FOUR ANGLES

———

"Matisse is always compared to Picasso," writes the Japanese artist Riichiro Kawashima in January 1933:

> Quite a long time ago [1913], when Picasso was living in a fashionable studio overlooking the Montparnasse cemetery, . . . I asked him, "Do you like Matisse?" He widened his big, bright eyes and said, "Well, Matisse paints beautiful and elegant pictures. He is understanding." . . . When I visited Matisse in Nice four years ago [1929], I asked him, "What do you think of Picasso?" After a moment of silence he said: "He is capricious and unpredictable, but he understands things."[1]

Each painter acknowledges a difference, and each offers laconic praise ("he is understanding . . . he understands things"). But the symmetry does not stop there. Consider the situation of two works that are far apart in time: in the late spring of 1916, Matisse paints *Still Life with a Plaster Bust* (fig. 2); in March of 1932, Picasso paints *Still Life: Bust, Bowl, and Palette* (fig. 3). Could there be a closer pairing? And how can the resemblance of the two works, executed almost sixteen years apart, be accounted for?

The standard explanation—that Matisse "influenced" Picasso—is highly unsatisfactory. The very notion of influence, with its implication of passivity, hardly squares with what we know about Picasso's omnivorous exploitation of styles, past or present. It would be just as unsatisfactory to say that Picasso was "influenced" by Ingres in the portraits drawn in the late teens, or by Delacroix in the *Women of Algiers* series of 1954–55: for the portraits engage in pastiche, and the series after the nineteenth-century artist is the expression of a desire to gather the past into an everlasting present.[2] In March 1932, Picasso attends to Matisse just as he attends on other occasions to Ingres and to Delacroix: he does so with a purpose.

In 1932, Picasso was anxiously preparing his first major retrospective, scheduled to take place in June and July at the Galeries Georges Petit—exactly a year after Matisse's own retrospective in the very same venue. To say that Picasso was thinking of Matisse would be an understatement. But why does he offer a response to *Still Life with a Plaster Bust* at this particular time?[3] Did he have something to tell Matisse—a score to settle, a corrective to offer?

Picasso knew very well that Matisse had painted the still life as a response to cubism, and that it constituted one of Matisse's few really accomplished blendings of his own compositional system with the cubist idiom. In 1916, it also marked the culmination of a particularly vivid exchange between the two painters.

The better to follow this exchange, we introduce a letter from the dealer Léonce Rosenberg to Picasso on November 25, 1915, in which Rosenberg discusses a recent visit to his gallery by Matisse, here called "the master of the 'goldfish'" (a reference to Matisse's *Goldfish and Palette* [fig. 5]). After showing two Picassos to Matisse—specifically, *Harlequin* [fig. 4] and *Green Still Life* (Z. II**, 485; The Museum of Modern Art, New York)—Rosenberg writes the following report to Picasso:

> Like me, the master of the "goldfish" was a bit nonplussed at first: for your *Harlequin* is such a revolution that even those who know your previous work were a little disconcerted. . . . After looking at your painting again and again, he honestly recognized that it was superior to anything you had done so far, and that it was the work he preferred to all others. Next to the *Harlequin* I placed your still life with a green background; you cannot imagine how this other work, while keeping all its splendid textural qualities, looked small in conception. . . . In your *Harlequin*, Matisse finds that the means contribute to the action, that they are equal to it, while in the still life there are only means, very beautiful but without object. Finally, he expresses the feeling that his own "goldfish" may have led you to your *Harlequin*.[4]

Rosenberg, in agreement with Matisse, gently criticizes Picasso's *Green Still Life* of summer 1914 (in which scholars have often read an echo of the 1911 *Red Studio*), adding that, in the eyes of Matisse himself, it was only upon painting his 1915 *Harlequin* that Picasso came to an understanding of Matisse's *Goldfish and Palette* of winter 1914–15 (fig. 5). And we can propose the following hypothesis: that Matisse's 1916 *Still Life with a Plaster Bust* was a move in a sequence of sharp exchanges, in a game of "tit-for-tat" between the two painters.

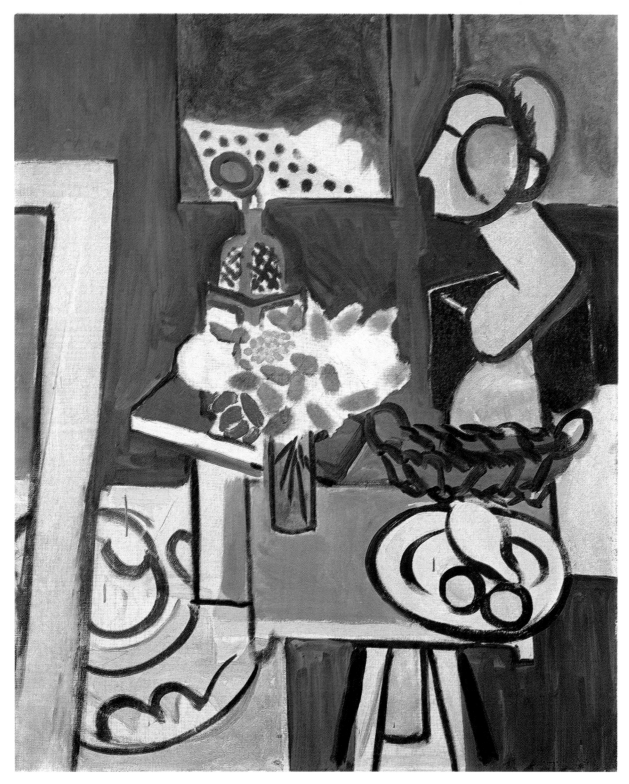

HENRI MATISSE
2 *Still Life with a Plaster Bust*, spring 1916
Oil on canvas. 39 ³/₈ x 31 ⁷/₈ in. (100 x 81 cm)
The Barnes Foundation, Merion, Pennsylvania

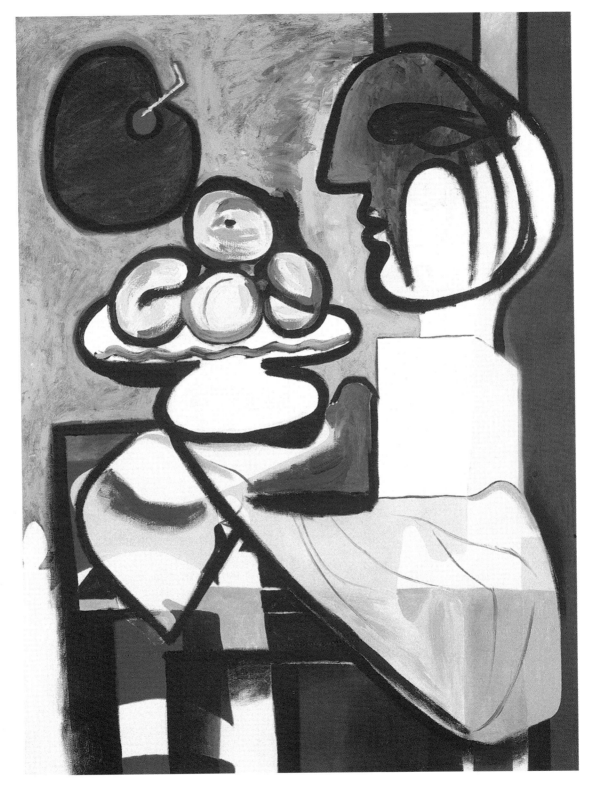

PABLO PICASSO
3 *Still Life: Bust, Bowl, and Palette*, March 3, 1932
Oil on canvas. 51 3/8 x 38 3/8 in. (130.5 x 97.5 cm)
Musée Picasso, Paris

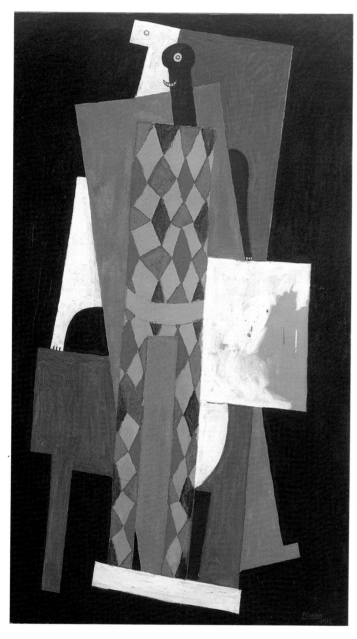

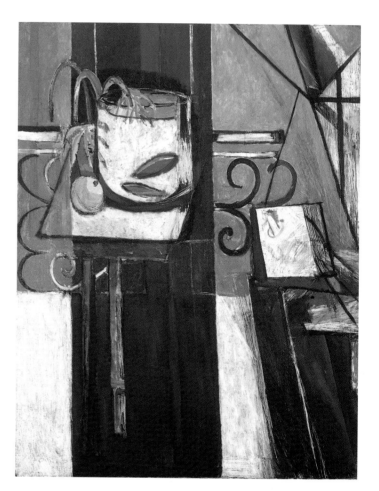

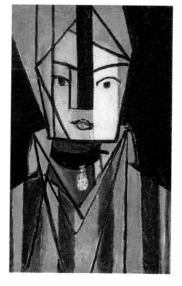

PABLO PICASSO

4 *Harlequin*, late 1915
Oil on canvas
72 1/4 x 41 3/8 in. (183.5 x 105.1 cm)
The Museum of Modern Art, New York;
Acquired through the Lillie P. Bliss Bequest

HENRI MATISSE

5 *Goldfish and Palette*,
winter 1914–15
Oil on canvas
57 3/4 x 44 1/4 in.
(146.5 x 112.4 cm)
The Museum of Modern Art,
New York; Gift and Bequest
of Florence M. Schoenborn
and Samuel A. Marx

HENRI MATISSE

6 *White and Pink Head*, fall 1914
Oil on canvas
29 1/2 x 18 1/2 in. (75 x 47 cm)
Musée National d'Art Moderne,
Paris

And the move was successful; it is patent when one compares Matisse's canvas with the earlier *Goldfish and Palette* or *White and Pink Head* [fig. 6]. The initial stages of these overworked paintings were more realistic.[5] In *White and Pink Head*, the face was gradually simplified into overlapping geometric planes; and in *Goldfish and Palette*, whose original theme was "the artist in the studio," the figure of the artist himself has been styled into a concatenation of such planes, until it almost disappears, its presence betrayed by a single thumb poking through a white plane (what is left of the palette). Common to both works is a progressive forcing of plane geometry upon the figures, as if they were being put into a straitjacket: such an imposition of a given grid, which induces an effect of transparency by superimposing planes of various size and shared contours, is alien to Matisse's usual manner. And it is with relief, no doubt, that Matisse watches Picasso dismiss, in his *Harlequin*, a procedure so hard to emulate, and come to terms with a pictorial language developed after the outburst of fauvism—the thinly painted, flat planes of vivid colors, the conspicuous use of unpainted areas of Matisse's painting from 1908–12.

In *Still Life with a Plaster Bust*, Matisse nods to Picasso, referencing the *Harlequin* in the runouts of gray paint that splash here and there, just as they do in the middle of the unpainted area of Picasso's canvas. But he is far less intimidated by the cubist method (as he understands it) than he was in *White and Pink Head* and *Goldfish and Palette*. He emphasizes an important stylistic feature of synthetic cubism—the dissociation of color and contour—that was present in the two earlier works, but he gives it a different function. In *White and Pink Head* and *Goldfish and Palette*, the device served to link all the planes in a web of projecting rays and anchor them in a claustrophobic, flattened space. Nothing of the sort happens in *Still Life with a Plaster Bust*: though the black contours are heavily accentuated—there are perhaps no thicker ones in all of Matisse's previous works—they do not weigh down on the forms, do not imprison them in a stilted network. On the contrary, they put some air in circulation. (A contour divorced or at least independent from color feels transient, in motion.) The superimposed black weave of the basket, for example, unmoored in any localized tone, softens the domination of the sculpted bust; the ambiguous translucence characterizing most of the lower left part of the canvas alleviates the intrusion of the yellow frame, a most unusual thrust in a work by Matisse—in fact we hardly even notice this intrusion, for everything else competes for our attention.

We also hardly notice the numerous orthogonals or near orthogonals that are mapping the picture as a whole. There is a cubist grid, but it now works as an agent of dispersion: like the distribution of color, or the quick gestural swirls of the black contours connecting the bust, basket, gourds, and whatever crawls on the pink background in the lower left, this grid contributes to the creation of a fluid space. In sum, Matisse, the painter of *Still Life with a Plaster Bust*, seeks to incorporate some of cubism's disjunctive language while keeping the expansiveness and decenteredness of his own best work. Using props visually as disruptive as Picasso's, he imagines spaces that fluctuate.

This, I would surmise, is why Picasso chooses to comment on this very canvas more than fifteen years later, during his Matissean spree of December 1931–April 1932. The similarities between the two pictures are extraordinary; in the unpainted areas; in the general placement of objects (Picasso's picture is far less populated, and therefore organized on a larger scale); in the simplified head and the curve of its cheek; and, at the bottom part, in the dissociation of color and contour. But the differences are even more extraordinary: while Picasso uses far fewer colors in his canvas than does Matisse, his contrasts are so electric that he needs the heavy contours to muffle them, acknowledging that the yellow/orange/red/purple modulations of the fruits would be hard to accept if they abutted directly onto the green background. And even when objects are similarly disposed in both paintings, the composition by Picasso is as much centered as the Matisse is dispersed; Picasso's black contours carry the fruit dish, the folds of the tablecloth, and the sculpted head into a sweeping X across the surface of the canvas, yet they stay away from the borders: no possible expansion there (the Picasso, though larger, feels smaller than the Matisse). Nor do we doubt that we are meant to single out the confrontation between the lifeless sentinel and the ripening fruits. Both works have a complex tangle of overlapping planes in their lower left quadrant, produced by a combination of reserved areas and independent contours; but in the Picasso, this area has become a repoussoir, causing us quickly to skim the lower half of the picture, so as to rest our gaze on bust and bowl.

To repeat: is Picasso saying something to Matisse, or settling a score, or correcting him? All of the above: he is saying, among other things, that the two of them belong to the same tradition; he is signaling that he too can use strident colors, provided he subdues their contrast with the interlarding of black between them; and he is amending Matisse's distributive mode of composition. It is interesting to note, in this context, that Picasso did not include his *Still Life: Bust, Bowl, and Palette* in his 1932 retrospective, while he packed the show with more than twenty canvases of the same eleventh-hour campaign; perhaps he felt that he had not distanced himself enough from Matisse in this picture, that any

comparison beween this work and Matisse's *Still Life with Plaster Bust* would prove detrimental to him; or perhaps he surmised that Matisse would not yet be in a position of agreeing to disagree with him; perhaps Picasso did not wish to jeopardize a dialogue that he had worked so hard to renew.

■ Dialogue

This brings us back to Kawashima's report. We know now that there was a lot at stake and that the word "understanding" is not to be taken lightly. Perhaps there is no better guide to its meaning than a definition proposed by the literary circle of Mikhail Bakhtin in 1929, in the course of expanding the notion of dialogue to every facet of social life: "Any genuine kind of understanding will be active and will constitute the germ of a response. . . . Understanding is to utterance as one line of a dialogue is to the next. Understanding strives to match the speaker's word with a *counter word*."[6]

Taking this definition of understanding literally—replacing "utterance" (or "word") with "work of art," and "speaker" with "artist"—let us undertake an experiment: what if the overall production of Picasso and Matisse were each examined exclusively in relation to the other? If we do so, the number of the utterances (works of art) appearing as responses, or as "counter-utterances," will be far greater than previously thought.

The great merit of Bakhtin's concept of "active understanding" is that it dispenses with the notion of "influence." To understand an utterance is already to respond. Furthermore, a response is always anticipated: "Any utterance . . . makes response to something and is calculated to receive a response in turn."[7] For Bakhtin and his school, an utterance always presupposes a real or imaginary addressee—which does not mean that the response will always be immediate (it could be delayed, as Picasso's *Still Life: Bust, Bowl, and Palette* demonstrates).[8]

Finally, any utterance occurs in, and is determined by, a real context. What is perhaps unique to Matisse's and Picasso's situation is that they are not only each other's primary addressee—such, at least, is the hypothesis on which our experiment is based—but also that their work constitutes the principal context of their respective utterances. With an important exception, one could write the history of the art produced in the first half of our century by drawing on Matisse and Picasso alone, which means that, when Picasso responds to Matisse, he addresses all that is not Picasso, all that does not stem from Picasso, and vice versa. The exception to this proposition is abstract art, something both artists rejected (Picasso more adamantly than Matisse)—a shared position of major consequence for the necessity and the possibil-

ity of their dialogue. This common refusal gives rise to their shared sense that they belong, though differing in age by half a generation, to the same world; it also gives them what they take to be one of their most important missions—reaching out to reactivate the past, and, in the process, anchoring our experience of modernity. In short, their dialogue is more than a private one; it is a matrix for most issues pertaining to the history of figurative art.[9]

Understanding as "response," the utterance "oriented toward an addressee," the sum of utterances as "context": these are the conceptual tools from Bakhtin's dialogical system that help us disentangle the complex and changing web of relationships between Matisse and Picasso from start to finish. By the time of Matisse's death, in 1954, the sustained exchange between the two artists had developed into a privileged colloquy, not without tones of nostalgia, each considering the other his principal interlocutor: "'We must talk to each other as much as we can,' [Matisse] told Pablo one day. 'When one of us dies, there will be some things the other will never be able to talk of with anyone else,'" reports Françoise Gilot.[10] Elsewhere—and I don't think this is due to a memory lapse—Gilot attributes the same sentence to Picasso, where he adds: "All things considered, there is only Matisse."[11] In the same vein, André Malraux recounts an irascible remark by Matisse, repeated one day to Picasso by a nun guiding a tour of the Vence chapel: "[Matisse] said to me, 'Sister, only one person has the right to criticize me, do you hear! It's Picasso.'"[12]

It would be wrong to suppose that this special understanding between the two painters characterizes their entire careers consistently. It should be noted, however, that the dialogue here at issue—in this study as in its accompanying exhibition—is conducted not between two individuals talking, but between their works of art. And in works of art as in personal conversations, a non-reply is itself a reply of sorts, if only a negative one: there are several stretches of time where Matisse and Picasso seem to ignore each other completely—even aggressively so.

It would also be wrong to suppose that we can subsume our own responses to Matisse and Picasso under the sole topic of their interaction (they converse with other artists, not necessarily the same ones, and, like all of us, with the world at large). Yet the prerogative of any experiment is to eliminate all but one parameter, so as to measure the ways and extent to which it affects a given constant: in our case, as in all dialogues, each constant—the developing work of one artist—will be the variable condition of the other.

This flexible and reciprocal situation between the two artists may have altered at Matisse's death, but the death of a speaker does not end a dialogue. Bakhtin's dialogic system helps us chart

the provisional conclusion of our experiment—the moving canvases Picasso realized shortly after Matisse died. In these works, from the *Women of Algiers* series (1954–55, figs. 223–226) begun only a few weeks after Matisse's death, to the numerous *Studio at 'La Californie'* paintings (1955–56, figs. 227, 228, 230, 231), and *Woman in a Rocking Chair* (1956, fig. 229), one can read Picasso's growing openness to Matisse's art, as if earlier caution were cast to the winds. Bakhtin notes that, for an utterance to elicit a response, it has to have ended.[13] Every work of art is an utterance per se, but when the life of an artist ends, his whole oeuvre becomes a single utterance; a reply will take on a new dimension—"understanding" becomes more inclusive, richer than before.

■ Misprision

But what about misunderstanding? Surely anyone engaged in a long-term interaction is bound to hit a wall from time to time. And what of intentional, willful, incomprehension? What about misunderstanding as a strategy—what Harold Bloom calls "misprision"? Bloom's model, developed in *The Anxiety of Influence* and subsequent books, is Oedipal for the most part, as it deals with the difficult relationships of young poets to their forebears, of sons to fathers. But even though Bloom acknowledges his debt to psychoanalysis, his model has little use for the notion of the unconscious. That the son has to kill the father in his "quest for identity" is established at the outset. Bloom concedes that the fear of "being flooded" and the sorrow of "latecoming" sometimes compels the "strong poet . . . to an otherwise unnecessary inclination or bias in his work."[14] Generally, however, his concern is not to uncover motivations, but to identify the weapon that is called forth to kill the father, and the aftereffect of the murder on the work of its perpetrator.

The weapons in question are strategies of misinterpretation. Bloom postulates that any strong reading is a misreading, that a cardinal and deliberate "error" of interpretation underpins the relationship of any strong poet or artist to the work of his or her predecessors. This primary misunderstanding of past rivals is the precondition for the poet's greatness and eventual liberation from the "anxiety of influence."

Bloom's main issue is that of legacy, of the painful coming to terms with the recent past, but his model can nevertheless be most useful when applied to the relationship of two contemporaries, especially since contemporaries can alternate roles, can sometimes be the crushing father and sometimes the rebelling son—without regard to actual seniority. As we have seen, Matisse became a recalcitrant apprentice when, for a short while, he decided to learn the language of cubism.

Despite its title, Bloom's book sets out to undermine the very notion of influence. And there is perhaps no better way to explain his point than by quoting Matisse, whose lucidity on this score was exemplary. In his very first published statement, an interview with Apollinaire whose manuscript he heavily edited, Matisse said:

> I have never avoided the influence of others. . . . I would have considered this cowardice and a lack of sincerity toward myself. I believe that the personality of the artist develops and asserts itself through the struggles it has to go through when pitted against other personalities. If the fight is fatal and the personality succumbs, it is a matter of destiny.

The interview was published in December 1907, probably not long after Matisse had seen the *Demoiselles d'Avignon* in Picasso's studio. Just to make clear which "other personality" Matisse has in mind at this juncture, Apollinaire's text alludes to the painter's ability to borrow from "all formal languages," including that of African art, whose statuettes are "proportioned to the passions that have inspired them." "But," Apollinaire remarks, "though curious to know the artistic capacities of all the human races, Henri Matisse remains above all devoted to the European sense of beauty."[15] (It adds some zest to this account to know that it was Matisse who had introduced Picasso to African art, perhaps less than a year before. Is Matisse suggesting, through Apollinaire, that Picasso has "succumbed"?[16])

Matisse has perfectly identified what Bloom's own predecessor, W. Jackson Bate, called "the burden of the past," characterizing it as the most trenchant problem facing the modern poet.[17] One might very well say that Matisse was obsessed with the issue, never tiring of quoting Cézanne's dictum ("Beware of the influential master"), adding: "When one imitates a master, the technique of the master strangles the imitator and forms about him a barrier that paralyzes him. I could not repeat this too often."[18] He was even worried, at the end of his life, about the effect of his own art on younger painters, and figured out on his own what historians of art and literature have termed the "law of the grandfather"—the idea that in order to free themselves from the intimidating accomplishments of the previous generation, artists and writers often leapfrog over parental authority.[19] Cézanne was limited by Courbet, notes Matisse, which is why he went to Poussin.[20] Matisse does not admit that he was wary of Cézanne's "influence," though it is most certainly the reason why he never made any effort to visit him at Aix, as his friend Charles Camoin had done.[21] But he often speaks of his exploration of the art of the distant past, or of non-Western civilizations, as having helped him find his way, and it is not very difficult to read between the lines: the recourse to

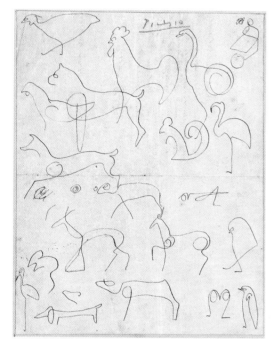

PABLO PICASSO

7 Sketch for illustration
of Apollinaire's *Bestiaire*, 1907
Pen and ink on paper.
8 ¹/₈ x 10 ¹/₈ in. (20.7 x 25.8 cm)
Musée Picasso, Paris

PABLO PICASSO

8 Sketch for *Mercure*, 1924
Graphite on paper
8 ¹/₄ x 10 ⁵/₈ in.
(21 x 27 cm)
Musée Picasso, Paris

"primitivism" and to archaism was, among other things, a way of outdoing Cézanne, and thus of getting beyond his reach.

An "influence," thus, only exists negatively (at least for what Bloom calls "the strong poet"). It is something that a "strong" artist combats even though, as Matisse says, he does not "avoid it." Not avoiding it is to find means of responding to it. The means for this response are precisely the various weapons that Bloom groups under the collective term of "creative misreading," and most of them are at work in the complicated tango danced by Matisse and Picasso throughout their careers. One of these is the corrective "swerve," or "misprision" proper, which we have noticed in Picasso's treatment of Matisse's *Still Life with a Plaster Bust.* But there are also multiple cases of "completion" in their dialogue, when one is telling the other that he has not gone far enough. A good example is provided by numerous sketches Picasso made in late 1906 or early 1907 for his (unrealized) project of illustrating Apollinaire's *Bestiaire* (fig. 7). In these drawings, where Picasso explores the rendering of an animal with a single contour, without lifting his pen from the paper, he is obviously aiming to outstrip the prodigious economy of means in Matisse's brilliant first

lithographs exhibited in March–April 1906, around the time the two artists met (fig. 9).[22] It is as if Picasso were saying: "What Matisse can do with a couple strokes, I can do with just one." (Picasso, however, was not satisfied by his attempt, and only in 1924, in works related to his stage curtain and set for the ballet *Mercure* [fig. 8], notably a series of etchings, did he make public this preoccupation for the single unbroken line).[23]

Another trope of misreading coined by Bloom is "daemonization." When Picasso is caricaturing Matisse, as happens on several rare occasions, he engages in this particular kind of put-down of his competitor's accomplishment, which also implies a self-imposed limitation on his own capacities. *Large Nude in a Red Armchair* of 1929 (fig. 10) cannot be seen but as an aggressive commentary upon Matisse's odalisques, particularly *Odalisque with a Tambourine* of 1925–26 (fig. 11), from which it directly borrows the pose. But in parodying his elder, Picasso is obliged to take into account parts of Matisse's system he would have been better off ignoring. The distribution of a decorative motif, for example, is very inefficient in Picasso's painting—the flowers of the wallpaper do not fulfill the role that they have in a Matisse,

HENRI MATISSE
9 *Back View of a Nude with Necklace*, early 1906
Lithograph
16 1/8 x 10 3/4 in. (45 x 27.9 cm)
The Baltimore Museum of Art;
Blanche Adler Memorial Fund

that of preventing our gaze from resting on the figure, and they appear quite vain, to everybody's loss. Daemonization, in Bloom's view, is a "self-crippling act,"[24] which is why Matisse and Picasso will have little recourse to it: their role is to keep the tradition of painting alive, not to smother it under a reciprocal assault.

Finally, what I called the conclusion of our experiment, the grand finale of the *Women of Algiers* (figs. 223–226), the *Studio at "La Californie"* paintings (figs. 227, 228, 230, 231) and *Woman in a Rocking Chair* (fig. 229), can perhaps be best accounted for through Bloom's last figure (somewhat pompously labeled "The Return of the Dead" or "apophrades"), in which the "uncanny effect is that the new poem's achievements make it seem to us, not as though the precursor were writing it, but as though the later poet himself had written the precursor's characteristic work."[25] Bloom's terminology being unduly arcane, there is no need to follow him to the letter, but the heuristic value of his mode of thinking is worth acknowledging, and carrying the notion of "anxiety of influence" into the battlefield of sibling rivalry can be extremely productive.

■ Rivalry

The mention of rivalry brings us to a third avenue of interpretation, proposed by René Girard in *Deceit, Desire and the Novel*.[26] Girard does not concern himself with the relationship between authors or artists but with that between fictional characters. His object is the structure of desire in the novels of Cervantes, Flaubert, Stendhal, Proust, and Dostoyevsky, where he detects a triangular relationship whose motto could be: "I only desire what the other desires, I only desire through the desire of the other, whom I thus try to imitate." This other, whom Girard calls the "mediator," can be entirely imaginary (the mediator of Don Quixote is the knight of chivalry epics; that of Emma Bovary is the heroine of Romantic love stories). But, in the evolutionist taxonomy elaborated in *Deceit, Desire and the Novel,* the distance between the desiring subject and the "mediator" gets smaller and smaller. After the hallucinations of Don Quixote and the fantasies of Emma Bovary, Girard analyzes the psychological motivations of the Vain character in Stendhal's novels, of the Snob and the Jealous in Proust's, and he concludes his study with the extraordinary case of Dostoyevsky's Eternal Husband, who cannot desire marrying a woman before he has pushed her into the arms of his rival (who had already stolen his first fiancée) and made sure that this rival will seduce her.

Of course, we cannot apply Girard's model without qualification. But even a brief survey of Picasso's and Matisse's careers enables us to perceive Girard's triangular structure in their mode of exchange, especially when, as in Dostoyevsky's story, it takes the form of a "gift." A gift implies a counter-gift, anthropologists tell us, which means that the giver dominates the receiver until the latter reciprocates with a larger gift.[27] Girard's model does not contradict this concept, but in his triangulation of desiring subject, mediator, and object of desire, the latter is the least important term. I give in order to induce in the other (the mediator, who receives my gift) a desire that I shall then wish to imitate. Sometimes (*contra* Girard?), this mimetic desire will simply peter out. Matisse "gave" African art to Picasso without returning much to it himself after having enflamed his rival. Perhaps Matisse lost interest because Picasso, tired of endless comparisons between his work and African art, soon began disclaiming any interest in it himself. (His famous answer to an enquiry—"L'art nègre, connais pas" ["African art, don't know anything about it"]—dates from 1920, but William Rubin suggests that Picasso's exasperation started much earlier.)[28] Let us note, however, Françoise Gilot's remark: "At least in front of Matisse, [Picasso] did not welcome discussions on that topic, and he dropped the subject if by any chance it was brought into the conversation"—which suggests that Matisse, long after the fact, still wanted to receive an "IOU."[29]

On another occasion, Matisse's behavior seems strangely similar to that of Dostoyevsky's Eternal Husband: in 1907 or 1908 he brought the Russian collector Sergei Shchukin to Picasso's studio—at the risk of losing the collector's support for his own work, just as he had lost or was about to lose the admiration of Gertrude Stein. It was a courageous move, for we know that Matisse never was overconfident, but it also might indicate that, for him, ranking high in a collector's pantheon didn't mean enough unless Picasso was nearby.

There are countless similar examples, such as this one from the early fifties, also recalled by Françoise Gilot, who describes how Picasso's appreciation of his own *Winter Landscape* of 1950 (fig. 207) grew after Matisse, to whom he had brought it in order to get feedback, had put the painting on the mantelpiece and offered to acquire it through barter. (In the end, the negotiations collapsed because Picasso kept upping the ante.)[30]

These gifts, or exchanges of objects, are only the anecdotal signs of an intense competition. Picasso, proudly speaking of Matisse's *Portrait of Marguerite* (which he had received in trade in 1907 from its maker), would tell Pierre Daix: "You've got to be able to put side by side everything Matisse and I were doing at that time. No one has ever looked at Matisse's painting more carefully than I; and no one has looked at mine more carefully than he."[31] The intensity of this mutual gaze, which often led them into directions they would not have taken if each had elected another

HENRI MATISSE
11 *Odalisque with a Tambourine*, 1926
(*above*) Oil on canvas
29 1/4 x 21 7/8 in. (74.3 x 55.7 cm)
The Museum of Modern Art, New York;
The William S. Paley Collection

PABLO PICASSO
10 *Large Nude in a Red Armchair*, May 5, 1929
(*left*) Oil on canvas
76 3/4 x 51 3/4 in. (195 x 130 cm)
Musée Picasso, Paris

emulator, was motivated by what Girard calls "mimetic desire." Matisse acknowledged it in 1941 when, reminiscing about his first patrons, he declared to Pierre Courthion: "The Steins were also buying Picassos. Picasso's painting interested me very much. One day, meeting Max Jacob on one of the boulevards, I said to him 'If I weren't doing what I'm doing, I'd like to paint like Picasso.' 'Well,' said Max, 'that's very funny! Do you know that Picasso made the same remark to me about you?"[32] And this mimetic desire can induce not only stylistic appropriations, but also a territorial tug of war. The best example of this is provided by Picasso's 1952 *War* and *Peace* murals in Vallauris (figs. 209 and 210), an ensemble prompted by Matisse's Vence chapel, just as Matisse himself had previously been stung by the public success of Picasso's works at the Palais Grimaldi in Antibes, a tit-for-tat exchange that struck early commentators.[33]

This brings us back to the dialogue as envisioned by Bakhtin, and we will see that this responsive system often determines how the works of Matisse and Picasso converse. The advantage of rapid response is that it inhibits resentment, as Max Scheler brilliantly demonstrated, almost eighty-five years ago, in *Ressentiment,* his great book on the affliction that plagues rivalry.[34] By answering a rival immediately, "tit-for-tat," envy does not fester into hatred.

■ Chess

Picasso's and Matisse's rejoinders, however, were not always fast-paced, and a more apt metaphor may be in order. It has to imply a ludic form of exchange, so as to remind us that resentment is, with rare exceptions, kept at bay. The ideal model, involving both a competitive rivalry and a complex temporality, not to speak of an extreme variety in the form of the repartees themselves, seems to me to be provided by chess, as it has been applied to art historical issues by Hubert Damisch.

Indeed, Damisch stresses two characteristics of chess that, to my mind, pertain to our experiment: "At any time during a chess game the distribution of pieces on the board can be considered either the product of a given history (the succession of moves from which it results) or a 'position'—in other words, a system—which contains all the necessary and sufficient information for the player whose turn comes next to be able to decide a move in an informed manner."[35] In short, the model chess provides is both linear and simultaneous, diachronic and synchronic. It emphasizes the inherent structure of any strategic game—the delimited field governed by a certain number of rules—and the historical component of that structure. It helps us grasp that, as Heinrich Wölfflin wrote long ago, "not everything is possible at all times in

the visual arts. Not all thoughts can be thought in all periods."[36] On Matisse and Picasso's chessboard, for example, abstraction is not allowed—it is excluded at the outset. But such limitations apply also at the level of specific moves. Combining the chess model and that of Bloom, imagine that "swerve," "completion," or "daemonization" are the equivalents, respectively, of the crooked march of the knight, the straight advance of the rook, and the oblique moves of the bishop. It is obvious that not every piece can be summoned at any time by a chess player; similarly, "completion" might not be the best move when one is in a weak position, and "daemonization" might be out of the question at certain times (Picasso deliberately avoided it in his posthumous reply to Matisse's last move); conversely, "swerve" might be an ideal maneuver out of a tight spot.

The advantage of the dynamic model of chess over a static binary opposition is considerable. The comparison of Picasso and Matisse to the North and South Poles has stuck in the literature ever since Fernande Olivier coined it in her 1933 memoirs.[37] While it is not without interest in its suggestion of expanse, the metaphor conveys a sense of insuperable fixity. It says that Matisse and Picasso always point their respective compasses in opposite directions.

Critics had not waited for Olivier to cast the two artists as antipodal, and John Elderfield has published a useful tabulation of the numerous clichés that emerged early on from such a dualistic classification.[38] A quick look at the distribution of qualities and attributes, neatly arranged by Elderfield in vertical, parallel columns, reveals the inadequacy of this frozen opposition (which was, of course, part of Elderfield's point): it is impossible to maintain, for example, that Picasso's art is always "monochromatic," "difficult," and geared toward "dissonance," while Matisse's is "colorful," "facile," and "harmonious." Their respective works may be describable in this way at times, but even a superficial examination of their art quickly reveals that these qualities often shift side from one artist to the other. What the bipolar structure does not allow is an account of those shifts, why and when they occur, and how they are answered.

This is exactly where the chess model helps us, because, as Damisch stresses, it implies temporality. First: at any given moment of a game, the actual configuration of the pieces on the board is the result of previous moves in that particular game. Second: a player, particularly a champion, is able to summon from his memory bank all other moves already tried by other players (including his partner-opponent) in a similar situation. In other words, the chess model involves both recent history and long duration. It makes us grasp how the past can be reactivated in the

present and gives a dynamic twist to delayed reactions. Picasso's *Still Life: Bust, Bowl, and Palette,* constitutes, as we have seen, such a delayed reaction, and we shall find many more instances, particularly during World War II, when the two artists had very little contact. And just as a chess player can draw from the past to calculate his own moves, he can use it to anticipate what his partner is going to do. Examined in this light, remarkable similarities such as that of Picasso's *Games and Rescue on the Beach* (fig. 74) and Matisse's 1933 *The Dance* for the Barnes Foundation (fig. 70) cease to be mystifying. Even though Picasso painted his canvas in November 1932 without having seen anything of Matisse's work for his Barnes mural, done in the seclusion of his Nice studio, he knew that Matisse was frantically trying to complete it, and he knew that the theme was dance. He had enough elements to imagine what Matisse's move would be, and thus to attempt topping it.

"You've got to be able to put side by side everything Matisse and I were doing at that time." Picasso's advice is a curator's dream. And it is, with one major adjustment, the dream that presides here. The adjustment is that the present book will not treat in detail the period Picasso had in mind (that is, the early part of his and Matisse's careers), mostly because their artistic dialogue in these years has already been well studied. By comparison, very little has been written about their later relationship.[39]

The exhibition that accompanies this study and is the practical part of our experiment will thus only concern the second round of the interaction between Matisse and Picasso, which began in the early thirties after a long interruption. But in limiting the corpus (if one can speak of Matisse's and Picasso's production during a quarter of a century as a limited corpus), we hope to allow for more intense scrutiny.

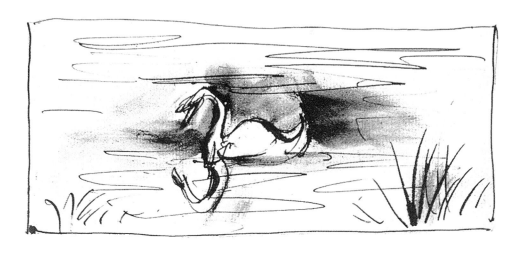

PABLO PICASSO

12 *The Scorpion/Swan*, 1935
Ink and gouache on paper
Association-Fondation Zervos, Vézelay

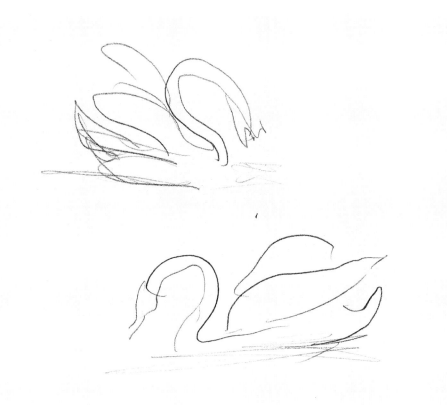

HENRI MATISSE

13 *Swan*, 1931
"Mallarmé" sketchbook
Pencil on paper
5 $^3/_8$ x 7 $^1/_8$ in. (13.5 x 18 cm)
Private collection

FOREIGN LANGUAGES

—

■ Seeing as

In 1968 at the age of eighty-seven, Picasso, seeing the reproduction of a still life he painted in 1895 at the age of fourteen, told his friend the poet Rafaël Alberti the following:

> I remember that picture as if I had done it yesterday. Do you see the grapes? While I was painting, I ate all the ones on the other side, the side that doesn't show in the painting. In other words, the only grapes left are the ones you see. In a certain sense it was a Herculean task, to arrange this bunch of grapes so that I could paint them as if I hadn't eaten a good half of them.[40]

And in 1942, when asked "Do you forget your works?", Matisse, at the age of seventy-three, offered this reply:

> Never. Although working every day for fifty years, I have painted quite a few. Whenever someone speaks of one of my pictures, even an old one, in calling to mind some of its features, without being able to remember the year I did it, I see very precisely the state of mind [*le moment sentimental*] I was in when I made it, and all its colors, as well as its place in my total work.[41]

Both artists, then, had total recall of their work. But the similarity ends there, and the anecdotes show something antithetical in their thinking. Eating half the grapes of a still-life arrangement would have been uncharacteristic of Matisse; he could not have gone forward with the picture. He could not have forgotten that the grapes were just a façade, and he would have lost interest in them.

Here are some examples of the Matissean way:

Speaking of several still lifes of oysters painted at the end of 1940, Matisse notes that he required freshly opened oysters each session: they had to have the right luster and smell, for it was his appetite that he wanted to render.[42] Again, when Etta Cone told Matisse that she liked his odd 1920 canvases representing a lump of fish lying on the beach at Etretat, but that she did not "want dead fish in [her] drawing room," Matisse replied that "they were not dead. I hired a boy with a sprinkling can to water them every half

hour."[43] He needed the fish to be shiny and squiggly, just as they were when he saw fishermen laying their catch down on the sand.

Matisse, in effect, needs the full presence of the object or motif, a materiality that prompts his initial impulse to paint or draw (this is less crucial in the case of sculpture). He needs to involve his whole perceptual apparatus, so as to "identify with" his motif. Painting from a hired model, he has to get very close, his "eyes less than a meter away from the model and knees within reach of her knees."[44] Like St. Thomas, he could not believe his eyes alone—hence his mistrust of impressionism.[45] To possess this full presence takes time; rendering something on canvas requires a slow impregnation of the senses—and the "presence" of a subject can be lost. Speaking of a work for which he had great expectations, Matisse writes to his son Pierre:

> Unfortunately my model, a beautiful eighteen-year-old Sicilian peasant, just won a beauty contest, and this went to her head—she's learning to dance exotic dances, like the rumba, etc., to dance in nightclubs. She was as beautiful as a fruit, so fresh that it was a pleasure to watch her. Now I wonder if she does not party all the time, because she has lost her colors and her healthy character. I don't know how to go on with my work, which was all about what she has lost.[46]

The slow soaking process is always the same: there is no difference, says Matisse, between painting a flower, a woman, an armchair, or a view from the window. This shocked Picasso. Matisse once told him, "When I'm through with a model, I just dismiss her, as I would an apple or a bunch of flowers." "But one can't do that," Picasso commented, "one can't treat a woman like an apple."[47] Of course, this statement can hardly be read as an expression of commiseration for the discarded model. But it makes sense as a symptom of incomprehension, for Picasso was not in the least interested in "identifying" with his motif or model.

It is not "identification" that Picasso is after, but interpretation: to paint anything, he has to "see" it first as something else. This process of transcoding is most obvious in his portraits.[48]

HENRI MATISSE
14 and **15** *Iris and Lips*, 1945
Sketchbook
Ink on paper
9 1/2 x 7 1/2 in. (24 x 19 cm)
Private collection

Françoise Gilot, whom Picasso drew and painted innumerable times, recalls that she only posed for him twice. The first session failed, and he tore up the drawings. For the second session, he asked her to pose in the nude:

> Pablo stood off, three or four yards from me, looking tense and remote. His eyes didn't leave me for a second. He didn't touch his drawing pad; he wasn't even holding a pencil. It seemed a very long time. Finally he said, "I see what I need to do. You can dress now. You won't have to pose again."[49]

Picasso sees "Gilot-as-flower," and this image, celebrated in *Woman-Flower* of 1946 (Z. XIV, 167), stays with him to the point of annoyance:

> Over the months that followed, Pablo worked on other portraits of me. He seemed greatly interested in doing a different kind of head, using a different symbol, but he kept coming back to the oval moon-shape and the plant forms. It exasperated him. "I can't do a thing about it," he said. "It just wants to be represented that way."[50]

The metaphoric seeing-as is essential to Picasso's art: it is why the surrealists thought him one of their kind. In his study of Picasso's poetry, André Breton singles out a line: "The swan on the lake plays the scorpion in its own way."[51] The accompanying drawing (fig. 12), dating from November 1935, can be seen as a direct response to Matisse's illustration for Mallarmé's poem "The Swan" (fig. 65) and even more to the preparatory drawings exhibited in February 1933. In numerous sketches for his etching of the swan, Matisse concentrates on the elegant movements of the bird, and on the pattern of feathers on the wings, but even when a swan that Matisse sketched in a park was "playing the scorpion," he simply could not "see" this, overlooking the reflection in the water (fig. 13). Matisse, indeed, cannot "see as." It is so unnatural to him that when surprised by the similarity between the curves made by the petals of an iris and by lips, he takes the trouble to jot down the word "*analogie*" in his sketchbook (figs. 14, 15). And he was certainly conscious of his resistance: concerning the face of an Inuit woman that he drew (exceptionally) from a photograph, Matisse told a visitor: "You see this smile, it looks like a fish. But I did not want to do a smile that would be a fish, that's Surrealism. . . . I did a smile and it so happens that it looks like a fish."[52]

By contrast, Picasso can only paint Gertrude Stein's face when he "sees" it "as" a mask. He labored over the portrait for months, with the American writer posing for hours at a sitting. Dissatisfied with the face, he erased it before departing for a summer vacation in Spain. There, under the spell of archaic Iberian sculpture, he suddenly saw Stein "as." Upon returning to Paris he painted in the face without hesitation, and in the absence of a model. Work on the extraordinary 1906 *Portrait of Gertrude Stein* liberated Picasso from the constraints of presence: in the process of painting this portrait, he hits on the metaphorical proclivity of his pictorial language. In the subsequent *Demoiselles d'Avignon,* and throughout the adventure of cubism, he explores it further. He gradually discovers something that came to be known, through the writings of Ferdinand de Saussure and his fellow linguists, as the "arbitrariness of the sign": they assert as a principle that signs do not arise by imitating the things they refer to, but by differing from other signs within a linguistic system. Signification is "oppositional": a word becomes meaningful as it opposes other words in a language. For Saussure, the meaning of signs depends upon context—first and foremost upon the context of the language in which those signs occur. This principle, transposed to the realm of a representational sign-system such as figurative painting, governs the placement of signs and the art of their spatial combination. The basic configuration of the human face, for example—with its bilateral symmetry, its pairing of eyes and ears, its nose, mouth, and hair—can be altered in any number of ways and still be read as a face. But to what extent can the figure be altered? Can the features of a face be dissociated and recombined according to a nonmimetic "syntax," with the basic figure still being read as a face? If a mouth is located in the place of an eye, do we read it as an eye or a mouth? What is the limit of legibility? These are among the questions that cubism addressed head-on.[53]

Picasso never misses an opportunity to underscore the combinatory nature of his sign system. Its simplest demonstration occurs in the famous 1942 sculpture of a bull's head (Spies 240), with the combination of a bicycle seat and handlebars producing the image. Nothing shows better than this sculpture how the remarkable economy of Picasso's semiological system issues from a conversion of metonymic signs (of fragments, which are the stuff of collage or assemblage) into metaphor. And Picasso accentuates the transient, migratory existence of these signs—the fact that they have no direct, immediate link to anything their combination might picture. When two identical marks refer to two entirely different things in a single cubist collage (the contents of a glass of beer and the stem of the same glass, the body of a violin and its shadow), we are invited to admire the transmutability of signs.

Just as Picasso could never understand what Matisse meant by "identification" with the model, Matisse had little empathy for Picasso's semiology. He wanted the beholder of his painting to feel an effect similar to that produced on himself, while he was paint-

ing, by the thing depicted. Picasso's rebuses, his elusive treasure hunts, were never accessible to him. Christian Zervos recalls a visit Matisse paid to Picasso's studio on the Boulevard de Clichy during the heyday of cubism:

> [Matisse] was shown a picture and asked if he understood it, if he saw what it represented. When he answered in the negative, Picasso went to fetch a mustache and applied it to the canvas, at which point Matisse started to detect a pair of eyes, a tie, etc. And Picasso explained that they [he and Braque] had wanted to free themselves from nature. The sudden addition of a determined object should be enough to allow a reading, analogically, of the whole picture. But Matisse would not let himself be convinced, and he replied that the colors and the canvas itself should be the only tools the painter needed.[54]

Although Zervos interprets Matisse's reluctance as a condemnation of collage, what he really rejects is the semiological principle at the heart of collage, the one whereby, following certain combinatory rules, anything can be made into a sign for anything else. What Matisse rejects is the lack of immediacy that this principle entails—the fact that a sign system presupposes a code (even if the code is different for each painting) and thus a decoding. Nothing could be more foreign to Picasso than Matisse's concept of the sign, as conveyed, for example, in what Matisse said to Aragon about his drawing of trees:

> I have to learn, patiently, how the mass of the tree is made, then the tree itself, the trunk, the branches, the leaves. First the symmetrical way the branches are disposed on a single plane. Then the way they turn and cross in front of the trunk. . . . Don't misunderstand me: I don't mean that, seeing the tree through my window, I work at copying it. The tree is also the sum total of its effects upon me. There's no question of my drawing a tree that I see. I have before me an object that affects my mind not only as a tree but also in relation to all sorts of other feelings. . . . I shan't get free of my emotion by copying the tree faithfully, or by drawing its leaves one by one, but only after identifying myself with it. I have to create an object that resembles the tree. The sign for the tree.[55]

A sign that would be able to render a full presence, without mediation: this is a contradiction in terms, for a sign is always predicated on the absence of its referent; it is, by essence, a substitute. Matisse knew that he sought what, upon closer examination, looked like a logical impossibility, and he sometimes felt immensely frustrated. Once, in front of a blue wall that had impressed him in Tangier in 1912 or 1913, he regretted not being able to render in painting the "sensorial intensity" of the blue color. To Gino

Severini he once confided that, in order to "discharge himself from the sensation of blue that dominated all others, he would have had to paint his whole canvas blue, like a wall painter."[56] He would have had to produce a monochrome. Nothing could be more opposed to the conception of the picture as a combination of signs than such an undifferentiated field of pure color. Matisse, one might say, was a phenomenologist, and Picasso a structuralist.

■ The Matisse System

As a pictorial strategy, the monochrome would not be available until the 1920s, and would not develop until after World War II. Matisse, in any case, would never have found it acceptable. But if he was opposed to the very idea of a system of arbitrary signs, he nevertheless invented a system through which he could convey the type of rush, the inarticulate flood, that he had experienced in Tangier. This system, highly articulate, rests on two equations. The first of these—coined by Matisse himself—is "quality = quantity"; the second could be written as "circulation + tension = expansion" (though the order of the terms is interchangeable). A brief review of this system is called for.[57]

In 1906, shortly before painting *The Joy of Life* (*Le Bonheur de vivre*) (fig. 175), Matisse has a revelation, which he refers to, directly or indirectly, in all his published essays and in most of his interviews. It can be summarized by this statement: "One square centimeter of any blue is not as blue as a square meter of the same blue."[58] The fact that color relations are above all surface–quantity relations has many immediate implications in Matisse's art. The most important, historically, is that the traditional opposition between color and drawing is suspended: since any single color can be modulated by a mere change of proportion, any division of a plain surface is in itself a coloristic procedure. "What counts most with colors are relationships. Thanks to them and them alone a drawing can be intensely colored without there being any need for actual color," writes Matisse.[59] Which is why, as he immediately adds, "It is not possible to separate drawing and color."[60] Hence his great difficulty with the cubist dissociation of these two elements (and, at the same time, his fascination with Picasso's ease in making the dissociation).

Other principles of the Matisse system also unfold from the quality–quantity equation, and I will sum up three of these. The first principle concerns the all-over nature of Matisse's best works. Since the particular color accord (and thus the mood) struck by a painting or drawing results in large part from the differences in quantity between the surfaces, it is impossible to work without also considering the totality of the surface to be covered. The second principle places scale at the center of Matisse's art: once the quality–quantity equation is admitted, it is impossible to enlarge any composition, to

square up any drawing. A picture has to be worked at its own definite size, by which—to speak like Barnett Newman, perhaps the only painter fully to follow Matisse on this score—one can "transcend size for the sake of scale."[61] The third principle brings us directly back to the issue of color: since modulation is now a function of surface proportion, traditional modeling would be not only redundant but hampering. Furthermore, the Matisse system signals the end of color values as distinct and fixed entities. Any color can perform any given job: even black can be the color of light.

Matisse, in order to "transcend size for the sake of scale," wants an art that expands, that swells. As Frank Stella once noted, we always remember a Matisse (that is, a pre-1917 or post-1930 work) as being larger than it really is.[62] Matisse's scale, based on a small number of flat planes, is always large, whatever the actual size of the canvas. This expansive feeling precludes any use of the traditional devices of spatial notation, such as perspective or modeling, which would hollow out the picture in depth and thereby tone down the lateral extension of scale. The best of Matisse's canvases are tensed to a maximum, like the membrane of a balloon ready to explode. (Picasso knew this very well: "Matisse has such good lungs," he used to say.)[63] This overall tension is enhanced by the economy of Matisse's art, no less radical than Picasso's ("Everything that is not useful in the picture is harmful").[64] It is the product of a total democracy on the picture plane, of a dispersion of forces: our gaze is forbidden to focus on any particular area of the picture. And it is from this all-over conception of the canvas, itself a function of the quality–quantity equation, that Matisse's notion of expression unfolds. As he states in his famous "Notes of a Painter" of 1908:

> Expression, for me, does not reside in passions glowing in a human face or manifested by violent movement. The entire arrangement of my picture is expressive: the place occupied by the figures, the empty spaces around them, the proportions, everything has its share.[65]

Since his goal is to condense in the painting or drawing all his sensations (once again, not only visual), Matisse proposes a visual equivalent of this sensory diffraction: he renders the diffusion of his gaze, placing the periphery in the center of his picture and making it impossible for our eye to come to rest. He sets out to blind us, so to speak, to work below the threshold of perception and slip into the subliminal. We never notice, for example, how unfinished, almost botched, are the hands of Matisse's figures in so many of his portraits. We could call his aesthetic an aesthetic of distraction. It precludes centering, which is to say, once again, that it is incompatible with Picasso's treasure hunt.

■ Early Skirmishes

Given the many antagonisms between their respective systems, it is a mark of their critical intelligence that Matisse and Picasso should have been so preoccupied with each other's achievements. The fascination begins when Matisse posits, in his *Joy of Life,* the two equations central to his art.[66] To the clashing quotations by *The Joy of Life* of all periods of Western art, and to the "primitivist" deformations of Matisse's early 1907 *Blue Nude* (fig. 156), Picasso directly responds in the summer of 1907 with the *Demoiselles d'Avignon* and *Nude with Drapery* (State Hermitage Museum, St. Petersburg). Matisse soon replies in turn with his exceptionally austere *Bathers with a Turtle* (1908, The Saint Louis Art Museum) while Picasso prepares a further response to Matisse's airy system in his compact *Three Women* (1908, State Hermitage Museum, St. Petersburg). This last canvas in its turn prompts Matisse to recast his answer to the *Demoiselles* with his daunting *Music* of 1910 (also at the Hermitage). Thereafter, both painters explore more or less independent concerns—Picasso his ongoing inquiry into the arbitrariness of the sign, Matisse the function of decorative profusion.

In 1912, when cubism is celebrated as the most advanced pictorial style of the time, and Picasso is crowned as its king, Matisse repairs to Morocco on two consecutive (and sulky) trips. Returning from his second journey, in February 1913, he decides to give cubism a try. Shortly thereafter, Picasso in turn explores Matisse's language—the 1914 *Green Still Life* and the 1915 *Harlequin* (fig. 4) being the major moments of this undertaking, as Matisse himself remarks (see p. 11 above).

Matisse's foray into cubism lasts four years, during which he produces some of his most arresting canvases, notably *The Piano Lesson* (fig. 27), *The Moroccans, Bathers by a River* (fig. 24), and *Still Life with a Plaster Bust* (fig. 2). But he soon realizes that the cubist idiom carries an inherent danger, one that Picasso himself identified in 1910, and which he definitively fended off in 1912 through the invention of collage. This danger was abstraction. Matisse—in *French Window at Collioure* (1914, Musée National d'Art Moderne, Paris), *The Yellow Curtain* (1915, The Museum of Modern Art, New York), and *Shaft of Sunlight, the Woods of Trivaux* (1917)[67]—comes close to a purely abstract art. He pushes the geometry of cubism to an undecipherable degree of distillation—impervious to the metaphoric migration of signs structuring the cubist picture and its open-ended reading. It is an outcome that he cannot accept.

The Music Lesson (fig. 16), realized the same summer as *Shaft of Sunlight,* is Matisse's farewell to cubism. And as Matisse himself remarks in a letter to Charles Camoin, this picture is a remake of

The Piano Lesson of the previous year (fig. 27).[68] In *The Piano Lesson,* Matisse had, in fact, paid a limited tribute to the cubist multiplication of analogies—the echo between the metronome and the shadow on the piano player's head is among the most famous formal rhymes of modern art; and there he also adopts one of the most daring of Picasso's strategies—namely the direct, confrontational mode of address in the staring glare of the *Demoiselles.* In *The Piano Lesson,* Matisse's son Pierre, at the piano, looks straight at us. But the eerie atmosphere of the painting, akin to that of De Chirico's empty cityscapes, and reminiscent of the 1910 *Music* in its stillness, is more a response to cubism than an incorporation of its tongue. Did Matisse feel that he was going in circles? That, after years of arduous labor, he had not advanced much his position on the chessboard? Or did he realize that Picasso, by then fully engaged in his neoclassic venture and his work for Diaghilev, had left the chessboard? Did Matisse take this temporary vacation for a definitive departure?

Matisse says farewell to cubism; but in so responding, he paradoxically takes leave of himself, and of what I have called his system. Regressive features of *The Music Lesson* include the return of modeling, of a more realistic mode of depiction, and to a certain extent, of centering: we are invited to watch a scene with relatively stable coordinates. The odd discrepancies of scale in the representation of its various figures still distinguish this canvas from a genre scene of the impressionist or post-impressionist kind (a direction that Matisse will vigorously pursue shortly thereafter). But his system of diffraction, giving rise to so many brilliant works after *The Joy of Life* (1906), is gone. *The Music Lesson* has a focus—the sculpted *Reclining Nude I (Aurora)*—and though the windowed view, with its luxuriant vegetation and its arabesques, still belongs to the Matisse system, it is also a view that recedes.

A few months after completing this canvas Matisse settles in Nice, rethinking impressionism. Until 1930 or so, he has nothing to communicate to Picasso. And when Picasso returns from his neoclassical excursion initiated by his departure for Rome in 1917, he finds that his partner is gone, vexed perhaps at having been ignored just as he was moving so close.

HENRI MATISSE
16 *The Music Lesson*, 1917
Oil on canvas. 96 3/8 x 79 in. (244.7 x 200.7 cm)
The Barnes Foundation, Merion, Pennsylvania

PABLO PICASSO

17 *Woman with a Tambourine (L'Odalisque)*, 1925
Oil on canvas
38 1/4 x 51 1/8 in. (97 x 130 cm)
Musée de l'Orangerie, Paris

LATE TWENTIES: THE STAGE

■ An Old Lion?

On June 13, 1926, Matisse writes to his daughter Marguerite: "I have not seen Picasso for years. . . . I don't care to see him again, . . . he is a bandit waiting in ambush."[69]

What prompted this bitter remark to his daughter? Did she irritate him by asking whether he planned to see a heralded exhibition of Picasso's work, set to open at the Galerie Paul Rosenberg on June 15? If so, the show itself would have irritated him even more: Picasso—fueling the trite view of his "eclecticism" as a kind of highway robbery[70]—infringes explicitly on Matisse's terrain in this show. And he does so in particular with a 1925 painting that bears the Matissean title of *L'Odalisque* in the exhibition catalogue (fig. 17)[71]. Picasso most certainly approved of this title, for he played a major part in organizing the show—his first in years.[72]

L'Odalisque, immediately purchased by Paul Guillaume—an ardent supporter of Matisse's early Nice period, who gave the work the new title of *La Danseuse au tambourin*[73]—is a textbook instance of the cubist principle of the analytic dissociation of color and contour. But with its oppositions of turquoise, purple, pink, and black (soft-pedaled slightly by browns and yellows), and its elliptical allusion to the decorative pattern of a skirt (animating the surface with sharp tricolor highlights—red/white/blue—against the black), this picture treads, more than ever, on Matisse's own turf.

Another riddle arises: had Matisse already completed his own *Odalisque with a Tambourine* (fig. 11) by the June opening of the Rosenberg show? This painting, assigned to the winter of 1925–26 by John Elderfield, is reproduced full-page in the September 1926 issue of *Cahiers d'Art.*[74] Matisse submitted it to the Salon d'Automne of that year (November 5–December 19, 1926), and whether or not he saw the Picasso at the Rosenberg exhibition in the summer, the prompt publication (and exhibition) of this painting amounts to a sharp reply. Picasso had told Matisse, as it were, that one could paint odalisques in flat planes of clashing colors, and that if he, Matisse, really wanted to stick to the traditional modeling to which he had returned after 1917 or so, then he would forfeit any copyright on his own earlier style. In *Odalisque with a Tambourine,* Matisse replies to Picasso with a burst of color that makes Picasso's chromatic acidity look pale; he adopts a technique that Picasso often uses, a black ground that electrifies the hues. Never in his early Nice period had Matisse summoned such a saturated vermilion, such vivid yellows applied by the palette knife with such determination. His modeling is also exaggerated; the flesh of his nude comprises a multitude of tonal modulations, from near-white to light brown, with excursions into mauve, and even into green, the whole being treated with a consistent value distribution and a well-established, single source of light. It is as if Matisse were saying to Picasso that no, he was not yet an "old disheartening and disheartened lion" (as André Breton had called him a few months earlier[75]), that he was still a master colorist with quite a few tricks up his sleeve, that the uniting of Corot's sculptural modeling with Redon's color saturation in a single canvas was no small achievement, and that he could produce effects as dazzling as he ever had in his pre-Nice idiom.[76]

But though Matisse may have wished not to admit it, he knew that he could not continue long in the manner in which he had worked from 1917—that it was wearing out. His first attempt to move forward is much remarked upon by the press. In June, during the Picasso exhibition, Matisse shows, at the Salon des Tuileries, the great *Decorative Figure on an Ornamental Ground* of 1925–26, his first radical departure from the style of the early twenties (fig. 211). Coming two years after his last solo exhibition in May of 1924—perhaps the most dogmatic manifestation of his Nice neoclassicism—this painting is quite a surprise: admirers of his recent odalisques, such as Jacques Guenne, barely hide their discomfort, criticizing the anatomic disproportions of the nude and the stylistic discrepancy between figure and background.[77] Others, such as Georges Charensol, are won over:

> Matisse, who has given for several years so many reassurances to the partisans of hedonism, wanted, it seems, to surprise us; it does not displease us—quite the contrary—that a painter so fully accomplished in his métier, and one who has long accustomed us to perfectly harmonious realizations, should once again embark on new adventures.[78]

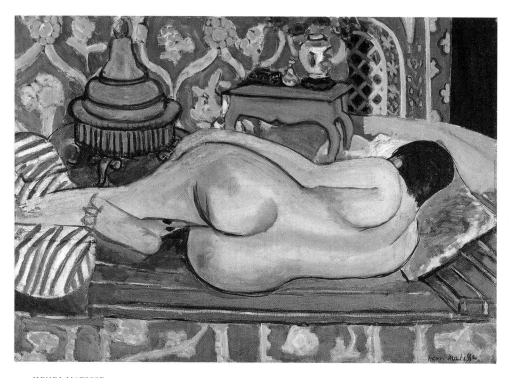

HENRI MATISSE

18 *Reclining Nude Seen from the Back*, summer 1927
Oil on canvas
26 x 36 ¹/₄ in. (66 x 92 cm)
Private collection

The highest praise comes from *Cahiers d'Art* in Tériade's scathing review of the mediocre Salon exhibition: "A movingly youthful Matisse, a canvas that proves art's sovereignty. Incontestably the most acute and gripping picture of this Salon. When we look at this painting, we do not fear old age, because the mind can stay so eternally young."[79] Those last words are an obvious reference to the famously sycophantic "Homage to Picasso," published two years earlier by the surrealists, in which Picasso was characterized as "the eternal personification of youth."[80] And with the reception of *Decorative Figure on an Ornamental Ground* there emerges a new critical dichotomy that would progressively solidify for the remainder of the twenties—a dichotomy between a "youthful" Matisse, and a Matisse as an "old disheartened lion" (the Nice painter of odalisques favored by the old guard).[81]

■ Crisis

Following the success of *Decorative Figure,* Matisse took greater liberty with his ponderous early Nice style, and he made sure to show publicly those "adventurous" paintings where one can sense his desire to reconnect with his work from the teens (even though he continued to produce and exhibit some classic odal-

isques as well). In 1927, Matisse sent to the Salon d'Automne *Reclining Nude Seen from the Back* (fig. 18) and *Odalisque with Gray Culottes* (fig. 19), two paintings that accentuate the contrast between figure and background, so striking in *Decorative Figure on an Ornamental Ground.* But here, as John Elderfield puts it, "the optical dazzle" of the decor is such "that it can appear impossible for us to focus on the figure at all. It is almost as if a flash bulb had gone off in front of our eyes."[82] Elderfield refers specifically to the colored vertical stripes of *Odalisque with Gray Culottes,* but his remark also holds for *Reclining Nude:* there, even the nude's huge, neolithic buttocks and her sulking, protracted pose—most unusual for Matisse—cannot arrest our gaze. Matisse is telling Picasso: "Here, for all your bravado, is something you cannot do—planting a massive figure in the midst of the canvas and blinding the viewer, so that the figure does not command the picture."

Matisse had Picasso in mind: to the same Salon he sent *Woman with a Veil* (fig. 20), though it was not exhibited. The painting recalls—with the white scratches in its black paint, and the swooping linear network emanating from its figure—the famous *Portrait of Yvonne Landsberg* of 1914, just as it also

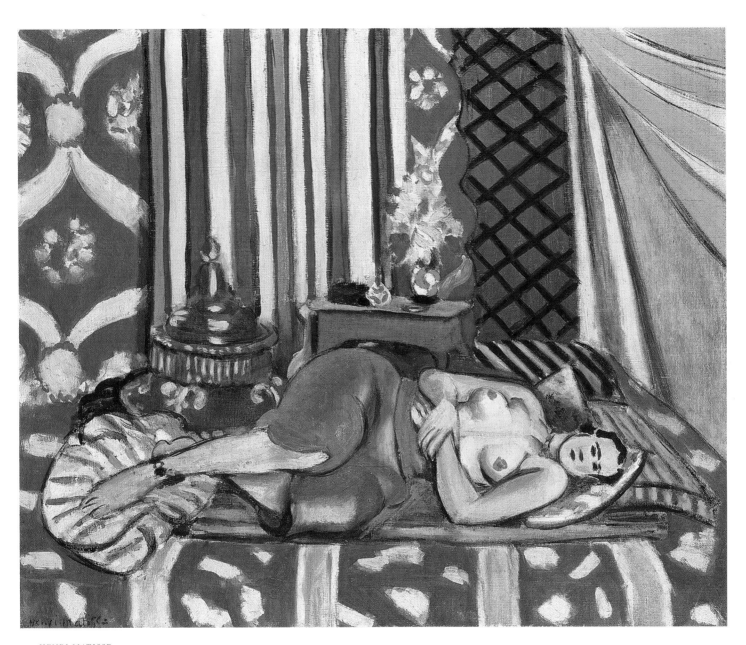

HENRI MATISSE
19 *Odalisque with Gray Culottes*, late 1926–spring 1927
Oil on canvas
21 1/4 x 25 1/2 in. (54 x 65 cm)
Musée de l'Orangerie, Paris

recalls—in its forward thrust of the sitter, its clashing colors, frontality, black lips, and masklike face—the 1913 *Portrait of Madame Matisse*.[83] And just as these works of the teens had engaged in a willing dialogue with cubism, so does *Woman with a Veil:* its geometrizing veil destroys the continuity of the head's contour, creating an unexpected non-anatomical arris that splits the forehead and the swoop of the cheek—a sharp demarcation of planes that seems directly borrowed from the many Picassos painted in the summer of 1909 and entitled *Head of a Woman.* Here, Matisse reaches out to cubism as efficiently as he did a decade earlier in *Still Life with a Plaster Bust* (fig. 2), and he does so for the same reason—seeking to annex cubism without surrendering to it, to expand it, to complete it, renouncing, at this juncture, neither the coloristic violence nor the decorative patterning of his own language.

Above all, the mode of address of *Woman with a Veil* is pure Picasso, and most unusual for Matisse: only a handful of his paintings (the case is somewhat different with his drawings) show the sitter in a frontal pose, sternly regarding the beholder.[84]

Matisse's next major canvas is *Still Life on a Green Sideboard* (Musée National d'Art Moderne, Paris), which he sends to the Salon d'Automne of 1928.[85] One could call this remarkably austere composition a farewell to the exuberance of Nice, had it not been promptly followed up by *Harmony in Yellow* (fig. 21)—Matisse's entry to the Salon des Tuileries in June 1929. Picasso again is directly addressed in this work, notably by an idiosyncratic grafting of styles—a feature that must have been most troublesome for Matisse, who always advocated the unity of the picture. Against this lifelong conviction, he asks himself in *Harmony in Yellow* whether he can put a Manet still life into the middle of an early Matisse, made up of the flat planes, vivid color, and jarring patterns that we find, for example, in the *Painter's Family* of 1911 (State Hermitage Museum, St. Petersburg). The stylistic collage of *Harmony in Yellow* is dumbfounding. Never has Matisse's impulse to blind the viewer been so efficient: we indeed have trouble perceiving the reclining woman in a black and yellow dress, unusually cropped at the waist by the frame. And never has the tonal modeling adopted by Matisse during his Nice period—here used in the Manet quotation—looked more contradictory to his own deepest bent. This is the work, I believe, that precipitates Matisse's crisis.

A few months later, Matisse grants Tériade an interview in which he furnishes a spectacular denial of any crisis. Though he speaks most lucidly about his youth (above all about his passage through divisionism to fauvism), he is nearly silent on the work of the most recent decade. At a telling moment, he alludes to his current situation:

For myself, since it is always necessary to advance and to seek new possibilities, I nowadays want a certain formal perfection, and I work by concentrating my means in order to give my painting the quality of a well-executed, finished object—which is perhaps external, but which is necessary at a given moment. This doesn't mean that it isn't necessary to mess up some canvas when you are young, that one shouldn't start at the beginning.[86]

Which is to say that Matisse, at the very moment when he re-examines his early work—a moment when it also becomes more and more difficult to paint—plays the role of the grand old man striving for the "well-executed, finished object"; striving, that is, for everything he rejected early in his career. He talks like an Old Master "condemned to masterpieces."[87]

■ *Cahier d'Art*'s Match

And Picasso? Does he think about Matisse? Why would he? Isn't he fawned upon by everyone—by the avant-garde, represented by the surrealists, and by the wealthy clientele of Paul Rosenberg? Is he not the unrivaled star, firmly positioned at the apex of the art market, with prices considerably higher than those fetched by Matisse?[88] Why would he look back to a less fortunate colleague of his earlier years?

I shall be bold here and contend that Picasso does indeed think about Matisse, increasingly so from 1926 forward; in particular, his paintings of 1928–30—the runners on the beach at Dinard, the large studios, the acrobats and dancers, and, of course, the odalisques—are made in part with the idea of teasing Matisse out of his self-imposed role as Old Master in Nice and back into the ring of modernity. That these 1928–30 Picassos constitute a summons to Matisse (*in absentia*) does not accord with their usual interpretation: they are most often associated, and exclusively so, with Picasso's family matters (the collapse of his marriage with Olga Khokhlova; his secret affair with Marie-Thérèse Walter)—as if the artist's personal life could alone explain the specific style he adopted in so many of his paintings at this particular moment.[89]

Before we look at the works, let us consider Picasso's world in the late 1920s. Who were Picasso's playmates in these years? Not his old cubist pals: it had been a long time since he felt he had anything to learn from them. Not the abstract artists: ever since his 1910 summer at Cadaqués, when, almost in a panic, he observed his art in the process of becoming more and more abstract, Picasso had been steering away from abstraction, which he always held in utter contempt. (When he occasionally came close, as in the very minimal *Guitar* of 1913 at the Musée Picasso [Daix, 597],

it was always to deny the possibility of abstraction, to demonstrate that anything can be the vehicle of an iconographic signification, that anything can be transformed into an image.)

And what about the surrealists, whom everyone credits with having awakened Picasso from his Ingresque dream, wresting him from his bourgeois "return to order," and plunging him back into the hubbub of avant-garde bohemia, a world he had left behind at the death of Apollinaire? Here lies perhaps the real motive for Picasso's renewed interest in Matisse: the surrealists, his most abject flatterers, had become demanding, and Picasso had little patience for this. As Elizabeth Cowling notes: "Since 1922, Breton had tenaciously pursued a campaign to annex Picasso for his movement, but in the end Picasso eluded him."[90]

Werner Spies remarks that "Picasso was in the middle of a tug of war when it came to surrealism." At one end were Breton and his followers, at the other were "Zervos and Tériade who from the start did their utmost to discredit Surrealism in polemics published in *Cahiers d'Art*."[91] It would be ridiculous to imagine Picasso running away from one group of zealots to fall happily into the arms of another, and even more ridiculous to think that he could prefer the turgid, pontifical prose of the two Greek art critics to the literary experimentations of the surrealist poets. But *Cahiers d'Art,* a journal devoting a good half of its space to the celebration of his genius, was by no means insignificant to him. In terms of commercial strategy, its sanctimonious tone was just what Picasso needed: it provided the intellectual butter on Paul Rosenberg's bread. And by the time Zervos began publishing Picasso's catalogue raisonné (the first volume appeared in 1932), the glorification of Picasso had become his major project in life. But his focus had not been so exclusive when the journal was launched in 1926. For several years, Picasso had to share its pages with Matisse.

During the first year of its publication, in fact, Zervos and his team staged a mini-tournament in *Cahiers d'Art.* It began immediately (the cover of the first issue was by Matisse, the second by Picasso) and was steadily pursued issue after issue. One round is perhaps the most telling. It consists of the review of the October 1926 Matisse exhibition at Paul Guillaume's gallery. The event in itself was extraordinary, a first in the history of modern art. Only three paintings were exhibited. The first, *Branch of Lilacs* of 1914, was lent by Matisse. But it was completely eclipsed by the two other, much larger paintings, which had been recently acquired by Guillaume: *The Piano Lesson and Bathers by a River,* both of 1916 and never before shown in public (figs. 27 and 24). Critics, needless to say, were puzzled by this highly dramatic mode of presentation ("Will we arrive at the single canvas exhibition?" asked one).[92] It is no surprise that *Cahiers d'Art* reproduced the two

paintings (*The Piano Lesson* full-page). But the accompanying text, written by Sylvain Bonmariage, contains a stunning anecdote. Mentioning his "old pal Metzinger" as a witness, and situating the event in 1909, Bonmariage recalls the first time he saw Matisse standing in front of a painting by Picasso. Hesitatingly, searching for words, Matisse supposedly said: "That, that's cubism. . . . I mean by that an immense step toward pure technique." Then, he added: "We'll all come to it." It is doubtful that Bonmariage's recollection is accurate, but we can be certain that its publication irritated Matisse—all the more so since it is followed by this declaration: "Picasso was the one to act. But it is undeniable that Matisse, already a famous artist in 1909, was the first to understand what Picasso wanted to achieve."[93]

What we witness, throughout this first year of *Cahiers d'Art,* is the gradual dramatization of the bipolar cliché: by the end of 1926, the numerous mentions of Matisse and Picasso have fallen into a pattern that will grow more and more predictable. On the one hand, both Matisse and Picasso are constantly pushed toward each other: for example, by juxtaposing two full-page illustrations in a general article in which they don't even need to be mentioned, or are just noted in passing—a common strategy in the journal. On the other, the comparison between the two artists becomes increasingly lopsided. During the remaining years of the decade, though Matisse is never directly mistreated by Zervos or Tériade, he is often belittled by occasional contributors.

A particularly damaging set of attacks, startling in its repetitiveness, came from the dealers in a series of interviews published in 1927. One by one, Paul Guillaume, Daniel-Henry Kahnweiler, Jos Hessel (from Bernheim-Jeune), Paul Rosenberg, Léonce Rosenberg, Étienne Bignou, and Berthe Weill are given a public forum. With the exception of Kahnweiler, all had been involved with Matisse. Yet either they do not even mention him, or they put him second. Berthe Weill, Matisse's first dealer, is the most generous: "Modern painting, it's Picasso and Matisse, perhaps more Picasso."[94]

All in all, while Picasso's work is invariably hailed in the journal as opening the door to the future of painting, Matisse's share dwindles and what little he gets usually takes the form of references to his early works rather than to current ones, notably in a series of articles on fauvism by Georges Duthuit, abundantly illustrated, in 1929–30.

In 1928, Zervos even publishes an essay supposedly devoted to Matisse, but which only mentions him in the title (while illustrating five works, three of them pre-Nice, including the *Portrait of Marguerite,* owned by Picasso).[95] Similarly, the longer essay Tériade finally devotes to Matisse, as if correcting the balance after

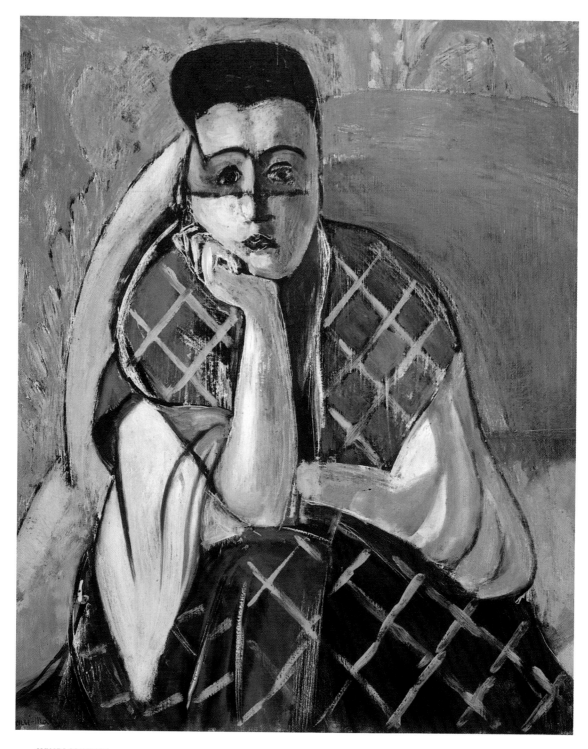

HENRI MATISSE
20 *Woman with a Veil*, 1927
Oil on canvas
24 1/4 x 19 3/4 in. (61.5 x 50.2 cm)
The Museum of Modern Art, New York;
The William S. Paley Collection

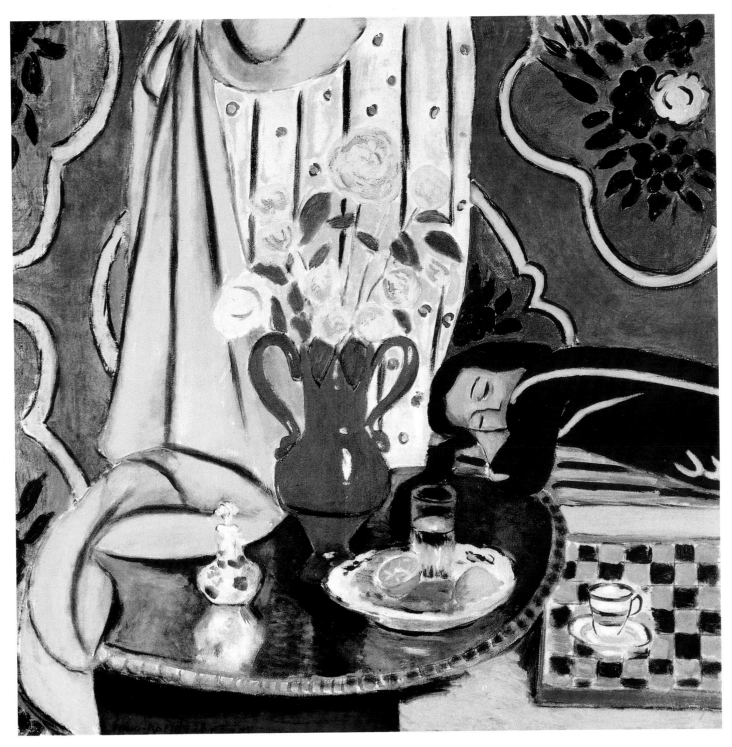

HENRI MATISSE
21 *Harmony in Yellow*, summer 1928
Oil on canvas
34 ⅝ x 34 ⅝ in. (88 x 88 cm)
Private collection

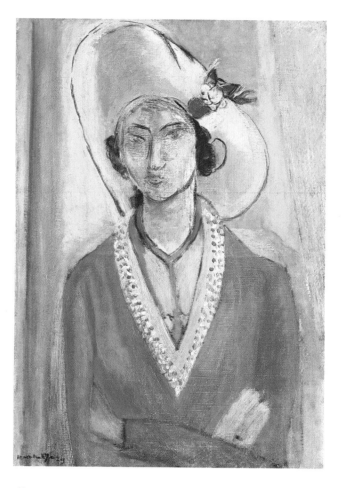

HENRI MATISSE
22 *The Yellow Hat*, 1929
Oil on canvas
25 5/8 x 17 3/8 in. (65 x 45 cm)
Private collection

so many pages devoted to Picasso, disavows its title. Though "L'Actualité de Matisse" ("The Currency of Matisse") is illustrated by a series of recent works, the text only alludes to Matisse's early production. And these allusions are not even specific. Tériade writes that "the Matisse issue is back on the agenda," but all he says is that the call to freedom of the artist's youth is an example to follow.[96] He fails entirely to discuss the works he reproduces. And he does not even attempt to comment on the contradiction between the consistent, nervous linearity and luminosity of the reproduced etchings and drawings and the stylistic uncertainty of the paintings. He thus misses the opportunity to speak about Matisse's crisis of the late twenties, a crisis to which the sequence of images testifies. He could have noted, for example, that Matisse had already renewed his pre-Nice style in the works on paper (they avoid modeling), but not so in his painting.

One canvas in the illustrated group, however, aspires to just this kind of renascence. *The Yellow Hat* of 1929 (fig. 22), solely constructed around the complementary contrast of yellow and violet, retains the tonal gradation that characterizes the Nice odalisques of the early twenties, but only locally so (the modeled head

and neck emerge very slightly from the much flatter robe and background), and it decidedly returns to the sparse and audacious color harmonies of 1906–15. After the clash of styles of *Harmony in Yellow* (fig. 21), Matisse attempts a blending here.

Matisse may well have found it frustrating that his effort to move into a new direction went unacknowledged by critics who professed to defend him: *Cahiers d'Art* did not even review the exhibition where *The Yellow Hat* was first presented—a one-artist show organized by the Galerie du Portique (November 7–25, 1929).[97] There is little doubt, however, that Picasso himself noticed the painting, though not, perhaps, in this venue. When it was exhibited in the Matisse retrospective at the Galeries Georges Petit in 1931, it may have had a more immediate impact. (As Linda Nochlin has observed, the violet/yellow opposition of *The Yellow Hat* dominates a series of pictures that Picasso painted just before his own retrospective in the following year at the same locale, his competition with Matisse being fully reactivated at that time.)[98] In any case, it is safe to assume that for Picasso "the Matisse issue is back on the agenda" by 1929. For several years he had been told explicitly by Zervos and company that there was

MARC VAUX
23 Exhibition "Picasso, Braque, Derain, Matisse,
Léger et Laurencin," April–May 1929
Galerie Paul Rosenberg, Paris

only one other artist comparable to him, and, by implication, that the outcome of the comparison was to his own advantage. Unlike the *Cahiers d'Art* literati, however, Picasso was looking rather than talking.

■ Teasing

In August 1926, Matisse informed the Galerie Bernheim-Jeune, with whom he had been dealing since 1909, that he would not renew his contract.[99] Paul Rosenberg, learning of this, began a ten-year campaign for Matisse to enter his stable. His strategy, to say the least, was counterintuitive: he kept organizing group shows in which the Matisses he acquired (mainly from the early Nice period) would be hung with Picasso's recent works—there to be dwarfed by them. The exhibition "Picasso, Braque, Derain, Matisse, Léger et Laurencin," held in April–May 1929, is a case in point (fig. 23). Three large paintings by Picasso, somewhat isolated from the rest of the exhibit, fill the short wall of a vast rectangular room: his spectacular *Painter and Model* of 1928 (fig. 25), his only slightly less impressive *Seated Woman* with the nailed fingers of 1927 (The Museum of Modern Art, New York; Z. VII, 77),

and his larger *Seated Woman* of 1926–27 (Z. VII, 81), related to the outrageous *Kiss* of 1925 (Z. V, 460), now at the Musée Picasso, Paris. Adjacent to these works, on the wall perpendicular to them, are three quintessential early Nice Matisses.[100] These are not only flooded by the rambunctious Picassos nearby, they are also assimilated, by mere propinquity, to the five typically vapid Marie Laurencins joining them on the same wall.

Is this the best way to enlist a reluctant artist? Was Rosenberg's installation dictated by Picasso? It would make sense as a tease, as an admonition, as an invitation to pick up the chessmen again.

Indeed, Picasso's own *Painter and Model* (fig. 25) would have been hard to conceive without works such as Matisse's *Piano Lesson* (fig. 27) or *Bathers by a River* (fig. 24)—two works he had recently seen again (as he also had *The Red Studio,* a sure invitation to treat that theme).[101] Not only is its compositional organization similar to that of *Bathers by a River* (vertical bands dividing the field), but the decorative pattern of white leaves on yellow ground is signature Matisse. Furthermore, the gray rectangle framed in black and yellow, which reads as a mirror, is a discreet allusion to Matisse's 1913 *Blue Window* (The Museum of Modern

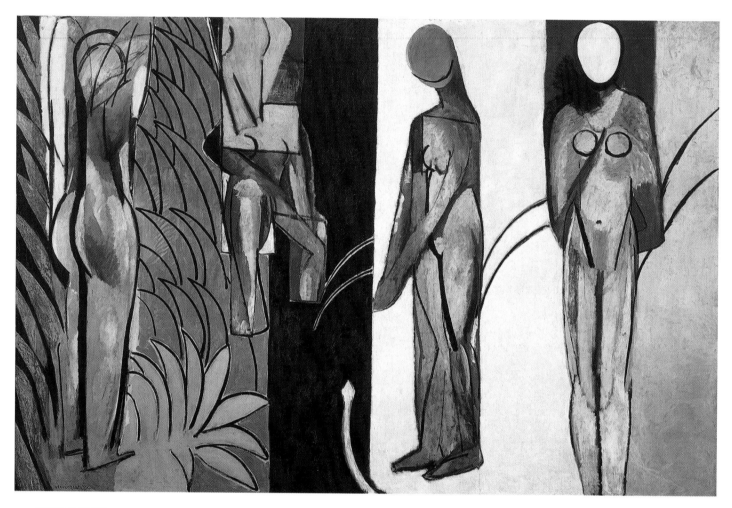

HENRI MATISSE
24 *Bathers by a River*, 1916
Oil on canvas
103 x 154 in. (261.8 x 391.4 cm)
The Art Institute of Chicago; Charles H.
and Mary S. F. Worcester Collection

PABLO PICASSO
25 *Painter and Model*, 1928
Oil on canvas
51 $^1/_8$ x 64 $^1/_4$ in. (129.8 x 163 cm)
The Museum of Modern Art, New York;
The Sidney and Harriet Janis Collection

PABLO PICASSO

26 *Figure and Profile*, 1928
Oil on canvas
28 3/4 x 23 3/8 in. (74 x 60 cm)
Musée Picasso, Paris

HENRI MATISSE
27 *The Piano Lesson*, summer 1916
Oil on canvas. 96 $^1/_2$ x 83 $^3/_4$ in. (245.1 x 212.7 cm)
The Museum of Modern Art, New York; Mrs. Simon Guggenheim Fund

Art, New York), the picture that prompted André Breton to write one of his first surrealist texts, and whose original title was *La Glace sans tain* ("The mirror without silvering").[102] The same empty gray (or black) frame is a common feature in other Matissean Picassos of these years. One finds it in *The Studio* (Z. VII, 142; The Museum of Modern Art, New York) of 1927–28 and in the *Large Nude in a Red Armchair* of 1929 (fig. 10). Often the quotation is more immediate: it is impossible to see *Figure and Profile* of 1928 (fig. 26, related to the *Studio* series), without thinking of the open window frame that crosses over the balcony at the center of *The Piano Lesson* (fig. 27). In each of his dozen paintings around the theme of the studio/interior in 1927–28 (plus a few more in 1929), Picasso signals us that he has Matisse in mind, as if fearful that we would miss the point, despite his works' emphatically flat planes of no less emphatically vivid color.

Picasso initiates another move with the invention of his *Minotaur* on January 1, 1928 (fig. 29)—perhaps the clearest demonstration of any that disjunction is the overall motor of his art. In cubist fashion, color and contour are markedly split; the beast's anatomy is disjointed by an ellipsis; and, above all, the buoyancy of the form is as remote as possible from the darkness of its theme. Could there be anything more remote from Matisse's world than this somber, dark, mythical creature? On the other hand, what could be closer to Matisse's dancers than the minotaur's Nijinsky-like jump and the arabesque of its unbroken line? Perhaps Picasso knew that Matisse had been working painfully for some months on an *Abduction of Europa* (fig. 30); if so, his bursting Minotaur would send some conflicting messages—inviting Matisse back into the ring, but also warning him to stay away from mythological or sexual violence, as indeed he had done since his *Nymph and Satyr* of 1908–09 (State Hermitage Museum, St. Petersburg). In this thematic arena, says Picasso, the match would be too uneven.

No Matisse looks more unfinished than *Abduction of Europa*, and none seems to have been so hard to realize (one unreliable informant claims the painter told him that "for that picture alone" he had made "three thousand sketches—yes three thousand for that painting alone").[103] None seems so stylistically disjunct from its theme: Matisse's Jupiter/bull remains as inoffensive as an ox, as stilted as a wooden prop for the stage. Since Matisse does not sign it (it bears an atelier stamp), he must have considered it unresolved. Yet he had a drawing for it reproduced in Florent Fels' 1929 book, and in 1932 visitors could see it dominating a wall in his Nice apartment, next to several Cézannes.[104] Only a few years later, however, in 1935, Matisse would be able to answer Picasso's challenge with regard to both myth and the representation of violence.

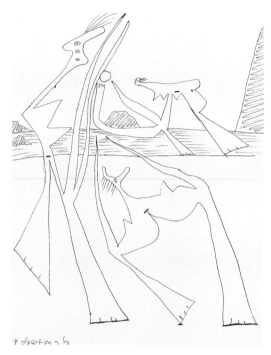

PABLO PICASSO
28 *Ball Game on the Beach*, August 18, 1928
"Dinard" sketchbook 1044, f. 42
15 x 12 ¼ in. (38 x 31 cm) Pen and ink on paper
Marina Picasso Collection (inv. 9255), courtesy
Galerie Jan Krugier, Ditesheim & Cie, Geneva

From Picasso's dancing *Minotaur* stem all his *Bathers Playing Ball*, painted at Dinard in August of 1928. Though the paintings themselves lack any reference to Matisse (their color is rarely intense, they are small and crammed, their tiny insectlike creatures are constrained by the frame but magnified by a zoom effect) Matissean references abound in their preparatory drawings (fig. 28)—open and expansive compositions, free of claustral effect, the agitated movements of the bathers recalling Matisse's *Dance* of 1910.[105]

A year and a half later, still in the same vein, comes Picasso's series of *Acrobats*. These acrobats seem at first even more firmly boxed in than the springing figures of the Dinard miniatures, their anatomy recombined to fit in the frame. But their scale has changed, and we feel closer to Matisse's spreading space. This change of scale is the result of several factors: most of these paintings have only one figure; they are much larger; there is no modeling whatsoever (their figures are flat silhouettes against a flat background); and their color scheme is a binary one (a single color for the figure, a single color for the ground). All these characteristics, excepting the first, echo Matisse's large composition of 1910: in *The Swimmer* of November 1929, perhaps the first of the

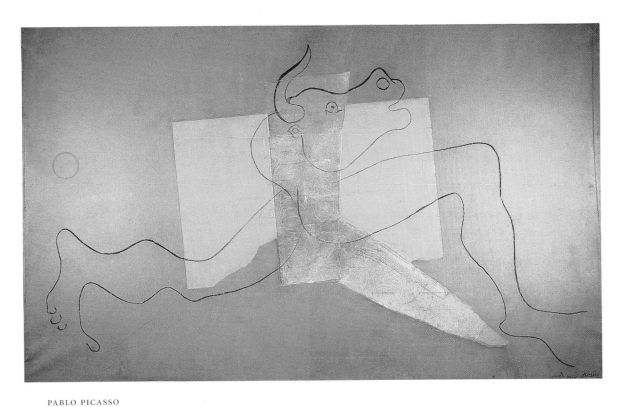

PABLO PICASSO
29 *Minotaur*, January 1, 1928
Charcoal and pasted paper on canvas
54 3/4 x 90 5/8 in. (142 x 232 cm)
Musée National d'Art Moderne, Paris

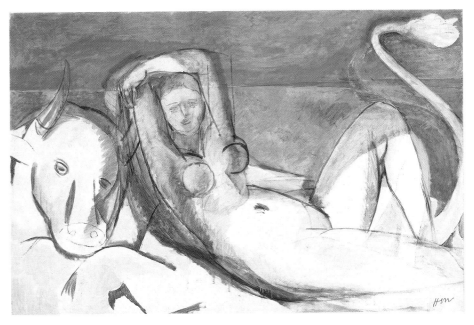

HENRI MATISSE
30 *The Abduction of Europa*, 1927–1929
Oil on canvas. 39 7/8 x 60 3/8 in. (101.3 x 153.3 cm)
National Gallery of Australia, Canberra

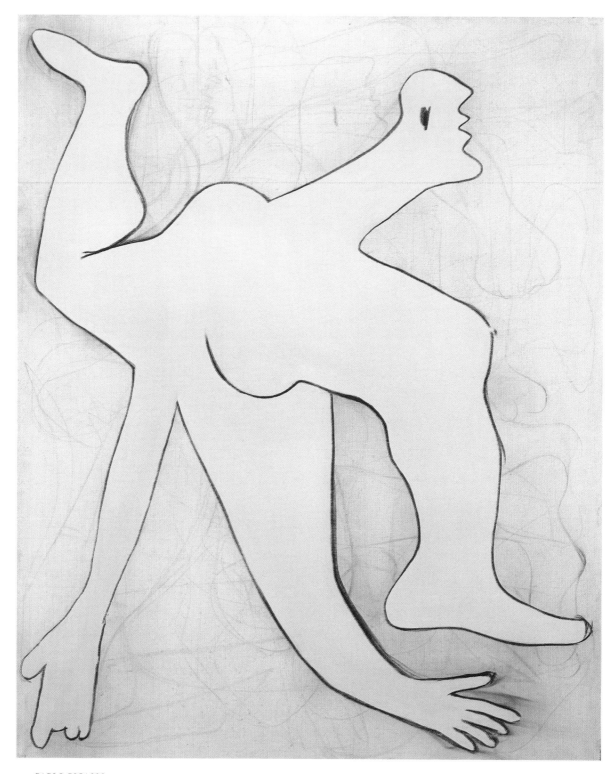

PABLO PICASSO

31 *The Blue Acrobat*, November 1929
Oil and charcoal on canvas
63 ³/₄ x 51 ¹/₈ in. (162 x 130 cm)
Musée Picasso, Paris

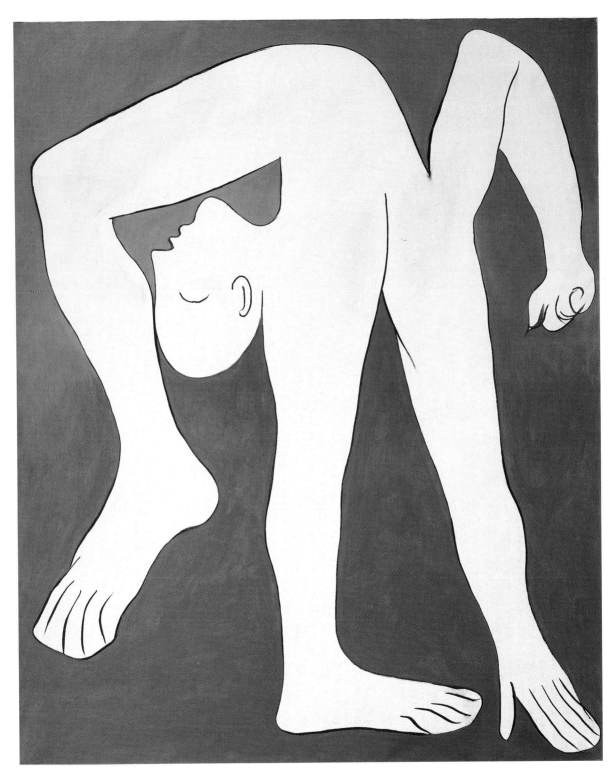

PABLO PICASSO
32 *The Gray Acrobat*, January 18, 1930
Oil on canvas
63 5/8 x 51 3/4 in. (161.5 x 130 cm)
Musée Picasso, Paris

series (Musée Picasso, Paris; Z. VII, 419), the figure's salmon body, floating against a blue ground, clearly addresses Matisse; in *The Blue Acrobat* of the same month (fig. 31), we find the color scheme nearly inverted (the body is blue, the ground unpainted cream canvas lightly soiled with charcoal); and in the masterpiece of the series, *The Gray Acrobat* of January 18, 1930 (fig. 32), Picasso, whose works are usually so centered, manages to have his melted figure touching or nearly touching all four sides of the frame at two separate points. The acrobat—a caged octopus whose tentacles momentarily retract before they engulf the prey—provides an impression of energy ready to burst outward.[106] Picasso here signals to Matisse that perhaps the round of the *Dance,* in the end, was too self-enclosed (Matisse, of course, could very well have retorted that achieving expansiveness, without translating the human body into an octopus, was the greater accomplishment of the two).[107]

■ Sculpture: Round One

It must have been frustrating for Picasso to keep sending messages to Matisse that went unanswered. He also knew that Matisse had a powerful chessman at his disposal in the realm of sculpture. It is this, more than the refusal of the committee that had commissioned it, that drove Picasso to abandon his first project for a *Monument to Apollinaire,* his first attempt at modeling since the *Head of Fernande* of 1909. (His second project for the *Monument*—a wire construction dating from the fall of 1928— is a landmark in the history of modern sculpture, existing in several sizes and places, among them The Museum of Modern Art in New York and the Musée Picasso in Paris. Renewing the tradition of constructivism evolving from cubist sculpture, and articulating a series of geometrically defined virtual planes, this "drawing in space," as Julio González called it, moves as far as possible from Matisse's conception of sculpture—unlike the first proposal, which deserves all our attention.)

Though this first project was aborted, and some doubt remains as to what Picasso actually showed the committee, his plans for the work are well documented, and those documents have been carefully studied by Michael FitzGerald (1987). They consist, first, of a series of highly finished drawings of giant nudes, made in two different sketchbooks in Cannes, between July 11 and September 24, 1927 (fig. 33); and second, of two small sculptures directly related to these drawings—entitled *Metamorphosis I and Metamorphosis II* (fig. 34).[108]

The drawings themselves, carefully shaded, represent sculptures in the round. Picasso, so goes the legend, intended to have these metamorphic beings erected as a sequence of massive mon-

uments all along La Croisette, the fashionable seafront boulevard of Cannes. That this desire was unrealizable at the time hardly explains why Picasso realized only two Lilliputian sculptures from his large number of extremely elaborate drawings. A standard explanation would be that Picasso's thought was moving too fast—that he lost interest. This is Werner Spies' position. According to Spies, Picasso did not pursue the project beyond the two *Metamorphoses* because he found them satisfactory.[109] I would argue to the contrary—that Picasso was not satisfied by them.

The drawings related to these two sculptures project volumes with smooth surfaces. Their shapes loudly require direct carving—in marble, no less, a material not to be seriously associated with Picasso. Its logical substitute is the procedural trio of clay-plaster-bronze, and this is exactly what Picasso tries. But clay has its limitations, and Picasso knew little about these. One is of weight and balance: cantilevering is not impossible, but very delicate.[110] A second limitation is of size (the smaller the sculpture, the freer the artist working in clay). And a third limitation is of surfacing: in bronze, the even surface of marble can of course be imitated (this was Brancusi's specialty), but it requires immensely time-consuming and tedious labor; and although Picasso enlisted González to teach him how to weld, he remained generally reluctant, until the late fifties, to ask for assistance and thereby relinquish total control.

Picasso's two *Metamorphoses* bear the stigma of these limitations. Although they are tiny (less than a foot tall), they are conceived with a monumental scale in mind and are bottom heavy. They display little of the precarious equilibrium of masses that characterizes so much of the Cannes drawings, which bestow on their ballooning shapes a humorous, levitational air—one that will only reappear in Picasso's paintings some five years thereafter, in the *Bather with a Beach Ball* of 1932 (Z. VIII, 147; The Museum of Modern Art, New York). And their surfacing is wrong: an attempt has obviously been made to smooth the clay, but Picasso, even with works as small as these, lacked the patience to finish.

In the late summer or early fall of 1928, Zervos published a front and back view of *Metamorphosis II* in his *Cahiers d'Art,* as the last illustrations for an article entitled "Sculptures des peintres d'aujour-d'hui."[111] To remind the reader that Picasso was not entirely a novice at modeling, Zervos reproduced several of his early bronzes as well (*Jester* of 1905, *Woman Arranging Her Hair* of 1906, and *Head of Fernande* of 1909, respectively Spies 4, 7 and 24), all of them traditionally pictorial. But this might have been a mistake on his part, for these works look pale next to the excellent sampling of Matisse's sculptures that he also proposed, from *The Serf* of 1900–03 to his latest, still unfinished, work, *Large Seated Nude* of 1922–29. Among

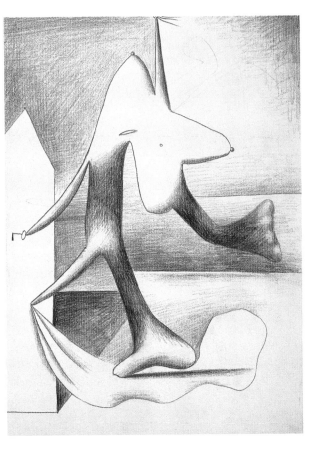

PABLO PICASSO

33 *Bather and Cabin*, summer 1927
"Cannes" sketchbook, f. 9r
Graphite on paper
11 ³/₄ x 9 in. (30 x 23 cm)
Musée Picasso, Paris

PABLO PICASSO

34 *Metamorphosis II*, 1928
Plaster
9 x 7 ¹/₈ x 4 ³/₈ in. (23 x 18 x 11 cm)
Musée Picasso, Paris

HENRI MATISSE

35 *Decorative Figure*, August 1908
Bronze. 28 ³/₈ x 20 ¹/₄ x 12 ¹/₄ in.
(72.1 x 51.4 x 31.1 cm)
Collection of Patsy R.
and Raymond Nasher, Dallas

PABLO PICASSO
36 *Seated Woman*,
spring 1929
Bronze (unique cast)
16 1/2 x 6 1/2 x 9 7/8 in.
(42 x 16.5 x 25 cm)
Musée Picasso, Paris

PABLO PICASSO
37 Study for the sculpture
Seated Woman,
May 5–6, 1929
Sketchbook, f. 37r.
Graphite on paper
9 1/4 x 12 in.
(23.5 x 30.5 cm)
Musée Picasso, Paris

other masterpieces of modeling one can see *La Vie (Torso with Head)* of 1906, *Reclining Nude I (Aurora)* of 1906–07, and *The Serpentine* (fig. 57) of 1909—works that had not been exhibited in Paris since 1913, at a time when Picasso was fully involved in his cubist constructions (three of which were also reproduced in the issue) and would have been at his least responsive to Matisse's sculpture.

Matisse's works offer a strong contrast to Picasso's attempts at modeling. Even the small ones, such as *La Vie,* are virtuoso demonstrations of all the possibilities of clay which Picasso had forfeited in trying to translate the marble dreams of his drawings into the clay *Metamorphoses.* The agitated surface of Matisse's sculptures register the process of their making without being pictorial (unlike Picasso's, they are not designed for the frontal view alone); their balancing of masses is stunning (the cantilever of *Large Seated Nude* is a feat of engineering); and they can be fairly large as well.

Did Picasso also find Matisse's *Decorative Figure* of 1908 (fig. 35)—one of his largest sculptures—reproduced somewhere? I would say that he did, for in May 1929 he made a series of drawings that clearly attempt to respond to it (fig. 37).[112] There are earlier and later drawings in the same sketchbook also indicating that Matisse is present in Picasso's mind.[113] It is in these drawings and in the sculpture that almost immediately came out of them, *Seated Woman* (fig. 36), that Picasso recognizes the genius of Matisse's sculpture, and the reasons why and how he would have to treat clay differently if he ever wished to compete. In *Seated Woman,* which rather poorly borrows the seemingly unprocessed

rolls of clay from *The Serpentine,* Picasso—unlike Matisse, who is striving for the indivisible continuity of his volumes— decides paradoxically that he will model as if welding. He will retain from Matisse a Rodinesque surface agitation (signalling a definite farewell to the possibilities of marble), and he will learn from Matisse how to manage weight. But while Matisse devertebrates, eliding the skeletal structure of the body, Picasso will concatenate—in keeping with his structuralist mode.

A few months later, when Picasso sees Matisse's *Seated Nude (Olga)* of 1909–10 (fig. 38) at the exhibition of Paul Guillaume's collection (May–June 1929), he finds confirmation that the path he has chosen is truly his own.[114] In order to do so, he had to tip his hat to *Olga*—the Matisse sculpture that most forcefully demands circumnavigation, splendidly baffling the beholder's expectation. For this work epitomizes one of the most inventive features of Matisse's sculpture—the suppression of any geometric or muscular arris, of any demarcation between planes. Moving around *Olga,* you are always caught up short: you suddenly realize that you are looking at her back, though a split second earlier it was her belly that was in view—and no matter how many times you go around, you can never find the place where the shift occurs.

Seeing *Olga,* so much more accomplished than his own stilted and frontal *Seated Woman,* momentarily arrests Picasso. He abandons modeling for a few months—welding metal with González and also carving wood. When he returns to clay and plaster, having seen many more of Matisse's sculptures, he is ready to take up the challenge.

HENRI MATISSE
38 *Seated Nude (Olga)*, 1909–10
Bronze. 16 1/4 x 9 3/4 x 13 1/8 in.
(42.5 x 24.6 x 33.2 cm)
Private collection

PABLO PICASSO
39 *The Sleeper*, March 13, 1932
Charcoal and oil on canvas
51 1/4 x 63 3/4 in. (130.2 x 161.9 cm)
Private collection

FIRST ACT: SNAP SHOTS

1930–32

■ Comeback

Matisse's situation, at the end of the 1920s, was somewhat dire. A growing number of European critics implied, or said openly, that he had reached the end of his creativity, and he was beginning to agree. While he could still work in sculpture, draw, and etch (testing his virtuosity in this medium by working blindfold), his painting was apparently done for: " Several times I've settled down to paint," he writes to Marguerite on November 21, 1929, "but in front of the canvas, I draw a blank."[115] He needed a vacation; on February 27, 1930, he sailed off to Tahiti by way of New York (where he was courted as a celebrity), returning to France three months later with the tangible harvest of a small painting on wood and a few sketches that he did not regard very highly—the notes of a traveler, so to speak.[116] Tahiti may be enchanting, but "one dies of boredom in Paradise."[117]

Upon his return, Matisse found himself at a crossroads. At the risk of lapsing into the languor he felt before his trip, he could resume his previous, respectable position; or, responding to Picasso's challenge, he could revive his pre-Nice self. Two exhibitions organized in his absence in Paris epitomized the two paths. With the first of these, called "Cent ans de peinture française," the Galeries Georges Petit was inaugurating its refurbished space, amid great fanfare. In it, Matisse was treated as an Old Master—the contributor to a prestigious survey course that included such major works as Seurat's *Circus* and Cézanne's *Card Players*.[118] In another, the Galerie Pierre—more modest and decidedly avant-garde—was showing an important selection of Matisse's sculptures, most of these dating from 1906–10, and assembled for the first time since 1913.[119] No juxtaposition of shows could better express the alternatives facing Matisse: to return placidly to his population of odalisques, or to renew a highly experimental streak in his art, interrupted in 1918.

Back in Nice for a few weeks before sailing again to America in September 1930 (this time as a member of the jury for the Carnegie International), Matisse mulled over the alternatives. In the meantime, he worked every day at *The Yellow Dress*, the painting he had abandoned in despair before leaving for Tahiti, which

shows that he had regained some confidence.

It is often assumed (without evidence) that during this brief return to his home base Matisse completed *Tiaré* (fig. 52), one of his most "abstract" sculptures, and *Venus in a Shell I*. Quite possibly he worked on them, given that sculpture was one of the few things he had been able to work on in 1929. But I would place at least the final state of these two works after Matisse's second trip to America, for the distilled contours they reveal, uncommon in his sculpture but typical of his pre-Nice painting, were always in his art the result of a long labor. At any rate, both sculptures indicate that Matisse was changing direction, revisiting in his sculpture the pictorial art of his youth. Both souvenirs of his Tahitian trip, they would be cast by the end of the year and included in the exhibition of Matisse's sculpture held in New York at the Brummer Gallery in January–February 1931.

Venus in a Shell I would also be the point of departure for a plate of the *Poésies de Stéphane Mallarmé*, Matisse's first illustrated book.[120] The book would only be published by Albert Skira in October 1932, but Matisse had already signed a contract for it and thus had already this commission in mind when he left again for New York.

His second sojourn in America was even more triumphant than the first, with the press chuckling at the role he played in awarding a Carnegie prize to Picasso, for a very classical 1923 portrait of Olga, à la Corot (Z.V, 53).[121] By 1930, however, Picasso was far from the "propriety" of such portraits. At Juan-les-Pins for the summer, he was doing small assemblages on upturned stretched canvases. Covered with sand, almost ashen, deliberately lowly and yet uncanny, they belong to the same "formless" vein as the 1926 *Guitar* made of rag, rope, and nails, so prized by the surrealists.[122] The Carnegie award—which Matisse had received himself in 1927—was a reminder: "You too are often a classic!" Not revenge, but perhaps a sign that Matisse is buying time while rolling up his sleeves.[123]

During this second trip, Matisse visited the Barnes Foundation, curious to see how his old works hung together, among them *The Joy of Life*. Alfred Barnes astounded him with

the commission of a large mural for the awkward space under the lunettes of the large room of his private museum.[124] Back in Paris in October, and after some hesitation, Matisse accepted the offer. Waiting for Barnes to finalize the deal during a visit at the end of the month, he worked on his sculpture *Back IV*, an obvious return to his pre-Nice preoccupations, particularly to his 1913–16 interrogation of cubism.[125]

After seeing some of the most glorious experiments of his youth at the Barnes Foundation, Matisse was prepared to experiment anew. The first sketches for the Barnes *Dance* were done in Merion, where he returned at Christmas to get a firm grasp of the space he was to "decorate" and its constraints. These sketches, like the 1910 *Dance* for Shchukin, are based on the central group of *The Joy of Life*.

Settling in Nice in early 1931 to complete the commission, he worked on it almost exclusively until May 1933, returning to Merion a third time for the installation. His only concurrent work, with the exception of *Venus in a Shell II* (1932), a cubist rendering of his recent sculpture, was for his Mallarmé illustrations. Since Mallarmé too was a part of Matisse's youthful baggage, this project also pushed him further toward his pre-Nice production.[126] And he would have learned, no doubt, that Picasso was working at the same time on a Skira commission of his own, etching illustrations for Ovid's *Metamorphoses*.[127] (Picasso—unlike Matisse, who agonized endlessly over the Mallarmé project—realized most of the Ovid between September 13 and October 25, 1930; Zervos published a lavishly illustrated study of Picasso's forthcoming book in the last issue of *Cahiers d'Art* for that year).[128]

Matisse lived in Nice for most of this period, going to Paris only when absolutely required to do so, and even then only briefly, grudgingly. He devoted very little attention to preparing his vast retrospective at the Galeries Georges Petit in June–July 1931; this, we shall see, was a mistake.

■ Sculpture: Round Two

And what was Picasso doing in 1930–31? Though not very productive himself, he made sure not to miss the opportunity to take a serious look at Matisse's art.

One such opportunity was the exhibition (mentioned above) of Matisse sculptures at the Galerie Pierre during June–July 1930. Though we do not know the exact composition of this show—André Salmon, in his brief review, vaguely mentions "about twenty bronzes"[129]—we can assert, with absolute certainty, the presence of eleven pieces, among them *La Vie* of 1906, *Head with Necklace* of 1907, *Two Women* of 1907–08, *Seated Figure, Right Hand on*

Ground of 1908 (fig. 40), and *The Serpentine* of 1909 (fig. 57). We can be almost certain of five more works, among them *Reclining Nude I (Aurora)* of 1907 and *Large Seated Nude* of 1922–29—both among Matisse's largest works in the round—and *Seated Nude (Olga)* (fig. 38). Finally, it is probable that two other works, including *Head of Marguerite* of 1915, were there.[130] (This account does not include any of the last three *Jeannettes*, though taking Picasso's Boisgeloup sculptures of 1931 as evidence, I am inclined to include either *Jeannette III* [fig. 41] or *Jeannette V* [fig. 51] in the list.)[131] In sum, the exhibition offered Picasso an excellent survey of Matisse's enormous power and inventiveness as a modeler.

Picasso, let us recall, aborted his foray into modeling the year before. Thereafter, he had been happily experimenting, with Julio González, in the new technique of welding iron. Into this medium, more appropriate to his conception of sculpture as assemblage, he translated the basic configuration of his *Seated Woman* of 1929 (fig. 36): the result of this complex process is *Woman in the Garden* (Spies 72), finished sometime in 1930.[132] As of July 1930, he was still working in the same "assemblage" vein, making numerous sketches for the welded *Head of a Man* of that year (Spies 80).[133] No doubt Picasso was exhilarated by the possibilities that welding opened to him; he felt, he told González, "as happy as [he] did in 1912."[134]

Happy with this new medium after his somewhat unsuccessful attempts at modeling with the two *Metamorphoses* and *Seated Woman* (figs. 34 and 36), Picasso tried a compromise. At the end of July 1930, he filled his sketchbook with ideas for a hybrid: a modeled sculpture, not unrelated to the series of drawings made in Cannes three years earlier, onto which the welded *Head of a Man* would be grafted.[135] This idea was never realized, but there is no doubt that the collection of Matisse's casts at the Galerie Pierre excited Picasso's envy. When he returned to Boisgeloup after his vacation on the Riviera, he tried to carve wood (one of the several thin *Standing Women* that he chiseled in the fall of 1930 directly refers to Matisse's *Serpentine*—she is, literally, an S—but how stilted she is by comparison! [fig. 42]).

■ Metamorphoses

It would be a few more months before Picasso picked up the (self-imposed) challenge. In the meantime, Matisse's presence had grown on him, with all the fuss about the Carnegie prize, and then the Skira commission. That Picasso, known to procrastinate on commissions, should race through the Ovid etchings is a sure indication that he wanted to finish first, thereby setting the terms of a competition with Matisse. He had already "illustrated" many

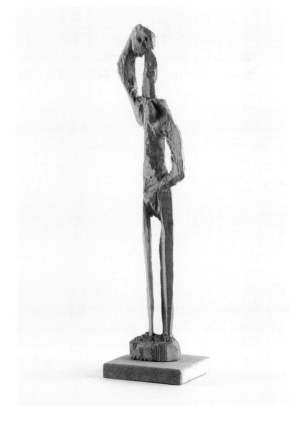

HENRI MATISSE

40 *Seated Figure,*
Right Hand on Ground,
fall 1908
Bronze
7 ¹/₂ x 5 ³/₈ x 4 ³/₈ in.
(19 x 13.7 x 11.2 cm)
Private collection

HENRI MATISSE

41 *Jeannette III*, 1911
Bronze
23 ³/₄ x 10 ¹/₄ x 11 in.
(60.3 x 26 x 28 cm)
Private collection

PABLO PICASSO

42 *Standing Woman*, fall 1930
Wood
7 ⁵/₈ x 1 ³/₄ x ⁷/₈ in.
(19.5 x 4.5 x 2.3 cm)
Musée Picasso, Paris

PABLO PICASSO

43 *Tereus and Philomela*,
October 18, 1930
Ilustration for Ovid's
Metamorphoses (1931)
Etching
Plate: 12 ³/₈ x 8 ³/₄ in.
(31.3 x 22.3 cm);
image: 8 ³/₄ x 6 ³/₄ in.
(22.3 x 17.1 cm)
Musée Picasso, Paris

PABLO PICASSO

44 *The Death of Eurydice*,
October 11, 1930
Illustration for Ovid's
Metamorphoses (1931)
Etching
Plate: 12 ³/₈ x 8 ⁷/₈ in.
(31.3 x 22.4 cm);
image: 8 x 6 ³/₄ in.
(22.3 x 17 cm)
Musée Picasso, Paris

PABLO PICASSO
45 *Three Nude Women*,
April 1931
Ilustration for Ovid's
Metamorphoses (1931)
Plate: 15 x 11 3/4 in.
(38.1 x 30 cm);
image: 5 1/4 x 6 5/8 in.
(13.9 x 16.9 cm)
Musée Picasso, Paris

PABLO PICASSO
46 *Female Back*,
April 1931
Illustration for Ovid's
Metamorphoses (1931)
Etching
Plate: 15 x 11 3/4 in.
(38.1 x 29.9 cm);
image: 5 1/4 x 6 3/4 in.
(13.2 x 17 cm)
Musée Picasso, Paris

books, but until now he had mainly confined his intervention to providing a frontispiece (only Max Jacob's *Saint Matorel* had been granted as many as four etchings, in 1911).[136] The Ovid, with its thirty etchings (fifteen full-size, the others half-size and placed at the beginning of each of the *Metamorphoses'* fifteen books) is a different matter altogether. In the full-size etchings, Picasso engages with the text as never before. Given his fascination, from the *Demoiselles d'Avignon* on, with the possible transformation of anything into a sign for something else, it should come as no surprise that the Latin poem stimulated him, even though, like earlier artists (Bernini excepted), he does not attempt to represent any actual metamorphosis.[137] As Lisa Florman notes, Ovid's text is far from classical—its "aggregative structure and lack of plotline" and its tales of violence and lust could even be characterized as anti-classical. The same is true, Florman continues, of the illustrations themselves, at least in the full-size ones, though they seem at first glance to be cast in the Flaxman-like idiom Picasso used in the late teens and early twenties, when working for the Ballets Russes. As Florman observes, Picasso here seeks at all costs, and by all means, to "invest the figures with the illusion of movement." In *Tereus and Philomela* (fig. 43), he combines two cubist devices: multiple contours (two lines or more instead of one, each enforcing a contradictory meaning), and the double contour (one line having the function of two). For example, the multiple contours describing Tereus' right leg "in a number of different positions, from fully extended to fully bent, with the knee resting on the print's lower margin," produce a stroboscopic effect in the manner of Muybridge. At the same time, the double contours (for example, the line marking the upperside of Philomela's left leg and the underside of Tereus' right arm) unsettle the readability of the figures, their struggle becoming a shifting tangle. In *The Death of Orpheus* (Geiser/Baer, I, 164), the shared S curve that links the torsos of two of Orpheus' attackers on the left "serves as a kind of arris, not so much distinguishing the figures as suggesting a pivot between them," while below, Orpheus' body is twisted, both front and rear. In *The Death of Eurydice* (fig. 44), the weight of Eurydice's limp body is accentuated by the double echo of the nymphs behind her, identical in their physiognomy, and pulled down by her precipitous swoon.

This relentless movement disappears in all but two of the half-size etchings. And in these smaller images, Matisse looms large, perhaps because the illustrations have no narrative function. Purely decorative, writes Florman—produced as "an afterthought"—their role is to "punctuate the long expanses of verse." Picasso had recently been exposed to some of Matisse's recent etchings (even if he missed the exhibition at Galerie du Portique

in November 1929, he would certainly have seen the reproductions published for the occasion by *Cahiers d'Art*). His various sitters, alone or grouped, male or female, are all siblings of Matisse's odalisques, especially in the image of three naked women that opens Ovid's fourth book, engraved in April 1931 (fig. 45). And what could be more like Matisse's linear economy than the essence of a back—hips, buttocks, and thighs—all traced in just three limpid lines (fig. 46)?

■ Picasso's Raid

These Matissean illustrations were done in the spring of 1931, and Picasso had good reason to be obsessed with Matisse at this moment, knowing that a massive retrospective of his rival's work was in preparation at the Galeries Georges Petit. It was a much publicized affair, highly anticipated, and Picasso must have known about it before the general public did, for Paul Rosenberg was in business with the consortium of dealers organizing it, and Rosenberg was a key player in Picasso's own retrospective of the following year, the plans for which may already have been under way.

The canvases Picasso painted in February and March 1931 attest to his competitiveness, but even more telling is their hastily organized exhibition at Rosenberg's "Exposition de quelques œuvres récentes de Picasso" (July 1–21, 1931). The show opened just as the Matisse exhibition at the Galeries Georges Petit was drawing crowds. That it was a last-minute affair is clear from its lack of a catalogue, which was contrary to Rosenberg's lavish custom, and from the small number of works exhibited—"four recent ones" and "four earlier ones," as Zervos notes in *Cahiers d'Art*, the latter including *Three Musicians* of 1921 (Z. IV, 331; The Museum of Modern Art, New York) and possibly *Painter and Model* (fig. 25).[138] There were also several plates from the Ovid.[139]

The recent works in the Rosenberg show were all large still lifes, three of them reproduced by the press (*Pitcher and Bowl of Fruit*, *Pitcher and Cup with Fruits*, and *Pitcher, Bowl of Fruit, and Leaves*, Z. VII, 322, 327, and fig. 48, respectively). The fourth painting could very well have been *Still Life on a Pedestal Table* (fig. 47): it is the only other picture of the period that matches the general description of the whole group in the contemporary reviews. Critics were struck by the "cloisonism" of these works (references are made to medieval art—to stained-glass windows for *Pitcher and Bowl of Fruit*, to illuminated manuscripts for the others); they were stunned by their vivacious colors; and they noted above all "the prestigious arabesques that envelop colors, cuddle them, coil up among them and make them swirl in their vibrating spirals."[140] Behind the erotic flourish of the rhetoric, no one can miss the hint of Matisse.

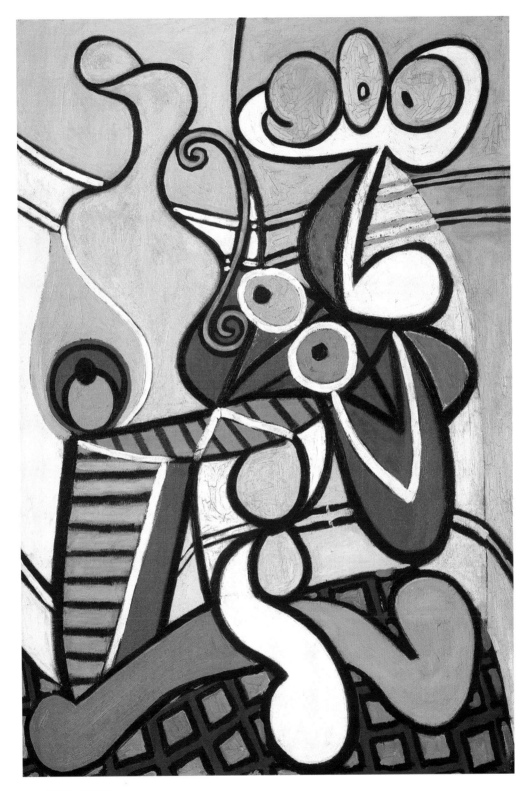

PABLO PICASSO
47 *Still Life on a Pedestal Table*, March 2, 1931
Oil on canvas. 76 3/4 x 51 1/4 in. (194 x 130 cm)
Musée Picasso, Paris

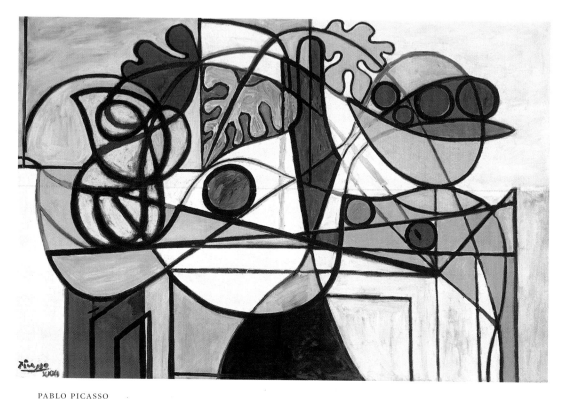

PABLO PICASSO

48 *Pitcher, Bowl of Fruit, and Leaves*,
February 14, 1931
Oil on canvas. 51 1/8 x 75 7/8 in. (131 x 195 cm)
The Saint Louis Art Museum;
Bequest of Morton D. May

But what critics knew at the time seems to have been forgotten during the past two decades, for these canvases—most notably *Still Life on a Pedestal Table*, but also *Pitcher, Bowl of Fruit, and Leaves*—have been exclusively characterized as cryptic portraits of Marie-Thérèse Walter.[141] Such a reading is not necessarily incompatible with our experiment: given the context charted above, it should not be surprising that, at this point of his career, Picasso would choose to signify sensuality via a detour through Matisse's language. Of course, Picasso's idiom is by no means faithful to the original Matisse; his corrective is very similar to the one he will propose a year later in *Still Life: Bust, Bowl, and Palette* (fig. 3, discussed pp. 11–15 above). Picasso appropriates the decorative excess (whirling arabesques, flicker effect, vivid colors—in fact, far more vivid than Matisse's), but he flatly refuses to disperse his composition. The black undulating lattice of *Pitcher, Bowl of Fruit, and Leaves* does not lead our gaze astray: it belongs to a closely knit web in which each object is assigned its specific zone, regulated perhaps even more than ever by geometric reasoning. (The four fruits of unequal size in the bowl at the upper right

perform a brief demonstration of the property of tangents—most un-Matissean in its pedagogy.) The multiplied fruits-as-breast of *Still Life on a Pedestal Table* (fig. 47) are indeed similar to Matisse's exploding flash bulbs, but this marshmallow universe is strictly governed by a central axis, and the heavy contours counteract the bedazzling effect that would otherwise result from the multiplication of complementary color pairs. Picasso is pursuing his tease (for all he knows at this juncture, Matisse is still lost in his cushy world of odalisques) and, at the same time annexing part of his rival's territory, making sure that this new colony obeys his own rule.

The attack fails: "The Picasso exhibition at Rosenberg's suffers somewhat from the proximity of Matisse's," notes one critic.[142] This is an understatement, for where the coverage of Matisse's retrospective was enormous, Picasso's exhibition got almost no press at all.

■ Matisse Has a First Class Burial

Matisse's show, despite its excellent attendance and the glitter of its grand opening, was also a flop in many ways, for it did nothing to still the talk, which had been growing since 1926, of his artistic

demise. Matisse, intensely involved with the Barnes project and not wanting to devote much energy to the show, had only signaled to Étienne Bignou, its chief organizer, that he did not want a "first class burial": and this is exactly what he got.[143]

The operation had been well planned, its publicity astute, including the publication of two special issues—one of *Les Chroniques du Jour* (entitled *Pour ou contre Henri Matisse*) in April 1931, two months before the opening of the show, the other of *Cahiers d'Art* (6, nos. 5–6), just in time for the exhibition (and reissued later as a book).[144] In spite of these well-coordinated efforts, however, the show itself was a failure. Henry McBride, comparing it to the retrospective held at The Museum of Modern Art, New York, only a few months later, said that one emerged from it "in a depressed state of mind," with the feeling that "the Matisse reputation had been hurt."[145] It was less an issue of the installation itself, though McBride complained of this too, than of the composition of the show: the Bernheims, who owned the Galeries Georges Petit, had obviously planned the show as a way to advertise their leftovers. As a result, the exhibition was heavily weighted toward the early Nice period.

Out of the 143 paintings numbered in the catalogue, about ninety were painted in the soft, tonal style of these years. From no. 41, *Still Life with Peaches and Glass* of 1918 (Washington 1986, no. 42) to no. 130, *Reclining Nude* of 1926 (Carra 422), all but a few belonged to this kind. The exceptions were the 1916 *Apples* from The Art Institute of Chicago and the 1908 *Music (Sketch)* from The Museum of Modern Art, New York, nos. 46 and 47, respectively, both wrongly dated 1918, and two works that Matisse had himself provided: the exceptional *Large Interior, Nice* of 1919–20 (no. 85), which belonged to his son Pierre (it is now at The Art Institute of Chicago) and the *Decorative Figure on an Ornamental Ground* of 1925 from his own collection (no. 118; here fig. 211). Not counting the few late uncatalogued additions, there were ten works dating from 1920, nineteen from 1921, nine each from 1922 and 1923, and twelve from 1924—the tamest years in Matisse's entire career. Enough to give anyone indigestion.

And in the forty or so works correctly dated as from Matisse's pre-Nice youth, there were relatively few landmarks. The press complained, and even the apologetic Tériade was forced to warn his readers that this was by no means a retrospective.[146] Several outstanding early works enabled some conservative members of the press to pursue, undeterred, their old tirade against the "wild beast": the *Woman with the Hat* of 1905 (no. 9; San Francisco Museum of Modern Art), *Marguerite Reading* of 1906 (no. 12; Musée de Grenoble), *Blue Nude* of 1907 (no. 17; here fig. 156), the 1912 *Goldfish and Sculpture* (no. 24; The Museum of Modern Art,

New York), the 1912 *Basket of Oranges* later acquired by Picasso (no. 13; here fig. 117), the 1914 *Interior with a Goldfish Bowl* (no. 27; Musée National d'Art Moderne), *The Yellow Curtain* of the same year (no. 28), recently acquired by The Museum of Modern Art, and *Rose Marble Table* of 1917 (no. 39). All of these works were lent by Matisse's early collectors, ex-students, or personal friends. To fill out the list, Matisse insisted on adding a few paintings from his own collection: a student work (his 1892 copy of a still life by David de Heim [no. 1; Musée Matisse, Nice]) and his "interpretation" of Chardin's *La Raie* from circa 1900 (no. 6; Musée Matisse, Cateau-Cambrésis). The press took notice of these very early paintings and nodded approvingly. Matisse also added a few works from the teens that were still in his possession: the 1914 *Woman on a High Stool (Germaine Raynal)* of 1914 (no. 26; The Museum of Modern Art, New York), and *Portrait of Greta Prozor* (no. 35) and *Painter in His Studio* (no. 37), both from 1916 (Musée National d'Art Moderne, Paris).[147]

Most works added by Matisse, however, were fairly recent, and belong to the "crisis" discussed above (pp. 34–36): from 1927, *Woman with a Veil* (no. 131; here fig. 20), *Classic Dancer* (no. 132; The Baltimore Museum of Art, Cone Collection), and *Reclining Nude, Seen from the Back* (no. 133; here fig. 18); the 1928 *Harmony in Yellow* (no. 136, here fig. 21); and the 1929 *Yellow Hat* (no. 141; here fig. 22).[148] Oddly, for Matisse, there was only one piece of sculpture, the *Large Seated Nude* of 1922–29. As the press informs us, there were also a hundred or so drawings, most of them in ink (critics, when they mentioned these, were struck by their lack of pentimenti). A journalist lamented that the Mallarmé book remained unopened, under glass:[149] since Matisse was only beginning to work on his illustrations (in the *Cahiers d'Art* volume, the publication date is given as 1932), there was probably not much to see at this point except for a luxurious box binding. Given that Picasso's Ovid was currently on display at Rosenberg's, this little piece of trickery was fair play.

The critical response to the Matisse exhibition was tepid: despite the usual howls from the old guard, Matisse was now regarded as a relic of the past, a closed case. Some of the most traditional critics rather liked the works from Nice, and adopted, in reverse, the critical cliché (they dismissed the early Matisse as a puerile babbler, and savored the mature one as an old French master).[150] As for the modernist critics, McBride, long an admirer of Matisse (his monograph on the artist had appeared in 1930), summed up their general view, implying along the way that Matisse's early audacities were indebted to Picasso: "It is scarcely conceivable that [Matisse] could have taken his free and high-handed attitude towards realism if cubism and other such innovations had not been in the air at the time he was forming his style. . . . He is vital though not profound. He does not search the soul."[151]

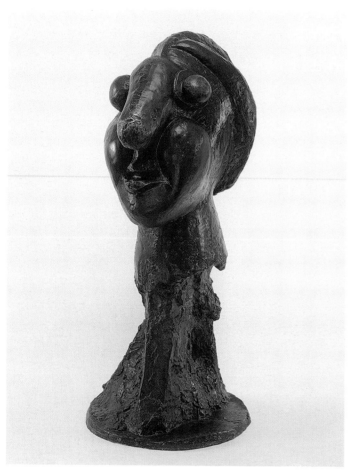

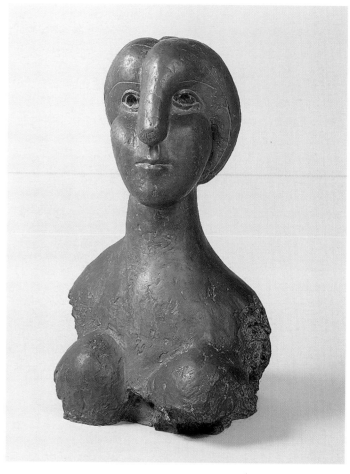

PABLO PICASSO
49 *Head of a Woman*, 1931
Bronze
33 7/8 x 12 1/2 in.
(86 x 32 x 48.5 cm)
Collection of Patsy R.
and Raymond Nasher,
Dallas, Texas

PABLO PICASSO
50 *Bust of a Woman*, 1931
Bronze (unique cast)
30 3/8 x 17 1/2 x 21 1/3 in.
(78 x 44.5 x 54 cm)
Musée Picasso, Paris

■ Sculpture: Round Three

Did Picasso rejoice at this fiasco? On the contrary, it seems to have worried him. About a week after the opening of Matisse's exhibition, he abruptly canceled a retrospective planned by Alfred Barr for The Museum of Modern Art in New York in the spring of 1932.[152] Negotiations for his Paris retrospective at the Galeries Georges Petit, also scheduled for the late spring–early summer, were probably under way, and he would not repeat Matisse's mistake: he would select and install the show himself, taking total control.

There is little doubt that Picasso also took a good look at the works displayed by Matisse and that, despite the crushing number of early Nice works, he was deeply impressed. Hence, perhaps, his pictorial silence during the next six months (marital difficulties, often invoked, had so far never interfered with his painting). When next he picked up his brush, he did so with a frenzy. From the end of December 1931 to mid-April 1932, he painted about thirty large canvases—a few still lifes, but most on the theme of Marie-Thérèse Walter asleep. All clearly relate to Matisse: Picasso exhibited a stunning group of twenty-two of them in his retrospective at Georges Petit's, from June 16 to July 30, 1932.

Picasso waited six months before reacting to Matisse's show in his painting. He did not, in the meantime, put his competitor out of

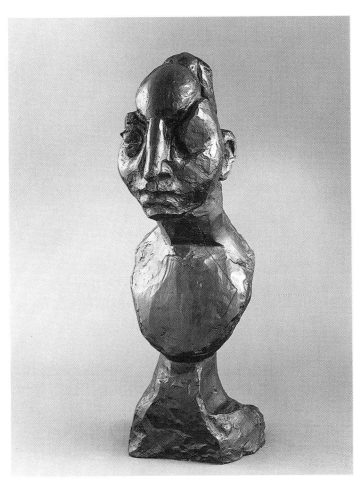

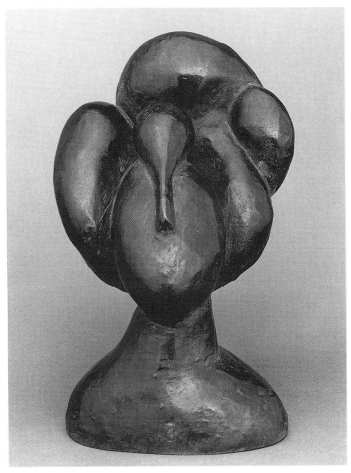

HENRI MATISSE
51 *Jeannette V*, fall 1913
Bronze
22 7/8 x 8 3/8 x 10 5/8 in.
(58 x 21.3 x 27.1 cm)
Private collection

HENRI MATISSE
52 *Tiaré*, 1930
Bronze
8 x 5 1/2 x 5 1/8 in.
(20.3 x 14 x 13 cm)
Private collection

mind, but took a detour through sculpture, returning at last to modeling. He may even have started just before the opening of the Matisse exhibition, for both *Head of a Woman* (fig. 49) and *Bust of a Woman* (fig. 50) figure on a sketch dating from June 13, 1931.[153]

These two sculptures amazingly recall Matisse's *Jeannette* series, particularly *Jeannette V* (fig. 51), with its globular right eye and the curved crease uniting the blinded left eye and cheek, a feature emphasized by Matisse in his pictorial rendering of the work (for example, in *Still Life with a Plaster Bust* [fig. 2]). In *Jeannette V*, the spoon-nose and forehead, almost a detachable implement, was an anomaly borrowed from the grafting method Picasso had just elab-

orated with synthetic cubism. Now Picasso repossesses and accentuates his invention. A comparison between Matisse's *Tiaré* (fig. 52) and Picasso's *Head of a Woman* and *Bust of a Woman* is a telling one: though Matisse, in *Tiaré*, again employs the nose-forehead spoon, cubism is far away; the implement is no longer detachable, having become the bulbous generator of the whole head. Matisse, eschewing metaphor in his painting, accepts it in his sculpture: *Tiaré* is his one and only "*femme-fleur*".[154]

In *Head of a Woman*, and even more in *Bust of a Woman*, Picasso emphasizes the metonymic aspect of his art. Even while modeling, he cannot prevent himself from taking stock of ready-made

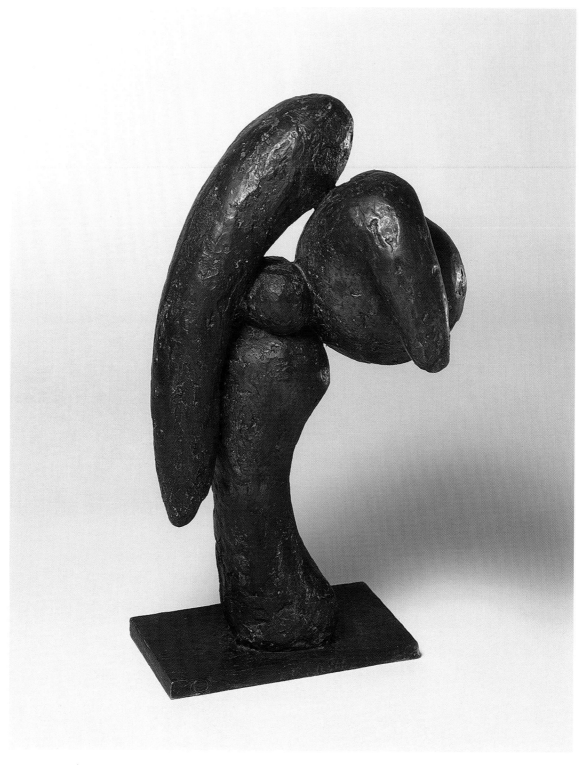

PABLO PICASSO
53 *Head of a Woman*, 1931
Bronze (unique cast)
28 1/8 x 16 1/8 x 13 in. (71.5 x 41 x 33 cm)
Musée Picasso, Paris

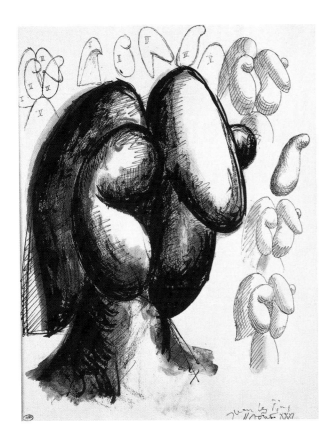

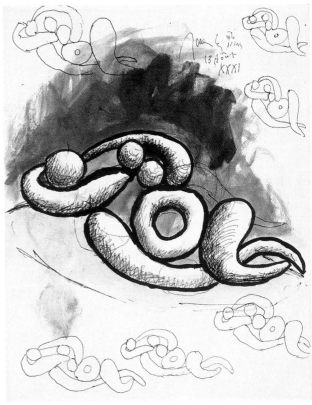

PABLO PICASSO

54 *Head of a Woman*, August 11, 1931
Ink and wash on paper
13 x 10 in. (33 x 25.5 cm)
Musée Picasso, Paris

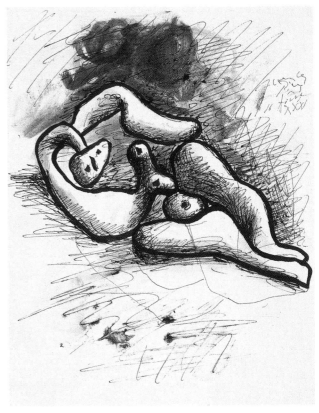

PABLO PICASSO

55 Study for the sculpture *Reclining Bather*,
(above right) August 13, 1931
Ink and wash on paper
12 3/4 x 10 in. (32.5 x 25.5 cm)
Musée Picasso, Paris

PABLO PICASSO

56 Study for the sculpture *Reclining Bather*,
(right) August 16, 1931
Ink and wash on paper
12 7/8 x 10 1/4 in. (32.6 x 26 cm)
Musée Picasso, Paris

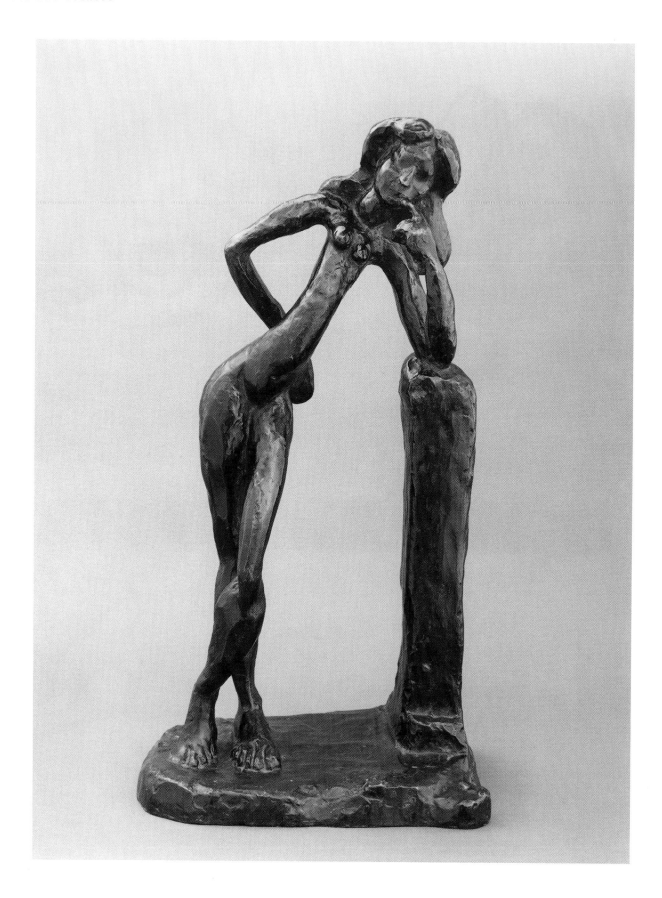

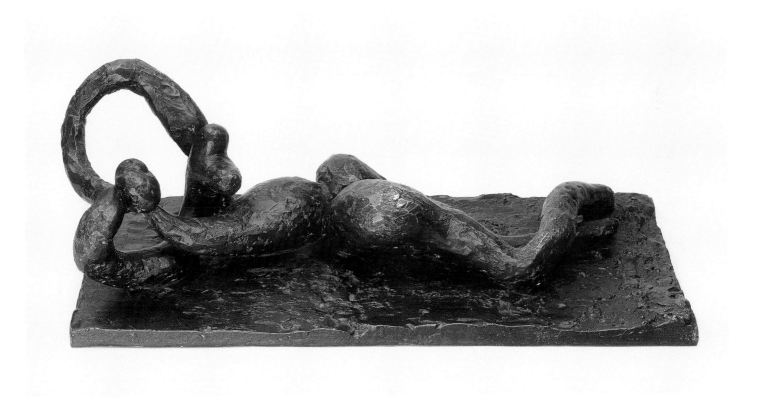

PABLO PICASSO
58 *Reclining Bather*, 1931
(*above*) Bronze
7 1/2 x 27 3/4 x 12 3/4 in.
(19 x 70.5 x 31.3 cm)
Musée Picasso, Paris

HENRI MATISSE
57 *The Serpentine*, 1909
(*left*) Bronze
21 1/2 x 11 1/2 x 7 1/2 in.
(54.6 x 29.2 x 19 cm)
Private collection

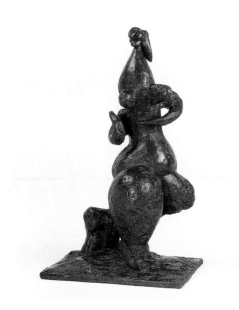

PABLO PICASSO
59 *Bather*, 1931. Bronze (unique cast)
27 1/2 x 15 1/8 x 12 3/8 in. (70 x 40.2 x 31.5 cm)
Musée Picasso, Paris

shapes and grafting them: thus the eye of the *Head* is a regular ball; the nose-forehead of the *Bust*, like Matisse's spoon, is the horn of a ram or perhaps a boomerang. In his next sculpture, also entitled *Head of a Woman* (fig. 53) and probably finished before Picasso left for his summer vacation, collage is loudly trumpeted. A drawing, done in Juan-les-Pins and dated August 11, 1931, spells everything out: the various elements are first drawn separately—each of them assigned a roman numeral—and then assembled (fig. 54). Picasso treats clay as if it were suitable for assembly blocks, as if he were a mechanic building a motor.

The studies for *Reclining Bather* (fig. 58), also made during that summer, testify even more precisely to Picasso's method: first, the geometric elements and their mode of combination are defined (fig. 55), next, the elements are streamlined into a figure (fig. 56). Placed against the seamless S-curve of Matisse's *Serpentine* (fig. 57), whose size it approximates, Picasso's arabesque can always be disassembled into independent entities. "Can" is not a strong enough word here: Picasso insists that we mentally take it apart.

Only the standing *Bather* (fig. 59 above and p. 240), which Picasso modeled upon returning to Boisgeloup in the fall, departs somewhat from the aggregative mode—and here in fact we are closer to Matisse and his fluent contrapposto. Picasso, of course, makes sure to outdo the anatomic disproportions of Matisse's sculpture: the enormous buttocks and odd legs of the latter's *Decorative Figure* of 1908 (fig. 35), for example, look mild by comparison.

■ Sleeping Beauties

Picasso is now ready to confront Matisse the painter. Most canvases from late December of 1931 to April of 1932 are all arabesque and pink flesh, sometimes set against a decorative background, and mostly depicting Marie-Thérèse Walter asleep.[155] Nothing could be more Matissean than the mellifluous black contours, or the lack of termination in the hands, which is something new in Picasso's vocabulary (hands lack finish in these paintings, both in the sense that they are drawn in shorthand, and that they are merely open-ended—a momentary halt in the movement that prolongs them). Even when a grimacing monster replaces the figure of Marie-Thérèse, an allusion to Matisse is clear: like the 1929 *Large Nude in a Red Armchair* (fig. 10), of which it is a remake, *Repose* (fig. 61) is an overt parody of Matisse's *Odalisque with a Tambourine* (fig. 11).

The color, however, is much more brash than anything Matisse ever proposed, partly because Picasso uses black to enhance his color clashes and to bring them to a paroxysm: in *Woman with Yellow Hair* (fig. 127), which integrates Matisse's art so well that, much later, Matisse's own *Dream* (fig. 128) will look like its twin, the stripes on the tablecloth are made into high-tension wires. In *The Mirror* (fig. 62), the orange lines on black ground, juxtaposed against the blue decorative pattern and the violent red crescent, are just short of Day-Glo. In *Nude on a Black Couch*,[156] it is the pinkness of the whole nymph that shines on its black jewel-casket, the amateurish sunset in the window adding an element of vernacular bad taste. With his colors, Picasso is saying that if he now paints odalisques, he does not want them to yield to any decorum—he does not want to be known, like Matisse, as a proponent of the French tradition. His *Sleep* (fig. 60) is even more posterlike than Matisse's 1907 *Le Luxe II* or *Young Sailor II*.[157] And the color in *Repose*, without the help of black contours, is even cruder.

This intensified abrasiveness of color, borrowing from the demoted language of advertisement, has all the characteristics of a demonization of Matisse's use of pure color. Picasso is always acutely aware of Matisse's structural mode of color, he holds it in awe. Whenever he ventures to say something about color, it is to distance himself from Matisse's system—as he does now. He begins an interview with Tériade, conducted a day or so before the opening of his Georges Petit show, with the following remark: "How often have I found that, wanting to use a blue, I didn't have it. So I used a red instead of a blue. Vanity of things of the mind."[158] This statement could not be more contrary to Matisse's concept of color, where each color plane plays a definite role in the overall "harmony" of the picture. Once the intensification of hues

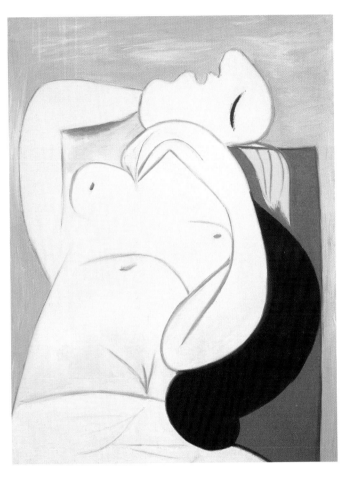

PABLO PICASSO

60 *The Sleep*, January 23, 1932
Oil on canvas
51 ¹/₈ x 38 ¹/₄ in. (130 x 97 cm)
Private collection

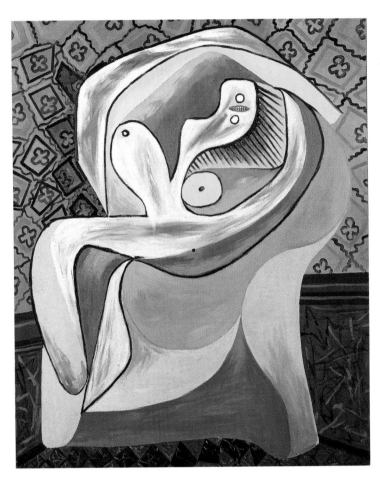

PABLO PICASSO

61 *Repose*, January 22, 1932
Oil on canvas
63 ¹/₄ x 51 ¹/₄ in. (162 x 130 cm)
Private collection

is seen only as a way to emphasize the arbitrariness of color, Matisse's unsurpassable gift as a colorist becomes irrelevant.

Picasso feels so buoyant that he even anticipates what would become, just a few years later, a favorite device of Matisse's for spreading out his compositions—the mirror reflection, a motif that Picasso himself was not usually fond of, and to which he would seldom return.[159] The celebrated *Girl Before a Mirror* (Z. VII, 379; The Museum of Modern Art, New York) belongs to this series, and the ample, unmodulated whitish buttocks of *The Mirror* (fig. 62) announce the many thighs unexpectedly reflected in Matisse's drawings of 1935–36.

As for Picasso's nudes, even at their most sinuous—in the delicate *Sleeper*, for example (fig. 39)—they remain centered, they form a loop around themselves. It is not by chance that the navel of the figure in *Repose* is conspicuously placed at the exact midpoint of the canvas, a little black circle that anchors our gaze. Once again, Matisse's territory is not to be explored without a compass.

■ Tied Game

Except for the unfinished *Sleeper*, all the canvases just mentioned, and many more of the kind, were shown at the Georges Petit retrospective in the summer of 1932—exactly one year after Matisse's retrospective. Picasso's most recent pictorial activity thus constitutes one of the best-represented periods in the exhibition (he stopped painting in April, probably devoting most of his time to the preparation of the mammoth show).

Picasso's retrospective was the far more comprehensive of the two: it comprised many more paintings (225 numbered works in the catalogue, though this figure also includes a few pastels and collages), seven sculptures,[160] and six illustrated books (including the Ovid, displayed in a special room). More important, Picasso's show was much better balanced than Matisse's retrospective. Though a hasty visitor may have been confused by its resolutely anti-chronological installation, all periods were in fact well represented; thanks to Picasso's own holdings, very few key works were missing.[161] The early years were superbly represented, ending with the 1906 *Two Nudes* (Z.I, 366; The Museum of Modern Art, New York); cubism even better, with fifty-five works dating from 1907 to 1914, though one can detect some emphasis placed on

analytic cubism: the best Horta landscapes, several heads of Fernande, *Girl with a Mandolin (Fanny Tellier)*, and *Portrait of Uhde* (Z. II*, 235 and 217). Up to the 1915 *Harlequin*, it was a blueprint for a crash course in the history of cubism. The neoclassical works of the late teens and early twenties, by contrast, were far less well represented, and the "surrealist works" were not downplayed, a sure sign that Picasso refused to have his choice dictated by the dealers. Many Matisse-oriented paintings were on view, notably the *Three Bathers* from 1920 (Z. IV, 169), the *Woman with a Tambourine (Odalisque)* (here fig. 17), and *Painter and Model* (here fig. 25).[162]

It was an extraordinary exhibition, of top "museum quality."[163] Picasso took no risks. If he had been anxious about the show, he was now justified in feeling safe. He even allows himself, in his interview with Tériade, some magnanimous (or patronizing?) words about his unfortunate rival: "In the end, everything depends on one's self. It's a sun in the belly with a thousand rays. The rest is nothing. It's the only reason why, for example, Matisse is Matisse. For he's got this sun in his belly. That is also why, from time to time, something is there."

But although the press coverage was even more extensive for Picasso's retrospective than for Matisse's, the critical response, with very few exceptions—not counting the obligatory special issue of *Cahiers d'Art*, an unwavering eulogy, twice the thickness of its issue for the Matisse show—was utterly negative and condescending in tone. Here is a sampling: Picasso is devoid of any painterly métier (Jacques Guenne); his situation is that of "a man endowed with an extraordinary intelligence for drawing and who would have deserved to have some genius, but who has none" (Claude Roger-Marx); "if we did not know that he was at the origin of some modern forms of art, we would not believe in him any more, he would not command our admiration and he would soon be forgotten" (Roger Lesbats).[164] Germain Bazin was the nastiest: "His current downfall is one of the most troubling problems of our time." He ends his review with a quote from the arch-reactionary Camille Mauclair: "He'll perish whole, after having amused a generation with his exercises."[165]

For all his efforts, Picasso flunked with the public. The score of his match with Matisse was a tie.[166]

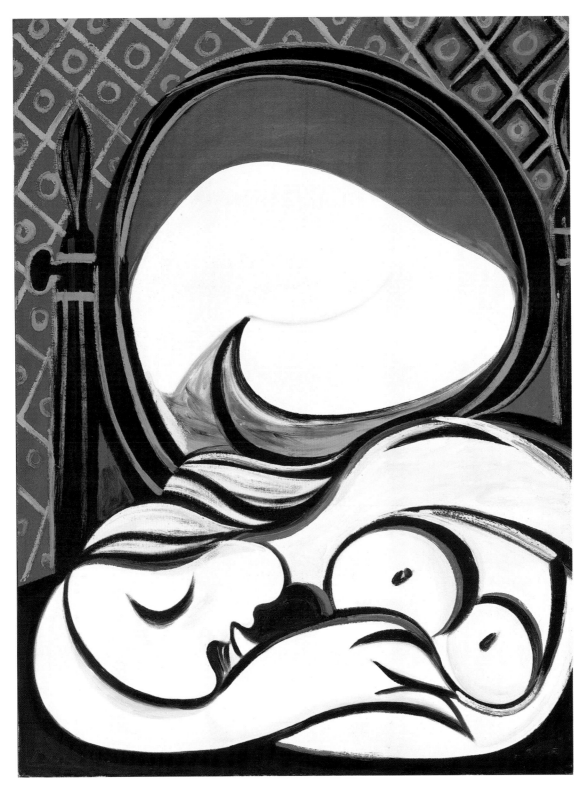

PABLO PICASSO
62 *The Mirror*, March 12, 1932
Oil on canvas. 51 $^{1}/_{2}$ x 38 $^{1}/_{8}$ in. (130.7 x 97 cm)
Private collection

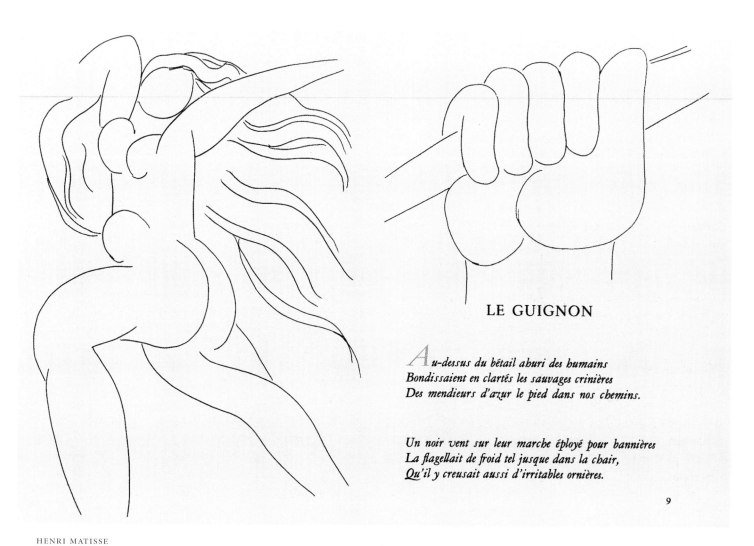

HENRI MATISSE

63 *Le Guignon*, 1931–32
Illustration for Mallarmé's *Poésies* (1932)
Etching. Each page : 13 1/4 x 9 7/8 in.
(33.5 x 25 cm)

SECOND ACT: MAKING PARTNERS

1932–39

■ Illustration, Equivalence, Decoration

Published in October 1932, the Mallarmé book constitutes, in effect, the first public sign that Matisse was re-entering the ring of high modernism. Did Picasso prompt him to do so with his Ovid, hailed as a splendid achievement? Advertising both books together, Skira staged a comparison between them. Given the high stakes involved, anxiety was not unwarranted: the Mallarmé was Matisse's first illustrated book, and he took a year and a half to complete it.

Almost from the beginning, Matisse had a clear idea of what should not be done. In an interview with Tériade, published the day of the opening of his Georges Petit exhibition, he even rejected illustration per se: a good poem does not need any accompanying image, which was also Mallarmé's own position.[167] "But," he added, "it is agreeable to see a good poet inspire the imagination of another artist. This latter could create an equivalent."[168]

This word equivalent points to an affinity between the aesthetics of Matisse and of Mallarmé. The most telling evidence for such an affinity is perhaps provided by the juxtaposition of Mallarmé's famous dictum— "To paint not the thing, but the effect it produces"—with Matisse's answer to a journalist asking him about his theory of art: "I do not literally paint that table, but the emotion it produces upon me."[169] Together with his work on *The Dance*, Matisse's plunge into Mallarmé's diffracted, dispersed language reunites him with the artistic credo of his youth.

One of the essential components of this credo is the notion of the "decorative," which should not be confused with the representation of decorative motifs, something that certainly occurs in Matisse's canvases, but more so during his Nice years than at any other time. The "decorative," as Matisse understood it, entails a diffusion of focus; it implies that everything counts in a painting, and that neither the figures nor any other element should get the lion's share of attention. The "decorative" is what replaces expression. It implies, in fact, the beholder's inattention, letting Matisse suggest the effect of the motif indirectly, subliminally. During the early Nice years, Matisse almost entirely neglected this concept. Then came the Mallarmé book, which is not illustrated, he says, but decorated.[170]

In a later text entitled "How I Made My Books," Matisse reveals how the Mallarmé project put him back on track. The visual unit of the book is the double spread, the left page usually bearing the printed text, in a typography chosen by Matisse himself, and the right page bearing the etching: "The problem was then to balance the two pages—one white, with the etching, the other comparatively black, with the type. I obtained my result by modifying my arabesque in such a way that the spectator should be interested as much by the white page as by his expectation of reading the text." Matisse compares his two pages to the juggling of a white ball with a black ball. And he insists on respecting the whiteness of the right-hand page: his etchings are "done in an even, very thin line, without hatching, so that the printed page is left almost as white as it was before printing." This aim accords well with Mallarmé's desire that "the whites assume importance" (the poet was writing about intervals between words, just as Matisse often referred to intervals between lines), but it also emphasizes Matisse's return to an all-over conception of the picture plane—his signature in the pre-Nice years. "The drawing," he wrote, "fills the entire page so that the page stays light, because the drawing is not massed toward the center, as usual, but spreads over the whole page."[171]

Picasso too used very thin lines in his Ovid, but there the similarity ends: his illustrations are all framed, and he never considers their physical placement in the book as a visual issue. The large etchings are placed in the middle of each of Ovid's fifteen books, and the half-page illustrations are placed at the beginning. No fuss. Matisse's first book, by contrast, is entirely orchestrated by the artist, down to the last detail. And the result was extraordinary.

The whites indeed "assume importance": the jumping nymph of the first image of the book, illustrating, or rather decorating "Le Guignon" (fig. 63); the wings of the swan decorating the first poem of "Petit Air" (fig. 65), the inundating hair of the upturned face beside the famous "Sonnet en x" (fig. 64), announcing Mallarmé's "La Chevelure" in the next double spread—all these images are splendid demonstrations of Matisse's ability to modulate the space of the page with arabesques that never function as closed contours. The whiteness of the paper combines with a

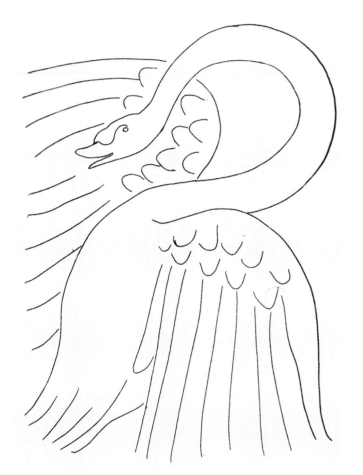

HENRI MATISSE

65 *The Swan*, 1931–32
Illustration for Mallarmé's
Poésies (1932)
Etching
13 1/4 x 9 7/8 in. (33.5 x 25 cm)

HENRI MATISSE

64 *Hair*, 1931–32
Illustration for Mallarmé's
Poésies (1932)
Etching
13 1/4 x 9 7/8 in. (33.5 x 25 cm)

66 *Nymphs and Faun*
Illustration for Mallarmé's
Poésies (1932)
Etching
13 1/4 x 9 7/8 in. (33.5 x 25 cm)

67 *Nymph and Faun*
Illustration for Mallarmé's
Poésies (1932)
Etching
13 1/4 x 9 7/8 in. (33.5 x 25 cm)

sense of unlimited linear extension to produce an effect of infinite radiance. We confront the Mallarmé prints as we do the 1910 *Dance* or the 1911 *Interior with Eggplant*, flooded by their expansiveness. True, not all the etchings are equally buoyant; somewhat paradoxically, in fact, the plates relating to "L'Après-midi d'un faune" are relatively static, even though one of them describes no fewer than seven frolicking creatures (fig. 66), and another, the lovemaking of faun and nymph (fig. 67).[172] Picasso, at the time, was showing how much more ardently one could represent the embrace of a mythical being.

■ *The Dance*

Expansiveness, inherent in Matisse's conception of the decorative, also defines *The Dance*. Precluding any use of the traditional devices of spatial notation, such as perspective or tonal modeling, which would hollow out the picture plane in depth, it causes us to remember a pre- or post-Nice work as being larger than it really is.

Though the complex story of the Barnes "decoration," as Matisse called it, has been well established by now, a summary is in order:[173] from the first sketches to the final version, we witness the progressive triumph of the "decorative." The first sketches, probably done *in situ* at Merion, are based on the composition of the 1910 *Dance*, itself an elaboration of the central round of dancers in *The Joy of Life*, a picture which was already hung in the Barnes mansion. But unlike the early paintings, these sketches imply a spatial recession, in which the awkward architectural pendentives of the room serve as columns around which the figures move. In a second group of sketches, Matisse renounces this idea, adopting a friezelike format, accentuating the lateral extension by cropping the figures. He is satisfied enough to try several color schemes (compare figs. 68 and 69); when he realizes that he cannot compose so vast a work on such a reduced scale, he has huge canvases stretched in the rented garage serving as a studio. There he starts painting what is known today as the first version of *The Dance*.

Working out a color harmony on a surface more than forty feet wide and ten feet high is an exhausting task: needing some encouragement, Matisse decided to look again at Giotto's fourteenth-century frescoes in the Arena Chapel, to which he had already turned in 1907. From Giotto, Matisse would learn that "flat tones without any gradation" are "a necessity of the fresco,"[174] after which lesson he rejects all tonal modeling in his mural, and invents his method of using large color cutouts.

Matisse learns something else from Giotto—what it means to deal with a mural, to work in an architectural space. He was mindful of the architectural frame, of course, as he worked on the first (and eventually discarded) version; but where he first considered

this frame as a theatrical prop for his figures, he now realized that he had to take the whole wall into account, even the openings below his "decorations." He grasped, in a word, the laws of what we call "site-specificity," and began to think of the Barnes composition as a gigantic ensemble from floor to ceiling and from wall to wall. As a result, he payed attention to what he did not notice at first: the light, the poor visibility of the composition as a whole, the compressed space and, above all, the need to make his mural work differently from the easel paintings beneath it.

It is at this juncture that Matisse elaborates a remarkable critical opposition, best formulated in his letters about the Barnes commission to Alexander Romm (letters in which Matisse also alludes to the plates for Mallarmé). There are two kinds of painting, easel painting and architectural painting. Given that the easel paintings he has been engaged in since 1918, with rare exceptions, have betrayed his earlier notion of the "decorative" as a system that diffracts our gaze, it is thus not surprising at this point that Matisse defines the easel painting as a work that "cannot be penetrated unless the attention of the viewer is concentrated especially on it"— as an absorptive artifact, to use Michael Fried's concept.[175]

Matisse's definition of architectural painting reveals that he is now ready to reactivate his conception of the "decorative." Noting that the absorptive aesthetic of easel painting (once again, as exemplified in his early Nice works) is based on mimesis, on the identification of the spectator with what he calls—borrowing from Romm's letter to him—the "human element," Matisse proposes for the mural an aesthetics of distraction, in which "the human element has to be tempered, if not excluded." "The spectator," he wrote, "should not be arrested by this human character with which he would identify, and which, immobilizing him, would separate him from the great, harmonious, living and animated association of the architecture and the painting."[176]

In defining the difference between architectural painting and easel painting, Matisse is able to advance with his work on the Barnes commission. Taken with the work on the Mallarmé, this progress explains why he is not utterly devastated when he discovers an error in the measurement of the Merion space. He temporarily folds the second version of *The Dance*, and works much faster on a third one—the one he finally installs at the Barnes Foundation on May 17, 1933 (fig. 70).

Exuberant at completing the Merion mural, Matisse believes that the opposition he enunciates between architectural and easel painting is necessarily related to the issue of site-specificity. This is a mistaken view, as we learn from the second version of *The Dance* (fig. 71). For this work is not site-specific (no space was ever going to duplicate that of the Barnes Foundation), yet it is

HENRI MATISSE
68 Study for *The Dance (Ochre Harmony)*,
early 1931
Oil on canvas
13 x 34 1/4 in. (33 x 87 cm)
Musée Matisse, Nice

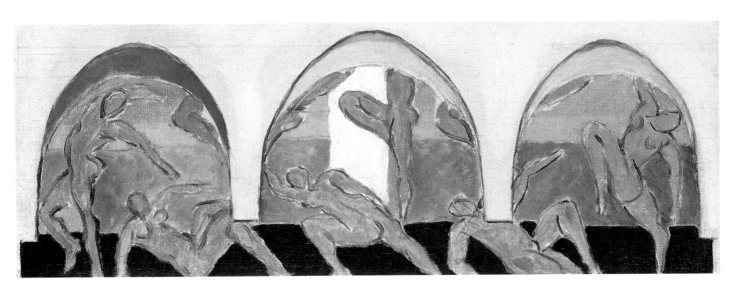

HENRI MATISSE
69 Study for *The Dance (Blue Harmony)*,
early 1931
Oil on canvas
13 x 34 1/4 in. (33 x 87 cm)
Musée Matisse, Nice

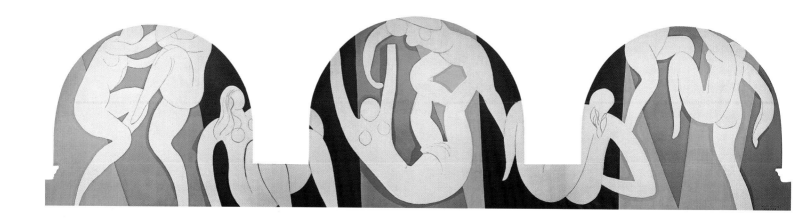

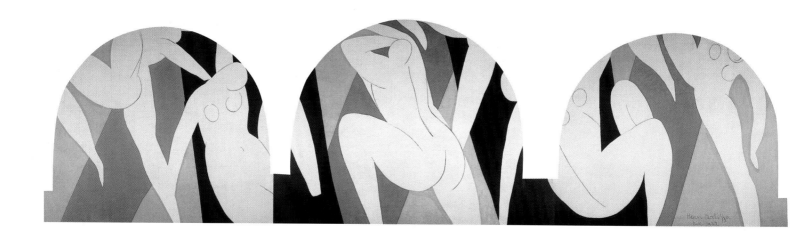

HENRI MATISSE

70 *The Dance*, 1932–33

(top) Oil on canvas
The Barnes Foundation, Merion,
Pennsylvania

Left panel:
133 ³/₄ x 173 ³/₄ in. (339.7 cm x 441.3 cm)
Central panel:
140 ¹/₈ x 198 ¹/₈ in. (355.9 x 503.2 cm)
Right panel:
133 ³/₈ x 173 in. (338 x 439.4 cm)

HENRI MATISSE

71 *The Dance*, 1931–33

(bottom) Oil on canvas
Musée d'Art Moderne de la Ville de Paris;
purchased by the City of Paris 1937

Left panel:
130 ³/₈ x 150 ¹/₄ in. (340 x 387 cm)
Central panel
140 x 190 ⁵/₈ in. (355 x 498 cm)
Right panel
130 ¹/₄ x 150 ³/₈ in. (335 x 391 cm)

even more of an "architectural" painting than the Merion version, which still retained something of the easel structure with its three distinct scenes between the architectural pendentives. When Matisse gives a final touch to this second version, he accentuates the rhythmic decentering of his composition, so as to ensure that we cannot "identify" with anything, cannot rest our eyes anywhere. In a word, he incorporates, in his pictorial art, a requirement—the "decorative," first explored in his youth—which he mistakenly regards as something architectural in a restricted sense.

■ Drawing as if to Dance

This is not to say, however, that Matisse is back to square one, that he is simply going to re-use a pictorial language that he abandoned for fifteen years. The work on *The Dance* and on the Mallarmé illustrations not only reconnect Matisse to his earlier accomplishments, they also oblige him to reinterpret, to recast, his way of thinking about art.

Evidence of this new turn is given in two sketchbooks filled with drawings of dancers and acrobats, made in preparation for the Barnes mural (figs. 72a–l), out of which Matisse creates a set of ten lithographs (figs. 73a–e). There is a striking similarity between these quickly jotted acrobats and the series of paintings by Picasso on the same theme (pp. 46, 50 above; figs. 31, 32 and 173).[177] They often recall the one-line drawings that Picasso made around 1906–07 for Apollinaire's *Bestiaire*, and his later sketches for the ballet *Mercure* (figs. 7 and 8). Matisse may have had Picasso in mind when sketching his acrobats: he would be reconquering a territory that had been usurped, reclaiming a piece on the chessboard.

At first, it is simply a matter of capturing the movements of the dancers and acrobats: the rapid sketch was something that Matisse mastered as a student, around 1900, when he was drawing in the streets with Albert Marquet, and which he more or less banned from his draftsmanship thereafter. Like these earlier drawings, the extraordinary sketches of 1931–2 capture the singularity of a movement or posture in a few strokes. Some of them even yield a kind of explanatory chart: next to the shorthand notation of a dancer's flexion, Matisse draws its more detailed "translation" (figs. 72h and l).

But there is more to these sketches than economy. They result in a radical transformation of Matisse's method of drawing. In his best drawings, he had always proceeded through distillation: he would draw and redraw the same motif, eliminating little by little all that was redundant or inessential (this was still the way he had worked on the Mallarmé illustration). The quick sketches of the acrobats short-circuit this patient process. Matisse is no

longer trying to refine an essence, but rather to internalize it—to capture within himself, synesthetically, as it were, the very movement he draws. He wants to identify with this movement, to draw as if he were dancing. And when he finally does the huge canvas of *The Dance*, the lines flow easily at the proper scale. In other words, the quick sketches are in no way compositional notations for the large mural, but they prepare Matisse himself for the direct "hand to hand combat [*corps à corps*] with the whole formidable surface."[178] Indeed, Matisse begins to conceive of drawing as akin to the activity of an acrobat. This metaphor often appears in his statements, especially after he perfects this new drawing method. An acrobat, a high-wire artist, will fall if he thinks on the wire (or so Matisse imagines); he has to prepare himself through hours of arduous exercises so that, when the time comes to perform, his mind can be empty and his body can make the right move spontaneously, without hesitation, without calculation.

It is at this point that Matisse introduced two concepts into his discourse, the second quickly superseding the first. While speaking to Tériade about Manet, in January 1932, he praised the painter for having been "the first to have made an immediate translation of his sensations, thus liberating the instinct. He has been the first to *act by sheer reflex* and in doing so to simplify the work of the painter."[179] But, no doubt encouraged by his conversations with André Masson, Matisse soon replaced "reflex" by "unconscious."

Matisse's first remarks on this notion, published in the journal *Minotaure*, are part of an anthology of artists' statements assembled by Tériade at the end of a jeremiad about art criticism. Tériade had circulated questions about chance, spontaneity, and the absence of model as the new emerging rules of artmaking. Picasso's answer was brief, jokingly recalling his experience of drawing in the dark.[180] Matisse's statement was less concise, and far more significant:

> The things that are acquired consciously permit us to express ourselves unconsciously with a certain richness. On the other hand, the unconscious enrichment of the artist is accomplished by all he sees and translates pictorially without thinking about it. An acacia on Vésubie [a river that enters the sea at Nice], its movements, its svelte grace, led me perhaps to conceive the body of a dancing woman.[181]

Later in the text, Matisse notes that it is the *conscious* studies made for the preparation of a picture that allow the painter, in front of his canvas, to "free his unconscious mind." This two-stage process—a long preparation through "conscious" studies and an

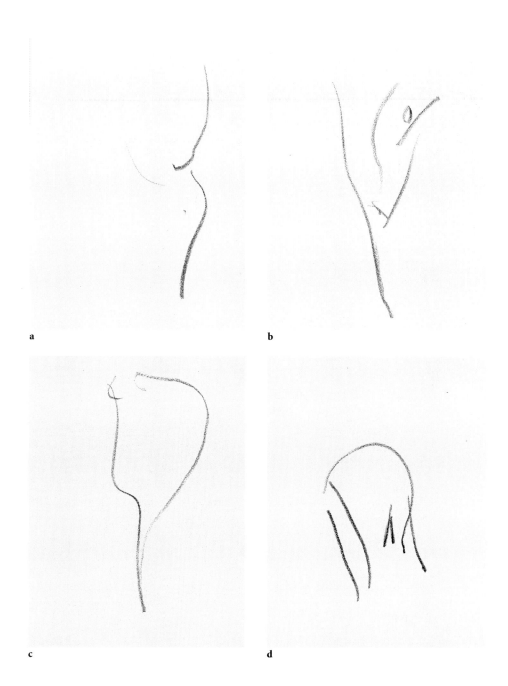

a

b

c

d

e

f

HENRI MATISSE
72 *Acrobats and Dancers*, 1931–32
a-g Sketchbook "nº 3"
Pencil on paper
10 3/8 x 8 1/4 in. (26.5 x 21 cm)
Private collection

g

h

i

j

k

l

HENRI MATISSE
72 *Acrobats and Dancers*, 1931–32
h–l Sketchbook "n° 4"
Pencil on paper
10 ³/₈ x 8 ¹/₄ in. (26.5 x 21 cm)
Private collection

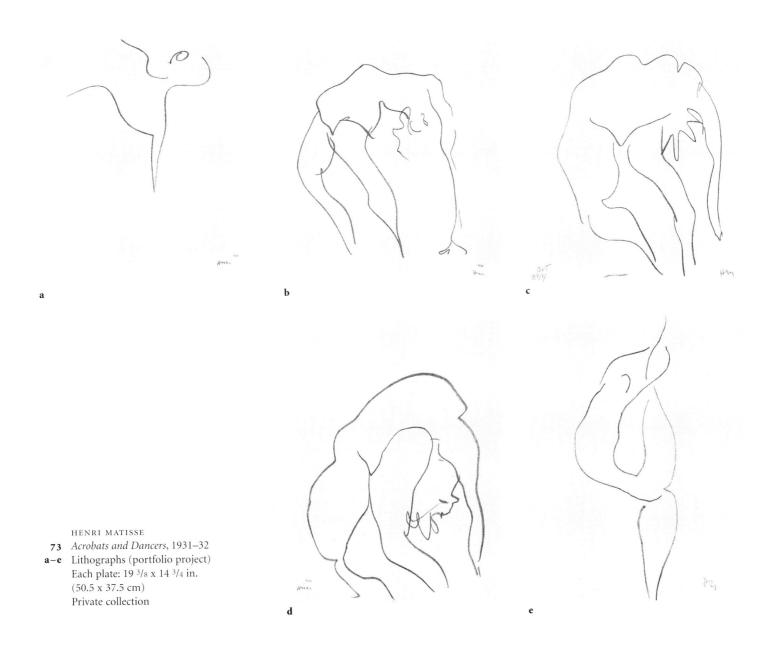

a

b

c

HENRI MATISSE
73 *Acrobats and Dancers*, 1931–32
a–e Lithographs (portfolio project)
Each plate: 19 ³/₈ x 14 ³/₄ in.
(50.5 x 37.5 cm)
Private collection

d

e

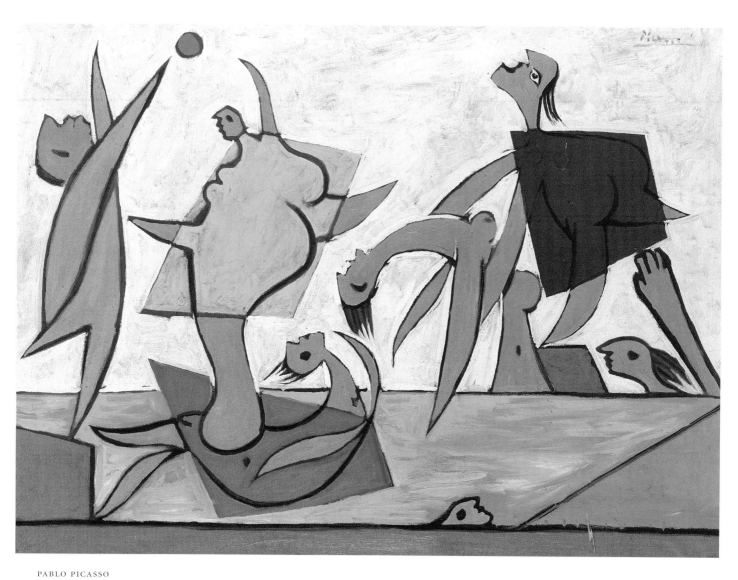

PABLO PICASSO

74 *Games and Rescue on the Beach*,
November 1932
Oil on canvas
38 ³/₈ x 51 ¹/₄ in. (97.5 x 130 cm)
Private collection,
on loan to the Staatsgalerie, Stuttgart

PABLO PICASSO
75 *The Dance*, 1933
a–f Pencil on paper
Each: 7 1/8 x 5 3/8 in. (18.1 x 13.3 cm)
a: Collection of Susan and Alan Patricof
b: Collection of Linda and Morton Janklow, New York
c: Collection of Eunice and Hal David, Los Angeles, California
d-f: Private collections
All courtesy Pace Wildenstein, New York

alla prima realization during which the painter "does not know where he is going and relies upon his unconscious"[182]—becomes, from now on, a hallmark of Matisse's aesthetics. He does not, however, master the method in drawing until about two years later. As for painting, only in the late forties will Matisse cease to lament about his incapacity to achieve the same kind of automatism in his canvases.

Matisse's switch from "reflex" to "unconscious" was perhaps infelicitous, since his notion of the unconscious had little to do with the Freudian concept, especially as it was somewhat trivialized by the surrealists. And no doubt it was misread at the time, for if *Minotaure* was theoretically edited by Tériade, André Breton considered it his fiefdom.[183] Matisse's use of the term is in fact much closer to that of Bergson (the only philosopher he read with some constancy) and of Proust, where the "unconscious" functions a bit like a reflex, often involving a kind of bodily automatism. It is an uncontrollable, synesthetic force of the kind that abruptly summons Proust's "involuntary memory." Proust, noted Walter Benjamin, "frequently speaks of the memory images deposited in limbs—images that suddenly break into memory without any command from consciousness when a thigh, an arm, or a shoulder blade happens to assume a position in bed that they had at some earlier time."[184] This is precisely what Matisse encountered when sketching his acrobats.

■ Quick Response

Notwithstanding Picasso's attempt at automatic poetry, and his conception of work as the continuous writing of a private diary, Matisse's goal of immediacy was utterly foreign to him. But this does not prevent him from wanting to respond to Matisse's "decorative" principle.

In November 1932, Picasso painted a series of canvases on a single theme, culminating in *Games and Rescue on the Beach* (fig. 74). This was just a month after the publication of the Mallarmé book, which still constituted the only evidence that Matisse's art was changing course.[185] At the time, there was much talk in Paris of the work in progress on *The Dance*, all the more so since Matisse was keeping it secret from absolutely everyone, save his assistant. *Games and Rescue on the Beach* is Picasso's anticipative response to *The Dance*, given the Mallarmé book—his anticipative outbidding. His prescience in this painting is uncanny: the flat tones, the contrapposto of the figures, the syncopated rhythm, the drama (half-violence, half-pleasure) —all the elements of this turbulent picture are "echoes" of Matisse's *Dance*.

Yet even though *Games and Rescue on the Beach* is far more

friezelike than usual, Picasso cannot prevent himself from centering the composition somewhat. As for the color scheme, it is among the clearest applications of one of his aesthetic principles (though usually reserved for the cohabitation of different styles in a single painting): colors are used to mark individuation of the figures, each conceived as being from a different species.[186] Several figures are coloristically "neutral" (including the drowned swimmer), but three others are emblazoned, respectively, with a red, a yellow, and a green coat of arms. These colored polygons, independent from the contour of the dancing figures they adorn, are also independent from each other. They do not constitute a coloristic accord: the picture is populated, but it describes solitude and disunity in the face of tragedy.

In the series of drawings on the theme of dance that follows (figs. 75a–f), Picasso comes closer still to Matisse—perhaps because he knows more about the recent development of his art. (First, even if Picasso did not yet own a copy of the Mallarmé book, he could have familiarized himself not only with the finished work but also with all the discarded plates and preparatory studies, exhibited in Paris for a week at the Galerie Pierre Colle [February 3–10, 1933]—the studies are all the more relevant since Matisse's serpentination of the figures is somewhat downplayed in the book when compared to the preparatory material. Second, the Picasso drawings might date from as late as November 1933, which would place them after the May 1933 publication of a large reproduction of the Barnes *Dance* in Louis Gillet's sympathetic article on this work.)[187] In the dance drawings, it is as though Picasso had even seen the acrobat sketches and the lithographs (which were not printed until much later), as though he had internalized Matisse's curves. Note again, however, the differences: the faceless nymphs of Matisse are now complete with eyes, nose, mouth, and all; the contours are closed; the composition centered, even if, as in *The Gray Acrobat* of 1930 (fig. 32), the figures brush the limit of the paper, sometimes even the corner, as if to touch base.

But Picasso no longer teases. A couple of weeks after the exhibition of the Mallarmé illustrations closed, he pays homage to his rival, or rather he signals that their match, after so many tryouts, has now officially begun, and that it needn't be so tense. In the drawing *The Studio*, dated February 22, 1933, one of Picasso's ballooning nudes crouches in levitation on a table, contemplating a picture placed on an easel, that depicts, unmistakably, a sleeping Matisse odalisque (fig. 76). Less than two months later, this lessening of the tension is further acknowledged in another drawing of two nudes (fig. 77); it seems to be a tribute paid to Matisse's *Tiaré* (fig. 52).[188]

PABLO PICASSO
76 *The Studio*,
February 22, 1933
Pencil on paper
10 3/8 x 13 1/2 in.
(26.2 x 34.3 cm)
Musée Picasso, Paris

PABLO PICASSO
77 *Two Figures*,
April 12, 1933
Pencil on paper
13 3/8 x 18 3/4 in.
(34.5 x 47.5 cm)
Musée Picasso, Paris

■ Violence

But Picasso is planning a new move. From March to May 1933, he works furiously on the etchings of his *Suite Vollard*. First, he produces a series of prints depicting the sculptor in his studio; these are as static as the best plates from the Ovid were dynamic and agitated, and more centered than ever. It is as if Picasso were declaring a categorical "No" to the Matissean "decorative": the figures are the focus, not the whiteness of the paper, even though this whiteness is modulated through the opposition of closed and open contours and through swift jumps in scale. Then, on April 22 and 23, comes a storm, sudden and unexpected (and long an enigma for scholars of the *Suite Vollard*): images of a man embracing a woman with such passion that they are often interpreted as depicting a rape (figs. 79 and 78).[189] On May 17, no doubt prompted by work he had just done in preparation for the cover of the first issue of *Minotaure*, Picasso ushers this mythical beast into the *Suite Vollard*. At first, the minotaur is idle (having a glass of wine with his naked lover); a few days later he is engaged in a sexual assault (Geiser/Baer, II, 356). The violence reaches a paroxysm in several drawings done at the end of June: all muscle, the minotaur pries open the nude body of his prey (fig. 80).

In the meantime, the first issue of *Minotaure* appears, with an enormous dossier on Picasso centered around an article by Breton and an extraordinary series of photographs by Brassaï revealing Picasso's considerable activity as a sculptor in the past few years. But the issue also contains the reproduction of a few works by Matisse—among them, the preparatory drawings for Matisse's *Nymph and Faun* (fig. 67), confirming Picasso's superiority in the drawing of erotic scenes. It is much clearer in these studies than in the final print that a nymph is being harassed (fig. 81), but how embarrassed Matisse seems to be in treating such a theme!

Matisse knew that violence was not his forte—it was a theme that he usually kept at bay—that he had indeed entirely ignored after his 1908–09 *Nymph and Satyr* (State Hermitage Museum, St. Petersburg). Yet he would suddenly return to it. Was it after having seen some of Picasso's "rape" scenes? The first works to be considered are two plates for the illustration of James Joyce's *Ulysses*. This project, like the Ovid/Mallarmé exchange, is a tit-for-tat affair between the two artists: the American publisher George Macy, of the Limited Editions Club, had first commissioned an edition of Aristophanes' *Lysistrata* from Picasso, before approaching Matisse with the Joyce project in March 1934.[190] Picasso had most certainly been frustrated by the puritanism of the American publisher. Where his initial sketches for the illustration of Aristophanes' great satyrical play (done on the same blue stationery as figs. 75a–f) were deliberately obscene, his etchings for the book are perhaps the most neoclassical, the most Davidian, he ever produced.

Their stiff, extraordinarily cold decorum is only counterbalanced by the (very poor) lithographic reproduction, in brick red, of thirty-four drawings which are more animated (fig. 82).

Perhaps stimulated by the idea of working in the same mythological terrain as Picasso, Matisse decides to illustrate *Ulysses* as if it were the *Odyssey* (a liberty he could take because he did not read English). The first plate he worked on, in the spring of 1934, was *Calypso* (which he privately called *The Battle*)—"the two women fighting, representing disorder in the house of Ulysses."[191] Because the publisher agreed to include facsimile reproductions of preparatory studies for the etchings, we can observe a gradual transformation from the fiery initial concept, where the rough pentimenti in charcoal signify the rage of the struggle (fig. 84), to the almost metallic tango of the definitive plate (fig. 83).

The Blinding of Polyphemus was done several months later, in the fall, by which time Matisse had seen Picasso's *Lysistrata* (the *Blinding* bears some resemblance to certain drawings reproduced in Aristophanes' text). The first version (fig. 85) and the final plate (fig. 86) are the most violent images Matisse ever produced. In the first, the claustrophobic zoom effect, the displaced right leg of the Cyclops, as if severed from his body, the stretched-out toes, the accelerated foreshortening of the figure of Ulysses, all give a baroque pathos to the scene, most unusual in Matisse's oeuvre. In the final, more tectonic, version, the claustrophobic aspect is emphasized even more, with the limbs of Polyphemus running along three sides of the frame, and Ulysses' shoulder paralleling the fourth. As a result, the spatial recession diminishes, but the drama is nevertheless enhanced by the extraordinary anatomical torsion of the victim's body: showing both buttocks and genitalia, Matisse is obviously treading on Picasso's space.

He would not stop there. A few months later, in March 1935, Matisse draws Hercules and Antaeus, after Pollaiuolo's celebrated image of their fight,[192] and in June of that year, he starts working on a large composition of a faun, theoretically serenading a sleeping nymph with his flute, but looking much more as if he were going to assault her (fig. 87). Perhaps Matisse overestimated his own capacity to stomach such aggressive imagery: the two paintings that issue from this essay in drawing remain unfinished, though he stubbornly worked at them periodically, notably during World War II, never reaching a definitive solution. Neither the delicate charcoal on canvas (fig. 88) nor the picture known as *La Verdure*, initially conceived as a cartoon for a tapestry (fig 89), come close to the savagery he had managed to depict in *Ulysses*. Perhaps because he had been exposed to some of Picasso's variations on the theme of the rapacious minotaur, he realized that he was not well equipped in the genre of violence.

PABLO PICASSO
78 *The Embrace I*
from the *Suite Vollard*,
April 23, 1933
Etching
11 3/4 x 14 3/8 in.
(30 x 36.5 cm)
Musée Picasso, Paris

PABLO PICASSO
79 *The Embrace III*,
from the *Suite Vollard*,
April 23, 1933
Etching
11 3/4 x 14 1/2 in.
(29.9 x 36.7 cm)
Musée Picasso, Paris

PABLO PICASSO
80 *Minotaur and Nude,* June 28, 1933
Ink and wash on paper
18 $^1/_2$ x 24 $^3/_8$ in. (47 x 62 cm)
Musée Picasso, Paris

L'APRÈS-MIDI D'UN FAUNE

Dessins de Henri-Matisse pour l'illustration de « Poésies » de Stéphane Mallarmé.

HENRI MATISSE
81 Studies for
Nymph and Faun
Illustration for
Mallarmé's *Poésies*, 1932
As published
in *Minotaure*, 1,
(June 1933), p. 72

PABLO PICASSO
82 *Struggle of the Women
and the Elders,*
December 1933
Illustration for
Aristophanes' *Lysistrata*,
(1934)
Lithograph
5 $^{1}/_{2}$ x 7 $^{1}/_{2}$ in.
(14 x 19 cm)

95

HENRI MATISSE

83 *Calypso*, 1934
Illustration for James Joyce's *Ulysses* (1935)
Soft–ground etching
11 $^{1}/_{8}$ x 8 $^{7}/_{8}$ in. (28.4 x 22.5cm)

HENRI MATISSE

84 Study for *Calypso*, 1934
Illustration for James Joyce's *Ulysses* (1935)
Charcoal on paper. 20 5/8 x 16 in. (52.5 x 40.5 cm)
Private collection

HENRI MATISSE
85 *The Blinding of Polyphemus*, 1934
(1st version) Discarded illustration for James Joyce' s *Ulysses* (1935)
Soft–ground etching. 11 1/4 x 8 3/4 in. (28.5 x 22.3 cm)
Private collection

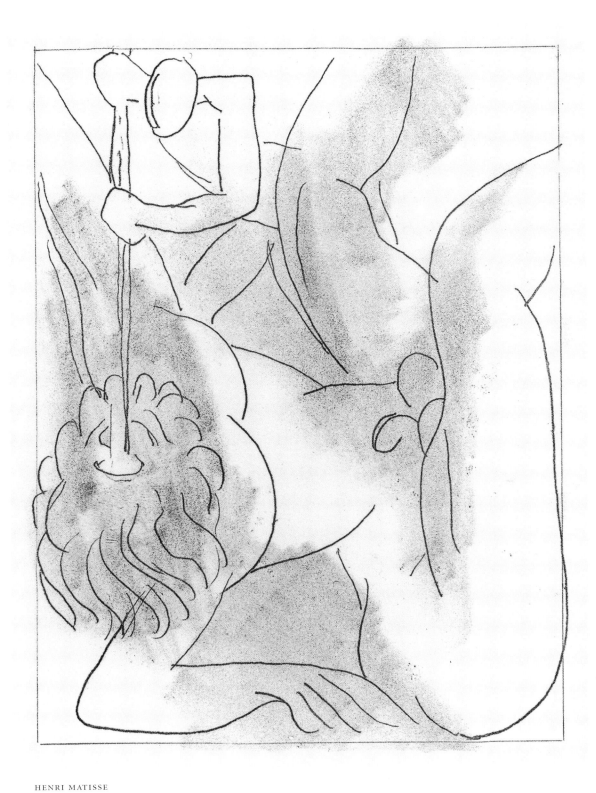

HENRI MATISSE

86 *The Blinding of Polyphemus,* 1934
Illustration for James Joyce's *Ulysses* (1935)
Soft-ground etching
11 ¹/₄ x 65 ¹/₈ in. (28.5 x 22.3 cm)

HENRI MATISSE

87 *Nymph and Faun*, 1935
Charcoal on paper
20 1/8 x 24 1/8 in.
(51.1 x 61.3 cm)
Private collection

HENRI MATISSE

88 *Nymph and Faun*,
1935–43
Charcoal on canvas
60 5/8 x 65 3/4 in.
(154 x 167 cm)
Musée National
d'Art Moderne, Paris

HENRI MATISSE
89 *La Verdure (Nymph in the Forest)*, 1935–43
Oil on canvas. 95 1/4 x 76 3/4 in. (242 x 195 cm)
Direction des Musées de France; Jean Matisse Bequest,
dépôt de l'État au Musée Matisse, Nice

■ Truce

In 1934 Picasso and Matisse began to see each other again in person. They would meet at exhibitions (discovering that they had a common taste for Miró), sign petitions for this or that social cause together (Matisse sometimes being the proselytizer), celebrate Paul Guillaume's memory, unite in their distaste for Gertrude Stein's *The Autobiography of Alice B. Toklas*.[193] They would meet as public figures, celebrities of slightly unequal status. (Simone Bussy recalls this period: "One day Matisse, entering La Coupole in Montparnasse, saw a thrill run through the whole place, its waiters all bounding towards him. Matisse murmured, 'They think I'm Picasso.'")[194] Soon the two begin to visit each other's studios for the first time since World War I, and their reciprocal engagement grows more intense.

Picasso sketched a lot of violent scenes that year, and these are most often read as ciphers of domestic trouble or, in the more recent literature, as links to the dramatic political turmoil of the time (drawings depicting a woman dismembered, even disemboweled, in the comfort of her interior; the death of Marat; or the goring of a horse in a corrida—the only one of these motifs that made it to a series of paintings).[195] But whenever he thought of quieter subjects, he invoked Matisse's art, sometimes works he had not seen for a long time.

Picasso's sensuous *Nude in a Garden* of August 1934 (fig. 91), for example, not only summons up a host of Matisse curvilinear nudes, but also offers a direct echo of Matisse's *Music Lesson* (fig. 16)—an echo, but also a critique. *The Music Lesson* established the need for distance in the depiction of sensuality. It is in fact doubly distanced: the lascivious nude is not made of flesh but of terracotta—it is the sculpture *Reclining Nude I* (*Aurora*)—and it is separated from us by various obstacles, including a wrought iron balustrade, Madame Matisse in a lounge chair, and a pond. From this painting—Matisse's last large canvas before he settled in Nice, and the gateway to the early Nice period—proceeded countless aloof odalisques who, no matter how proximate the point of view, always seem remote and unattainable. Picasso, by contrast, zooms in and bypasses the obstacles, transporting us to the garden. It is not so much that the luminous nude is up close, but that the compactness of her body and the contradictory excess of her orifices makes the beholder "experience some of the visual disorientation which attends carnal knowledge," to quote the remark Leo Steinberg once made of the *Suite Vollard* embrace (fig. 79).[196] She is both an ovoid and a Möbius strip, her limbs curled up against her but never hiding anything: breasts, navel, sex, anus, all are visible, and the continuity of her curves appeals to our sense of touch.[197]

Paul Rosenberg refused to exhibit Picasso's *Nude in a Garden*,[198] but that same year the artist initiated an elaborate visual argument, bearing fruit in 1935, that would have a marked effect on Matisse. It combines three thematic threads: the female figure absorbed in reading (a topic magnificently treated by Matisse in his 1906 *Marguerite Reading* at the Musée de Grenoble); the painter and his model; and the reflection in the mirror.

Picasso explores the first of these themes in March 1934, with a series of canvases actually showing two women captivated by a book or journal, their Matissean pose obvious (Z. VIII, 190–194). The second theme is initiated in an April 1934 sketchbook, where Picasso revisits his 1932 sketches on the painter-and-model motif. He now tackles the issue of representation through a kind of ambiguity that was long a favorite trope of Matisse's—the deliberate confusion of a window with a depicted picture within the picture (see, for example, the 1911 *Interior with Eggplant*). Picasso concludes the series by adding a touch of his own to this motif—sketches revealing that the woman is only a sculpture, and the artist, only Pygmalion.[199]

From these sketches, two canvases are generated in May. One of these, *The Painter*, now at the Wadsworth Atheneum, Hartford (Z. VIII, 205) is a revision of the 1931 *Still Life on a Pedestal Table* (fig. 47).[200] The other, *Nude with Bouquet of Irises and Mirror* (fig. 90), elides Pygmalion but retains other elements of *The Painter*, notably the pyramid overlapping the nude's head—a triangulation which now spreads to most of the picture, clashing with the roundness of breasts, buttock, and knees. The pose is extremely contorted, yet logical: the nude maintains her equilibrium by pushing her hand against the wall; the tree outside endures hard winds; the small boxlike proscenium undulates while framing the scene. This is an agitated painting. Yet the diffuse presence of Matisse still looms, and Picasso gives us a cipher: the nonreflecting mirror in the orange frame at the bottom of the canvas.

This last element is perhaps what initiated the third series of sketches, done in February 1935, which incorporated the two previous themes. The result was two pictures showing a woman drawing herself in front of a mirror and another sleeping at a table nearby, reading no more (she was still a reader in a canvas painted a month before, *Woman Reading* [Z. VIII, 260; Musée Picasso]).[201]

Unlike Matisse, who used mirror reflections as devices for spatial dispersion from the outset of his career (see, notably, his 1903 *Carmelina*), Picasso was not fond of them—which is why he often elected to pay tribute to Matisse's "mirror without silvering" (thus without reflection) in the 1913 *Blue Window*.[202] In the February

PABLO PICASSO
90 *Nude with Bouquet
of Irises and Mirror,*
May 22, 1934
Oil on canvas
63 3/4 x 51 1/4 in.
(162 x 130 cm)
Musée Picasso, Paris

1935 sketches, however, he takes them on. Of these, the first two picture a woman-artist-as-surrealist-creature drawing in front of a mirror that reflects a realist image of herself;[203] several other sketches forget about the mirror and bring in the second woman, sleeping, with her head resting on her arms, folded in turn on a table. These images concentrate on the posture and the anatomical differences between the two characters, or on the curves of the lone sleeper.[204] The last sheets reintroduce the mirror, reflecting, with good catoptric logic this time, the room and not the draftswoman.[205]

The result of this last campaign is *Interior with a Girl Drawing* (Z. VIII, 263; The Museum of Modern Art, New York), and the painting nicknamed *The Muse* (fig. 93), both from February 1935. The Matisseanism of these canvases is inescapable (although, unlike the Matissean mirror, Picasso's is not placed frontally, and thus it more immediately reveals its nature—specifically, that is not a canvas). William Rubin, speaking of the New York painting, refers to "the contouring of certain Moroccan Matisses—an affinity reinforced by the contrast of the rich lavender of this figure's costume with the saturated orange of her slippers and with the forest- and olive-greens of her hair and foot."[206] But a similar claim could also be made about *The Muse*, whose color range is strikingly similar to Matisse's 1912 *Basket of Oranges*, which Picasso will later acquire (fig. 117).

■ Matisse's Turn

These two paintings, and another of 1935—most probably the Musée Picasso *Woman Reading* (Z. VIII, 260)—were among thirty-eight Picassos shown in a lamentable exhibition entitled "Les Créateurs du cubisme," mounted by Raymond Cogniat at the Galerie des Beaux-Arts (March–April 1935). Matisse made the trip from Nice especially to see the exhibition (he had been told that the recent Picassos were dynamite); he even visited it twice. In his letters to his son, he expresses his disappointment at the exhibition as a whole ("it looks sad and youthless") but does not specifically mention the works by Picasso, whom he met and found crabby.[207]

There is no doubt, however, that Matisse took a good look at the three recent Picasso paintings. Back in Nice, he immediately started working on *The Dream* (fig. 94), which he finished in May 1935. It was a direct response to Picasso's (Matissean) sleepers seen in Paris. Matisse pays special attention here to an enormous hand that flows down the picture like the hair of the upside-down face in the Mallarmé book (fig. 64). Where the hands of Picasso's sleepers are too busy holding a head (The Museum of Modern Art version), or too tightly gathered to form a cushion (*The Muse*), Matisse paints a moment when space starts to warp off from this world and into a dreamland.[208]

PABLO PICASSO
91 *Nude in a Garden*, August 4, 1934
Oil on canvas. 63 ⁷/₈ x 51 ¹/₄ in. (162 x 130 cm)
Musée Picasso, Paris

HENRI MATISSE

92 *Large Reclining Nude* (formerly, *The Pink Nude*)
May–October 31, 1935
Oil on canvas. 26 x 36 ¼ in. (66 x 92.7 cm)
The Baltimore Museum of Art; The Cone Collection

Matisse's next canvas, *Large Reclining Nude*, better known as *The Pink Nude* (fig. 92), is even more ambitious, and relates directly both to his early work and to the Barnes decoration: the pose is that of *Reclining Nude I (Aurora)* and of *Blue Nude* (fig. 156) but reversed. *The Pink Nude* was developed from May until the last day of October with cutouts of colored paper, just as *The Dance* had been.[209] We can follow its progress (always in the direction of simplification) through the more than twenty photographs of its various stages, eight of them published together as early as the end of 1935.[210] (Matisse's willingness to disclose his working method certainly impressed Picasso: around that time Picasso did mention this possibility for himself, though he only resorted to it on very rare occasions.)[211] But more important here is the stark mode of address to the beholder that is strikingly Picassoesque in *The Pink Nude*, and this just at the time when Picasso seemed, conversely, to be veering toward Matisse's absorbed poses. A perfect *chassé-croisé*, it seems, each artist stepping into the shoes of the other.

That fall, after working on *The Pink Nude*, and responding to a criticism, growing in the press, that his work was cold and distant,

his gaze too detached, his figures kept under glass like fish in an aquarium, Matisse started to execute some extraordinary drawings of nudes. In these drawings, he engulfs us in the visual field, and makes us fill the spot he occupied the moment before, at arm's reach from his recumbent, spilling model (fig. 95).

The sense of utter intimacy is even enhanced, in certain of these drawings, by a *mise-en-abîme* where Matisse shows his hand drawing the drawing itself (fig. 96). But this is by no means in order to test the possibility of an absolute mastery of the visual realm. On the contrary, these drawings chart the space of a dispersion where one would expect a synthesis. They aim—paradoxically, and certainly against Picasso's "drawing as if to possess" (to borrow a phrase from Leo Steinberg)—to show that absolute proximity can only lead to the irreconcilable distance of a dispossession. The drawing-within-itself leads to a representation at a third remove, that of the drawing-within-itself-within-itself. Aggravating the confusion, a nude drawn at the second remove does not strike precisely the same pose as her larger "original" (the position of the head is slightly different), and details are

PABLO PICASSO
93 *The Muse*, January 21, 1935
Oil on canvas
51 1/8 x 63 3/4 in. (130 x 162 cm)
Musée National d'Art Moderne, Paris

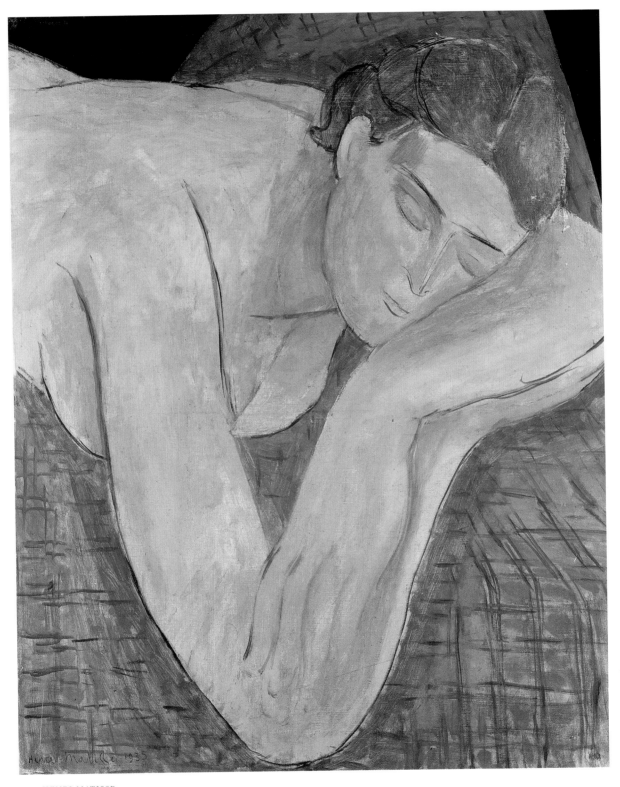

HENRI MATISSE
94 *The Dream*, April–May 1935
Oil on canvas. 31 1/8 x 25 5/8 in. (81 x 65 cm)
Musée National d'Art Moderne, Paris

HENRI MATISSE
95 *Reclining Nude,*
1935
Pen and ink
on paper
17 3/4 x 22 1/4 in.
(45 x 56.5 cm)
Collection of
Dina Vierny

HENRI MATISSE
96 *Reclining Nude
in the Studio,*
1935
Pen and ink
on paper
17 3/4 x 22 3/8 in.
(45.1 x 56.8 cm)
Private collection

HENRI MATISSE

97 *Artist and Model Reflected
in a Mirror*, 1935
Pen and ink on paper
Dimensions and
whereabouts unknown

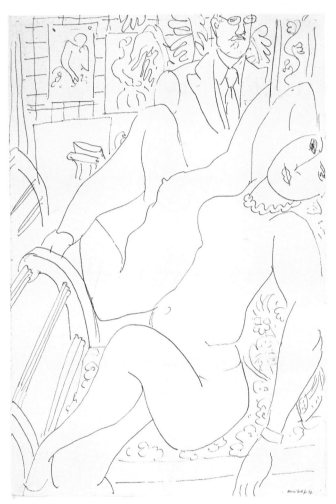

HENRI MATISSE

98 *Artist and Model Reflected in a Mirror*, 1937
Pen and ink on paper
24 1/8 x 16 1/16 in. (61.2 x 40.7 cm)
The Baltimore Museum of Art; The Cone Collection

deleted, as from an object at the periphery of the visual field (the place of the paper for an artist looking at his model). Even more important, a mirror, equaling the drawing-within-itself in the opposite corner of the sheet, sends back an image of the nude from the rear that does not quite match the frontal view. And further spatial confusion is staged by the proliferation of decorative motifs blurring boundaries between levels of reality.

Even when Matisse chooses the more traditional mode of self-reflexivity (portraying himself reflected in the frontal mirror, rather than drawing his hand drawing), he makes sure that our sudden plunge into the field of the image, with its nude pressed against the picture plane, will be disorienting (fig. 97). But where the impossibility of specular identification is underlined, proximity and distance become the central topic: we are placed before the paradox of specular identification, asked to come forward, and then again displaced by the sentinel of the mirror, whose place we cannot usurp.

Matisse is rightly proud of his accomplishment, and he exhibits some of these drawings at the Galerie Renou et Colle in November 1935. He agrees to publish them in a special issue of *Cahiers d'Art* devoted to his recent drawings,[212] and continues the series until 1937, capitalizing on a possibility of displacement allowed by the mirror (fig. 98).

■ Picasso Returns

In early 1936, Picasso, brooding and unable to paint for several months now (he kept writing poetry at a furious pace), was pampered by his dealers and admirers. In March 1936, Rosenberg put together an exhibition of his 1931–34 works, under the fallacious title "Exposition d'œuvres récentes de Picasso" (March 3–31). Assembled at the last minute, it contained several works previously exhibited in group shows (including the 1931 *Pitcher and Bowl of Fruit*; Z. VII, 322) and some of the 1932 pictures already shown in the Georges Petit retrospective, such as The Museum of Modern Art's *Girl Before a Mirror* (Z. VII, 379) (a response to Matisse's recent drawing show?), and several "sleeping beauties." All in all, the Matissean vein of Picasso's work dominated the show.[213]

Was it in order to counterbalance this impression that Picasso exhibited, at the same moment, among other drawings, his images of the embracing minotaur at the Galerie Renou et Colle (where Matisse had just had a show)?[214] His works were also dominating the exhibition "L'Art espagnol contemporain," which opened at the Jeu de Paume on February 12.[215] The press on all these events was amazingly positive, given its usual nastiness. "For a fortnight at the end of February and beginning of March, until Herr Hitler

gave us something else to talk about, all Paris was talking of Picasso," noted Clive Bell a few months later.[216] The artist slowly emerged from his melancholic creative block.

Being reminded of Matisse's existence might have helped or hindered, depending on how the pendulum of depression swung. On April 27, The Museum of Modern Art in New York mounted an exhibition called "Modern Painters and Sculptors as Illustrators": one illustration, on the catalogue cover, is a plate from the Ovid; another, on the title page, a plate (a closed fist) from the Mallarmé book. In May, Rosenberg finally convinced Matisse to let him host an exhibition of his recent works. The May 2–30 show included *The Dream* (fig. 94) and *Large Reclining Nude* (*The Pink Nude*) (fig. 92); several portraits and small nudes; the amazingly "unfinished" *Sketch: Standing Nude and Painter* of 1936; and, surprisingly, *La Verdure* (fig. 89), in a state that must have temporarily pleased Matisse.

At about the same time, Matisse and Tériade selected illustrations to appear in the ninth issue of *Minotaure*, for which Matisse designed the cover: he also offers his own image of a minotaur, spreading the sparse features of its contourless face across the page in a few brushstrokes. His is a version where the air circulates: it lacks the *horror vacui* characterizing most of Picasso's renderings. Several works pertaining to the chess match with Picasso were reproduced, notably *Nymph and Faun* (fig. 87) and the drawing of a nude reflected in a mirror. More important, three of the paintings shown at Rosenberg's were each reproduced next to three photographs of earlier states.

On June 12, Picasso, evidently stimulated by the Rosenberg exhibition, etches another minotaur, far more humanoid than before, contemplating a sleeping odalisque straight from Matisse. And he exorcises a demon: after the second state of this plate, a large part of the odalisque's body is in shadow (compare figs. 99 and 100). Following this minor purge, Picasso is ready to return to the demands of painting, and to those of the Front Populaire, for which Matisse was often by his side. The two of them rally in support of the Spanish Republic, and presided over the formation of a "Union pour l'Art" committee, meant to prevent the old guard from taking over the Exposition Internationale of 1937, already in preparation.[217]

■ Public and Private Tango

The year 1937 would see an intense competition staged between the two artists, through group and personal exhibitions, and at the same time a growing willingness on their part to understand and comment each other's idiom.

Let us quickly review the public situation. In the summer of 1936, the city of Paris, through the curator Raymond Escholier,

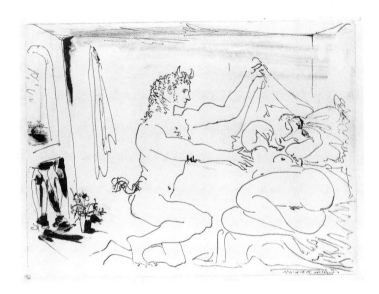

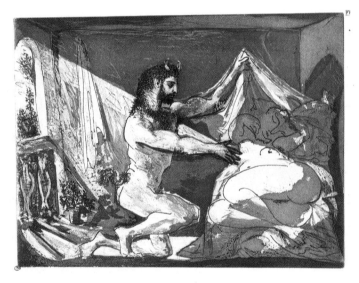

PABLO PICASSO

99 and **100** *Faun Unveiling a Sleeping Woman*,
June 12, 1936 (1st and 6th states)
Aquatint
12 1/2 x 16 3/8 in. (31.6 x 41.7 cm)
Musée Picasso, Paris

bought the last version of Matisse's *The Dance*.[218] Perhaps already knowing that Matisse would not be solicited for the Exposition Internationale—where the French state, celebrating the greatness of French art since the Middle Ages, was designing an exhibition of the "Chefs-d'œuvre de l'art français"— Escholier proposed a Matisse retrospective within "Les Maîtres de l'art indépendant," a counterbalancing exhibition that he was organizing for the municipal Petit Palais.[219] Excited by the prospect that the Russians would lend (in the end, they did not), and determined not to repeat the mistake of letting others take charge (as he had done for his Georges Petit retrospective), Matisse was actively involved in the selection of works for Escholier. Sixty-one of his paintings are listed in the catalogue (along with *The Serpentine*, reproduced there), and others, illustrated in the press, must have been added as well: the ensemble, running from 1897 (*La Desserte*) to 1936, must have been imposing (the Nice odalisques did not flood it). And with *The Dream* (fig. 94) being chosen as the exhibition's poster, Matisse was crowned its king.

Rosenberg, foreseeing as much, had warned Picasso that his allotted space at the "Maîtres" show would be too small.[220] Picasso, with only half the number of Matisse's works, chose wisely: his selections included the 1906 *Portrait of Gertrude Stein*, the 1913 *Woman in an Armchair* (Z. II**, 436), the 1915 *Harlequin* (fig. 4), and The Museum of Modern Art's version of *Three Musicians*. And his participation marked his official inclusion, finally, in the "School of Paris." The old guard protested—following the exhibition there was a nasty debate, in the town hall, about the way Paris taxpayers' money was being spent—but the protests did not reverse the trend.[221]

Nevertheless Zervos was not satisfied with the treatment accorded to Picasso in "Les Maîtres de l'art indépendant." He therefore organized another exhibition, intended to denationalize the issue, called "Origine et développement de l'art international indépendant," at the Jeu de Paume. There he attempted to redress the balance with eleven Picassos, mostly cubist works (including *Ma Jolie* [Z. II*, 244] now in The Museum of Modern Art in New York) and six Matisses (these by no means insignificant—*The Moroccans*, *The Yellow Curtain*, and *Le Luxe I*, for example). Picasso, for his part, was finishing *Guernica*: it was officially unveiled at the Spanish Pavilion in mid-July, where Matisse saw it in August.[222]

Before the openings of "Les Maîtres de l'art indépendant"(June 17) and "Origine et développement" (July 30), Matisse opened a second one-artist show at Rosenberg's (June 1–29), launching a final round of artistic exchanges with Picasso before the war. The twenty canvases Matisse exhibited there (only four from 1936, the rest from 1937), were of three kinds: the first was characterized by

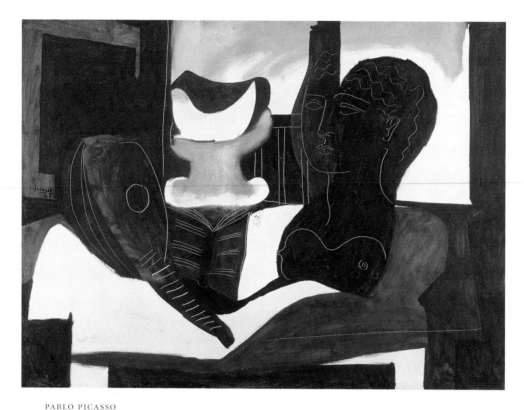

PABLO PICASSO
101 *Still Life with Ancient Head*, 1925
Oil on canvas. 38 ¼ x 51 ⅛ in. (97 x 130 cm)
Musée National d'Art Moderne, Paris

figures painted in the style he had already presented to the public a year before in this gallery and deriving from *The Pink Nude*, with flat planes of pure colors, flatter than anything he had done since *Le Luxe II*; the second, by an exuberant return to decorative profusion—as distinct from Matisse's use of the "decorative," which does not necessarily entail profusion —to a degree not seen in his art since the *Seville Still Life* and *Spanish Still Life* of 1910–11 (*Purple Robe and Anemones* [The Baltimore Museum of Art] and *Woman in a Purple Robe with Ranunculi* [fig. 113] are good examples); the third, by a conspicuous use of the separation between color and drawing—a device that Matisse had always avoided after his short-lived attempt to "learn" cubism in the teens (he had always considered this separation to be a flaw rather than a device).

This third kind of painting—an about-face for Matisse—arose from a new take on Picasso's art, as can be seen in the pairing of Matisse's *Ochre Head* (fig. 102) with Picasso's 1925 *Still Life with Ancient Head* (fig. 101). In canvas after canvas, Matisse highlights, with obvious delight, his capacity to separate color and contour, something he had long thought impossible, and which had made it so hard for him fully to digest cubism. Zervos was quick to perceive the link between these new works and Picasso's "analytic"

method: in *Cahiers d'Art* he reproduces full-page—face-to-face on a spread—Matisse's extraordinary *Rumanian Blouse with Green Sleeves* (fig. 104), so close to Picasso's art in its discontinuities, and Picasso's 1930 *Seated Woman* (Z. VII, 314), painted in a very similar chromatic range.[223]

The comparison does not escape Picasso, who has been exploring Matisse's territory during the previous few months, and most spectacularly in his *Seated Woman in Front of a Mirror* of February 16, 1937 (fig. 103). From this point on, to the outbreak of World War II, we witness not a duel but a tango, each artist enjoying their partnership more and more. Each seems enthralled by the other's art, and a renewed camaraderie transpires as well in their public relations. Thus, on February 10, 1938, Picasso solicits Matisse in writing (quite a feat, since Picasso never wrote): "Be the first to inscribe your name on the list of painters who want to offer a true museum to the Spanish people, and give us an important work."[224]

Matisse keeps examining the possibilities offered by the divorce of color and contour, the most important work of the kind being *The Conservatory*, painted in May 1938 (fig. 107). In *The Arm*, painted in June (fig. 108), he adopts Picasso's use of the metonymic part for the whole, and paints the fragment of a body,

HENRI MATISSE
102 *The Ochre Head*, February 9–17, 1937
Oil on canvas. 28 5/8 x 21 1/4 in. (12.7 x 54 cm)
Private collection

PABLO PICASSO
103 *Seated Woman in Front of a Mirror,*
February 16, 1937. Oil on canvas. 51 1/8 x 76 3/4 in. (130 x 195 cm)
Kunstsammlung Nordrhein-Westfalen, Düsseldorf

something he had always avoided, except in his sculpted *Study of a Foot* (c. 1909).[225] *The Arm* is unique in Matisse's corpus: the arm plays a game of "as if"—as if it were a boa, boneless and rampant—just as Picasso's swan reflected in the lake looks "as if" it were a scorpion (p. 27 above). (Notice also the decor: the harlequinery of the robe is directly lifted from Picassos of late 1908). This work is so anomalous in Matisse's oeuvre that one is inclined to think of it as a study reserved for the privacy of the studio. But Matisse sold it to Rosenberg, who exhibited it in the last show he devoted to the artist (October 24–November 12, 1938), an exhibition that Matisse neither planned nor saw.

In July, revisiting cubism more directly in his charcoal drawings, Matisse gives alternative versions of the same nude—some all in curves (fig. 105), but with a twisting of the body that recalls his *Blinding of Polyphemus* (fig. 86); still others, the clearest approximation he ever gave of the cubist idiom: only a supplementary distortion of the feet would change one certain *Reclining Nude* (fig. 106) into a Picasso.

After venturing so far into foreign territory, Matisse would retreat to his home base: in *The Green Rumanian Blouse* of March 1939 (fig. 109), the tentacular hand does not quite transmute into an octopus; the chopped-up arm, though paying homage to cubist discontinuities, is not so severely dissected that we have to think twice to rejoin its parts. The network of arabesques, the color chords so craftily balanced that we fail to notice their audacity, the absorption of the figure—all belong to Matisse's turf. This picture would perhaps not have existed without Picasso's challenge, but it comes as a respite after a fever.

In the early spring of 1937, before becoming involved with *Guernica*, Picasso pursued a serious probing of Matisse's art. I have already mentioned his large *Seated Woman in Front of a Mirror* (fig. 103). But he also began a series of colorful still lifes that become all the more Matissean after he visits the second Matisse show at Rosenberg's (June 1–29, see above, pp. 111–112). In some of these still lifes, he even adopts a pictorial technique that Matisse favored two decades earlier—that of scratching—

HENRI MATISSE

104 *The Rumanian Blouse with Green Sleeves*, late March–April 1937
Oil on canvas. 28 3/4 x 23 5/8 in. (73 x 60 cm)
Cincinnati Art Museum; Bequest of Mary E. Johnston

and he uses it to organize a Matissean compositional dispersion (fig. 110).

Picasso pursues this path throughout the following year, though not without some resistance. In October–November 1938, he paints *Reclining Nude in a Brown Landscape* (fig. 111), as if to remind Matisse (or himself, in connection with Matisse's early work) that a barren stage is no less powerful than a luxurious one. The strong bipartition (earth/sky), rare in Picasso's art, recalls Matisse's 1910 *Music* and its eerie world of silence. But *Woman Seated in a Garden* of December 1938 (fig. 114) moves in the opposite direction: it attempts to incorporate Matisse's all-overness, recently brought to a paroxysm in paintings such as *Woman in a Purple Robe with Ranunculi* (fig. 113). And once again Picasso reveals his desire for having us focus on the figure, however distracting its context. What most distinguishes this painting from a Matisse is not so much its angular landscape (the sun a quadrangle mirror, the foliage spiky), but, rather, that the meandering excess surrounding the enthroned figure never bewilders us.

It is Picasso's turn to retreat: in *Reclining Woman with a Book* of January 1939 (fig. 112), Matisse is only a quote —the flowering branches at the window. Picasso asserts the gap between his art and that of his rival (his grotesque reclining woman not even a distant cousin of Matisse's numerous recumbent figures)—a gap which can also be seen as a bridge.

Matisse concurs with this possibility in a spectacular fashion. Though he probably did not see Picasso's last exhibition at Rosenberg's (January 17–February 18, 1939), which comprised many of the 1937 colorful still lifes mentioned above (including

fig. 110), there is strong evidence that he saw at least some of the works in May 1939.[226] *Daisies* (fig. 116), finished on July 16, contains a direct quotation from Picasso's *Basket of Flowers and Pitcher* (fig. 115). Matisse had not painted flowers in this deliberately childlike manner since the 1916 *Still Life with a Plaster Bust* (fig. 2), nor would he do so again (excepting for *Reader on a Black Background* [Musée National d'Art Moderne, Paris], completed in August 1939). There are other allusions to Picasso in *Daisies*—the figure takes on the color of her background, a common trope of cubism; her contour is relatively independent of the red surface (another cubist conceit); and some of its discreet elements are gathered as in a collage. But the space of the painting, fluid and decentered, is Matisse's own: and though the painting has much in common with his 1916 canvas, there is not the slightest trace of anxiety over his difficulties in grasping cubism.

On July 28, 1939, Picasso returned to Paris from Antibes to attend Vollard's funeral. During the few days he spent there, he visited Matisse's studio (in fact, a studio he was renting from Mary Callery). On July 31, Callery wrote to Matisse that Picasso, back in the south, spoke to her about his new canvases "done in this light that I know so well."[227] Seeing the black backgrounds of *Daisies* and *Reader on a Black Background* in the sunny studio they were depicting no doubt made a great impression on Picasso. The blackness of *Night Fishing at Antibes,* which he began painting immediately after his short trip to Paris, is generally explained in terms of the political climate of the time (war was imminent). Yet even though Picasso would not, unlike Matisse, make use of black as a color of light, he might also have been encouraged to paint a nocturnal scene after seeing the most recent works of his partner.

HENRI MATISSE

105 *Reclining Nude Seen from the Back*, July 1938
Charcoal on paper
23 5/8 x 31 7/8 in.
(60 x 81 cm)
Private collection

HENRI MATISSE

106 *Reclining Nude*, July 1938
Charcoal on paper
24 x 31 3/8 in.
(61 x 79.7 cm)
Collection of Roger and Brook Berlind

HENRI MATISSE

107 *The Conservatory*, November 1937–May 1938
Oil on canvas. 28 ¼ x 23 ½ in. (71.8 x 59.7 cm)
Private collection

HENRI MATISSE

108 *The Arm*. January–June 1, 1938
Oil on canvas. 18 1/8 x 15 in. (46 x 38 cm)
Private collection

HENRI MATISSE

109 *The Green Rumanian Blouse,* March 1939
Oil on canvas. 24 x 18 1/8 in. (61 x 46 cm)
Private collection

PABLO PICASSO

110 *Still Life*, April 25, 1937
Oil on canvas
15 x 24 in. (38 x 61 cm)
Private collection

PABLO PICASSO

111 *Reclining Nude in a Brown Landscape,*
October–November 1938
Oil on canvas
35 3/8 x 46 5/8 in. (90 x 118.5 cm)
Private collection

PABLO PICASSO
112 *Reclining Woman with a Book,*
January 21, 1939
Oil on canvas
38 ¹/₂ x 51 in. (97.8 x 130 cm)
Private collection

HENRI MATISSE
113 *Woman in a Purple Robe with Ranunculi*, February 1–4, 1937
Oil on canvas. 31 7/8 x 25 5/8 in. (81 x 65 cm)
The Museum of Fine Arts, Houston; The John A. and Audrey Jones Beck Collection

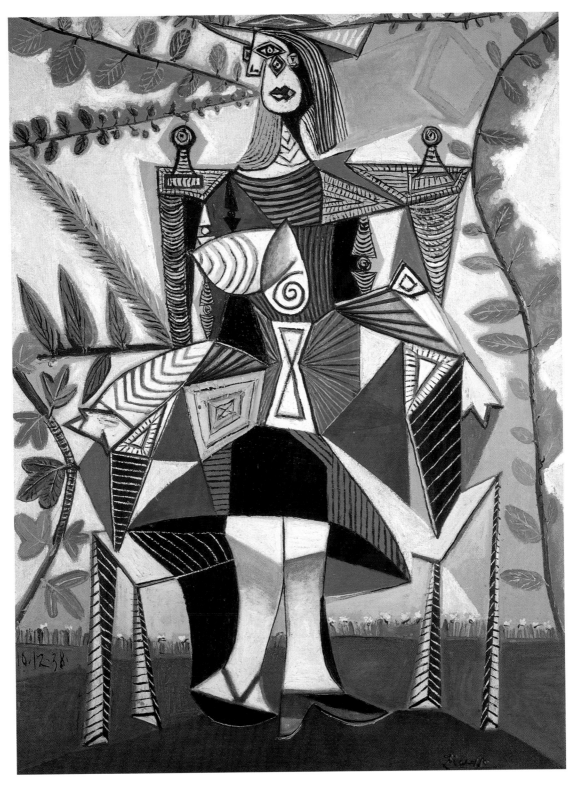

PABLO PICASSO

114 *Woman Seated in a Garden*, December 10, 1938
Oil on canvas. 51 1/2 x 38 1/4 in. (131 x 97 cm)
Collection of Mrs. Daniel Saidenberg

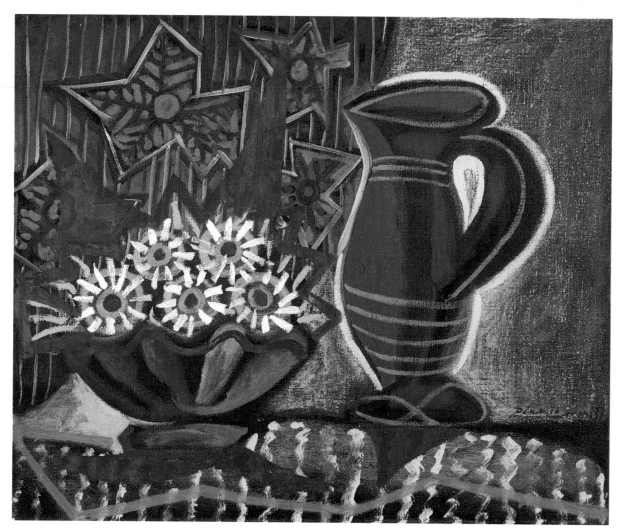

PABLO PICASSO
115 *Basket of Flowers and Pitcher*, March 1937
(above) Oil on canvas
23 7/16 x 27 1/2 in. (59.6 x 69.9 cm)
Yale University Art Gallery,
New Haven, Connecticut

HENRI MATISSE
116 *Daisies*, July 1939
(right) Oil on canvas. 38 5/8 x 28 1/4 in. (98 x 71.8 cm)
The Art Institute of Chicago;
Gift of Helen Pauling Donelly in memory of her parents,
Mary Fredericka and Edward George Pauling

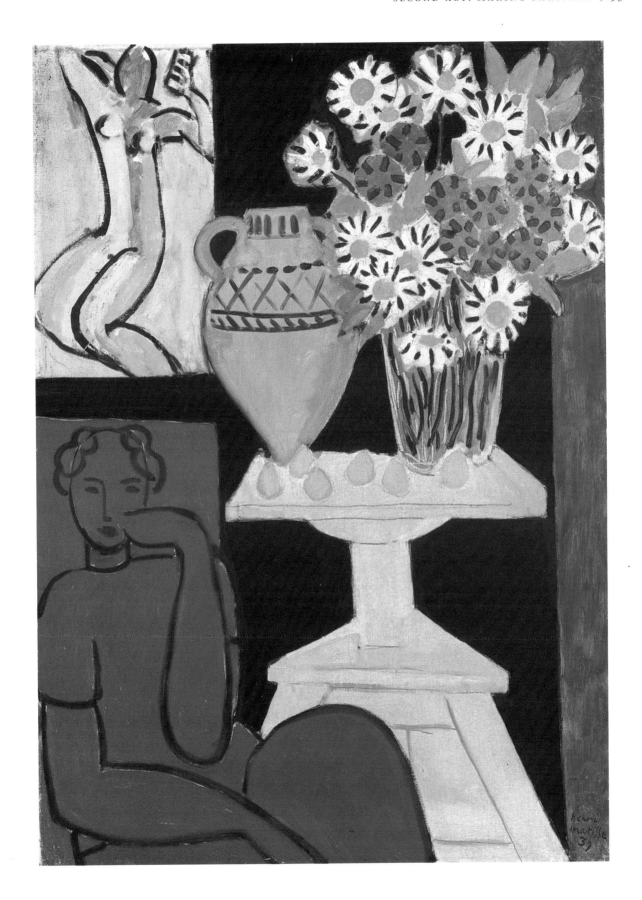

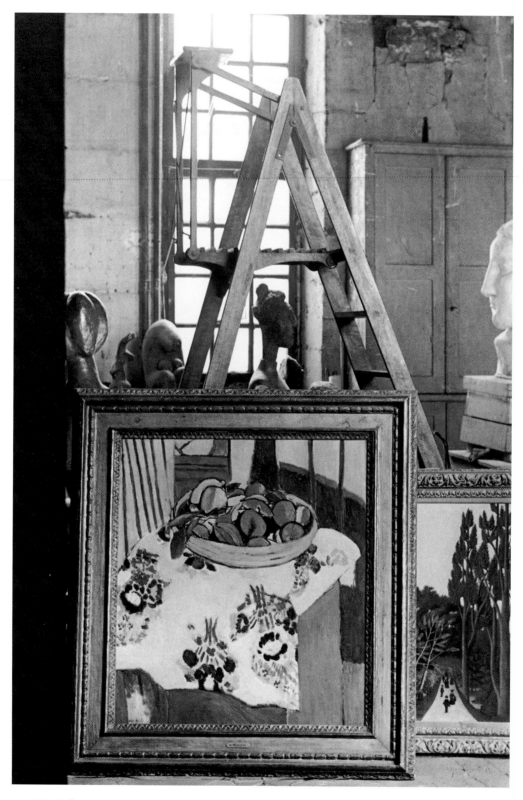

BRASSAÏ

117 Matisse's *Basket of Oranges* (1912) in Picasso's studio,
rue des Grands-Augustins, Paris, 1943

THIRD ACT: PARALLEL PLAY

1940–44

■ Peace (Two Lives, One War)

A few days before the onset of the war (September 3, 1939), Picasso leaves for Royan. Lacking paint materials, he mainly sketches; between January 10 and March 14, he fills half of two sketchbooks with more than seventy images of an odalisque—in contrapposto, standing, kneeling, or seated, her arms raised above and behind her head (fig. 118).[228] Initial sketches show that the series began as a study of Delacroix's *Women of Algiers*,[229] but the pose is not to be found in Delacroix's masterpiece: Picasso sees the nineteenth-century painter through the eyes of Matisse, who renders innumerable odalisques in this pose. We could call the fury with which Picasso draws his nude and her raised arms a sustained bout of "Matisse fever."

Sustaining other bouts of this fever throughout the war, Picasso would summon up Matisse's work at will: on May 2, 1940, for example, he makes two drawings (figs. 119 and 120) comprising his closest revision ever of the 1935–36 series by Matisse (figs. 95–97).[230] But where Matisse wants to lose us in an impossibly dazzling fusion between the distant space we see and the phenomenological space we inhabit, Picasso splits this topic, drawing one sketch with a mirror reflection, and another with the nude spilling downward; he clearly distinguishes reality levels, distancing the beholder by adding a faun or a bearded man (Matisse?), and encoding the scene into a favorite theme (the sleepwatcher).[231]

For the next four years, despite their very different settings, both painters would live strangely similar lives, staying at home, keeping a low profile, and refusing, as much as possible, to interact with Germans. By virtue of their fame and wealth, both are somewhat shielded from the hardships facing their fellow citizens. They work in private: for example, the publication of Picasso's illustrated edition of Buffon's *Histoire naturelle* can hardly be counted a public act, since only 226 copies of the work were printed. (Prepared for Vollard in 1936–37, and left unfinished at the dealer's death, the project was realized in 1942, not without fear, by Martin Fabiani. Matisse received a copy).[232]

Picasso, under close watch as one of the two non-Jewish artists forbidden to exhibit by the Nazis (Léger was the other) is partic-

ularly vulnerable as a foreigner.[233] His life during the Occupation has been very well documented—the studio filled every morning with visitors (many from the Resistance) anxious to see the most recent productions; occasional chilling visits from Nazi officials; evenings devoted to working, well into the night.[234] Only rarely are any of his works sold, and even more rarely hung—probably without his consent—in a group show, almost inevitably to be withdrawn by German censors. Surrounded by friends, and cautious above all not to anger the Nazis, Picasso lives a comfortable, but also unusually discreet, life.

Except for a five-month stay in Lyons following surgery in January 1941 that almost costs him his life, Matisse remains in the south. When Allied bombardments of Nice become too menacing, he moves to his villa in Vence; his perimeter gradually narrows: health and transportation permitting, he visits a few friends—among them Pierre Bonnard, who lives nearby. Confined to bed on several occasions for months at a time, he continues to draw, and even to paint, without interruption. He also welcomes guests—dealers rarely, publishers and writers more frequently, including journalists to whom he sometimes (and somewhat reluctantly) grants interviews.

On the whole, Matisse avoids making any ripples, even though he is particularly repelled by the vile trip taken to Berlin by his ex-fauve acolytes (Vlaminck, Derain, Friesz) under Nazi patronage.[235] Limiting his participation to group shows, Matisse exhibits with a salon just once—at the 1943 Salon d'Automne (he was openly begged to do so, in support of young artists feeling deserted by their elders).[236] His one solo show, in November of 1941, is an exhibition of drawings—some of them fresh from his pen—at the newly opened Galerie Louis Carré; it wins great critical acclaim, and, in the exhibition guestbook (probably sent to Matisse at the close of the show), one can find, among those of other artists and intellectuals, the signature of Picasso.[237] Matisse's other main public production is *Dessins: Thèmes et variations*—a book issued by Fabiani in 1943, prefaced at length by Louis Aragon, and carefully reproducing, in full-page, seventeen series of drawings (158 sheets in all).[238] Matisse also completes the

PABLO PICASSO
118 *Standing Nude with Raised Arms,*
early 1940
"Royan" sketchbook, fol. 40 r.
Graphite on paper
6 ¹/₄ x 4 ¹/₈ in. (16 x 10.5 cm)
Musée Picasso, Paris

illustrations for Montherlant's *Pasiphaé*, published as well by Fabiani in 1944—a luxury item, like Picasso's Buffon, and therefore a semiprivate publication: just as Matisse received a copy of the Picasso book, so Picasso receives a copy of the Matisse.[239]

From this summary description, it becomes clear that the German occupation changed the rules of the game, just at the moment when the two artists were finding an amicable kind of routine. Now they have to base their notion of each other's current work on such scraps of information as they can gather, and on their prodigious visual memory. Competitive anxiety between them disappears, replaced by solicitude and something like solidarity. Matisse, for example, is outraged when the rumor circulates in New York that Picasso has been declared crazy and interned in an asylum: "This is revolting! It comes from the enemies of Pablo's painting—the same gossip was already launched . . . when he began his extraordinary researches, cubism. . . . He lives with dignity in Paris, works, does not want to sell and solicits nothing. He took upon himself all the dignity that his colleagues have abandoned in such an unbelievable way."[240] And he is particularly moved to learn that, like himself and contrary to many

rumors, Picasso has rejected all offers of emigration: "If everyone who has any value flees France, what will remain of France?"[241]

The war is also the period when Matisse corresponds directly with Picasso,[242] inquires most about him from common friends, jots down remarks about him in his notebooks. Sometimes the musing is light, unexpected, yet almost always tainted with nostalgia. On February 7, 1944, for example, while in Vence, Matisse records this thought:

> Villa Céleste a robust olive tree—old, with its main branches much cut down—has young branches that dance and express the promise of a new life. I pass by it every day and often I think of a painting by Picasso, representing a Provençal town or the outskirts of such a town. In the foreground a large tree, an olive tree it seems to me, also quite heavily pruned. The gap between the young shoots and the important trunk had struck me and had always seemed unlikely to me. Now I see what enticed him to represent such a thing.[243]

Or note this sudden query to Charles Camoin, the accomplice of his early career:

PABLO PICASSO
119 *Faun and Sleeping Woman*, May 2, 1940
Pen and ink on paper
14 5/8 x 18 1/8 in. (37 x 46 cm)
Whereabouts unknown
(Z. X, 515)

PABLO PICASSO
120 *Crouching Man and Reclining Woman*, May 2, 1940
Pen and ink on paper
15 x 18 1/4 in. (38 x 46.4 cm)
Whereabouts unknown
(Z. X, 516)

PABLO PICASSO
121 *Portrait of Dora Maar*, 1942
Oil on canvas. 24 1/$_4$ x 19 3/$_4$ in. (61.6 x 50.5 cm)
Private collection. Courtesy of The Elkon Gallery, Inc., New York

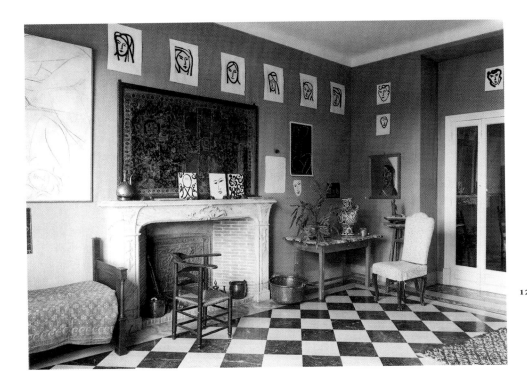

122 Apartment of Matisse (Hotel Régina, Nice) Picasso's *Portrait of Dora Maar* is hung above an owl-shaped vase, also by Picasso

Jean Puy told me that during WWI the two camouflage sections, one run by Segonzac and the other . . . by whom? each had a rabbit for a mascot, one called Picasso, and the other Matisse. In the comparative discussions about the two animals, people did not use the word rabbits. They'd say "Our Picasso is more beautiful than your Matisse!" Who was running the second section?[244]

And Picasso? He was never that loquacious,[245] except when writing poetry—there is quite a lot of that during the cold winters of the Occupation, and even a play.[246] But he certainly has his old friend on the back burner, a burner ready to flare up at the slightest stimulation (the flares always seem to come abruptly, Picasso's hyperreactive mode being paradoxically intensified by the dearth of direct stimuli). The evidence, as we shall see, lies in his work; but on the more anecdotal side, Picasso takes great pride in letting his visitors be greeted at the studio on the rue des Grands-Augustins by Matisse's *Basket of Oranges*. He even uses the picture as a yardstick for taste, placing it next to an El Greco that someone wants him to buy, and which does not pass the test.[247]

In short, Matisse and Picasso are now truly each other's imaginary addressee. Pierre Courthion, writing in Switzerland during the war, notes that the first question Matisse asks a visitor from Paris will invariably be: "And Picasso? What is he doing?" And, Courthion adds, "I have no doubt that . . . Picasso is similarly curious to know what Matisse has painted."[248]

■ Barter

Among their rare interactions at this time, we should include the barter of paintings between them—an early practice, abandoned in 1907. In October 1941, Matisse, as a gesture of thanks to Picasso for keeping an eye on his bank vault, sends him a drawing which modestly renews the exchange. At first he chooses a sketch for *Still Life with a Magnolia* (fig. 134)—dedicating it with care (fig. 123)—then changes his mind and chooses another sketch.[249] Picasso, in June of 1942 or 1943, then ups the ante—by having Max Pellequer, their mutual friend and banker, convey to Matisse, as a get-well present, a *Portrait of Dora Maar* (figs. 121 and 122). "It's Dante confronting Hell," writes Matisse to Pellequer: "I find the space in front of the face wholly expressive of something immense. What magic!"[250]

In November 1942, Picasso acquires Matisse's *Basket of Oranges* (fig. 117), painted in Morocco in 1912 (he receives it from Fabiani in exchange for one of his own paintings dating from 1906):[251] Matisse, who proudly reports this event to his daughter Marguerite in a letter dated November 15, 1942, has to wait for Pellequer's next trip down to Nice to be able to send another painting to Picasso; in a note to Pellequer, dated June 15, 1943 and attached to this picture, Matisse proposes that Picasso choose a different work if he should so prefer—and indeed Picasso does so:[252] he picks the *Seated Young Woman in a Persian Dress* of December 1942 (fig. 124).

HENRI MATISSE
123 *Still Life with a Magnolia,*
September 1941
Pen and ink on paper
15 ³/₄ x 20 ⁷/₈ in. (40 x 53 cm)
Private collection

HENRI MATISSE

124 *Seated Young Woman
in a Persian Dress,*
December 1942
Oil on canvas
16 7/8 x 22 in.
(43 x 56 cm)
Musée Picasso, Paris

HENRI MATISSE

125 *Tulips and Oysters
on a Black Background,*
February 11–12, 1943
Oil on canvas
24 x 28 3/4 in.
(61 x 73 cm)
Musée Picasso, Paris

Picasso picks this picture from a group of Matisses being photographed by the Paris publisher André Lejard: as artistic director of the Éditions du Chêne, Lejard was producing a book entitled *Matisse: Seize peintures 1939–1943*, to be published in November 1943 as part of a series that would include—most surprisingly in the context of the Occupation—Picasso as well.[253] Given the scarcity of images seen by each artist of the other's recent work, these books constitute important material for their intellectual exchange.[254] And Picasso has the good fortune to see the paintings themselves; on June 24, 1943, after having mentioned Picasso's choice of *Seated Young Woman in a Persian Dress*, Pellequer writes the following to Matisse:

> Picasso and I were enchanted to see your last productions at Lejard's. We long for all your paintings and would like to take them all. . . . I had a mad desire to take the largest still life, the one with a bunch of tulips [*Tulips and Oysters on a Black Background*, fig. 125]. . . . Picasso is absolutely delighted with his painting, and on my next trip he'll be very happy to entrust me with a painting of a different kind, with more violent colors. . . . He thinks of painting a rooster for you. He was so happy to see your canvases, he could not stop admiring them, moving them around. . . .[255]

Matisse is impressed by Picasso's choice: "I am very happy to know that Picasso chose the *Seated Young Woman in a Persian Dress*, which I consider the flower of my heart. I did not think it would be quite understandable right away. I'm really happy it pleases him."[256] And, perhaps confusing Pellequer's enthusiasm for Picasso's, Matisse offers Picasso the *Tulips and Oysters on a Black Background*; on November 13, he writes to Picasso that the painting is available, and that he impatiently awaits the canvas promised by Pellequer in return: "Please note that I'm not focused on a rooster. I want a beautiful Picasso."[257]

Picasso does not rush to retrieve *Tulips and Oysters on a Black Background*. We do not know precisely when this picture enters his household;[258] nor do we know when Picasso's own end of the barter—not a rooster, but the *Still Life with Pitcher, Glass, and Orange* (fig. 1) of July 20, 1944—reaches Matisse.[259] It was often placed over his bed, presiding at his conversations with visitors.[260]

■ **To Paint with Bricks: Round One**

Despite his poor health, Matisse rarely departed from his stoicism, even during the worst times of the war. His only true moments of discouragement periodically concern his capacity "to realize," as Cézanne would say. On January 13, 1940, while working on *The Rumanian Blouse*, he writes to Bonnard: "I am paralyzed by some element of conventionality that keeps me from expressing myself

as I would like to do in paint. My drawing and painting are separating." His drawing is fine, he says—perfectly suited to his needs—"but my painting is hampered by new conventions of flat planes of local color, which I must use exclusively to express myself, without shading or modeling, and which must all interact to suggest light." This does not accord well with his desire for "spontaneity": he has to find "an equivalent for [his drawing] in color."[261]

When he writes these self-deprecatory words about his own pictorial language, Matisse has just finished several canvases in which his color seems constrained, no matter how vivid the hue. It is as if he drew his model, then drew the decorative patterns of her surroundings, then filled the color in—an academic technique that squarely contradicts his aesthetics of fusion. Nor does the result enhance the expansiveness of his drawing, which requires the whiteness of the paper. Not only do his color and drawing separate instead of unite, they do harm to each other.[262]

The best of these recent paintings (begun in December 1939, but finished a week before his January 13 letter to Bonnard) is *Still Life with a Sleeping Woman* (National Gallery of Art, Washington, D.C.). Matisse seems to have immediately perceived that in it the divorce of color and drawing is a matter of scale: the black decorations on the sleeves of the sleeper's blouse breathe more loudly than the rest of the picture, no matter how turbulent the rhododendron leaves want to be. A day later (January 7, 1940), he begins a canvas—*The Dream*—that looks almost as if he has cut up the earlier painting and zoomed in (fig. 126), perhaps recalling his 1935 painting of the same title (fig. 94).

In March 1940, considering *The Dream* finished, Matisse returns to the far more arduous *Rumanian Blouse*, which he completes in early April, leaving for Paris immediately afterwards.[263] From an early "realist" state (in which a seated woman, lost in her thoughts, appears in three-quarter profile against a decorative background) to the final canvas (a stark frontal view with many details deleted), Matisse struggles long and hard.[264] He finds the right scale for the Rumanian blouse, whose ornamental motif dances freely against the whiteness of the scraped-out canvas. Coming back to Nice in August 1940 (through a complicated and exhausting route due to the panic following the German invasion), Matisse looks afresh at *The Dream*—against *The Rumanian Blouse*—and he cannot resist an impulse to rework it. The new version (fig. 128) is one of his most audacious paintings, and provides a critique of *The Rumanian Blouse*, where the redness of the background still looks as if it were applied as an afterthought, and the black contours of face and hair confine what they delimit. In *The Dream*, color and drawing do not split while trying to merge; they form a duet, the sweeping black line echoing, but not enclosing,

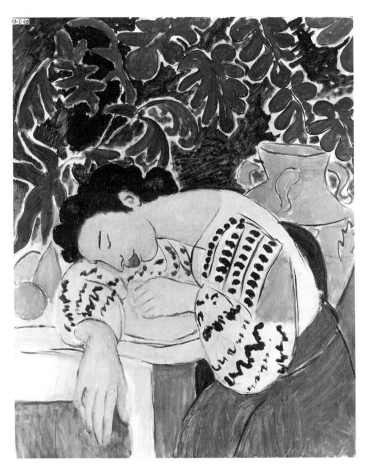

HENRI MATISSE
126 *The Dream*, early state,
January 13, 1940

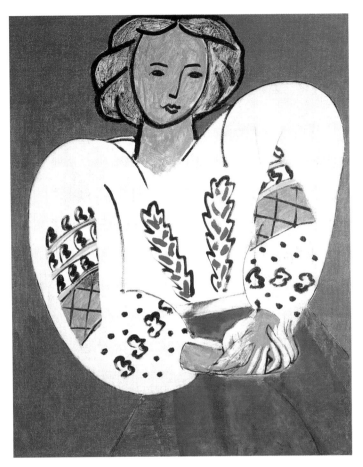

HENRI MATISSE
126 b *The Rumanian Blouse*,
December 1939–April 1940

Overlapping planes and free-floating contours: is it odd that Matisse should suddenly land in the garden of Picasso? It is as if he had just remembered the *Harlequin* of 1915 and its syncopations (fig. 4), or the "sleeping beauties" of 1931–32. In *Woman with Yellow Hair* (fig. 127), Picasso had told Matisse: "Here is what I'd do if I were you." And in *The Dream* of October 1940, Matisse gives him a calm reply: "Yes, but you don't have to relinquish your cubist dissociations for the sake of your demonstration. And you know very well that my colors are more subtle than you care to admit: I give to my 'cold vermillion, through its neighboring colors, the depth, the suppleness of Venetian red.' I could have used Venetian red right from the start, but 'its effect on its neighbors is far less intense.' The violet of the table, the warm pink of the flesh, the glowing yellows, the ebony ink—none of this would resonate half so much if I had chosen a ready-made solution. But I commend you for reminding me of something: to keep my color and my drawing from splitting, to combine them in the single 'decorative' effect, I should let each of them run its course freely."[265]

On September 25, a few days before finishing *The Dream*, Matisse begins his *Still Life with Shell* (fig. 129), a work whose challenge will engage him until early December. As with *The Dream*, he meets the challenge by summoning Picasso. Putting down his brush for a moment, he cuts colored paper into the shapes of the various objects in his still life, shuffles them around, then glues them in place on another canvas (fig. 130). As for *The Dance* in 1931–1933, or in *Large Reclining Nude (The Pink Nude)* in 1935, this technique has little to do with Picasso's collage— no plane is fragmented here—but Matisse summons Picasso as he understands him. And, in doing so, he arrives at a result as remote as possible from Picasso's centripetal mode of composition. For each element in this work is discrete, and its friezelike arrangement, akin to that of the 1910 *Music*, evokes a musical score—an association enhanced by the parallel lines at top and bottom (unusually straight, made of tensed string, and slightly slanted in the collage). But unlike the notes of a traditional score, the fruits, shell, cup, and pots all float.[266]

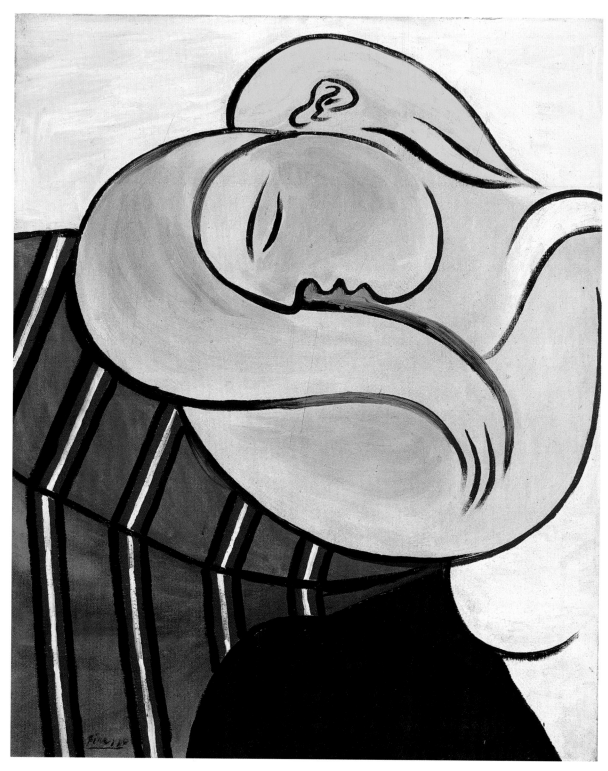

PABLO PICASSO
127 *Woman with Yellow Hair*, December 27, 1931
Oil on canvas. 39 3/8 x 31 7/8 in. (100 x 81 cm)
The Solomon R. Guggenheim Museum, New York;
Thannhauser Collection, Gift, Justin K. Thannhauser, 1978

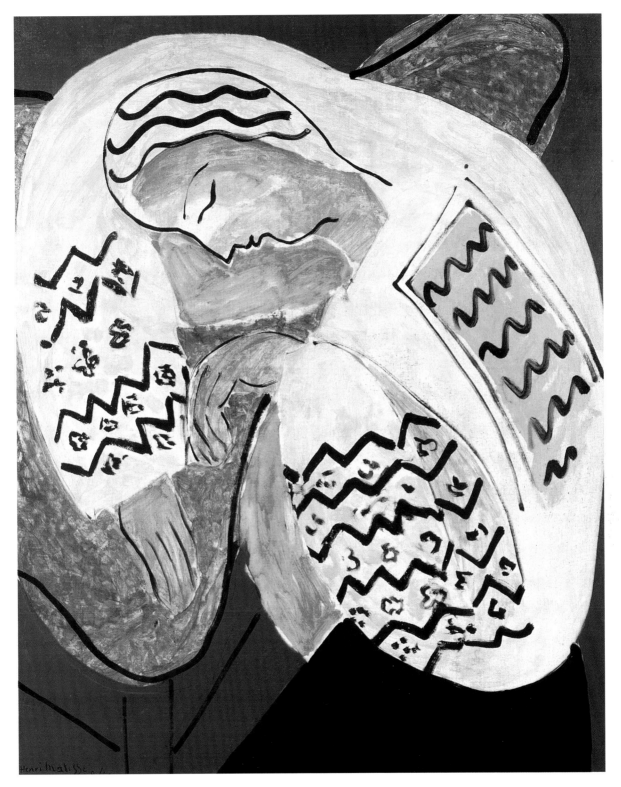

HENRI MATISSE
128 *The Dream*, January–October 4, 1940
Oil on canvas. 31 7/8 x 25 5/8 in. (81 x 65 cm)
Private collection

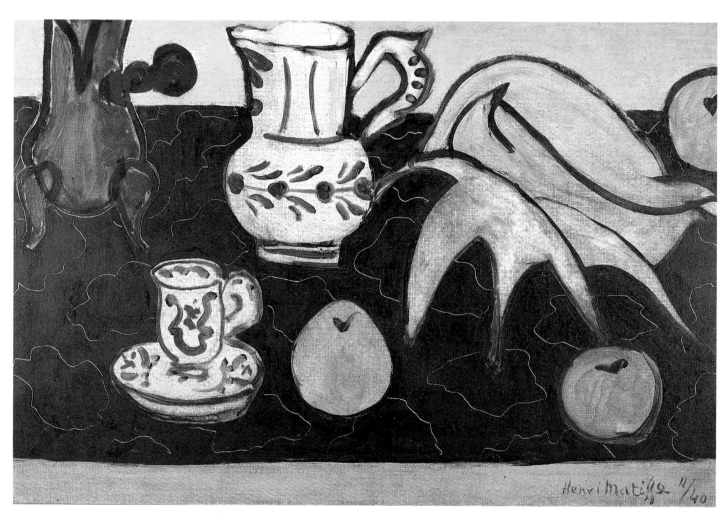

HENRI MATISSE
129 *Still Life with Shell,*
September 25–December 4, 1940
Oil on canvas
21 1/4 x 32 1/4 in. (54 x 82 cm)
Pushkin State Museum of Fine Arts,
Moscow

HENRI MATISSE
130 *Still Life with Shell*, 1940
Mixed media on canvas
23 5/8 x 36 in. (59 x 91.4 cm)
Private collection

On December 7, 1940, the painting just finished, Matisse writes jubilantly to Théodore Pallady: "I think I went as far as I can go in this abstract vein," and explains that, in order not to repeat himself, he is now forcing himself to paint oysters in a more realistic manner. Alluding to his early Nice period, he indicates that he wants to go back to the scent of oil painting, which he had ignored for too long, to get closer to the matter of things.[267] To his son he wrote that these oyster canvases were begun as a rest from the hard work of *Still Life with Shell*, adding: "Direct vision. Without transposition. It's between Renoir and Manet for the moment."[268]

This temporary retreat into his early Nice style was short lived. A month after finishing *Still Life with Shell* Matisse is in Lyons for surgery, and he does not return to his studio until the end of May 1941. Although his first canvases testify to his desire to pick up painting where he had left off, the soft-pedaled "Manet" tonalities are abandoned by August, when he starts thinking about a composition that would further explore the vein found with *Still Life with Shell*. At first—in a manner uncharacteristic of himself but quite typical of Picasso—he draws the motif as if he were turning around it (figs. 132 and 133). But soon enough he would encamp himself squarely in front of his "arrangement," as he called it, never to move. *Still Life with a Magnolia* (fig. 134) is the result of an intense labor, and Matisse is proud of the outcome. In 1946, he would still say that the picture is "his favorite."[269] Indeed, it long remained the standard by which he judged his other works. "I am settling to paint with the same energy that I drew," he noted after a particularly prolific season of drawing, "I'm going to paint *with bricks*. I don't know where this expression came from; I mean that I'll work in density. Something like my red and black still life with a shell."[270] Only with the large interiors painted in Vence, in 1946–48, did Matisse feel that he had surpassed the achievement of *Still Life with a Magnolia*.

The painting is even more paratactic than *Still Life with Shell*, because it is flatter—there are almost no indicators of spatial depth: the table is gone, the objects are all seen in elevation, except for a small plate under the blue vase; the variations of light and shade are too schematic to be read in any realistic fashion. It is also solemn. The color is fiery. No such scarlet sea had bathed a Matisse painting since the 1911 *Red Studio*. We are in an oneiric universe of grave overtones: the tentacles of the central magnolia bunch, backed by the mandorla of the copper cauldron, recall the myth of Medusa's head—the one with snakes for hair, petrifying to those who look on. The painting as a whole addresses the spectator frontally, evoking *Music* in its response to the violent assault of Picasso's *Demoiselles*

d'Avignon.[271] (What tempers the affinity of *Still Life with a Magnolia* with *Music* is the air that circulates between the figures—the white areas that surround the objects even as they are traced in heavy black contours, the light of the blank canvas that shows through the brushwork.)

Still Life with a Magnolia is completed on October 21, 1941, after which date Matisse devotes most of his energy to works on paper. The only picture of importance painted during the winter of 1941–42 is the audaciously "unfinished"-looking *Woman with Pearl Necklace* (fig. 131). It reveals that Matisse remains mindful of Picasso's discontinuities, and of the migratory capacity of his signs. Provided he can tame them, he still wants to incorporate these qualities. In its discontinuities, *Woman with Pearl Necklace* echoes the 1937 *Rumanian Blouse with Green Sleeves* (fig. 104) and, in a contrary sense, the 1939 *Daisies* (fig. 116), where the female figure absorbs the color of the chair in which she sits.

At the end of August 1942, when Matisse returns to painting, he does so yet again by way of excursion into Picasso's terrain. With *Dancer in Repose* (fig. 157) and *Dancer and Rocaille Armchair on a Black Background* (fig. 136), Matisse feels that, where he had been merely "coasting," he was "finally engaged in the serious match with painting."[272] The dancer of the first picture has a conglomerate body—her lower part twisted, her legs like eels, her upper torso frontal, squared off, with the line defining both her left bicep and her clavicle quoting directly from early cubism. In the second canvas, she casts a more relaxed, odalisquelike pose, but the Picassoesque metaphoricity is stronger: the Venetian chair by her side is a monstrous android. Two oblique lines, traced over her right wrist and arm, signal the link with Picasso. Such spatial markers entangling the figure in a network of coordinates are an anomaly in Matisse's art; and after this brief acknowledgment of Picasso's claustral space, Matisse moves away from it as much as possible and seeks to obtain in his color the freedom he has recently reached in drawing (see below). The result is a series of five pictures on a single subject—a woman by a French window—painted in September–October of 1942, and the *Seated Young Woman in a Persian Dress* (fig. 124), painted in December 1942 (and soon to be selected by Picasso in their barter arrangements). A new fluency pervades these pictures, accentuated by the thinness of the paint film and the growing role played by the aura of unpainted white surrounding the figures. This lightness of touch is pursued in the best works of the following months, notably *Tulips and Oysters on a Black Background* of February 1943 (fig. 125—Matisse's other gift to Picasso). With more than half the canvas covered in

HENRI MATISSE
131 *Woman with Pearl Necklace*, February 1942
Oil on canvas. 24 3/8 x 19 5/8 in. (62 x 50 cm)
Private collection

HENRI MATISSE
132 *Still Life*, August 1941
Pen and ink on paper
16 x 20 ¹/₂ in. (40.6 x 52.2 cm)
Musée National d'Art Moderne, Paris

HENRI MATISSE
133 *Still Life, Fruits and Pot*, August 1941
Pen and ink on paper
20 1/2 x 15 3/4 in. (52 x 40 cm)
Musée National d'Art Moderne, Paris

HENRI MATISSE
134 *Still Life with a Magnolia,*
August 25–October 21, 1941
Oil on canvas
29 1/8 x 39 3/4 in. (74 x 101 cm)
Musée National d'Art Moderne, Paris

PABLO PICASSO
135 *Coffeepot and Candle*, April 8, 1944
Oil on canvas
28 ³/₄ x 36 ¹/₄ in. (73 x 92 cm)
Musée National d'Art Moderne, Paris

HENRI MATISSE

136 *Dancer and Rocaille Armchair
on a Black Background*, September 1–6, 1942
Oil on canvas
20 x 25 ¹/₂ in. (50.8 x 64.8 cm)
Private collection

black, the picture is a tour de force attesting to Matisse's unmatched coloristic abilities: the criss-crossed scrapings on the black surface almost offhandedly transform that surface into a luminous area, checking the saturated yellow of the lemons.

■ Drawing Bloom

After this last pictorial flourish, Matisse paints little until the end of the war, and his rare canvases seem to have lost their tension. His priorities have shifted: not until he meets Picasso again will he catch the painting bug. He is now intensely involved in his illustrated books.

These constitute, in fact, a major component of Matisse's activity during the war, what kept him upbeat, for he can easily work on them even when his health confines him to bed. He had started working on the luminous white and black linocuts for Henry de Montherlant's *Pasiphaé* in August 1941, while convalescing after his surgery (the book occupies him intermittently for two years; it appears in May 1944). Then, it will be the turn of Ronsard's *Les Amours* (begun in the fall of 1941) and of Charles d'Orléans' *Poèmes* (begun a year later)—not to mention *Dessins: Thèmes et variations* and *Jazz*, which do not quite belong to the same category since there it is the text, written afterwards, that "illustrates" the images (*Thèmes et variations* was launched at the end of 1941 and published in June 1943; *Jazz* is mainly a postwar affair, but its initial phase dates back to early 1943).[273]

Matisse always considered *Pasiphaé* as a pendant for his Mallarmé: the problems are similar but reversed, for the page of text here is "relatively white," and has to be balanced against the black of the illustrations.[274] Among the very first plates are a series of variations on an embrace motif (fig. 137), which Matisse ultimately rejects for the Montherlant book, but which he will return to in the Ronsard (fig. 138).[275] Since the subject of the amorous embrace is itself irremediably Picassoesque (as is the mythical theme of Pasiphaë's love), Matisse revisits early sites of his competition with Picasso, finally "look[ing] at the journals, *Minotaure*, *Cahiers d'Art*, *Verve*, which [he] had never taken the time to do."[276] No doubt Matisse would think of his distant friend while gouging the contours of a young prancing bull: apart from the print that he chooses for *Pasiphaé* itself [fig. 141], we have eight other versions, tested in numerous sketches [fig. 140]. He extends his study of this topic to the Ronsard *Amours* (fig. 142), where a vigorously membered Jupiter attends to the abduction of Europa far more convincingly than in 1927–29 (fig. 30). Nor is there any doubt that Matisse recalls his earlier contest with Picasso concerning the ability to draw a figure with a single contour (p. 18 above): his line reaches a climax of economy in a profile streaking

the black ink like a flash of lightning (fig. 143). In the Ronsard *Amours*, it is the more complex curves of a female nude that are drawn with few strokes (fig. 144), recalling the very onset of his match with Picasso (fig. 9).

Some images of the Ronsard are hard to date with any precision: did Matisse receive his copy of Picasso's Buffon (fig. 145) before drawing so many sketches for the tiny vignette of a mosquito (fig. 146)? Nor can we date the image of a round, straight from the 1910 *Dance*, that illustrates a Ronsard "Chanson" (fig. 139). But this image reveals, perhaps more than any other plate, that Matisse conceived of his illustrated books, after what he calls the "resurrection" following his surgery, as a youth bath.

As for *Dessins: Thèmes et variations* (fig. 147), it has a different function: Matisse intends it as a pedagogical device, as a demonstration of the drawing method he has been developing since 1935. The book seems to take the *Still Life with a Magnolia* as its point of origin. Not only does Matisse include a series of sheets directly related to this picture: the idea itself for the publication began while Matisse was endlessly familiarizing himself, through drawing, with the various objects represented in this painting. Visitors to Matisse's studio-apartment were struck by this frenzy of drawings from the winter 1941–42 when they saw the sheets pinned, from floor to ceiling, on the walls of three rooms (fig. 148). Matisse would call this constantly shifting display "the cinema of [his] sensibility."[277]

It is while working at the series of drawings assembled in *Thèmes et variations* (which seem to be finished by April 1942) that Matisse best articulated the opposition between conscious and unconscious work that he had first broached in *Minotaure*. As noted above (p. 90), the opposition cannot be read in strict Freudian terms. There is no liberation of repressed desires or instincts in the "unconscious" drawings (the "variations"), but a kind of Zen emptying out of the self, a "letting go," an abdication of control only possible when total control has been secured. This control is obtained during the long drawing sessions (three to four hours) during which Matisse progressively "takes possession" of his model or motif, "as if learning by heart all its peculiarities":[278] the result is a single, worked over "matrix"—the "theme" drawing. Working on the "theme" drawing, most often in charcoal, does not require Matisse's full attention (he chitchats with the sitter); but for the "variations" on this theme, always linear (without modeling) and always done rapidly in pen or pencil, he is almost in a trance. Lydia Delectorskaya, who often posed, compares him at work on "variation" drawing to a somnambulist: the slightest distraction, a knock on the door, the ring of the telephone, makes him lose contact with the work.[279]

HENRI MATISSE
137 *Embrace*, August 1941
Proposed illustration
for Henry de Montherlant's
Pasiphaé (1944)
Linocut
9 $^5/_8$ x 7 $^1/_8$ in. (24.5 x 18 cm)
Private collection

HENRI MATISSE
138 *Embrace*, 1942–43
Illustration
for *Florilège*
des Amours
de Ronsard (1948)
Lithograph
Page: 15 $^1/_8$ x 11 $^5/_8$ in.
(38.5 x 29.5 cm)

HENRI MATISSE
139 *D'embas la troupe . . .* , c. 1943
Illustration for *Florilège des Amours de Ronsard* (1948)
Lithograph
Page: 15 ¹/₈ x 11 ⁵/₈ in. (38.5 x 29.5 cm)

HENRI MATISSE
140 Sketch for *Un meuglement différent des autres*, 1943
Illustration for Henry de Montherlant's
Pasiphaé (1944)
Sketchbook
Pencil on paper
8 5/8 x 6 7/8 in. (22 x 17 cm)
Private collection

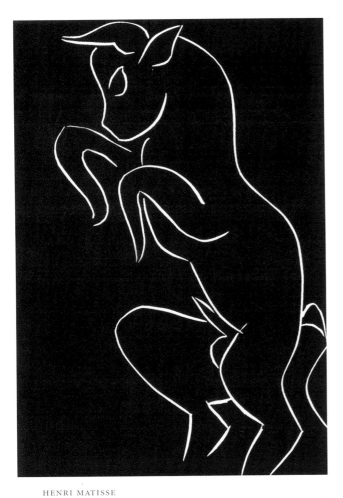

HENRI MATISSE
141 *Un meuglement différent des autres*, 1943
Illustration for Henri de Montherlant's
Pasiphaé (1944)
Linocut
9 5/8 x 6 7/8 in. (24.5 x 17.5 cm)

HENRI MATISSE
142 *Jupiter and Europa*, c. 1943
Illustration for *Florilège des Amours de Ronsard* (1948)
Lithograph
Page: 15 1/8 x 11 5/8 in. (38.5 x 29.5 cm)

HENRI MATISSE

143 *L'angoisse qui s'amasse en frappant sous ta gorge*, 1943
Illustration for Henry de Montherlant's *Pasiphaé* (1944)
Linocut
9 5/8 x 6 7/8 in. (24.5 x 17.5 cm)

HENRI MATISSE
144 *D'un orenger . . .* , c. 1943
Illustration for *Florilège des Amours de Ronsard* (1948)
Lithograph
Page: 15 1/8 x 11 5/8 in. (38.5 x 29.5 cm)

PABLO PICASSO
145 *The Dragonfly*, 1936
Illustration for Buffon's *Histoire Naturelle* (1942)
Etching
10 $^5/_8$ x 6 $^7/_8$ in. (27 x 20.5 cm)
Musée Picasso, Paris

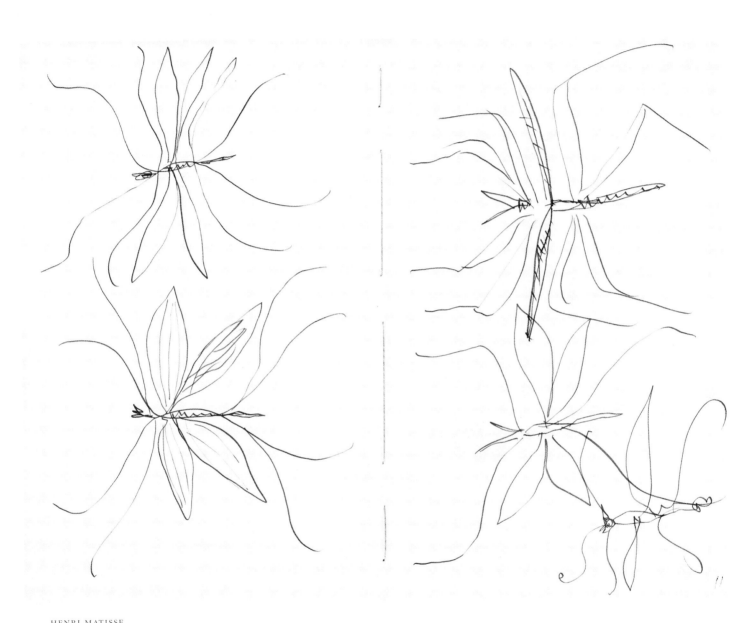

HENRI MATISSE

146 *Mosquitos*, c. 1943
Study for a vignette
in *Florilège des Amours de Ronsard* (1948)
Sketchbook
Pen and ink on paper
11 3/8 x 15 in. (29 x 38 cm)
Private collection

F1

F2

F3

F4

F5

HENRI MATISSE

147 *Dessins: Thèmes et variations*, F series, 1941

F1–F10 F1 (*Thème*): charcoal on paper
F2–F5 (*Variations*): pen and ink on paper
F6–F10 (*Variations*): crayon on paper
15 ³/₄ x 20 ¹/₂ in. (40.2 x 52.6 cm)
Musée de Grenoble

F6

F7

F8

F9

F10

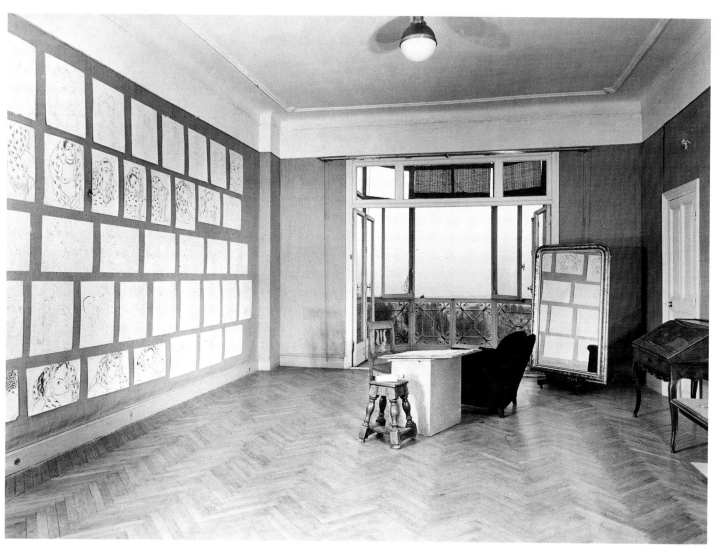

MAURICE BÉRARD
148 Matisse's apartment at Hotel Régina,
Nice, winter 1941–42
On the wall, several series
of *Thèmes et variations*

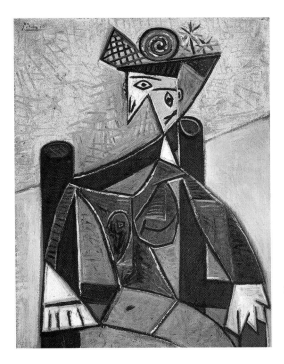

PABLO PICASSO
149 *Portrait of a Seated Woman*,
October 23, 1941
Oil on canvas
35 ³/4 x 28 ¹/2 in. (90.8 x 72.4 cm)
Private collection

It would be a mistake to equate the plates of *Thèmes et variations* with the photographs of pictures in progress that Matisse liked to have reproduced, or with the many sketches through which an artist, Picasso foremost among them, arrives at a solution for a particular painting. In fact, Matisse makes a clear distinction, on this score, between his work on paper and that on canvas: there are no "states" in his "variations," they are all *alla prima*. There is no probing, no trial and error in *Thèmes et variations* (except for the pentimenti of the "theme" drawing).[280] The goal is not to demonstrate the inexorable advance toward a final perfection won through a progressive elimination of unnecessary details.[281] The published book is not bound: each series of the excellent facsimile reproductions, printed on stiff paper, is like a deck of cards that one can shuffle at will, even if a sequence number indicates the chronological order in which they were made. There is no teleology, no climax. Matisse-the-moralist surely wants the younger generation to know that hard labor always precedes his linear drawings, but the loose organization of the book emphasizes the resulting freedom.

Matisse regarded the "considerable effort" he had put into this work "one of the most important of [his] life." "It is like an eclosion," he writes to his daughter, "one of the reasons why I wanted to go on living."[282] And to his son: "It came as a blooming after fifty years of effort. Now I have to do the same thing in painting."[283] He will only achieve this after the war, with the great Vence interiors of 1947–48.

■ Picasso's Bouts of Matisse Fever

And what is the other player doing during the Occupation? Picasso goes through a difficult period of adjustment (no works are dated by Zervos between August 1940 and January 1941, and only a handful before May 10, 1941). But he soon develops a productive routine, rarely interrupted, which includes periodic mental checks on Matisse. Most often these checks are prompted by some external event, a concrete reminder of Matisse's existence.

The need to confront Matisse first strikes Picasso at the thematic level, with three specific topics predominating: the woman with a hat, the odalisque, and the image reflected in a mirror.

The first of these topics seems to have obsessed Picasso during World War II more than at any other period. He had often painted Dora Maar or Marie-Thérèse Walter in this way, but from May 1941 on, the subject often recurs in series. *Portrait of a Seated Woman* of October 23, 1941 (fig. 149), for example, belongs to a group of at least nine pictures depicting a woman with a hat, all done between October 12 (the day he receives a drawing by Matisse; see p. 133 above) and November 17, 1941 (Z. XI, 336, 340, 342, 345–349). Sometimes Picasso invents extravagant headgear, the most famous of these oddities being *Woman with a Fish Hat* of April 19, 1942 (Z. XII, 36); but even in more banal form, the hat becomes conspicuous. Allowing that Picasso may first have encountered Matisse's work during the fauve scandal of the 1905 Salon d'Automne, where *Woman with the Hat* was the butt of the public's derisive laughter, it is not surprising that his bouts

of "Matisse fever" would lead him back to this theme. After the war, he alludes sarcastically to this association, when his competitive instincts are aggravated by Matisse's completion of his Vence chapel: "Grande chapellerie moderne/ (À l'Odalisque Repeinte)/ Henri Matisse chapellier modiste [The great modern hat shop/ (At the Repainted Odalisque)/ Henri Matisse milliner hatter.]"[284]

A second theme from Matisse—the recumbent odalisque, her arms behind her head—strikes a deeper chord in Picasso: though he paints just a handful of these during the war, he devotes much thought to them.[285] Not only are these canvases his largest at the time—foremost among them *L'Aubade* (fig. 150) and the great *Reclining Nude* (fig. 155)—but he also draws innumerable studies for them. Indeed, the painting of this theme seems to have raised Picasso out of the paralyzing anxiety he suffered at the onset of the Occupation.

This theme first appears in a gouache of January 25, 1941 (Z. XI, 92) and then again, after a period of idleness, in a series of drawings begun on May 19 (Z. XI, 123–142). In one of them, clearly the first inkling of what will become *L'Aubade*, a sleepwatcher is added (Z. XI, 138). In June 1941, Picasso attempts to situate his odalisque (Z. XI, 174, 180–186) in a series of drawings that recall his Delacroix musings in the Royan sketchbooks (fig. 118). In July, a bearded man puts in an appearance (Z. XI, 223). (Two years later, Picasso, talking to Brassaï about his drawings of a man with a beard, relates this masculine feature to his father—then promptly shifts to the topic of Matisse's drawings.)[286]

In mid-August and for several weeks, Picasso at last returns to his recumbent odalisque, and to *L'Aubade* (Z. XI 238–266, 275–279, 308, 309, 311, 312, 314, and figs. 151a–q, 152a–b), concentrating first on the pose of the odalisque. Although he freely explores the "simultaneous" views of her buttocks and pubis (already present in the earlier sketches of May), he hesitates to extend this multiplicity of aspects to his figure's face. Whereas in May he had adopted the extreme solution of combining a *profil perdu* with a regular profile steering in the opposite direction,[287] by August he seeks a less flagrant discontinuity. On September 23, the simultaneous views are nearly gone and the face, in the manner of Matisse, is empty but ovoid (fig. 152b). The setting, already determined on August 18 (Z. XI, 249), varies little throughout the rest of the process: it is an austere, claustral cell holding a huge couch and an upright cabinet, the perspectival trapeze of the ceiling adorned with a dangling lampshade, a surveying eye—straight from *Guernica*, as Leo Steinberg remarks—that is mirrored, one month later, by a carpet even more ocular (figs. 151c–o).

A third theme inspired by Matisse at this time is the topic of mirroring in general: on August 23, in several drawings of a female bust, unrelated to the sketches for *L'Aubade*, Picasso justifies the combination "*profil perdu*/divergent profile" by letting the mirror reflect the back of a head, as if to say, in the manner of Lewis Carroll, that all things are possible in a reversed universe (Z. XI, 268, 270).[288] Two days later, he enriches, with a mirror, the cabinet of the cell where the odalisque of *L'Aubade* is cloistered; a second figure, absent since May, makes her return. Picasso fiddles for a few weeks with the position of the sleepwatcher, and of her mirror-image as well; with the fourth drawing made on September 18 (fig. 151d), he clamps her down on a stool; here she remains, lost in the contemplation of her own image, in no fewer than fourteen sketches drawn over a two-day period.

This series of sketches, precisely because they recall so clearly Matisse's 1935–36 drawings with a mirror (figs. 96-98), reveals how different has become the working method of the two artists. When Matisse was drawing his "variations" in ink after having studied his "theme" in charcoal, he was always trying to forget this preparatory labor, so as to jump without a safety net. Picasso, on the contrary, proceeds by analysis, dealing first with the setting and the position of the odalisque, then shifting his attention elsewhere—to the mirror-image itself, which he had always regarded as a preserve belonging to Matisse, and best left undisturbed. The mirror becomes the variable in Picasso's series of sketches—the seated woman drawing progressively closer to her mirror image, the back of her "real" face abutting the reflection of her front (fig. 151i), then receding, almost to merge once again. Unlike the sheets of *Thèmes et variations*, these sketches cannot be shuffled like a deck of cards, they operate rather like a flip book, a technique that Picasso further developed in his later years.[289] Matisse wanted to bathe us in the flow of his "cinema"; Picasso segments this flux, which is precisely what allows him to experiment at will with a single variable.

During this brief period of intense labor, Picasso finds another way to summon Matisse: he transforms the dress of a late cubist *Seated Woman in an Armchair* into a cheapened Matissean blouse by adding to it, at the last minute, a pattern of white rings (fig. 154).[290] This picture is quite exceptional, for it represents one of the few occasions when Picasso demonized Matisse during the war. Was the mirror of *L'Aubade* giving him so much trouble that he had to vent his temper on the side? The downgrading of Matisse's refinement is obvious: this is not the lady of your dreams, her garment an elaborate evening dress, but a concierge or a maid in her day-to-day work attire (Picasso often opposes his own vulgarity to the fastidiousness of Matisse).[291] Furthermore, though he uses bright hues, Picasso makes sure that his color does not breathe: heavily impastoed, opaque, and electrified by black

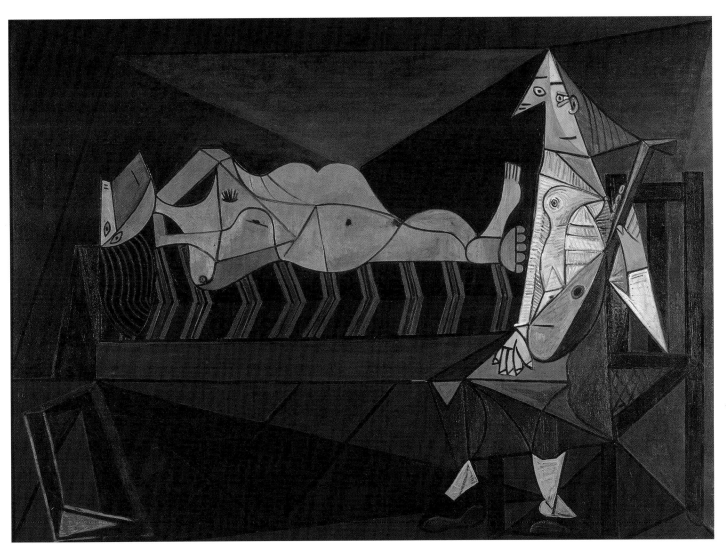

PABLO PICASSO
150 *L'Aubade*, May 4, 1942
Oil on canvas
76 ³/₄ x 104 ³/₈ in. (195 x 265 cm)
Musée National d'Art Moderne, Paris

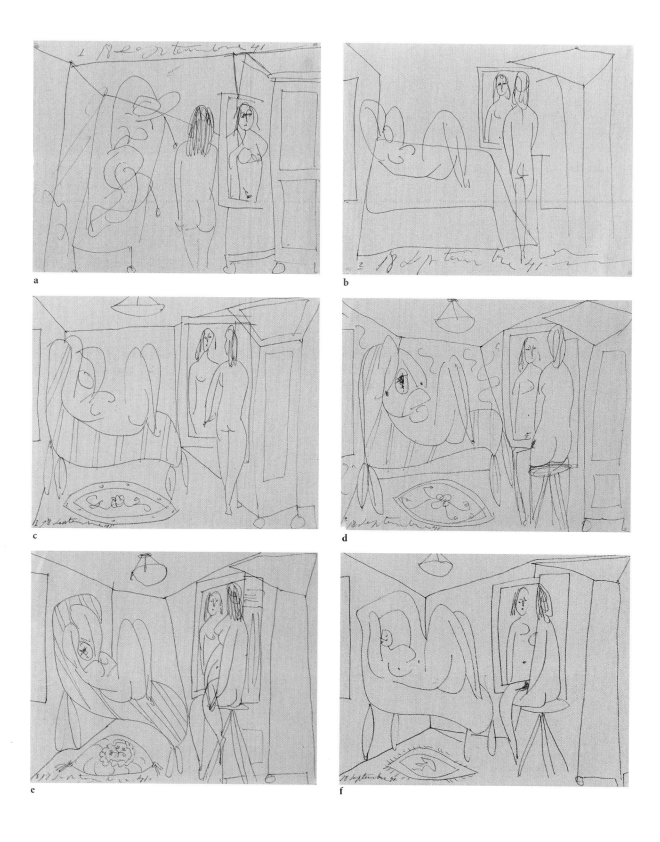

PABLO PICASSO

151 Studies for *L'Aubade (The Mirror)*, 1941

a–q Pen and ink on paper
8 1/4 x 10 5/8 in. (21 x 27 cm)
Musée Picasso, Paris

q: With handwritten annotations
concerning color.

l

m

n

o

p

q

a

b

PABLO PICASSO

152 Studies for *L'Aubade (Reclining Nude)*,
a–b September 23, 1941
Pen and ink on paper
8 ¹/₄ x 10 ⁵/₈ in. (21 x 27 cm)
Musée Picasso, Paris

a

b

PABLO PICASSO

153 Studies for *L'Aubade (The Couch)*, 1941
a–b Pencil on paper
8 ¹/₄ x 10 ⁵/₈ in. (21 x 27 cm)
Musée Picasso, Paris

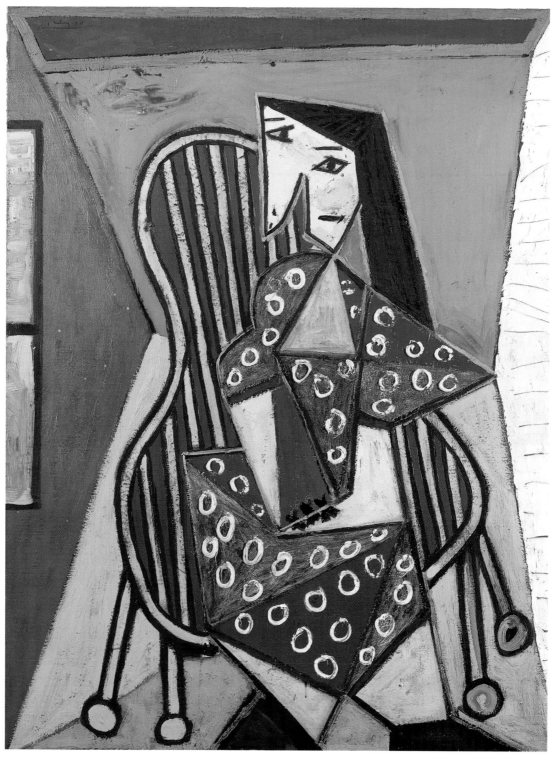

PABLO PICASSO

154 *Seated Woman in an Armchair*, 1941
Oil on canvas. 51 x 38 in. (129.5 x 96.5 cm)
The Currier Gallery of Art, Manchester, New Hampshire;
Anonymous Gift, 1953.3

(a common feature of his art when demonizing Matisse), his flashing colors put the beholder on guard.

In November 1941, Picasso sees the exhibition of Matisse's drawings at the Galerie Louis Carré (November 10–30), many of them linear drawings of the "variation" type, including some with a *mise-en-abîme* setting of *Still Life with a Magnolia*. This prompts a new investigation of the composition of *L'Aubade*, particularly of the recumbent nude, who had become too seductive, definitely too Matissean (Z. XI, 364–373). The devenustation it is now subjected to (to borrow Leo Steinberg's term), is counterposed by a sudden burst of decorative patterning in the decor (Z. XI, 365). The mirror reflection, however, remained problematic. On January 2, 1942, Picasso tries a completely new alternative—the sitter is behind the odalisque on the bed, whose legs implausibly extend into the reflection of a mirror that has remained parallel to the picture plane (Z. XII, 3).

Picasso then ceases working on the elaboration of *L'Aubade* until early May, when he promptly brings it to a quick conclusion. After so many Matissean probings, the mirror is gone or, if the frame in the foreground is a mirror, it does not function as a reflective surface. The general blackness of the canvas could not be more nocturnal, the devenustation of the nude more complete, the chamber more inhospitable. The striped pattern of the bedspread on which the ex-odalisque rests, has become a fishbone; the sleepwatcher a grotesque buffoon.

Picasso may have regretted abandoning his excursion into Matisse's turf, for in September he returns to the recumbent nude, this time with direct reminiscences of early Matisse (the mirror, a piece admitted only late in their game, is omitted). In its ochre-brown-gray color scheme, Picasso's large *Reclining Nude* (fig. 155), refers to the Cézannian and analytic phases of cubism; but it also alludes to what immediately precedes them: with its emphasis on the sculptural definition of the body, the dramatic serpentination of the figure, the right arm bent behind the head, it is as much an homage to Matisse's *Blue Nude* of 1907 (fig. 156) as it is to Picasso's own *Nude with Drapery* (Z. II*, 47) of the same year (a response at that time to the Matisse). Although *Reclining Nude* may allude to the harshness of the war years (the recent enforcement of the anti-Semitic laws in France has been offered as an explanation of the canvas' somber tone), Picasso was also clearly mourning the tit-for-tat joust of his youth.[292]

There would be many other bouts of "Matisse fever" in Picasso's work through the end of the war, but none so serious as that of the summer and early fall of 1943, just after he sees Matisse's recent canvases at Lejard's in June. First, he paints the rooster that Max Pellequer promised Matisse, but which Picasso

decides to keep for himself (as Matisse had done for his drawing inscribed to Picasso in 1941 [fig. 123]).[293] Then, on July 10, he pays tribute to Matisse's *Portrait of Marguerite*, a canvas he had owned since 1907 (Z. XII, 258).[294] Not until August does he respond directly to the paintings he discovers at Lejard's.

One of these belongs to an August 1942 series depicting a dancer in an armchair: like *Dancer in Repose* from the same series (fig. 157), it has an undulating tiled floor, but the body of the resting woman is far less convoluted. Picasso picks up on the seasick tilting, transforming the armchair itself into a bag of eels entrapping the sitter (fig. 158). Drawing upon his studies for the couch of *L'Aubade* (figs. 153a–b), he makes numerous sketches of the arabesque of the rocking chair (Z. XIII, 71–72, 75–80), some after finishing the painting, and apparently no more than one of the figure herself, leaving no doubts as to his primary focus.

Picasso waits until October before making his version (Z. XIII, 130) of another Matisse from the Lejard group—the *Woman with a Veil* of February 1942, which Matisse described to Aragon as "a little Manet."[295] Meanwhile, he paints one of his largest canvases of the Occupation, *Chair with Gladiolias* (Z. XIII, 123), which recalls Matisse's works of 1908–10—in particular, *View of Collioure* of 1908, *Lady in Green* of 1909, and *Girl with Tulips (Jeanne Valderin)* of 1910 (New York 1992, pls. 97, 117 and 130 respectively). Add a few still lifes with a reflecting mirror (Z. XIII, 127–128), and you have a full-fledged recurrence of Matisse fever.

The genre of the still life, however, in which Picasso is at his most prolific during World War II, also marks the point of his greatest resistance to Matisse's art. We do not know of Picasso's reaction to *Still Life with a Magnolia* when this is first exhibited in the Salon d'Automne of 1943, but Françoise Gilot writes about its reception in 1945:

> Picasso found it too decorative. Furthermore, the open composition, with the copper cauldron partly out of the picture and the objects barely touching each other, not isolated or intersecting frankly, was anathema to the master of cubism. It set his teeth on edge. . . . I must have looked absorbed and thoughtful, because as we came out of the museum, Pablo concluded the visit by saying, "So you think it works, this juxtaposition of objects without cause-effect relationship? Matisse is a magician, his use of color is uncanny. This makes me hungry all of a sudden."[296]

Picasso cannot and will not accept the paratactic organization of Matisse's "all-over" space. It sets "his teeth on edge." And so he affirms, in countless still lifes painted during the Occupation, that objects have to be anchored in a network of coordinates, that space is boxlike and not expandable. To Matisse's indeterminate

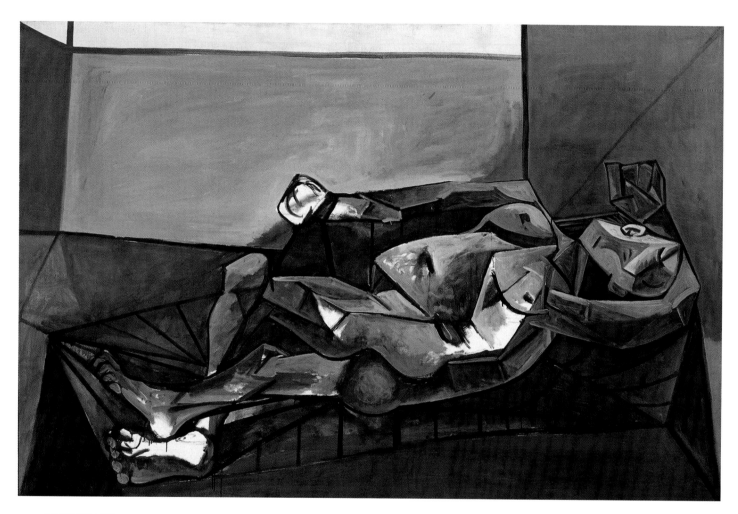

PABLO PICASSO
155 *Reclining Nude*, September 30, 1942
Oil on canvas. 51 $^{1}/_{4}$ x 76 $^{3}/_{4}$ in. (129.5 x 195 cm)
Sammlung Berggruen in den Staatlichen Museen
zu Berlin-Preußischer Kulturbesitz, Berlin

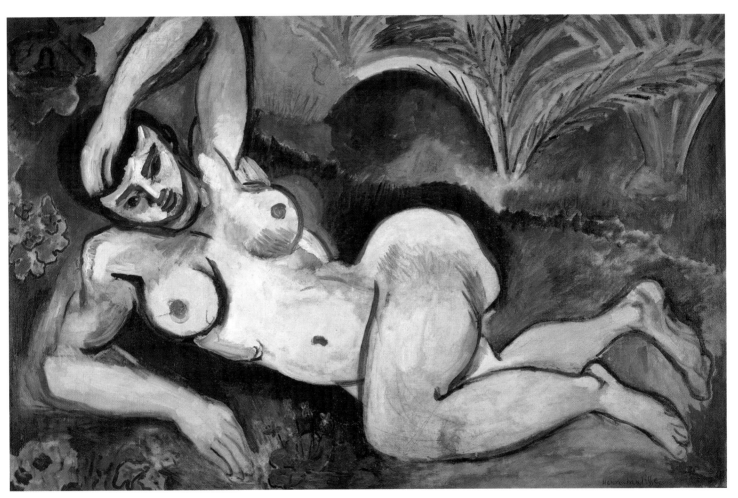

HENRI MATISSE
156 *Blue Nude ("Souvenir of Biskra"),* early 1907
Oil on canvas. 36 ¹/₄ x 55 ¹/₄ in. (92.1 x 140.4 cm)
The Baltimore Museum of Art;
The Cone Collection

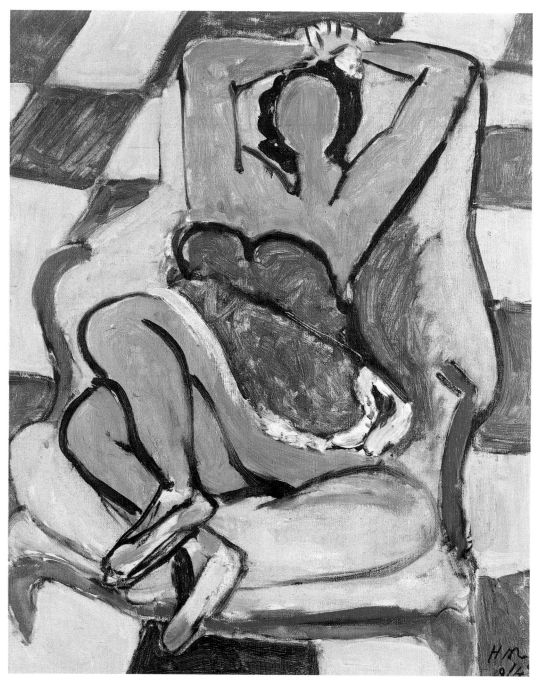

HENRI MATISSE
157 *Dancer in Repose*, August 24–30, 1942
Oil on canvas. 18 1/8 x 15 in. (46 x 38 cm)
Private collection

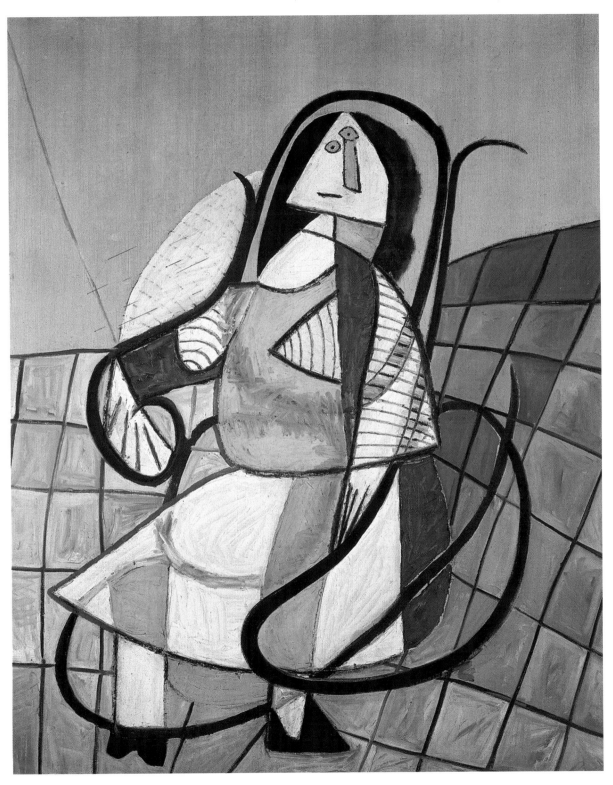

PABLO PICASSO
158 *The Rocking Chair*, August 9, 1943
Oil on canvas. 63 ³/₈ x 51 ¹/₈ in. (161 x 130 cm)
Musée National d'Art Moderne, Paris

bath of red in *Still Life with a Magnolia*, he responds, uncharacteristically, with a single predominant color (turquoise) in *Coffeepot and Candle* (fig. 135). But the color does not inundate his canvas; the objects do not float, they remain pinned down. Even the mirror, reflecting the light, does not allow our gaze to wander.

The most famous of Picasso's wartime still lifes is undoubtedly *Still Life with Steer's Skull* (fig. 159). The subtle color harmony (purple, pink, brown, blue, emerald green, and all the possible shades on the tonal scale, from white to pitch black) is very Matissean.[297] Even the care Picasso takes with the velvety glazing is unusual. But everywhere the law of the frame is enforced: "You shall move no more than I do," says the morbid skull to its beholder. *Still Life with a Magnolia* also addresses the spectator

violently, but after the "clarion call" of color, as Matisse used to say, it allows the beholder to experience the flow of expansion, to swell along. With Matisse, the terror of the Medusa's head has to be overcome; Picasso does not want to free us from its spell.

Only once does Picasso invite Matisse's all-over "decorative" space into the world of his still life; he does so in a series of drawings of a tomato plant done at the very end of the Occupation, on July 27, 1944, as a direct response to *Thèmes et variations*. The first of these (fig. 160), could almost be signed by Matisse—compare with one of his numerous sketches of a mustard plant (fig. 163). The second and third drawing, even if they become more angular than Matisse's fluidity would allow, remain centrifugal (Z. XIV, 14 and fig. 161). In the last drawing (fig. 162), however, with its heavy highlights that tell you where to look, Picasso is back in his own universe.

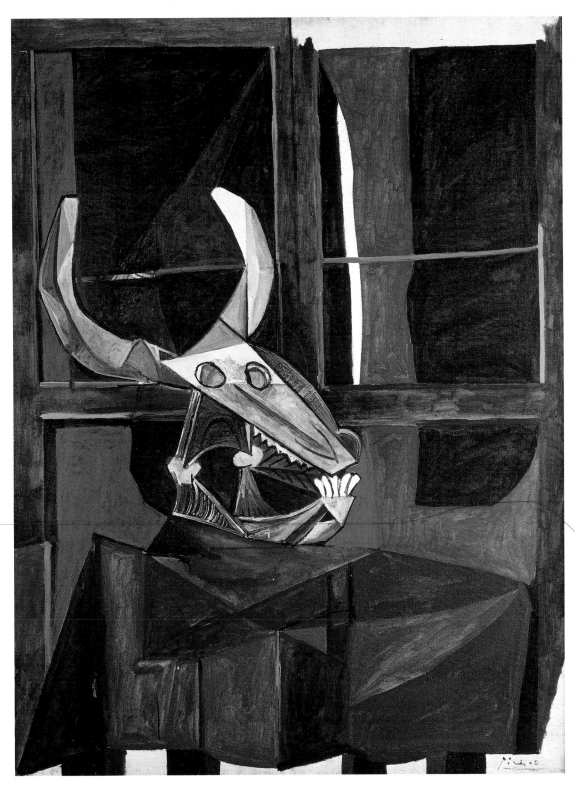

PABLO PICASSO
159 *Still Life with Steer's Skull*, April 5, 1942
Oil on canvas. 51 ¼ x 38 ¼ in. (130 x 97 cm)
Kunstsammlung Nordrhein-Westfalen, Düsseldorf

PABLO PICASSO

160 *Tomato Plant*, July 27, 1944

(above left) Conté on paper

Dimensions and whereabouts unknown

PABLO PICASSO

161 *Tomato Plant*, July 27, 1944

(above right) Conté on paper

26 x 19 $^7/_8$ in. (66 x 50.5 cm)

Ludwig Museum, Cologne

PABLO PICASSO

162 *Tomato Plant*, July 27, 1944

Conté on paper

26 x 19 $^7/_8$ in. (66 x 50.5 cm)

Marina Picasso Collection (Inv. 4607),

courtesy Galerie Jan Krugier,

Ditesheim & Cie, Geneva

HENRI MATISSE
163 *Mustard Plant*, c.1943
Sketchbook, Pencil on paper
11 ³/₈ x 15 in. (29 x 38 cm)
Private collection

HENRI MATISSE
164 *Interior with Egyptian Curtain*, 1948
Oil on canvas. 45 ³/₄ x 35 ¹/₈ in. (116.2 x 89.2 cm)
The Phillips Collection, Washington, D.C.

FOURTH ACT: REUNION

1944–54

―――

■ Postwar Officialdom: Two Salons

Just as the Occupation had done, Liberation changes the rules on August 26, 1944. Matisse and Picasso must now contend with an unrelenting press staging and promoting their differences. Both are now treated as national treasures by many factions of the French intelligentsia, as well as by art institutions, but there is a marked dissymmetry in their public life. Owing to his age and health, Matisse's habits are not fundamentally altered at the end of the Occupation. Picasso, by contrast, instantly becomes a star with a quasi-official status.[298]

The trend becomes pronounced with the 1944 Salon d'Automne—the "Salon de la Libération," as it was nicknamed—where Picasso is celebrated by a special exhibition of at least seventy-three canvases and five sculptures, confirming and broadcasting his stardom (fig. 165). On October 5, the day before the Salon opened, the daily newspaper of the French Communist Party, L'Humanité, boasts on its front page: "The Greatest Painter Alive, Picasso, Joined the Party of the French Renaissance." The story of Picasso's membership overshadows news of the war front.[299] The immediate, expected, result is a Salon crowded with visitors, many of whom had never set foot in a museum or gallery.

The uproar is considerable. One pugnacious group of visitors takes down Picasso's 1942 Bull Head (the sculpture made from a bicycle seat and handlebars) as well as several canvases. The problem may be compounded by the selection of works: rather than presenting a retrospective of his work, Picasso shows primarily his production of the last six years, concentrating on the war period, thus depriving this new audience of any historical key that would have facilitated an entry into his world.[300]

Matisse missed the exhibition, but he was immensely curious (asking Camoin if he had seen it, he commented: "People speak a lot about it, there were demonstrations against it in the street. What a success!")[301] He was understandably puzzled when he heard that his own Basket of Oranges of 1912 was displayed by Picasso among his works (he mentioned this in a letter to his son, not without pride).[302] And, like everyone else, he was much intrigued by Picasso's decision to join the Communist Party.[303]

He was anxious to visit him when he came to Paris for two weeks in April–May 1945.[304]

Matisse could always retreat from the agencies of various political and intellectual factions, but Picasso—backed, and politely coerced, by a formidable Communist machine—would remain attached to a party that never refrained from the use of him. Picasso could not help but envy Matisse his independence.

This may underlie a contradiction at work in the several Picasso still lifes of a skull and pitcher, dating from the spring of 1945—a conflict between their dark theme of vanitas, and the lightness of their color and paint handling. In the first work of this series, dating from March 10 (Z. XIV, 87), there is no such contradiction; the confrontation between skull and pitcher is exceptionally tense—the skull "mean and hard as a bullet," as Leo Steinberg remarks.[305] Three days later, Picasso adds another character to the cast of his still lifes—a bunch of leeks, standing in for the crossbones; the tightness of his composition begins to ease off. In less than a week, he paints at least six canvases representing this triad, the leeks alternately limp or throbbing claws (Z. XIV, 88, 93, 95–97, 99).

What immediately strikes observers of certain canvases from this group is their freshness: "I push them less and less," remarks Picasso. "If I go beyond a certain stage, it would no longer be what it is. I would lose in spontaneity what I might gain in solidity. I use less and less color, and allow the virgin canvas to play its part more and more."[306] No utterance could be more Matissean. In the second group of canvases based on this composition—three pictures presumably painted in early May (only fig. 166 is dated[307])—a fourth element is added, variously a book or an oil lamp. The connection to Matisse (who, incidentally, had just visited Picasso) is spelled out in the quantity of canvas reserved, and in the way the whiteness of the canvas shows through when covered with pigment. Note also the white band of unpainted canvas around the objects, allowing the color to breathe—very efficiently so between yellow and black, as in Matisse's Tulips and Oysters on a Black Background (fig. 125), which Picasso had finally retrieved from Fabiani's storage room.[308]

At the end of June 1945, Matisse was again in Paris, where he remained until mid-November. There is little doubt that he saw Picasso's exhibition at the Galerie Louis Carré (June 20–July 13), the artist's first commercial solo show after the war. (He might have been amused by the number of pictures depicting a woman with a hat—eight canvases—as well as by the coloristic vitality of the still lifes, notably by two pictures of a candlestick, a coffee pot, and a mirror, from the same series as fig. 135). The event was well orchestrated, an elaborate catalogue published (*Picasso Libre: 21 peintures 1940–45*), and the reviews were very positive, arguing (against all evidence) that there was a huge difference between these works and those which had created a scandal at the Salon d'Automne a few months before.

Having received ample evidence concerning the fickleness of the press and the Parisian public, Matisse paid careful attention to his participation in the 1945 Salon d'Automne. Like Picasso the previous year, he was to be celebrated by a special one-artist show. Unlike his rival, however, he took the idea of a mini-retrospective seriously. In fact, Matisse insisted on his beginnings: out of the forty-three paintings in the show (six of them not in the catalogue), he exhibited no less than nine pre-1903 canvases.[309] Curiously, he showed only one strictly fauve canvas, the fiery *Girl Reading* of 1905–06 (The Museum of Modern Art, New York), but he included *Le Luxe I* of 1907, *The Yellow Curtain* of c. 1915, and *Portrait of Greta Prozor* of 1916, none of them easy works.[310] Furthermore, the Nice years were almost entirely omitted, represented only by two canvases of the "crisis period," one of them *Reclining Nude Seen from the Back* of 1927 (fig. 18). After that, Matisse's selection jumped forward to the late thirties (notably with *Daisies* [fig. 116]) and to the war years, with twenty-two paintings of the forties, including *Seated Young Woman in a Persian Dress* (borrowed from Picasso, fig. 124).[311] All in all, this was a very consistent selection, and the press was extremely laudatory. Even *Les Lettres Françaises* (Picasso's camp) joined in, publishing a long interview in which Matisse stood his ground, distancing himself from the "social-realist" views on art usually expressed in the journal.[312]

■ Diplomatic Exports

The postwar competition between Matisse and Picasso takes an official turn with a joint exhibition at the Victoria and Albert Museum (December 5, 1945 to January 15, 1946). Matisse begins worrying about the show as soon as the idea is broached, asking Picasso which frames he would use—he wants his own to look the same, and prefers the simplest kind—and whether Picasso would lend the three Matisse paintings that he had recently acquired.[313]

On August 3, 1945, Matisse writes as follows in one of his notebooks:

> Tomorrow Sunday, at 4 o'clock, visit from Picasso. As I'm expecting to see him tomorrow, my mind is at work. I'm doing this propaganda show in London with him. I can imagine the room with my pictures on one side, and his on the other. It's as if I were going to cohabit with an epileptic. How quiet I will look (even a bit old hat for some), next to his pyrotechnics, as Rodin used to call my works! I still go for it head on, I never recoiled from a heavy or embarrassing neighbor. Justice will prevail, I always thought. But then, what if he was right? People are so nuts![314]

Matisse is right to be concerned about the reception of his work in London. Exhibiting five more paintings than Picasso (thirty against twenty-five), he is nonetheless eclipsed. Each decides to stick with the divergent strategies adopted for their recent Salon d'Automne exhibitions, Matisse presenting a digest of his mini-retrospective—with essentially the same selection of early works and fewer canvases from the forties[315]—and Picasso, paintings dating from the war years, coming straight from his studio, with the exception of the 1939 *Night Fishing at Antibes*, lent by Zervos.[316]

Although no one in London tries to take Picasso's works off the walls, as some tried to do in Paris the year before, the commotion is considerable and the exhibition packed. Even though the press, initially at least, tries to treat the painters equally, the public focuses on Picasso. Week after week the London *Times* publishes letters from readers filled with rage—one from Evelyn Waugh particularly to be lamented; his rare sympathizers are reduced to pointing out that the show was entirely financed by the French government.[317] The exhibition was far better received when, depleted of Picasso's *Night Fishing at Antibes* and of five works by Matisse, it traveled to Manchester and Glasgow. But by then reports of the London fracas had reached Paris. The conservative press, nostalgic for the Pétain regime, cried out that Picasso was not fit to be the ambassador of French culture. Waldemar George, a vociferous reactionary from 1930 on, entitled one of his articles "The Art of Picasso Is Not French."[318]

If Matisse seems to have paid scant attention to this uproar, and to the relative lack of response his own work elicits in London, it is probably because he is having better luck in Paris. In November 1945, shortly after the close of his mini-retrospective at the Salon d'Automne, Tériade published a special issue of the luxurious journal *Verve*, devoted entirely to the art he had produced during the war, with many outstanding color reproductions (vol. IV, no. 13). Entitled *De la couleur*, it reveals on its cover and as its

MARC VAUX
165 Picasso's exhibition at the 1944 Salon d'Automne,
"Salon de la Libération"

PABLO PICASSO
166 *Skull, Lamp, Leeks and Pitcher*, May 6, 1945
Oil on canvas. 31 $^7/_8$ x 39 $^3/_8$ in. (81 x 100 cm)
Marina Picasso Collection (Inv. 13069),
courtesy Galerie Jan Krugier, Ditesheim & Cie, Geneva

a

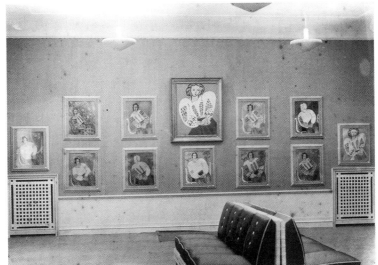

b

c

MARC VAUX

167 Matisse's exhibition
a–c at the Galerie Maeght, Paris,
December 1945

frontispiece something that looks, in retrospect, like the genesis of *Jazz*. Soon there follows a Matisse exhibition at the Galerie Maeght—an inaugural show for what would become the most important gallery in postwar France. Even though Matisse is back in Nice and bedridden, he controls the installation, and the exhibition, unthinkable today, proves to be extraordinary: in keeping with his escalating fear that the younger generation of artists would misjudge his recent pictures as being quickly and easily done, Matisse selects six paintings recently shown at the Salon d'Automne, and surrounds each work with photographs recording its progress—every photograph individually framed at a size only slightly smaller than the size of the painting itself (figs. 167a–c).[319]

Picasso saw the show.[320] Though we do not know exactly when he did so, his work affords a clue: on the very day of the opening, he begins his famous series of lithographs of a bull, progressively "simplified" in eleven different "versions" (rather than "states," even if successively worked on the same stone). As Irving Lavin remarks, this set stands apart in Picasso's graphic production: unlike Matisse, Picasso always relished experimenting with the sequential states of a print, but would follow the traditional route of gradually complicating his composition. In the bull series, however, the animal is rendered at first fairly realistically (its large mass fully shaded, with many nuances in the modeling), only to end up as nothing more than a few lines—nothing more than a cipher (the last version dates from January 17, 1946).[321] As Isabelle Monod-Fontaine notes, this subtractive, painstaking method, antithetical to everything we know about Picasso's working procedure, is exactly the method Matisse had followed in his painting until then (though no longer in his drawing). Nothing could be clearer on this score than the series of photographs surrounding *The Rumanian Blouse* or *The Dream*, a painting that already played its role in the continuing exchange between Matisse and Picasso (see above p. 137).[322]

■ Visit

In 1946, postwar exchanges between the two assume a pattern that would only change with the death of Matisse in 1954. They play out their game in three ways: first, as frequently reported in the press (it made good copy), they would participate jointly in public events; second—most eloquently recorded by Françoise Gilot, who captures Picasso's ambivalent, Oedipal relation to the senior Matisse—they would meet in private; third, and least discussed, they would interact with their work.

On the public front, 1946 was an eventful year, replete with charity group shows. The most important of these often politically

oriented exhibitions was "Art et Résistance" at the Musée d'Art Moderne de la Ville de Paris, in February–March. Sponsored by the Association des Amis des Francs-Tireurs et Partisans Français (the militants of the Resistance movement better known as F.T.P.), the exhibition was intended to help rebuild national pride. Judging from the critical reception, both artists failed to match expectations. Picasso exhibited *Charnel House* (Z. XIV, 76; The Museum of Modern Art), the first canvas painted in his new allegorical mode at the urge of his Communist watchdogs. The Party press was disappointed, declaring the painting unfinished and too pessimistic (as well as too generic) in its depiction of human suffering.[323] As for Matisse, he was ridiculed for having sent drawings picturing his daughter as an F.T.P.[324]

At the same time as "Art et Résistance," Matisse's December 1945 exhibition at the Galerie Maeght traveled to Nice, at the request of the municipality (it was placed in the casino!). Surprisingly, it created a commotion, with student demonstrations and letters to the editor of the local newspaper.[325] Not without amusement, Matisse wrote to his son that this was "a repetition of what happened in Paris for the Picasso exhibition" (at the 1944 Salon de la Libération).[326] In April and May 1946, respectively, the Picasso–Matisse exhibition at the Victoria and Albert Museum traveled to Amsterdam and Brussels (with some revisions). The catalogues present the two artists as powerful equals (figs. 168, 169), and the critics do the same. One review was simply entitled "Matisse = Picasso," an economical summary of the general reception of the show.[327]

Picasso, often on the Riviera, now visits Matisse with regularity—in Vence, and then in Nice. The first visit, in mid-March of 1946, has been described with great verve by Françoise Gilot.[328] To Picasso's irritation, Matisse suggested that he could paint Gilot's portrait, and that, if he did so, he would paint her hair green. This proposal was the genesis of Picasso's *Woman-Flower*—"Matisse isn't the only one who can paint you with green hair," Picasso said to Gilot.[329]

What did Picasso see during this first postwar visit? Most certainly quite a number of line drawings and prints (many always adorned the walls of Matisse's studio); cutouts (Matisse had almost finished working on *Jazz*, though it would only be published in November 1947); and the first canvases of the late group of works produced in what is commonly known as the Vence period. Among the pictures completed at the time of Picasso's visit are: the triptych *Leda* and *Young Woman in White* (Aragon 1971, I, pl. 36; II, pl. 67), *L'Asie* (*Asia*) (fig. 170), *Interior in Yellow and Blue* (fig. 220) and *The Rocaille Armchair* (fig. 171).

We do not know what Picasso thought of *L'Asie*, but we can assume that his reaction would have been equivocal. The unusual

Catalogue cover
168 Matisse and Picasso exhibition
Palais des Beaux Arts, Brussels,
May 1946

Catalogue cover
169 Matisse and Picasso exhibition
Stedelijk Museum, Amsterdam, 1946
Collection Stedelijk Museum

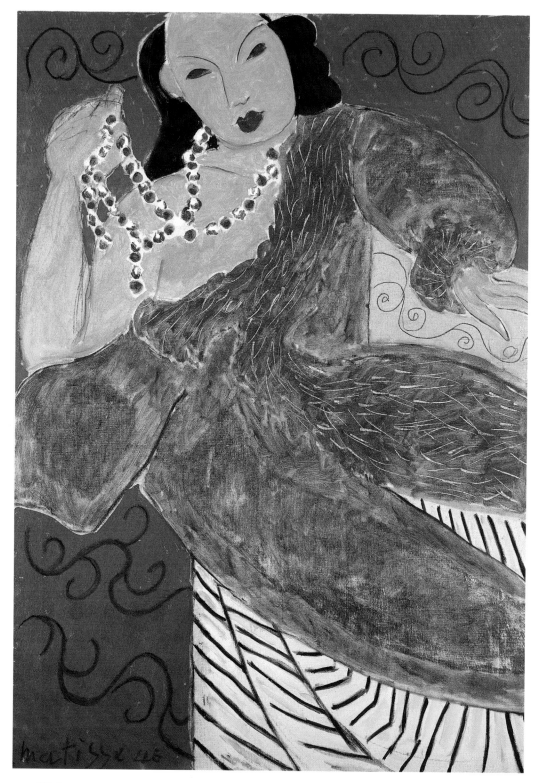

HENRI MATISSE

170 *L'Asie* (*Asia*), 1946
Oil on canvas. 45 ³/₄ x 32 in. (116.2 x 81.3 cm)
Kimbell Art Museum, Fort Worth, Texas

HENRI MATISSE
171 *The Rocaille Armchair*, 1946
Oil on canvas. 36 ¹/₄ x 28 ³/₄ in. (92 x 73 cm)
Musée Matisse, Nice

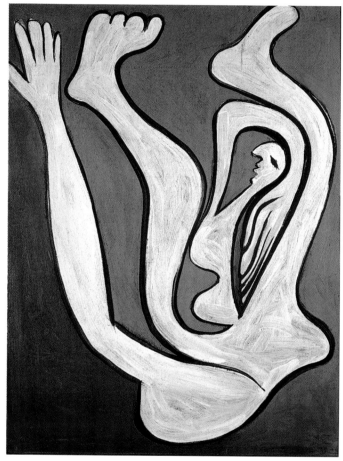

PABLO PICASSO

173 *Female Acrobat*, January 19, 1930
(above) Oil on plywood
25 ¹/₈ x 19 ¹/₄ in. (64.2 x 49 cm)
Marina Picasso Collection (Inv. 12540),
courtesy Galerie Jan Krugier,
Ditesheim & Cie, Geneva

HENRI MATISSE

172 Study for the illustration of René Char's *Artine,*
(left) 1945–46
Sketchbook
Pencil on paper
8 ⁵/₈ x 6 ³/₄ in. (22 x 17.3 cm)

agitation of this painting, the fierceness of the vermilion ground, the amazing variety of textures and glazes, the frontal address of the figure conceived as a central wheel spinning around—all this was bound to please him. But he would not have appreciated the fuss of the fuzzy, velvety purple area, with its complex thin underpaint layers, which he would have associated with Bonnard, a painter whose work he profoundly disliked (Picasso would have been right in this association: shortly after his visit, Matisse would loan the picture to Bonnard, who greatly admired it).

As for *The Rocaille Armchair* (fig. 171), Gilot reports that Picasso found it hard "to stomach": "There is not even a suggestion of verticality or horizontality, while this oyster-shell-life monster pours out its guts outside the canvas. It gives me vertigo."[330] Odd to hear Picasso resenting metaphor, his daily bread. Would he have preferred *Interior in Yellow and Blue* (fig. 220)? Here Matisse pays even more tribute to Picasso's way of thinking: first, by anthropomorphizing the same armchair (it is now marching toward us), and next, by dissociating color and drawing more than in any other picture since the 1939 *Daisies* (fig. 116). It is almost as if color had become an element of collage. The canvas is divided into a checker pattern of four rectangular areas (the two yellow ones merging), almost independent of the objects that populate them. The equality of the two blue rectangles, neatly balanced in their respective corners, contradicts the different spatial orientation of the planes they depict (one is a table, the other an open door)—as in so many of Picasso's cubist works.

Picasso does not react directly, but makes a move in another area—in Matisse's domain of the cutout, devised as a fusion of color and drawing, a "direct carving into color." We know from Françoise Gilot that Picasso came to admire Matisse's cutouts, particularly from a technical point of view (she records his fascination at watching Matisse working in December 1947).[331] But when he sets out to paint the *Woman-Flower* a few weeks after his first post-war visit, he rebels against the abolition of the color/drawing distinction, clearly stating their incommensurability, and reaffirming the traditional (academic) supremacy of drawing. As Matisse had done (or as his assistant did), he "painted a sheet of paper sky-blue," and, as Matisse would do, he "began to cut out oval shapes" corresponding to his idea of Gilot's face. There the analogy stops, for on these oval cutouts, "he drew in, on each of them, little signs for the eyes, nose, and mouth."[332]

The paper cutout technique is the last of a long series of inventions through which Matisse explores the consequences of the "quantity/quality" equation which he had established as central to his art at the very beginning of his career (see pp. 28–29 above). In Matisse's mind, the cutout units—undivided planes of flat colors—provide the most immediate proof that the qualitative effect of a color depends on the quantity of surface it covers. By drawing on the surface of a cutout rather than letting its overall contour be solely in charge of the modulation, Picasso says in reply: "Your technique does not work, at least not for me." Whenever he cuts a silhouette from a piece of paper (most often a piece of white paper), he cannot resist adding a mouth here, a pair of eyes there.

Woman-Flower was painted in Paris on May 5, 1946. In mid-June, Matisse is also in Paris, where he stays for almost a year, until April 1947. One can assume that he sees Picasso's second exhibition at the Galerie Louis Carré (June 14–July 14, 1946). It is very similar in composition to the previous show in the same gallery, and there are almost no postwar pictures (the only big novelty for Matisse would have been *Night Fishing at Antibes*). Yet he would have been puzzled (pleased?) to see that Picasso's version of the *Rape of Europa,* the only work from 1946, was as unconvincing as his own treatment of the subject in 1927 (fig. 30),[333] and he would have nodded in approval at a picture such as the *Seated Woman in an Armchair* of 1941, already known to him in reproduction (fig. 154).

But Matisse himself is treading on Picasso's mill: at this juncture he seems to be working on the illustrations of *Artine,* a surrealist text written in 1930 by René Char, the mutual friend of both artists. This project was never realized, but the many sketches Matisse made for it directly recall Picasso's acrobats of 1929–30 (figs. 172, 173). This was a minor excursion, however, for during his stay in Paris in 1946–47, Matisse is fully engaged in his paper cutouts. He paints very little (if at all) but supervises the printing of several illustrated books—notably the *Letters of Marianna Alcaforado* (the "Portuguese Nun"), Baudelaire's *Fleurs du Mal,* and, most importantly, *Jazz.* He also realizes in paper cutouts the cartoons of the tapestries *Polynesia, the Sky* and *Polynesia, the Sea* and of the decorative panels *Oceania, the Sea* and *Oceania, the Sky* (fig. 195).

■ *The Joy of Life*

A month after Matisse arrived in Paris, Picasso headed South, where he stayed until late November 1946. And it was there, in an ensemble of drawings, easel paintings, and panels completed in the Palais Grimaldi at Antibes, that he really picked up the dialogue with Matisse.

The Joy of Life (fig. 174), painted in October–November 1946, certainly does not share the coloristic exuberance of Matisse's 1906 picture of the same title (fig. 175)[334]—its highly absorbent support of fibrocement sucked up most of the luster from the paint, which was not a regular oil paint, but a kind that is used for

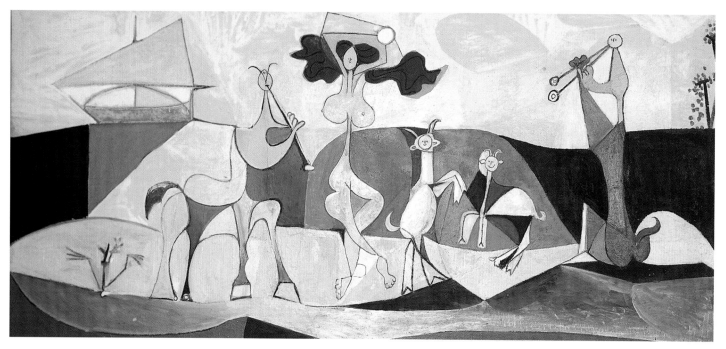

PABLO PICASSO
174 *The Joy of Life* or *"Antipolis"*, 1946
Oil on fibrocement
59 x 98 ³/₈ in. (120 x 250 cm)
Musée Picasso, Antibes

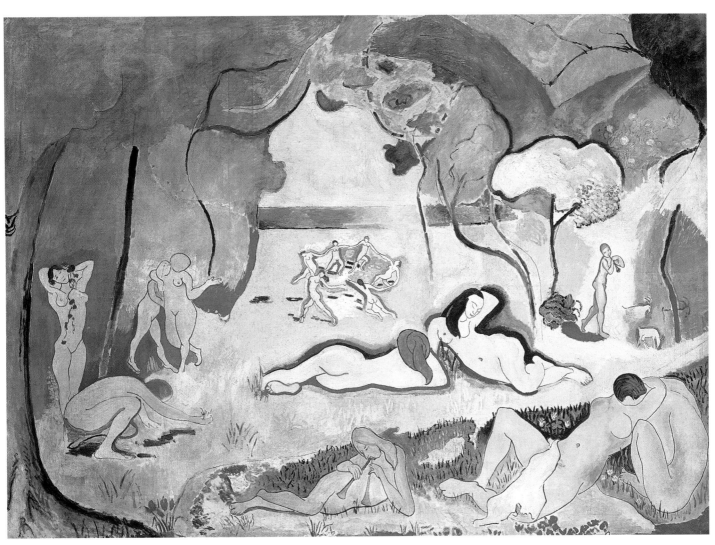

HENRI MATISSE
175 *The Joy of Life (Le Bonheur de vivre)*,
winter 1905–06
Oil on canvas
69 1/8 x 94 7/8 in. (175 x 241 cm)
The Barnes Foundation,
Merion, Pennsylvania

boats. Although its composition features Picasso's usual centrality, the painting has clearly been conceived to recall Matisse's inaugural canvas: despite its symmetry the distribution of the figures is more paratactic than in the Matisse, and the swooping curves partake of Matisse's circulatory system. In all the drawings related to this large composition—later published in a special number of *Verve* (V, nos. 19–20 [April 1948]) and collectively known as the "Antipolis" series—Picasso seems to be making a mental check of his friend's graphic devices (figs. 177–179). He uses silhouettes without (or with a minimum of) internal contours, which leads him to yet another common feature of Matisse's art, the featureless face. The abduction of a woman by a centaur (fig. 178) rehearses the embraces in Matisse's Montherlant and Ronsard books (figs. 137, 138); the centaurs and woman trying to catch a bird (fig. 179) dance like the creatures in the Ronsard (fig. 139).

One might think that this homage to Matisse was mainly a constraint of iconography—that in choosing to treat such Mediterranean mythical themes, Picasso was compelled to revisit the compositions of his competitor. But that would be reverting the order of priorities, for Picasso's Matissean exploration in the fall of 1946 also appears in other genres. Some of Picasso's still lifes, for example, drawn (fig. 180) or painted (fig. 181), could not be closer to Matisse's art: the objects float, free of the linear web of coordinates that usually locks them in place in Picasso's work. The fluency of the drawings, the luminosity of the canvases are clear, unmitigated paeans to Matisse's craft.

When Matisse came back to Vence at the end of April 1947, he was understandably curious about what Picasso had been doing in Antibes. We know that he went to see Picasso on June 12, but probably to the house the artist was renting in Golfe-Juan, not to Antibes.[335] There he would have been shown some of the potteries that Picasso had been doing during the past summer, and a series of pictures of a woman in an armchair—flamboyant in color, almost kitsch, in which his own recurrent fascination for the folk embroideries of Rumanian clothing was being exaggerated (fig. 176).

The two painters most certainly talked about the possibilities of ceramic and mural painting during that summer.[336] Three months later, just a day after Picasso again visited him with Gilot, Matisse sent him an urgent letter. During a bout of insomnia, he had suddenly thought that Picasso should do "a true fresco in the Antibes Museum": "We'll find a mason able to prepare the mortar for you—in any case Italy, the country of fresco, is not far. I am convinced that you would do something stunning, and very simply at that. I would like you to do the job, because it is impossible for me, and I know you'd do it much better than I. Think about it. It's important for all. Forgive my insistence. It's my duty."[337]

Matisse does not seem to have gone to the Palais Grimaldi until April 1948. "I saw the Museum of Antibes," he writes to his son, "There are some extraordinary Picassos."[338] He goes back a second time two weeks later: "I went this morning to study what he had done, pencil in hand. There is a reclining woman that I call the *faux col* [detachable collar] because that's what jumps at you at first sight. After having spent half an hour drawing it, passing by it again, I again saw a *faux col*. Picasso is a kind of superior clown, like Grock (this said without any mean-spiritedness)."[339]

Matisse was referring to a series of large sketches he made after several Picasso panels, painted either on wood or on fibrocement, in particular *Reclining Nude on a Blue Bed*, which he drew twice (figs. 182–184). It is not easy to understand what could have particularly arrested Matisse in this work. He certainly could relate to its theme and thus appreciate the lasting effect of his early *Blue Nude* ("Souvenir of Biskra") on the art of his friend (all of Picasso's reclining nudes are, in some way, comments upon Matisse's). This is perhaps why he also chose to sketch *Reclining Nude on a White Bed* (fig. 185, 186).

Françoise Gilot tells us that shortly afterward Matisse showed these sketches to her and Picasso (in order to testify to the seriousness of his study?), and she notes that what seemed to have interested Matisse most was the "way in which some curvilinear torsions led the eye to visualize together those planes that simultaneously showed a front and a back view of the same figure."[340] But I tend to think that it was rather the metaphoricity of Picasso's art that Matisse verified once more (the woman as *faux col*), seduced here by the comic side of it (Grock was an immensely famous French clown). This is confirmed in his sketches after *Reclining Nude on a Blue Bed*, where he accentuates the similarity of the curves defining the breast and the buttocks. The sketches made after the other panels also lead to the same conclusion. Matisse ignores the more numerous Matissean Picassos in the Palais Grimaldi (figs. 180, 181), concentrating instead on the most cubist ones, *Still Life with Bottle, Sole and Ewer* (figs. 187, 188) and *Still Life with Fruit Dish, Guitar, Plate, and Apples* (figs. 189–191). This last work in particular drew his attention, because of its extreme emphasis on the migratory nature of sign: the plate on which the two apples stand has the same eye/fish shape as the foot of the fruit dish (inside the blue triangle) and the brown shadow of the guitar's neck; the white rectangle of the fruit dish is an enlargement of the ornament around the guitar's central hole; the blue triangle rhymes with the white body of the guitar or the smaller area with its keys; circles (apple, keys, acoustic hole) and gourdlike shapes pop up here and there. Each element is duplicated elsewhere on the panel but kept in place by the spatial markers differentiating table and wall.[341]

PABLO PICASSO
176 *Woman with Blue Hands*, February 18, 1947
36 1/4 x 28 5/8 in. (92 x 72.7 cm)
Private collection. Courtesy Nancy Whyte Fine Arts

PABLO PICASSO

177 *Centaurs and Woman Grilling Fish,*
November 6, 1946
Pencil on paper
20 1/8 x 26 in. (51 x 66 cm)
Musée Picasso, Paris

PABLO PICASSO

178 *Centaur Abducting a Woman,*
November 5, 1946
Pencil on paper
20 1/8 x 25 7/8 in. (51 x 65.7 cm)
Musée Picasso, Paris

PABLO PICASSO

179 *Centaur, Woman, and Bird,*
November 6, 1946
Pencil on paper
20 1/8 x 26 in. (51 x 66 cm)
Musée Picasso, Paris

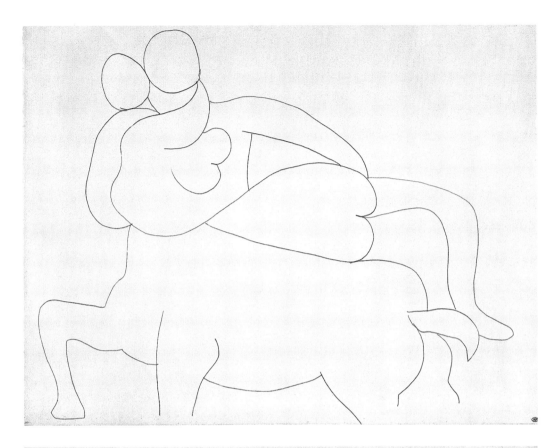

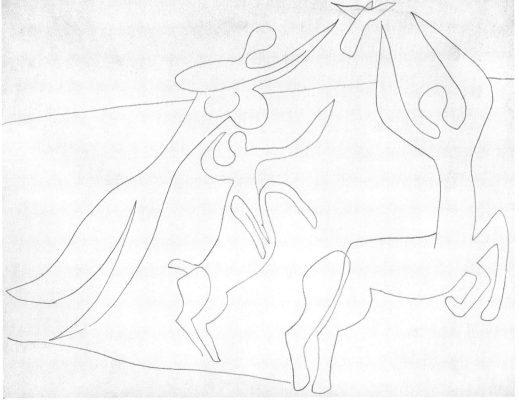

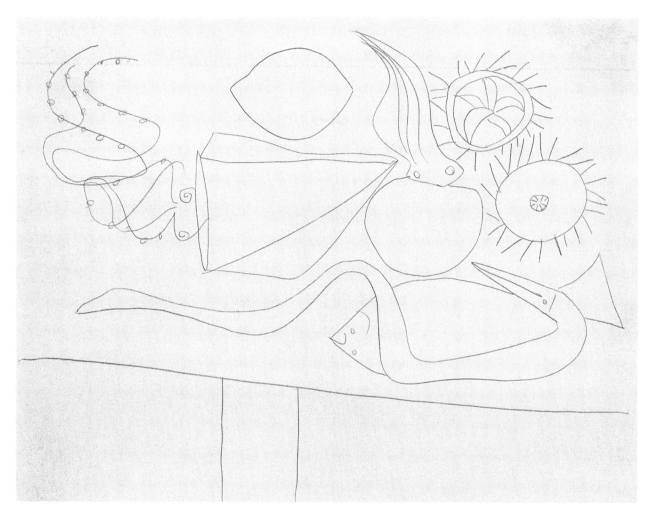

PABLO PICASSO

180 *Still Life with Two Sea Urchins, Muraena,*
Sole, Octopus, Cuttlefish, and Lemon,
October 22, 1946
Pencil on paper
19 ⁵/₈ x 25 ⁵/₈ in. (50 x 65 cm)
Musée Picasso, Antibes

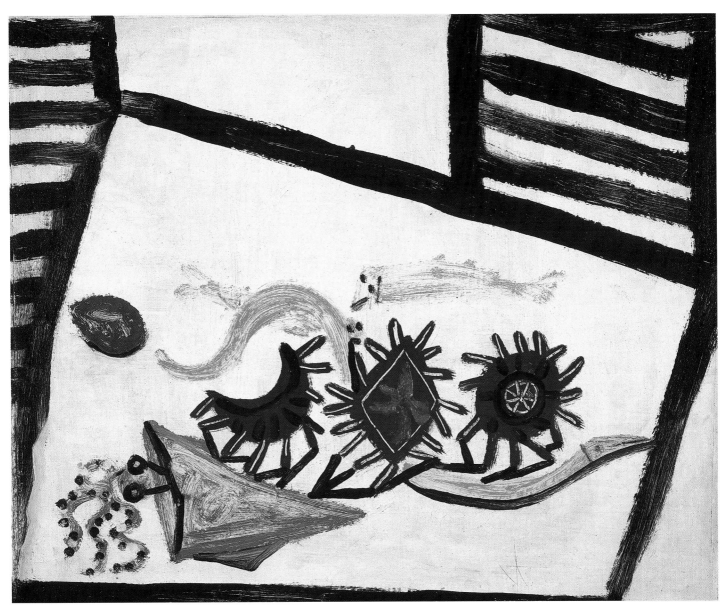

PABLO PICASSO
181 *Still Life with Venitian Blinds*, October 1946
Oil on canvas
23 ⁷/₈ x 28 ⁷/₈ in. (60.5 x 73.5 cm)
Musée Picasso, Antibes

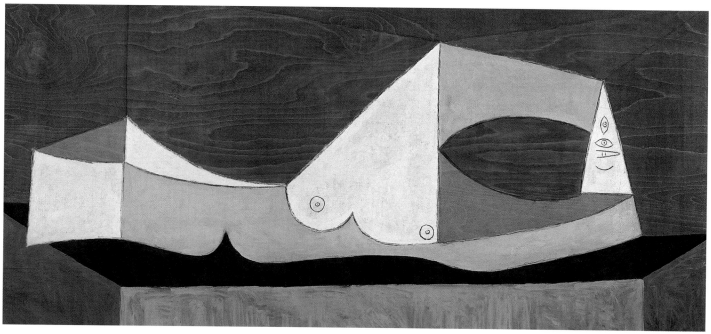

PABLO PICASSO

182 *Reclining Nude on Blue Bed*,
November 13, 1946
Oil and charcoal on plywood
39 3/8 x 82 5/8 in. (100 x 210 cm)
Musée Picasso, Antibes

HENRI MATISSE

183 and **184** Sketches after Picasso's
Reclining Nude on Blue Bed, 1948
Sketchbook
Pencil on paper
9 x 11 3/4 in. (23 x 30 cm)
Private collection

PABLO PICASSO
185 *Reclining Nude on White Bed*, November 1946
Oil on fibrocement
47 1/4 x 98 3/8 in.
(120 x 250 cm)
Musée Picasso, Antibes

HENRI MATISSE
186 Sketch after Picasso's *Reclining Nude on White Bed*, 1948
Sketchbook
Pencil on paper
9 x 11 3/4 in.
(23 x 30 cm)
Private collection

PABLO PICASSO
187 *Still Life with Bottle,*
Sole, and Ewer,
September 1946
Oil and Conté
on fibrocement
47 ¹/4 x 98 ³/8 in.
(120 x 250 cm)
Musée Picasso,
Antibes

HENRI MATISSE
188 Sketch after
Picasso's
Still Life with Bottle,
Sole, and Ewer, 1948
Sketchbook
Pencil on paper
9 x 11 ³/4 in.
(23 x 30 cm)
Private collection

HENRI MATISSE
189 and **190** Sketches after Picasso's
*Still Life with Fruit
Dish, Guitar,
Plate, and Apples*, 1948
Sketchbook
Pencil on paper
9 x 11 3/4 in.
(23 x 30 cm)
Private collection

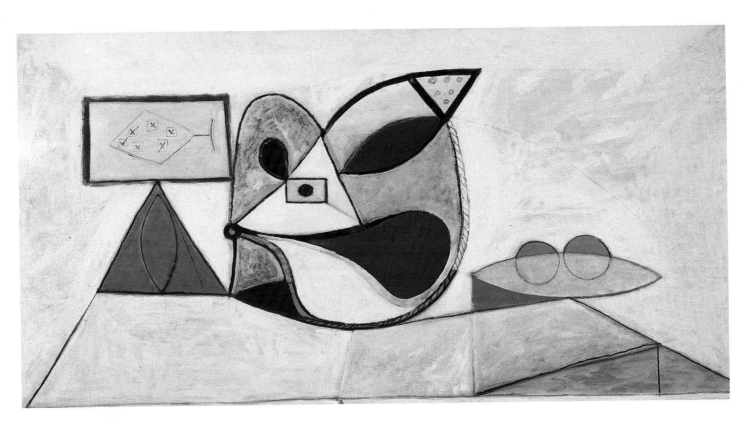

PABLO PICASSO
191 *Still Life with Fruit Dish, Guitar, Plate, and Apples,* 1946
Oil and charcoal on plywood
37 3/8 x 68 7/8 in. (95 x 175 cm)
Musée Picasso, Antibes

In his sketchbook, therefore, Matisse conscientiously notes the features of Picasso's art that are most foreign to his own work. The gesture seems puzzling at first: Matisse, nearing eighty, was not an apprentice trying to learn from established masters.

■ To Paint with Bricks: Round Two

A few months earlier, Matisse had written to his friend André Rouveyre that, to obtain a painting in relation to his drawings, "those that come directly from my heart, traced with utmost simplicity" and "free from the accidental," he was compelled to "represent the objects without any vanishing lines. I mean seen frontally, almost one next to the other, linked through my feeling, in an atmosphere engendered by the magic of color relations. Why not be logical and employ only local tones, without any reflections. Characters all on the same plane as in a shooting gallery [*jeu de massacre*]. . . ."[342] Matisse is here describing the pictorial language he had developed in *Still Life with a Magnolia* (fig. 134) at the beginning of the war, but which he had since then left more or less unexplored. During the winter of 1947–48, he at last felt confident enough to return to it—calling it a "very arduous path" in his letter to Rouveyre. And it again prompted him to revisit Picasso's mode of address to the beholder.

At first, he "dilutes" the language into a serial effect, testing various color relations on a single motif, and still admitting into the composition several spatial markers, such as the receding obliques of the table (though less and less conspicuously). The eight 1947 canvases representing two young girls reading in an interior, each with a different color combination, were all reproduced in a special issue of *Verve* (vol. IV, nos. 21–22) along with other canvases of 1946–48. The sheer juxtaposition of these images emphasized the range of color transpositions available to Matisse (no doubt he wanted to insist, pedagogically, on this point; one thinks of Albers' numerous *Homage to the Square* paintings). The "shooting gallery" aspect was a bit lost in the demonstration, but all the subsequent works of this season attest to the "very arduous path" Matisse was taking. This is the period of some of his greatest works, known as the Vence interiors, notably the *Red Interior: Still Life on a Blue Table* (fig. 193) and *Interior with Egyptian Curtain* (fig. 164), for me, Matisse's masterpiece from the second part of his career, under consideration here.

In these works, Matisse finally finds a way of applying to painting the method of drawing he had mastered in *Thèmes et variations* (p. 149 above). He first treated the canvas as if it were a "theme" drawing, worrying the surface with pentimenti. Then, when he felt that his motif was fixed, he asked his assistant to erase all traces of paint. He could now regard the canvas as he did the

HENRI MATISSE
192 *Portrait of Lydia Delectorskaya*, 1947
Oil on canvas
25 3/8 x 19 5/8 in. (64.3 x 49.7 cm)
State Hermitage Museum,
St. Petersburg

virgin sheet of paper of a "variation" drawing. At first this method was not always successful: to be certain that he had reached a complete automatism of gesture, he sometimes had to repeat the erasure process until he could become the acrobat he wanted to be. The spontaneous look of these canvases is thus the result of an elaborate, slow method. The whiteness of the blank, which shows through more often than usual, is deceiving (asked how the unsoiled white areas could match the account just given of Matisse's working process, Lydia Delectorskaya remarked that she was a "pretty good eraser").[343]

Parallel to these *jeu de massacre* paintings, whose luminosity would bedazzle Picasso, and before his day trips to Antibes, Matisse had painted a "late cubist" portrait of Lydia Delectorskaya (fig. 192), and a picture of "a pineapple with its wrapping paper," as he summarily described it to his son (fig. 196).[344] Far from sharing with the other Vence interiors an apparent effortlessness—

HENRI MATISSE
193 *Red Interior: Still Life on a Blue Table*, 1948
Oil on canvas. 45 5/8 x 35 in. (116 x 81 cm)
Kunstsammlung Nordrhein-Westfalen, Düsseldorf

full of pentimenti, it is more a "theme" than a "variation"—this canvas combines elements of the cubist syntax (dissociation of color and contour; overlapping of planes and its attendant effect of transparency; ambiguous sculptural corporeality of the wrapping paper unfolding around the fruit).

Large Red Interior (fig. 197), the last of the Vence interiors and the last major canvas Matisse ever painted, both acknowledges and ends this cubist excursion, flooding the pineapple picture with a sea of red. It epitomizes the achievement of a lifetime of painting, touching base with the great expanse of the 1911 *Red Studio*. It proposes a space even more engulfing than that in the early work, a gravity-free immersion into color, where even a cubist-derived picture of a pineapple and its wrapping would not seem out of place.

■ All-Over or Not

Matisse was perfectly aware of having reached a new level of accomplishment in his Vence interiors. In June–September 1949, he showed all of them in an exhibition of his recent works at the Musée National d'Art Moderne in Paris.[345] That Picasso knew most of these works, admired them and predicted that they would be critically acclaimed, is certain. As soon as he heard about the plans for Matisse's exhibition, he launched a counter-attack, which amused Matisse: "I have read in the newspaper," he wrote to Father Couturier, coordinator of the Vence chapel project, "that Picasso is preparing an exhibition of large canvases at the Pensée Française. Is it a summer show, like that of the Musée [d'Art] Moderne? In the ring we'll thus be inseparable, in Paris as well as on the Riviera. I'm awaiting his offensive about which I've heard from different quarters. Some people fear for me. . . . I'll keep you posted about the match."[346] Picasso's show at the Maison de la Pensée Française, a private cultural center controlled by the Communist Party, was one of his most astonishing moves in the ongoing match: among the sixty-four canvases exhibited, the most salient hailed Matisse's idiom.[347] The largest were the two versions of *The Kitchen*, dating from November 1948. The first black-and-white version in particular (fig. 194) would hardly be conceivable without Matisse's recent large ("decorative," all-over) cutouts, such as *Oceania, the Sky* (fig. 195). *The Kitchen* certainly refers to Miró as well, to Picasso's own tiny "lines and dots" sketches of 1924, which were reproduced as illustrations for Balzac's *Chef d'œuvre inconnu*, and to his later illustrations for Reverdy's *Chant des Morts*, a book that Matisse greatly appreciated.[348] But the sheer breadth of *The Kitchen* is Matisse's.

However, Picasso could not prevent himself from fastening the web of his composition onto the frame, making it a cage

imprisoning our gaze rather than a swelling surface. In other words, he swerves from Matisse's "decorative" democratization of the picture plane. The second version of *The Kitchen* is a case in point: the background, no longer white but of various shades of gray, is hierarchically organized into zones of different value and, more important, several areas delimited by the linear network are now filled with secondary figures such as little birds. The scale immediately dwindles, forbidding us to take in the canvas as a whole and asking us instead to munch its surface bit by bit.

A similar effect is obtained in *Claude in His Crib* (fig. 200), whose Provençal floor tiles and wrought-iron arabesques are direct quotes from Matisse's Vence interiors. But the baby's face, confronting us head on, captures our attention, annulling the overall distribution of the decorative patterns. Picasso is perfectly aware of the fact that he is resisting Matisse. Around that time he said to Françoise Gilot:

> As long as you paint just a head, it's all right . . .but when you paint the whole human figure, it's often the head that spoils everything. If you don't put in any details, it remains just an egg, not a head. You've got a mannequin and not a human figure. And if you put too much detail onto the head, that spoils the light. . . . Instead of light you've got shadows, which makes holes in your composition, and the eye can't circulate freely where it wants to.[349]

The idea that a composition should not have any hole, and that our gaze should freely circulate, comes straight from Matisse and could even be called antithetical to Picasso's art. But rather than read this statement as self-criticism, I would read it as a judicious explanation of Matisse's system: Picasso immediately understands why the figures of his friend's canvases are often faceless (more and more so in later years)—a void he himself would only rarely allow.

Also at the Maison de la Pensée Française exhibition was a series of pictures done in mid-March 1949 that demonstrates the continued importance of both heterogeneity and centeredness in Picasso's art. He has some trouble with the proportion of the head in a canvas depicting a seated woman (Gilot), and puts it aside when Fernand Mourlot, who was printing all his lithographs, brought a proof for his inspection—a face (also Gilot's):

> That morning he took the lithograph . . . and pinned it, just as it was, onto the canvas, the top edge of the lithograph corresponding exactly to the top edge of the canvas. It was really an "impossible" thing to do because it threw the picture plane completely out of focus. . . . The painting was very colorful and the lithograph was black-and-white. It made, therefore,

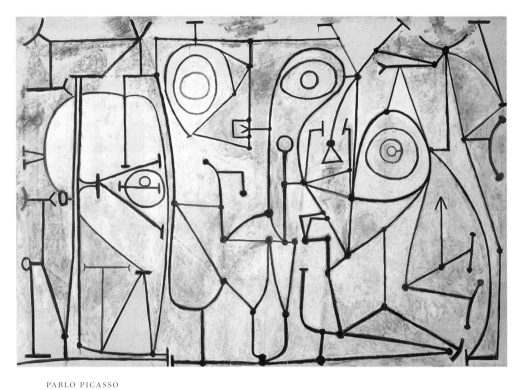

PABLO PICASSO

194 *The Kitchen*, November 9, 1948
Oil on canvas. 69 x 98 1/2 in. (175.3 x 250 cm)
The Museum of Modern Art, New York;
Acquired through the Nelson A. Rockefeller Bequest

HENRI MATISSE

195 *Oceania, The Sky*, 1946
Gouache on paper, cut and pasted on paper mounted on canvas
Maquette for silkscreen. 70 1/4 x 145 1/2 in. (178.3 x 369.7 cm)
Musée Matisse, Le Cateau-Cambrésis

HENRI MATISSE
196 *The Pineapple,* 1948
Oil on canvas. 45 3/4 x 35 in. (116 x 89 cm)
The Metropolitan Museum of Art, New York;
The Alex Hillman Family Foundation Collection

HENRI MATISSE
197 *Large Red Interior*, 1948
Oil on canvas
57 1/2 x 38 1/4 in. (146 x 97 cm)
Musée National d'Art Moderne, Paris

PABLO PICASSO
199 Illustration for Prosper Mérimée's
(above) *Carmen*, 1949
Etching
12 ³/₄ x 10 in. (32.5 x 25.5 cm)
Musée Picasso, Paris

HENRI MATISSE
198 *Nadia Smiling*, 1948
(left) Aquatint
13 ⁹/₁₆ x 10 ¹⁵/₁₆ in. (34.5 x 27.8 cm)
Private collection

PABLO PICASSO
200 *Claude in His Crib*, December 25, 1948
Oil on canvas. 51 1/8 x 38 1/4 in. (130 x 97 cm)
Private collection

such a tremendous contrast in color as well as in form and plane, that it delighted him. He removed the lithograph and immediately painted in, in the spot where he had pinned it up, the same composition . . . that was represented in the lithograph. He considered it such an exciting discovery that he made four or five other paintings embodying the same principle, but not based on any existing lithograph.[350]

Nothing could have been less receivable to Matisse than such a graft, nothing could be more averse to his notion of the "decorative," which considers the whole as an indivisible unity—be it the surface of the canvas, or a book, or an entire building. But there is more to the story of these "grafted" pictures: not only do the vivid color and patterning of this series recall Matisse's work, but the "lithograph" that Picasso painted on the first of these canvases (Z. XV, 129) is itself a manifest quotation of Matisse's numerous aquatints of 1948 (fig. 198). Picasso had undoubtedly admired them, for in his illustrations for *Carmen* (fig. 199), he already paid tribute to the way in which Matisse matches the proportions and scale of the sheet of paper to that of the depicted face.[351] Now he was reverting to his cannibalistic mood, utilizing Matisse's fusion of a face and a page as just an element of collage—the very opposite of fusion.

■ Temple versus Chapel

Matisse did not see the exhibition at the Maison de la Pensée Française (he did not even go see his own at the Musée National d'Art Moderne), but he kept abreast of what Picasso was doing. He showed great interest in Picasso's ceramics, for example, amazed by the sheer quantity of the production. As one would expect, Matisse preferred the pots whose form was wholly invented—the "sculpted" ones—but he disapproved of the dishes whose surface served as a neutral ground for drawing, as if there was no difference between a plate and a canvas (in his conception of the "decorative," the very possibility of a neutral ground is cancelled at the outset).

At the time of the Maison de la Pensée Française exhibition, Matisse was seeing Picasso's ceramics more often than their maker, for he had to make many trips to the Vallauris pottery workshop which, thanks to Picasso, was producing the tiles of the ceramic murals in the Vence chapel.[352] Picasso, as is well known, was scandalized that Matisse would undertake a religious project, which he saw as utterly compromising—"he's whoring," he even said to Lydia Delectorskaya.[353] Matisse retaliated, of course, condemning any propaganda art as "documentary," "anecdotal," in short, as "no longer art."[354] But when reminded of his mercenary work for the Communist Party, Picasso endlessly argued that it

had nothing in common with Matisse's chapel, for he, at least, fully adhered to the Party's ideology.

Picasso nevertheless took an interest in Matisse's Vence chapel, often coming to check on its progress. He continued to disdain its religious program, but was impressed by Matisse's courage in undertaking the demanding task at such an advanced age. When the first batch of ceramic tiles cracked while being fired, Picasso immediately rushed to Nice in order to comfort his bedridden friend.[355] And when the Maison de la Pensée Française asked him to persuade Matisse to hold an exhibition there, Picasso accepted Matisse's proposal to show in this Communist den, among other works, a vast ensemble of drawings and paper cutouts devoted to the chapel.[356]

Conversely, even though Matisse always gently scolded Picasso for his propagandistic work, he kept agreeing to his requests to sign petitions launched by the Communist Party.[357] Perhaps he disapproved of Picasso's saccharine peace doves, multiplied for the benefit of the Comintern-orchestrated World Peace Movement, but he was also perhaps amused that this torrential flow of images was initiated by his own gift of three pigeons to Picasso (and by Aragon's ignorance of the anatomical difference between pigeons and doves).[358] Matisse probably also would have liked Picasso's transformation of the dove into the various letters of the word "Europe" on the (unrealized) project for a cover of the Communist journal *Europe*—so similar to his own floral design for the cover of the special issue of *Verve* on his postwar painting (figs. 201, 202).[359]

That the chapel was in part a response to Picasso's work at Antibes was noted in the press at the time, but not the extent to which Matisse thought about Picasso when he conceived his *Stations of the Cross* (fig. 203). On April 29, 1949, while he was experiencing enormous problems with its composition, he took a cab to the Palais Grimaldi. Was it upon his return that he drew his particularly dramatic charcoal studies for the Ninth Station (*Christ Falling for the Third Time*, fig. 206), and the Fourteenth Station (*Entombment*, figs. 204, 205)? Picasso's cubist angularity helps Matisse find an expressive solution that would counterbalance the two panels of the *Virgin* and *Saint Dominic* on the adjacent wall. Indeed, the definitive composition of *The Stations of the Cross*, finished in February 1950, stands in sharp contrast to the "decorative" concept Matisse celebrates everywhere else in the building. (*The Stations*, incidentally, is the work Picasso preferred, together with the chasubles.)[360] Certainly Matisse did not entirely relinquish his all-over, centrifugal principle. For canonical reasons, Matisse adheres to the linear order of the biblical narrative, but he keeps this obligation to a minimum: the "boustrophedonic"

PABLO PICASSO
201 Proposed cover illustration
for *Europe*,
November 18, 1949
Pencil on paper
20 1/8 x 26 in. (51 x 66 cm)
Musée Picasso, Paris

HENRI MATISSE
202 Cover for *Verve* (6, nos. 21–22), 1948
14 x 10 3/8 in. (35.5 x 26.5 cm)

HENRI MATISSE
203 *The Stations of the Cross*, 1950
Ceramic tiles
The Chapelle du Rosaire, Vence

disposition of his panel, starting from the lower left corner, would be impossible to read without the help of the number affixed to each scene. As he himself noted, the various stations "intermingle," the whole composition spreading from the center.[361] But never before had Matisse sought and achieved such pathos in his art. The abrupt, enormous changes of scale from one scene to the next, the schematism of the figures, often no more than mere ciphers, the roughness of the execution—"very rough, it will prompt most people who see it to despair," he noted—[362] all this forces us to focus—forces our gaze to stop at each station.

This rare search for the pathetic explains why, in April 1949, Matisse takes a renewed interest in Picasso's *Portrait of Dora Maar* (fig. 121), hanging it next to his bed. Asked what moved him in this picture, he answers: "The anguish of this figure, the terrible expression of this face." Abiding by the cliché, "he would repeat that each of the two, Picasso and himself, are at a pole."[363] Angst being Picasso's domain, he is the one to consult: "What Picasso does, he does it with his blood," says Matisse.[364] And, no doubt, this work on *The Stations of the Cross* allows him to appreciate Picasso's gloomy *Winter Landscape* (fig. 207), so diametrically opposed to his own art, prompting him to hang this painting, on loan from Picasso, among his projects for the chasubles of the Vence chapel (fig. 208).[365]

Even before the Vence chapel was inaugurated (June 25, 1951), Picasso announces his desire to realize a "Temple of Peace" in Vallauris (this name, however, as Dominique Forest remarks, is most probably apocryphal).[366] On August 6, 1950, his sculpture *Man with a Sheep*, which he gave to the Communist municipality of Vallauris, was unveiled with great fanfare by Party officials: it is at this point that the city puts at Picasso's disposal a deconsecrated twelfth-century chapel.[367] There are strings attached to the offer: as made explicit in the wooden speeches of the unveiling ceremony for *Man with a Sheep*, Picasso was to paint a work that would please "the workers" (that is, the Stalinist oligarchy of the Party)—something, perhaps, like André Fougeron's social realist *Parisian Women at the Market*, as opposed to Picasso's recent *Massacre in Korea*, deemed politically wrong.[368]

Picasso's first idea was to use Matisse's own medium, ceramic tiles, to realize his two murals, one for peace and one for war (he apparently even thought about a stained-glass window at some point, though one is hard put to determine where it would have been placed).[369] Finding the tiles impractical because of the curved surface of the vault, Picasso settled for fresco, finally answering Matisse's call, after a five-year delay, and this proved

impossible also (the walls were too humid). Even fibrocement, the material of many panels in the Palais Grimaldi, was unusable—not sufficiently flexible. Almost two years later, Picasso opted for masonite boards (figs. 209, 210).

Between April and September 1952, Picasso filled three sketchbooks with about three hundred drawings. He began to paint in August, and he was unusually anxious about the work, admitting absolutely no one into his studio, "not even Françoise," wrote Cocteau to Matisse. In the same letter, dated September 19, 1952, Cocteau reports that Picasso told him: "If I were in Nice, I would go and see [Matisse] every morning. I do not go to Nice on account of these 100 square meters of fresco. Explain to him why I have not seen him for a year." Cocteau urges Matisse to contact Picasso: "As I told him that you'd certainly like to see him, he asked: 'Are you so sure he'd like to see me?'"[370]

The sheer size of the two murals (each ten meters long and 4.7 meters high, larger than *Guernica*) would be enough to explain why Picasso had Matisse constantly in mind, as the many iconographic elements that he borrows from him make clear (for example the flutist of the *Peace* panel, straight out of the 1910 *Music*): Picasso was as intimidated by the vastness of the area he had to cover as Matisse had been when working on *The Dance* in 1933. The result of Picasso's efforts answer Matisse's chapel almost point by point. The first striking differences are in the light and the proportions, but these come with the architectural territory: unlike the brightness inundating the building in Vence, with its aerial high ceiling, Picasso's "temple" is dark and claustral, the two panels abutting at the apex of the low vault. Picasso had even imagined leaving the space without any illumination, forcing "the visitors [to] wander along the walls with a candle in hand, as in a prehistoric cave, uncovering the figures one by one."[371]

This fantasy, building on the architectural given, reveals a more fundamental discrepancy between Matisse's conception of mural painting and Picasso's. As noted above, even in *The Stations of the Cross*, Matisse could not prevent himself from de-narrativizing. The idea of a linear, piecemeal apprehension of a painting was just anathema to him. Picasso, for his part, explained his opposition to Matisse's all-overness when speaking about his Vallauris project: "In modern painting, every touch has become a precision operation, part of a job as meticulous as the watchmaker's. You paint a figure's beard, it happens to be red, and this red makes you change everything in the picture to suit it, to repaint all the surroundings as though in a chain reaction. I wanted to avoid that, to paint as one writes, as quick as thought, with the rhythm of the imagination itself."[372]

HENRI MATISSE
204 and **205** Studies for
Entombment
(Fourteenth Station
of the Cross), 1949
Charcoal on paper
19 x 24 ⁵/₈ in.
(48.2 x 62.6 cm)
Musée Matisse, Nice

216

HENRI MATISSE
206 *Christ Falling for the Third Time*, 1949
Study for the Ninth Station of the Cross
Charcoal on paper
18 1/8 x 24 3/4 in. (48 x 63.3 cm)
Musée Matisse, Nice

PABLO PICASSO
207 *Winter Landscape*, December 22, 1950
Oil on wood panel
40 1/2 x 49 1/2 in. (102.9 x 125.7 cm)
Collection of Kate Ganz

HÉLÈNE ADANT

208 Matisse's bedroom at Hotel Régina, Nice, c. 1952
On the wall: maquettes of chasubles for the Vence chapel
On the mantel: Picasso's *Winter Landscape* (1950), on loan to Matisse

PABLO PICASSO

209 *War*, 1952
210 *Peace*, 1952
 Oil on fiberboard
 Each: 188 ¹/₈ x 398 ¹/₄ in.
 (477.8 x 1011.6 cm)
 Vallauris

■ Final Volley

Matisse did not see *War* and *Peace*. As soon as the panels were finished they were sent to Rome, then to Milan, for a traveling Picasso retrospective. They were badly received in Italy, and upon their return to France Picasso was in no rush to have them installed; even after the February 1954 installation, the "temple" remained closed for more than five years. Thus Matisse never had the chance to appraise them. Picasso kept visiting him in Nice, however, so he must have seen Matisse's last tribute to their life-long dialogue, a series of cutouts on the theme of *Blue Nude* (fig. 213), done in 1952. Here Matisse not only returns to a pose he had used in one of his most celebrated pictures, *Decorative Figure on an Ornamental Ground* of 1925–26 (fig. 211), but also to Picasso's 1930 caricatural transformation of this figure into a surrealist specimen of the devouring praying mantis (fig. 212). Matisse filled a whole sketchbook in an attempt to devise new solutions for the articulation of limbs, solutions that would incorporate but also "correct" (in Harold Bloom's sense) Picasso's disjunctions. We can see Matisse toying with the idea of offering simultaneously several contradictory positions for the buttocks (figs. 214, 215), of severing a foot (fig. 216), of making the contour of an arm also function as that of the back (fig. 217). The resulting four cutouts are more architectonic than anything Matisse ever did in this medium. But though the pose of these seated caryatids and their placement on the page should have bridled the figures, the sheer circulatory arabesque of their torsion nullifies any sense of restraint. They feel less boxed-in by the frame than Picasso's elastic acrobats of 1929–30.

On July 9, 1953, it was Picasso's turn to pick up the pose, and to reclaim as his the simultaneity of aspects that Matisse had momentarily explored (fig. 218). Or maybe he was just acknowledging the exchange, as he had done four months earlier with *The Chinese Chest of Drawers* (fig. 219). This canvas represents Picasso's first attempt to deal with the spatial flotation of the Vence interiors; but he did not yet turn to the last works in this series, choosing instead the 1946 *Interior in Yellow and Blue* as a reference (fig. 220)—that is, a picture in which Matisse ostensively alludes to his own syntax. Though the handling differs enormously in the two works (Picasso's is on laminated wood, so no whiteness could show through the paint layer), their structure is remarkably similar.

On December 16, 1953, Picasso drew the first of 180 drawings, collectively known as *The Human Comedy*, in which a painter is depicted in his studio with his nude model, often in the company of a third figure (another painter, a collector-client, a dealer).[373] The painter is almost always grotesque, and often bearded, represented in utmost proximity to the model, an arrangement that parallels Matisse's way of working. The allusion has not escaped scholars.[374] In one of the first of these drawings (Z. XVI, 56), Picasso reuses the type of a comic little dwarf that had appeared in his oeuvre in 1936 (Z. VIII, 277), at a time when Matisse was engaged in his spectacular series of *mise-en-abîme* drawings of the painter and his model.[375] What prompted the sarcastic return of these caricatures?

The answer is perhaps the sad expectation of death, for Picasso seems to have been obsessed with Matisse in December 1953. On December 6, he draws a dance straight from the 1906 *Joy of Life*, even reinstalling the sixth dancer eliminated by Matisse in his 1909 and 1910 versions (Z. XVI, 32). On the 27th, he spreads Christmas tree decorations all over his canvas (fig. 221). On the 29th and 30th, in two versions of *The Shadow*, alluding to what he saw as the "desertion" of Françoise Gilot—who brought the children, but did not stay for the holiday—Picasso cast his shadow as a cutout silhouette in the door of his bedroom (Z. XVI, 99, 100). Also on the 30th, he painted an odalisque in the studio, the first in years, overspilling from a couch hovering above a patterned carpet (Z. XVI, 96).[376] The manic doodles of *The Human Comedy* help to deflate the anxiety and melancholy of a moment that can only be read, retrospectively, as a spell of anticipated mourning. Picasso alludes to Matisse once more in May of 1954: the painterly device he used in *Claude Drawing, Françoise and Paloma* (fig. 222) is identical to that in *Games and Rescue on the Beach* (fig. 74), and the areas of reserved canvas, the scraping of the paint layer, the thin brushwork, all add supplementary Matissean touches to the work, but the chromatic scale is now somber, and the towering, overprotective mother ominous.

PABLO PICASSO

212 *Seated Bather*, early 1930
(above) Oil on canvas
64 ¹/₄ x 51 in. (163.2 x 129.5 cm)
The Museum of Modern Art, New York;
Mrs. Simon Guggenheim Fund

HENRI MATISSE

211 *Decorative Figure on an Ornamental*
(left) *Ground*, winter 1925–26
Oil on canvas
51 ¹/₈ x 38 ⁵/₈ in. (130 x 98 cm)
Musée National d'Art Moderne, Paris

HENRI MATISSE
213 *Blue Nude II*, 1952
Gouache on paper, cut and pasted, on paper
45 3/4 x 32 1/4 in. (116.2 x 81.9 cm)
Musée National d'Art Moderne, Paris

HENRI MATISSE

214–217 Sketches for *Blue Nude* series
Sketchbook. Crayon on paper. 8 1/4 x 10 5/8 in. (21 x 27 cm)
Whereabouts unknown

PABLO PICASSO

218 *Seated Woman*, July 9, 1953
Oil on canvas. 51 1/4 x 37 3/4 in. (130.2 x 95.9 cm)
The Saint Louis Art Museum; Gift of Mr. and Mrs. Joseph Pulitzer, Jr.

PABLO PICASSO
219 *The Chinese Chest of Drawers*, March 22, 1953
Oil on plywood. 58 x 45 in. (147.3 x 114.3 cm)
Virginia Museum of Fine Arts, Richmond, Virginia;
Collection of Mr. and Mrs. Paul Mellon

HENRI MATISSE
220 *Interior in Yellow and Blue,* 1946
Oil on canvas
45 ⁵/₈ x 35 ³/₄ in. (116 x 81 cm)
Musée National d'Art Moderne, Paris

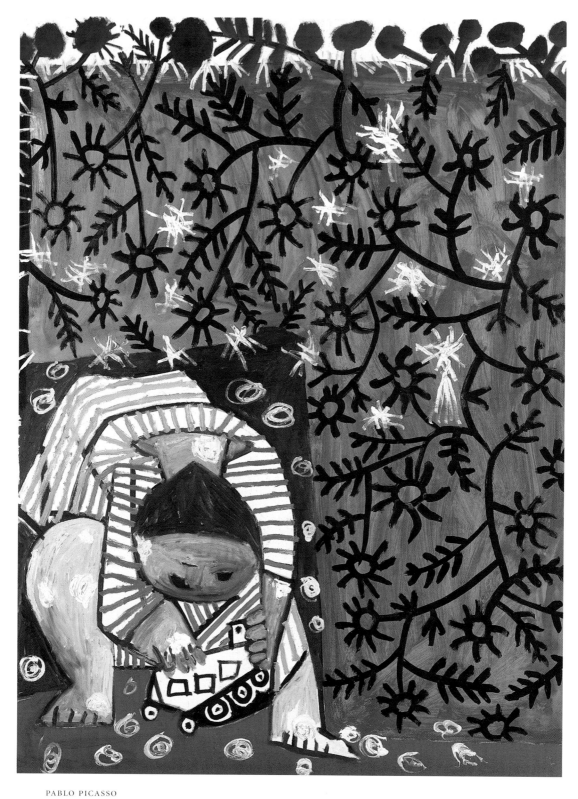

PABLO PICASSO

221 *Child Playing with a Toy Truck,* December 27, 1953
Oil on canvas. 51 1/4 x 38 1/4 in. (130 x 96.5 cm)
Musée Picasso, Paris

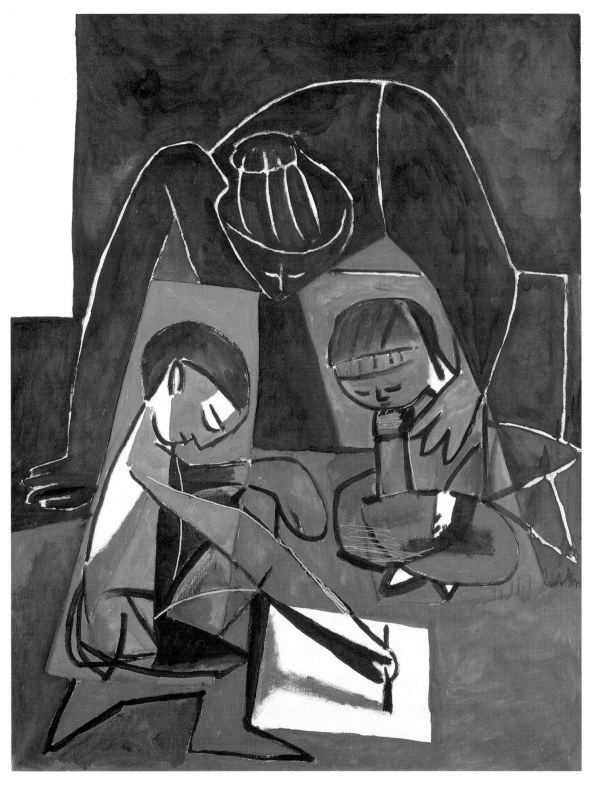

PABLO PICASSO
222 *Claude Drawing, Françoise and Paloma*, May 17, 1954
Oil on canvas. 45 $^3/_8$ x 35 in. (116 x 89 cm)
Musée Picasso, Paris

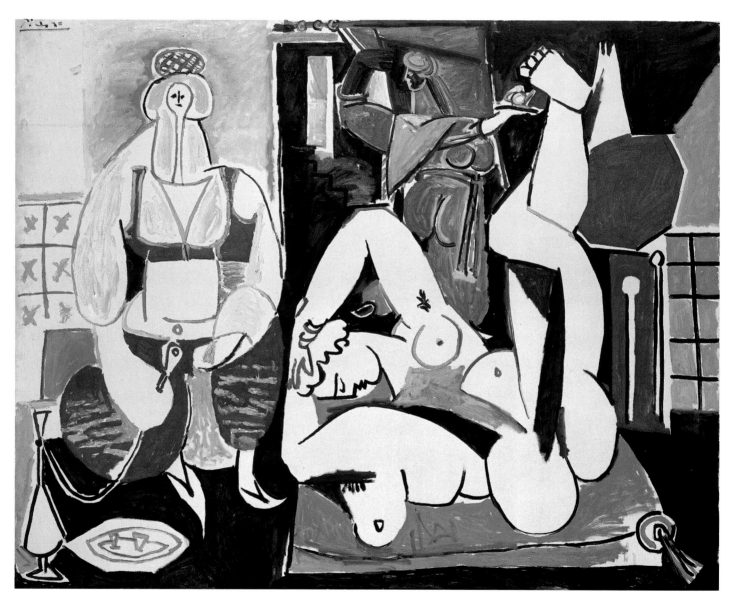

PABLO PICASSO

223 *Women of Algiers* version H,
January 24, 1955
Oil on canvas
51 ¹/₄ x 63 ⁷/₈ in. (130.2 x 162.3 cm)
Private collection

PICASSO IN MOURNING

―――

Matisse died on November 3, 1954. Picasso did not go to the funeral. He did not even come to the phone when Marguerite Duthuit repeatedly called, letting someone else answer instead.[377] What at first seems like indifference was actually terror in the face of the abysmal void. For half a century, his debate with Matisse had been a structuring force. But now, "Who [was] there to talk to?"[378]

It took Picasso only six weeks to react, for the first version of the *Women of Algiers* dates from December 13, 1954. "When Matisse died he left me his odalisques as his legacy," he told Roland Penrose.[379] Already in 1940 he had directly associated Delacroix, whom he most admired, with his rival (p. 129 above). Françoise Gilot reports: "He had often spoken to me of making his own version of *Women of Algiers* and had taken me to the Louvre on an average of once a month to study it. I asked him how he felt about Delacroix. His eyes narrowed and he said: 'That bastard. He's really good.'"[380] Now, in late 1954, was the moment to act, to kill two birds with one stone: to address one "bastard" with the help of an earlier one, to populate the world with imaginary interlocutors in order to alleviate the sadness of this new, inescapable, and definitive, solitude.

About this brilliant set of fifteen canvases, done in two months (the last one is dated February 14, 1955), there is not much to add to the monumental study published by Leo Steinberg in 1972.[381] Let us only note that version H (fig. 223), the eighth canvas, dated January 24, 1955, is the most Matissean picture of the series, with its bright colors, loose texture, and large unpainted areas. Situated at the exact midpoint of the work, it is, as Steinberg points out, "the moment of crisis." The two aspects of the sleeper that Picasso wanted to convey do not merge:

> Upper and lower breasts, the supine view and the prone, are separated by no-man's land, where the color is murky and a black wedge concedes the impossibility of the task. The parts sunder like a trunk split down the middle. Separated by 180 degrees, the contrasting aspects refuse to incorporate.[382]

It is not by chance that the "crisis" should have erupted when Picasso went deeper into Matisse's territory, just as it is not by chance that Picasso could solve his problem only after resorting to one of Matisse's tricks, one that he had often dismissed for his own use: the elision of the facial features. The problem was, as Steinberg puts it, to have the sleeping figure "seen both front and back . . . without physical dismemberment, without separation of facets [unlike cubism], but as a compact close-contoured body which denies itself neither as an object of vision nor as self-centered presence."[383]

The solution, identified by Steinberg, is found in the antepenultimate canvas of the series, the monochromatic version M (fig. 224): the straight, almost horizontal base of the figure becomes a rotating edge, at one extremity defining her lower back, at the other her chest. Having solved the problem, Picasso now reintroduces color, at first timidly in version N (fig. 226), and then, in the final canvas, with a vengeance (fig. 225). Notice, however, that this final canvas is, despite its conflagration of decorative patterns, the least Matissean of the group. The sedate odalisque smoking a hookah, faceless in the three previous canvases (as in earlier pictures of the series) is now the only one of the four women with physiognomic features. She looks straight at the beholder, as the *Demoiselles d'Avignon* had done half a century before. Her hair and veils form a mesmerizing mane. In many ways, she gets the lion's share. She is guarding, but almost aggressively. Mourning, this painting says, is also a way of overcoming. Nothing like death to bring out the Oedipal structure of a relationship.

Only in the fall of 1955 is Picasso able to calm down (if one can call a frenzy of work calming). In eight days (October 23–31), he paints eleven canvases on the theme of "a plaster cast in the studio," the very theme with which he had privately engaged in a pictorial conversation with Matisse in 1932 (fig. 3). Each of these vertical pictures (figs. 227, 228) constitutes an homage to Matisse's Vence interiors, particularly to the luscious *Egyptian Curtain* (fig. 164).[384] In their coloration some are moderate, others dramatic, but all tell of Picasso's admiration for these works of 1947–48, which had filled him with envy at the time, or at least anxiety, and prompted him to try stealing the show by quickly hanging his last

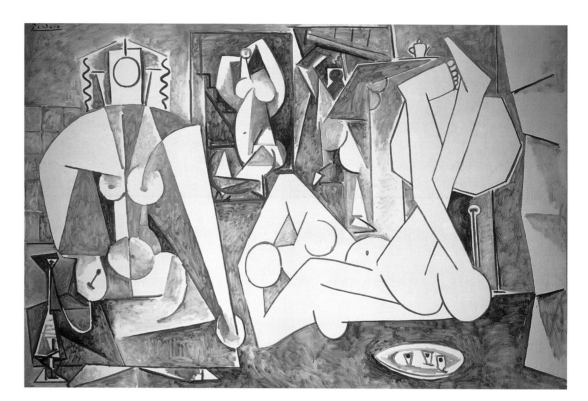

PABLO PICASSO
224 *Women of Algiers*
version M,
February 11, 1955
Oil on canvas
51 1/4 x 76 3/4 in.
(130 x 195 cm)
Private collection

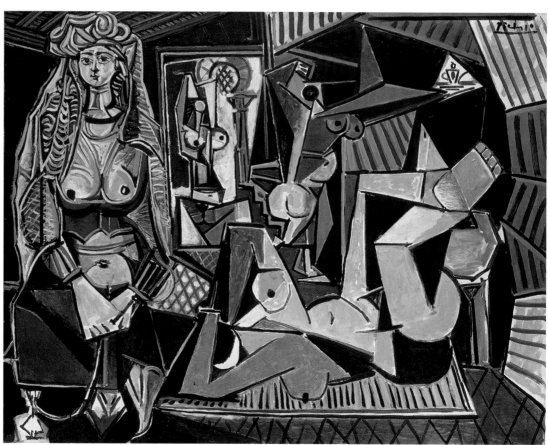

PABLO PICASSO
225 *Women of Algiers*
version O, 1955
Oil on canvas
44 7/8 x 57 5/8 in.
(114 x 146.4 cm)
Private collection

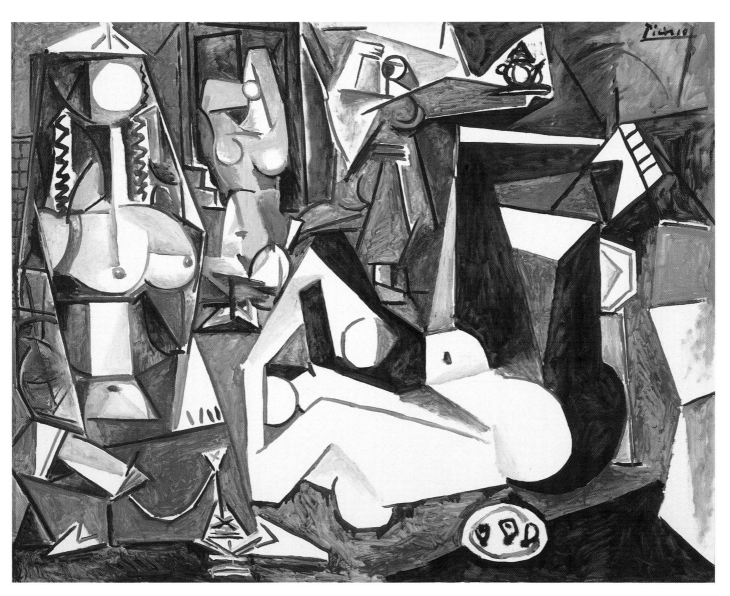

PABLO PICASSO
226 *Women of Algiers* version N,
February 13, 1955
Oil on canvas
44 $^1/_2$ x 57 $^3/_8$ in. (113 x 145.7 cm)
Washington University Gallery of Art,
St. Louis

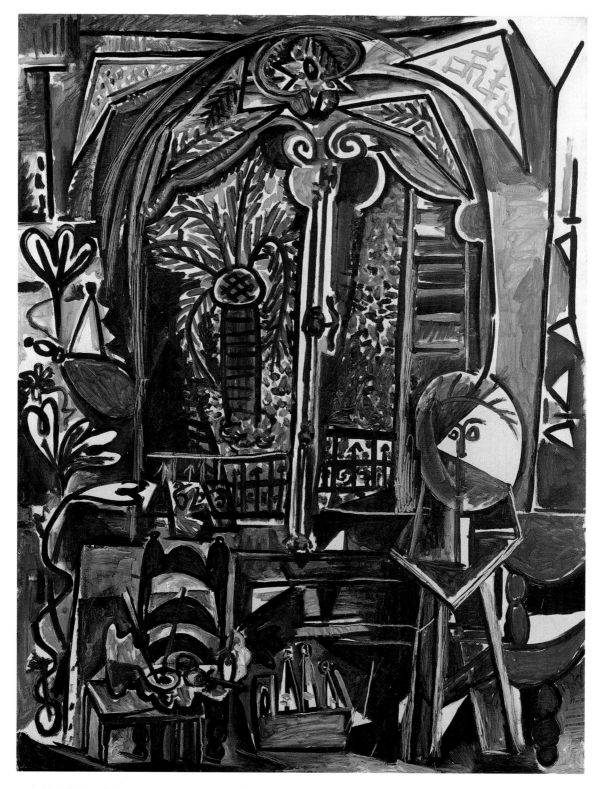

PABLO PICASSO
227 *The Studio at 'La Californie'*, October 28, 1955
Oil on canvas. 45 ⁵/₈ x 35 in. (116 x 89 cm)
Daros Collection, Switzerland

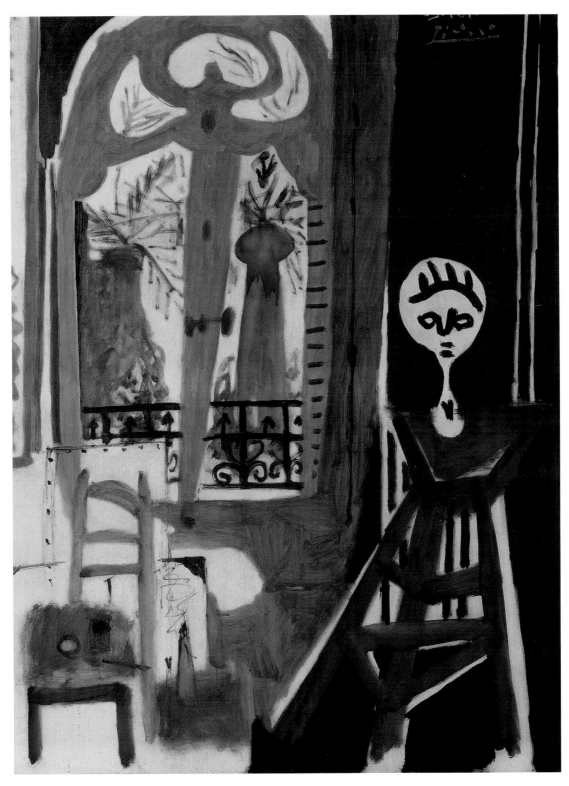

PABLO PICASSO
228 *The Studio at 'La Californie'*, October 23, 1955
Oil on canvas. 45 ⅝ x 35 in. (116 x 89 cm)
Musée National d'Art Moderne, Paris. Donation Louise et Michel Leiris

crop of pictures on the walls of the Maison de la Pensée Française, just as Matisse was having his own exhibition at the Musée National d'Art Moderne (see p. 206 above).

The work of mourning is undoubtedly successful. It is as if the death of Matisse had freed a particular fiber which Picasso always kept repressed in his art, as if he had to wait for his partner's demise to be able to publicly acknowledge how much he cared for him. *Woman in a Rocking Chair*, dating from March 26, 1956 (fig. 229), attests to the completion of this liberating process. Nothing seems to me more Matissean in Picasso's entire oeuvre: the brush-work, the flat planes of pure color, the reserved white halos around the objects, the blank face, even the quotation of a palm tree. And yet, what could be more Picassoesque, with such a dis-membering and remembering of the body, such a crumpled knot at the center, and such a generalized metaphoricity: the sharklike belly, the phallic right arm and neck, the eyeglass shape of the rocking chair? The work is a hybrid: Picasso has cofathered a can-vas with his competitor.

Four days later, he begins a new series of works on the theme of the studio, this time in the horizontal format. In the first of these (fig. 230), a white canvas stares at us in the middle of the picture; on the right of the painting, in another picture within the picture, a seated woman in odalisque attire is frontally represented. But it is the central blank that draws us like a magnet. The palm trees, the complex architecture of a Moroccan dish, the leafy pat-tern of the Art Nouveau doors, the sensuous texture—the set is clearly awaiting Matisse's entry; the reserve of the white rectangle is a postmortem invitation. In two other paintings, the white rec-tangle similarly suspends the atmosphere. In the fourth (fig. 231), the ominous blank has been painted over (it is now grey). This version of *The Studio at 'La Californie'* is more than half-covered with black, but no canvas of the series is brighter. On the right, the beginnings of a large picture depicting a woman combing her hair, translated into the arabesque of a Matisse *Blue Nude*, her shape swiftly scraped from the wet paint, tell us that the studio is no longer idle, that grief has done its work.

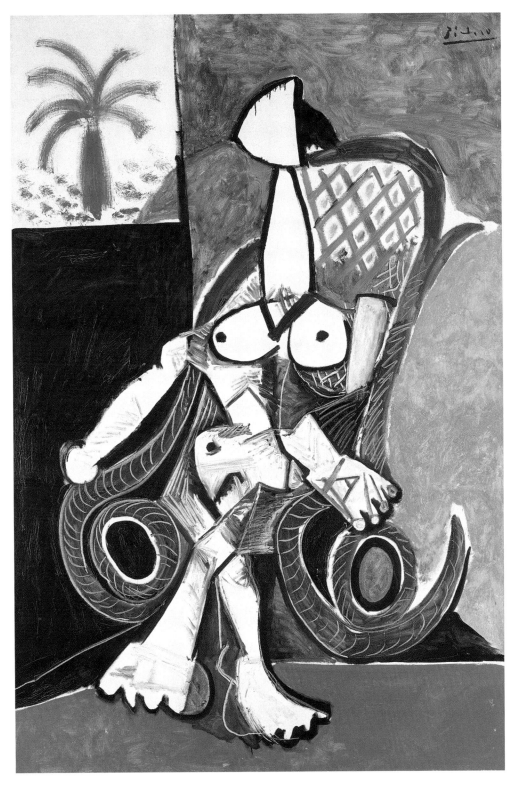

PABLO PICASSO
229 *Woman in a Rocking Chair,* March 26, 1956
Oil on canvas. 77 ¹/₈ x 51 ¹/₄ in. (195.8 x 130.3 cm)
The Art Gallery of New South Wales, Sydney

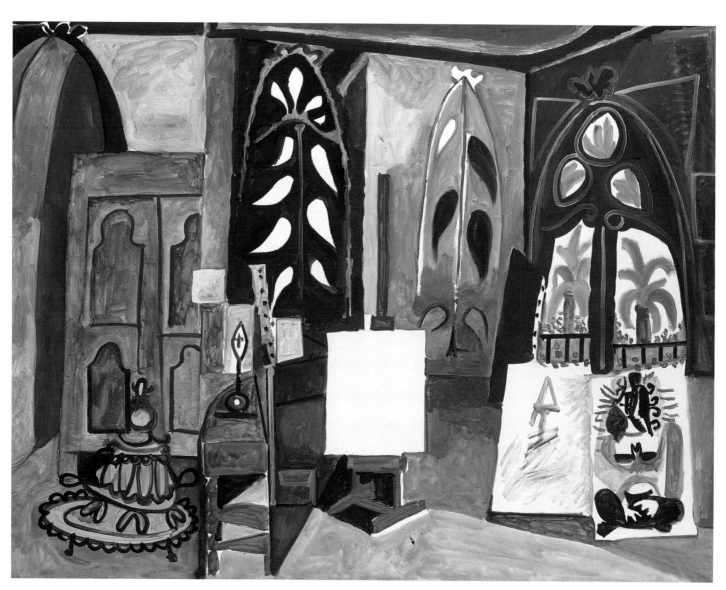

PABLO PICASSO
230 *The Studio at 'La Californie'*,
March 30, 1956
44 ⁷/₈ x 57 ¹/₂ in. (114 x 146 cm)
Oil on canvas
Musée Picasso, Paris

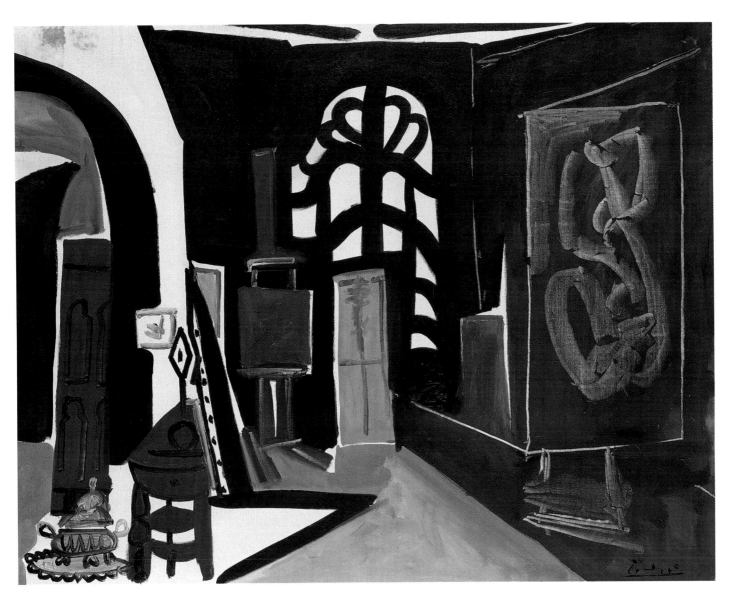

PABLO PICASSO

231 *The Studio at 'La Californie',* April 2, 1956
Oil on canvas
28 ⁵/₈ x 36 ¹/₈ in. (72.7 x 91.8 cm)
Private collection

PABLO PICASSO
59 *Bather*, 1931. Bronze (unique cast)
27 $^1/_2$ x 15 $^1/_8$ x 12 $^3/_8$ in. (70 x 40.2 x 31.5 cm)
Musée Picasso, Paris

Notes

Introduction

1. Riichiro Kawashima, *Matisse* (Tokyo: Atelier-Sha, 1934), translated in Flam 1988, p. 294. Kawashima's preface is precisely dated at the end of the text (so is, by inference, his visit to Matisse); Picasso lived in the studio mentioned by Kawashima, rue Schoelcher, from August 1913 to June or July 1916. Kawashima refers several times to a trip he took to France in 1913; another such trip would have been unlikely during World War I.

2. On Picasso and pastiche as a defense strategy, see Krauss 1998, passim; on Picasso's use of the past to counter the linear view of history as progress, see Galassi 1996, esp. pp. 17–18, and Florman, forthcoming.

3. *Still Life with a Plaster Bust* was not included in the 1931 Matisse retrospective. Yet it is more than likely that Picasso had seen it earlier. (It was shown in the Matisse exhibition at the Galerie Bernheim-Jeune, May 2–16, 1919; see Flam 1986, p. 504, n. 31. Picasso's correspondence with Diaghilev [May 12, 1919, MPP] shows that, contrary to what is often assumed, he had not yet left Paris for London. I thank Hélène Seckel for this information.) Furthermore, *Still Life with a Plaster Bust* was reproduced full-page in the special issue of *Cahiers d'Art* dedicated to Matisse at the occasion of his Georges Petit show (6, nos. 5–6 [1931], fig. 46, p. 279).

4. Léonce Rosenberg to Picasso, November 25, 1915; quoted in Seckel 1998, p. 166, n. 20.

5. For the gestation of *White and Pink Head,* see Monod-Fontaine 1989A, pp. 46–49. For *Goldfish and Palette,* see Elderfield 1978, pp. 100–02.

6. Volosinov 1986, p. 102.

7. Ibid., p. 72.

8. Bakhtin 1986, p. 69: "Sooner or later what is heard and actively understood will find its response in the subsequent speech or behavior of the listener. In most cases, genres of complex cultural communication are intended precisely for this kind of actively responsive understanding with delayed action."

9. My views are similar here to those elegantly expressed by John Elderfield (1992, p. 13) in the introductory section of his "Describing Matisse."

10. Gilot/Lake 1964, p. 264.

11. Gilot 1990, p. 316.

12. André Malraux, *Tête d'obsidienne,* quoted in Daix 1996, p. 177. Similar statements are reported by Father Couturier. As he was telling Matisse that Picasso liked him and had been moved to see his photograph pinned on the revolving bookshelf by the bed, Matisse said: "Yes, he is the only one to have the right to criticize me."

Abreviations used in notes

AHM:
Archives Henri Matisse, Paris

MPP:
Documentation of the Musée Picasso, Paris

PML:
Pierre Matisse Archives,
The Pierpont Morgan Library, New York

n.d.: no date
n.p.: no page number

Couturier also reports: "As Picasso heard one day someone saying behind him 'I just saw a rather ugly Matisse,' he swiftly turned round and snapped back, 'This is not true. Matisse never did anything ugly'"; Matisse/Couturier/Rayssiguier 1993, p. 82. Picasso expressed his admiration for Matisse until the end. Shortly before his death Angela Rosengart heard him saying: "There is no bad Matisse"; *Besuche bei Picasso* (Stuttgart: Daco-Verlag Gunter Bläse, 1973), p. 59.

13. See Bakhtin 1986, pp. 75–76.

14. Bloom 1973, p. 65.

15. Henri Matisse, "Interview with Guillaume Apollinaire" (1907), translated in Flam 1995, p. 29.

16. On Matisse's discovery of African art in 1906 (contemporary with that of Derain) and his communication of it to Picasso, see Jean-Louis Paudrat, "From Africa," in New York 1984, I, pp. 139–41. Max Jacob gave multiple versions of the event, which are discussed and republished in Seckel 1994, pp. 53–57, 193, 206, 209, 224, and 292.

17. W. Jackson Bate, *The Burden of the Past and the English Poet* (Cambridge, Massachusetts: Harvard University Press, 1970), passim.

18. "Henri Matisse Speaks to You" (1950), in Flam 1995, p. 189. I have slightly altered Flam's translation of Cézanne's sentence as quoted by Matisse, "Défiez-vous des Maîtres influents." In an earlier text Matisse uses the singular form: "Défiez-vous du Maître influent"; see Matisse's "Observations on Painting" (1945), in Flam 1995, p. 158. In this instance as well I would alter Flam's translation.

19. On Matisse's concern about his possibly negative influence on the younger generation, see his famous letter to Henry Clifford, first published in the catalogue of his retrospective at the Philadelphia Museum of Art, 1948; Flam 1995, pp. 182–83. This anxiety was consistent with his own youthful fears: "The young painter who cannot free himself from the influence of the preceding generation is bound to be sunk," he kept saying; "Observations on Painting" (1945), in Flam 1995, p. 158. On the "law of the grandfather," see Bate, *The Burden of the Past*, p. 22. Bate attributes it to Northrop Frye, but Walter Friedlaender formulated it much earlier in his 1930 essay "The Anti-Mannerist Style"; see the later English version, *Mannerism & Anti-Mannerism in Italian Painting* (New York: Schocken Books, 1965), p. 54.

20. "Henri Matisse Speaks to You" (1950), in Flam 1995, pp. 188–89.

21. On this point, see the enlightening remarks of Dominique Fourcade, in Fourcade 1976, pp. 103–06.

22. "Exposition Henri Matisse," Galerie Druet, Paris, March 19–April 7, 1906. The list of works exhibited, reproduced in Benjamin 1987, p. 286, does not permit us to identify the specific lithographs that were included in the show. It is interesting to note that all but one of the various accounts given by Max Jacob of the role played by Matisse with regard to the discovery of African art are immediately followed by a discussion of Picasso's one-contour sketches such as those done for Apollinaire's *Bestiaire*—as if Jacob himself were unconsciously linking them to Matisse's art; see Seckel 1994, pp. 193, 206, 209, 292.

23. Geiser/Baer, I, nos. 90–95. See also many pages in the three sketchbooks for the set of *Mercure*, now in the Musée Picasso, Paris; Léal, I, nos. 27–29.

24. Bloom 1973, p. 109.

25. Ibid., p. 16.

26. Girard's book originally appeared in French (*Mensonge romantique et vérité romanesque*, 1961). For a brilliant demonstration of the usefulness of Girard's model for the history of art, see Krauss 1993, pp. 243–308.

27. As described by Marcel Mauss in his landmark "Essai sur le don" of 1923, this is the open-ended structure of potlatch; Mauss, *The Gift*, trans. Ian Cunnison (New York: W.W. Norton, 1967).

28. On this famous remark to Florent Fels and its context, see William Rubin, "Picasso", in New York 1984, p. 260 and nn. 61–66.

29. Gilot 1990, p. 269.

30. Ibid., pp. 219–29. See also the much shorter version of this story in Gilot/Lake 1964, p. 268.

31. Daix 1987, p. 64. I have altered the published translation, which is inaccurate.

32. Henri Matisse's remarks to Courthion are partially quoted in Schneider 1984, pp. 733–34. Just after this passage Courthion alludes to Matisse's 1916 *Still Life with a Plaster Bust*. This dialogue is part of a series of conversations with Courthion, dating from 1941, which were to be published by Éditions Albert Skira under the title *Bavardages*. At the last minute, André Rouveyre dissuaded Matisse from publishing them. Courthion's manuscript is at the Getty Research Institute for the History of Art and the Humanities, Los Angeles, where I was graciously given access to it.

33. On May 6, 1951, Joseph A. Barry wrote in *The New York Times Magazine*: "By no coincidence Picasso will start turning the vaulted Romanesque chapel into a 'temple of peace' this spring or just about the same time that Henri Matisse will be inaugurating the Dominican chapel that he has been building and decorating at Vence, eighteen miles away. Such has been the nature of their long rivalry that Matisse had indicated his intention of creating a chapel about three years ago, or roughly when the Museum of Antibes was being dedicated to Picasso for the extraordinary work done there."

34. Max Scheler, *Ressentiment* (1915), trans. William W. Holdheim (New York: Schocken Books, 1972), p. 46.

35. Damisch 1997, p. 80. Damisch has been exploring the methodological advantages of the chess model in numerous essays since the late seventies. For a recent overview, cf Damisch 2000, passim.

36. Heinrich Wölfflin, "Ueber den Begriff des Malerischen," Logos: *Internationale Zeitschrift für Philosophie der Kultur*, 6 (1913), pp. 1–7, as quoted by Joan Hart, "Reinterpreting Wölfflin: Neo-Kantianism and Hermeneutics," *Art Journal*, 42, no. 4 (Winter 1982), p. 296.

37. Olivier 1965, p. 84.

38. Elderfield 1992, pp. 20–22.

39. Pierre Daix's *Picasso/Matisse* (Daix 1996), the most recent among a steady flow of publications, covers everything that happened after World War I in just a couple of pages.

Chapter 1

40. Picasso, quoted in Roberto Otero, *Forever Picasso: An Intimate Look at His Last Years* (New York: Harry N. Abrams, 1974), p. 116. I am grateful to Leo Steinberg for having reminded me of this anecdote.

41. Matisse, radio broadcast, in Flam 1995, p. 146.

42. Matisse to Pierre Courthion, in *Bavardages*, unpublished memoirs, 1941 (see n. 32 in the Introduction), p. 124. Matisse adds that he could not bring himself to eat the shellfish, even though he liked them very much: "The painting session had made them different for me from all the others offered in a restaurant."

43. "Matisse in Philadelphia," *Newsweek*, April 12, 1948, p. 84.

44. Matisse, quoted in Aragon 1972, I, p. 104.

45. "The painter should come to his model with no preconceived ideas," he wrote. "Everything should come to him in the same way that in a landscape all the scents of the countryside come to him: those of the earth, of the flowers linked with the play of clouds, of the movements of the trees and of the different sounds of the countryside" Matisse, "Portraits" (1954), in Flam 1995, p. 222.

46. Henri Matisse to Pierre Matisse, February 17, 1935, PML.

47. Reported in Father Couturier's diary, August 14, 1951, in Matisse/Couturier/Rayssiguier 1993, p. 402.

48. As William Rubin remarks, "It was rare for Picasso simply to paint the image of the person in front of him: his view of his subjects was almost invariably filtered through a rich web of personal and artistic associations which found visual expression in the transformations of his subject"; in "Reflections on Picasso and Portraiture," in Rubin 1996, p. 26.

49. Gilot/Lake 1964, p. 115.

50. Ibid., p. 121.

51. André Breton, "Picasso poète," *Cahiers d'Art*, 10, nos. 7–10 (1935), p. 191.

52. Matisse/Couturier/Rayssiguier 1993, p. 325.

53. Picasso's progressive discovery of the "arbitrariness of the sign," and his exploration of the consequences of this principle in art at the time of cubism, has been studied in depth by Leo Steinberg, Rosalind Krauss, and myself. Rosalind Krauss' numerous essays on Picasso's cubism are summarized in her most recent book (Krauss 1998). For my own essays, see "Kahnweiler's Lesson," in Bois 1990, pp. 65–97, and "The Semiology of Cubism," in Zelevansky 1992, pp. 169–208. Leo Steinberg's lecture on Picasso's cubism and Saussurian linguistics (first given in 1976) remains unpublished, but I greatly benefited from my numerous conversations on this topic with the author. See also Steinberg's participation in the discussions following the presentation of my paper and that of Krauss, published in Zelevansky 1992. In "Kahnweiler's Lesson," I list the various authors who had earlier on, but more summarily, related Picasso's cubism to structural linguistics (pp. 289–90, n. 67).

54. Christian Zervos, "Notes sur la formation et le développement de l'œuvre de Henri Matisse," *Cahiers d'Art*, 6, nos. 5–6 (1931), pp. 246–48.

55. Quoted in Aragon 1972, reprinted in Flam 1988, p. 344.

56. Gino Severini, "La Peinture d'avant-garde: Le Machinisme et l'art—reconstruction de l'univers" (1917), reprinted in *Témoignages* (Rome: Éditions Art Moderne, 1963), p. 63.

57. For further (and much longer) discussions, see "Matisse and Arche-Drawing," in Bois 1990, pp. 4–63, and Bois 1994, passim.

58. Quoted in Aragon 1972, II, p. 308.

59. Matisse, "The Role and Modalities of Color" (1945), in Flam 1995, p. 155.

60. Ibid.

61. Barnett Newman, "Preface to *18 Cantos*" (1964), reprinted in *Barnett Newman: Selected Writings and Interviews,* John P. O'Neill, ed. (New York: Alfred A. Knopf, 1990), p. 183.

62. Frank Stella, quoted in Jean-Claude Lebenzstejn, "Eight Statements," *Art in America,* 63, no. 4 (July–August 1975), p. 75.

63. Gilot Lake 1964, p. 271.

64. Matisse, "Notes of a Painter" (1908), in Flam 1995, p. 38.

65. Ibid.

66. The fast paced tit-for-tat that this work initiated between Matisse and Picasso has often been described. For the most recent account, see Daix 1996, pp. 25–129. See also Bois 1994, pp. 99–115, and my essay "*Matisse's Bathers with a Turtle,*" *Bulletin of The Saint Louis Art Museum,* 22, no. 3 (Summer 1998), pp. 8–19.

67. New York 1992, pl. 215.

68. Matisse to Camoin (undated but from the summer of 1917), in Camoin/Matisse 1997, p. 105.

Chapter 2

69. Quoted in Labrusse 1996, II, pp. 556–57.

70. See Krauss 1998, pp. 96–97.

71. Z. V, 415. Zervos titles the painting *Danseuse au tambourin allongée.*

72. See FitzGerald 1995, pp. 158–69.

73. For the title given by Guillaume, see Waldemar George, *La Grande Peinture contemporaine à la Collection Paul Guillaume* (Paris: Éditions des Arts à Paris, 1929), p. 180. The work is now known as *Femme au tambourin* (*Woman with a Tambourine*) and is part of the Jean Walter/Paul Guillaume bequest, Musée de l'Orangerie, Paris. The title *La Danseuse au tambourin* is the result of an obvious contamination from Matisse's stock of images.

74. Elderfield 1992, p. 194. The canvas is signed and dated 1926, but this is of little significance, since Matisse dated works, like most artists, by their date of completion. Along with other Matisse odalisques, the picture is reproduced in an article by Georges Duthuit entitled "Œuvres récentes de Henri Matisse," *Cahiers d'Art*, 1, no. 7 (1926), pp. 153–71. If (*contra* Elderfield) Matisse painted his canvas after Picasso's show, he would have been working unusually fast. But it is not entirely impossible. The rendition of the wallpaper in greenish turquoise offers some evidence (albeit slight) for this supposition: this color, conspicuous in Picasso's "odalisque" painting, is not common in Matisse's oeuvre and he had not been using it for this particular wallpaper in his pictures of the early twenties.

75. André Breton, "Le Surréalisme et la peinture," *La Révolution surréaliste*, 2, no. 6 (March 1, 1926), p. 31.

76. Together with *Odalisque with a Tambourine*, Matisse sent a 1923–24 canvas known today by the same title to the 1926 Salon d'Automne, this one much more faithful to the subdued tonalities of the early Nice period. This second picture is reproduced in color in Los Angeles 1966, no. 60, p. 93, under the title *Odalisque with Tambourine*. We should note that even though its color contrasts are not as violent and flashing as those of the other odalisque in the Salon, the Moroccan decor provides Matisse with the opportunity to bombard us with a repetition of red circles on a blue background (the contrast being tamed, however, by the white ring which rims each circle). Obviously, Matisse had wanted to emphasize what we could call the retinal aspect of his work in his entry to the Salon.

77. Jacques Guenne, "Le Salon des Tuileries," *L'Art Vivant* (June 1, 1926), reprinted in Monod-Fontaine 1989A, pp. 79–80.

78. Georges Charensol, "Le Salon des Tuileries," *L'Amour de l'Art* (June 1926), reprinted in Monod-Fontaine 1989A, p. 79.

79. E. Tériade, "Propos sur le Salon des Tuileries," *Cahiers d'Art*, 1, no. 5 (1926), p. 110.

80. "Hommage à Picasso" was published in *Paris-Journal* on June 20, 1924, two days after the scandal at the first performance of *Mercure*, a ballet choreographed by Léonide Massine to a score by Eric Satie with a set by Picasso. Written by André Breton and Louis Aragon, the "Hommage" was signed by fourteen people, most of them surrealist writers. The text is reprinted in Douglas Cooper, *Picasso Theatre* (1968; ed. New York: Harry N. Abrams, 1987), p. 60, where one also finds a good discussion of the events surrounding the ballet.

81. André Levinson's devastating review of Florent Fels' book on Matisse (*Henri Matisse* [Paris: Chroniques du Jour, 1929]) provided the most articulate critique of the "old lion" and of his advocates, especially those who were denying a discontinuity between the great 1906–13 inventor, who had "planted the seed of modern art," and the Nice Matisse. These are two different Matisses, writes Levinson, and the second "neglected, evaded and tacitly disavowed the first." Protesting that Fels only reproduced a handful of pre-Nice Matisses while in fact his text dwells on the adventurous Matisse, Levinson calls this book a fraud. One can only like the Nice period, he asserts, at the expense of the groundbreaking production of Matisse's youth. Those who claim to perceive no discrepancy between the two Matisses are either blind or dishonest; by restoring in his painting tonal color, traditional modeling, perspectival space (to some degree), and a much more centralized mode of composition, Matisse turned his back on the "unprecedented achievements" of his beginnings; André Levinson, "Les soixante ans de Henri Matisse," *L'Art Vivant* (January 1930), translated as "Henri Matisse at Sixty," in Flam 1988, pp. 240–44. Three months later, Fritz Neugass, reviewing Matisse's first retrospective (at the Thannhauser Gallery in Berlin, February–March 1930; 265 works) gave the *coup de grâce*. Declaring the series of odalisques "tiresome," he laconically declared: "The sexagenarian artist today has reached the end of his development"; Fritz Neugass, "Henri Matisse, pour son soixantième anniversaire," *Cahiers de Belgique* (March 1930), translated as "Henri Matisse, for His Sixtieth Birthday," in Flam 1988, p. 244. Fortunately for Matisse, he was not in Europe to read Neugass' death sentence—he had sailed for Tahiti

at the end of February and was at that moment being celebrated in New York, his first stop on the way to the exotic island. But he probably heard echoes of it at some point and, more important, had heard all the warnings. The ever-growing flow of negative criticism from modernist circles that Matisse had to face from the mid-twenties on, just as he was more and more accepted by the establishment (notably by the state), probably played a role in his decision to take a leave of absence. But the main factor was Matisse's crisis of inspiration. there is a sharp decrease in his production from 1926 to 1929, the year when, frustrated at his incapacity to finish *The Yellow Dress* (The Baltimore Museum of Art), he decided to call it quits.

82. Elderfield 1992, p. 38. Elderfield is right to relate the flicker effect of *Odalisque with Gray Culottes* to Matisse's earlier work, for example, *Corner of the Artist's Studio* of 1912 (Pushkin Museum, Moscow), though perhaps *Interior with Eggplant* of 1911 (Musée de Grenoble) would provide an even better example. On the importance of this bedazzling strategy in Matisse's art, see also Bois 1994, passim.

83. For the relationship of *Woman with a Veil* to *Portrait of Yvonne Landsberg*, see Labrusse 1999, p. 143; for the link to *Portrait of Madame Matisse*, see Matthew Armstrong's entry on *Woman with a Veil* in William Rubin, *The William S. Paley Collection*, exh. cat. (New York: The Museum of Modern Art, 1992), pp. 88–91.

84. Most of the pictures in question are pre-Nice, for example, *The Piano Lesson* (fig. 27) or the second *Portrait of Auguste Pellerin* of 1917 (Musée National d'Art Moderne, Paris). In general Matisse's sitters (hired models or acquaintances) appear absent-minded— "absorbed," as Michael Fried would say—their gaze a directionless blur. Fried's concept of absorption (which he opposes to "theatricality") presupposes the negation of the beholder (absorbed figures do not address the spectator). It was first exposed in *Absorption and Theatricality: Painting and the Beholder in the Age of Diderot* (Berkeley: University of California Press, 1980), and further discussed in his subsequent books.

85. The black opening of the green chest immediately recalls the *French Window at Collioure* of 1914 (Musée National d'Art Moderne, Paris). But in revisiting his work of the teens, Matisse revisits Cézanne as well (and so it struck the critics at the time)—a way perhaps, both in the teens and in the late twenties, to indirectly exorcise Picasso. On the Cézannism of this painting and

contemporary criticism, see Monod-Fontaine 1989A, pp. 84–85. Matisse was perfectly conscious of the fact that this work represented a new departure: he sold it for one symbolic French franc to the Association des Amis des Artistes Vivants so that it would be given to the Musée du Luxembourg, and thus "correct" the way he was represented in this museum (with *Odalisque with Red Culottes* of 1921, typical of the Nice period).

86. E. Tériade, "Visite à Henri Matisse," *L'Intransigeant* (January 14 and 22, 1929), translated in Flam 1995, pp. 83–86 (translation slightly modified).

87. In 1925, when Matisse was reaching a turning point in his career, he had spoken with Jacques Guenne about his impoverished youth: "For my part, I have never regretted this poverty. I was very embarrassed when my canvases began to get big prices. I could see myself condemned to a future of making nothing but masterpieces!"; Jacques Guenne, "Entretien avec Henri Matisse," *L'Art Vivant* (September 15, 1925), translated in Flam 1995, p. 82.

88. For a comparison of prices, see FitzGerald 1995, p. 156.

89. As far as I know, Françoise Gilot and Werner Spies are alone in having linked Picasso's work of this 1928–30 period to the earlier work of Matisse. Spies 1995, p. 29, compares the linear configurations of the Dinard sketchbook of summer 1928 to Matisse's 1910 *Dance*. Gilot 1990, p. 50, though understandably retaining the family connection, notes that in Picasso's 1929 *Large Nude in an Red Armchair* (fig. 10) "He symbolically killed two birds with one stone—his own wife, Olga [Khokhlova], and the master who had passed into Delacroix's camp," i.e., Matisse.

90. Cowling 1985, p. 101. Cowling examines the growing pressure put on Picasso by the surrealists, and the painter's symmetrical distancing from the movement. By 1929, though they remained friendly toward him, the surrealists no longer considered Picasso "one of them."

91. Spies 1995, pp. 16–18.

92. André Warnod in *Comoedia* (Fall 1926), as quoted in Paris 1993, p. 508. No critic mentions *Branch of Lilacs* (New York 1992, pl. 175), but its presence is attested by the lecture Duthuit gave at the opening of the show and by the correspondence related to this event; see Duthuit 1992, pp. 49–51.

93. Sylvain Bonmariage, "Henri Matisse et la peinture pure," *Cahiers d'Art*, 1, no. 9 (1926), pp. 239–41.

94. Christian Zervos, "Nos Enquêtes: Entretien avec

Mademoiselle B. Weill," *Feuilles volantes: Supplément à la revue* Cahiers d'Art, 2, no. 3 (1927), p. 2. All the interviews with dealers are published in this monthly "supplement" to the journal.

95. Christian Zervos, "Idéalisme et naturalisme dans la peinture moderne, IV: Henri Matisse," *Cahiers d'Art*, 3, no. 4 (1928). The text is mostly an attack against surrealism and does not concern Matisse in any way.

96. E. Tériade, "L'Actualité de Matisse," *Cahiers d'Art*, 4, no. 7 (1929), pp. 285–90. This essay, well-illustrated (six paintings, thirteen works on paper, mostly etchings) was the only one devoted to Matisse that year. It is sandwiched between a generous presentation of Picasso's beach paintings made at Dinard in the summer of 1928 (in the previous issue), and a similarly generous presentation of his "projects for a monument" that he had drawn at the same time (following issue).

97. This exhibition was held on the occasion of the publication of Florent Fels' monograph on Matisse. *The Yellow Hat* was reproduced in a review published in *L'Art Vivant*, 5 (November 1, 1929), p. 861.

98. Subtitled "Violet, Yellow and Marie-Thérèse," the second section of Linda Nochlin's article on Picasso's color is almost entirely devoted to the use of the violet/yellow contrast in the December 1931–April 1932 series of paintings after Marie-Thérèse Walter. Picasso's use of the violet/yellow pair culminated in the grotesque bathing suit of the elephantesque *Bather with a Beach Ball* of August 1932, now at The Museum of Modern Art, New York. See Nochlin 1980, pp. 120–23 and 177–83.

99. See Guy-Patrick and Michel Dauberville, *Matisse: Henri Matisse chez Bernheim-Jeune* (Paris: Éditions Bernheim-Jeune, 1995), I, pp. 62–63.

100. The three Matisse pictures are: *The Painting Session* (Scottish National Gallery of Modern Art, Edinburgh) and *Plaster Figure, Bouquet of Flowers* (Museu de Arte de São Paulo), both of 1919, and *Pianist and Checkers Players* of 1924 (National Gallery of Art, Washington, D.C.).

101. From 1926 on, Picasso had been exposed both to a fair amount of pre-Nice Matisse and to Matisse's obvious growing desire to part from the stilted universe of his Nice odalisques. The exhibition of *Bathers by a River* and *The Piano Lesson* in October 1926 had been preceded by a group show, "Trente ans d'art indépendant, 1884–1914: Retrospective de la Société des Arts Indépendants" held at the Grand Palais from February 20

to the end of March 1926. It included an important selection of pre-Nice works by Matisse, among them *Le Luxe I*, *Portrait of Greta Prozor,* and *Painter in his Studio* (all three pictures at the Musée National d'Art Moderne, Paris), and *The Red Studio* (The Museum of Modern Art, New York). Picasso was not represented at the exhibition (he had never participated in the Salon des Indépendants, which the show was commemorating), but he surely visited it, if only to see the Cézannes, Van Goghs, Seurats, and Rousseaus. There were several such recapitulative exhibitions in the late twenties, the last major one being the presentation, at the Galerie Bernheim-Jeune, of Paul Guillaume's private collection (May 25–June 7, 1929) where *The Piano Lesson* seems to have been shown again, along with Picasso's 1925 *Odalisque*.

102. "La Glace sans tain" is the first poem in André Breton's and Philippe Soupault's *Les Champs magnétiques* of 1920, which marks the beginning of automatic writing. A note to the poem's title, in a copy of the book annotated by Breton, refers to Matisse's painting. See André Breton, *Œuvres Complètes* (Paris: Bibliothèque de la Pléiade, Gallimard, 1988), I, p. 1148–49.

103. Michel Georges-Michel, *From Renoir to Picasso* (London: Victor Gollancz, 1957), p. 37, as quoted in Michael Lloyd and Michael Desmond, *European and American Paintings and Sculptures 1870–1970 in the Australian National Gallery* (Canberra: Australian National Gallery, 1992), p. 165. On this canvas and its uniqueness in Matisse's oeuvre, see Monahan 1995.

104. A March 1932 photograph taken by Gallatin is reproduced in Monahan 1995, p. 112.

105. The Dinard sketchbook (CD) is reproduced in facsimile in Spies 1995. It should be noted that the preparatory drawings (CD 33–39, 42–45) are very different from those recording paintings after the fact (CD 21–24, 32, 46–48, 50–53), which are more numerous in this sketchbook. In his essay, Spies reproduces the paintings in question; he also compares the drawings to Matisse's *Dance*.

106. The octopus metaphor of Picasso's *Acrobats* was perceived by critics at the time. In a review of the Picasso exhibition at Paul Rosenberg's in July 1931, Pierre Guéguen, probably referring to the painting of January 18, 1930 (which does not seem to have been in the show), multiplies the metaphors: "The painting of the boy-octopus, white limbs on gray background, represents a human possibility that tells us more about

the body than a scrupulous anatomy would. The arms, the legs, the thin trunk, all have become the rays of a strange wheel, with the head as hub. No matter how the picture is placed, no matter which side is up, the boy-star has received such an excellent constructive education that he always falls on his limbs"; Guéguen, "Picasso et le métapicassisme," *Cahiers d'Art*, 6, nos. 7–8 (1931), p. 326.

107. Although Picasso kept all the pictures of the *Acrobat* series in his collection (an indication that they had a special significance for him), he allowed them to be reproduced before they were even dry, in *Documents*, the journal that the dissident Georges Bataille had launched against Breton a year before; Michel Leiris, "Toiles récentes de Picasso," *Documents*, 2, no. 2 (March 1930), pp. 67–69. The rush is obviously a mark of self-confidence, yet within the framework of our experiment, we can posit that the main urgency was to draw Matisse out of his Nice retreat. But Matisse was on his way to Tahiti when this issue appeared.

108. See Léal, II, nos. 35–36. Many of these drawings had been published by Zervos, first in a huge special issue of *Cahiers d'Art* on Picasso (13, nos. 3–10 [1938]), then in his catalogue raisonné (Z. VII, 84–88, 90–109).

109. Spies 1995, p. 7.

110. For Picasso's struggle with the weight of clay while he was modeling *The Man with a Sheep* during World War II, see Brassaï 1966, p. 161.

111. Christian Zervos, "Sculptures des peintres d'aujourd'hui," *Cahiers d'Art*, 3, no. 7 (1928), pp. 277–314.

112. For other drawings, see Léal, II, no. 38, fols.17r–19r, and 38r (this last one probably done after the sculpture).

113. The drawings comprise sketches for paintings such as *Woman, Sculpture and Vase of Flowers* of 1929 (Z. VII, 259), belonging to the *Studio* series, or for the series of *Acrobats* of late 1929–early 1930; Léal, II, no. 38, fols. 25r–32v, 58r–65r.

114. The other sculpture in the show, *Jeannette II* of 1910, with its barely flattened pellets of clay and the sharp cut-out plane of the ellided cranium, must have strengthened Picasso's interest in Matisse's way of laying bare the modeling process.

Chapter 3

115. Labrusse 1999, p. 150.

116. To Brother Rayssiguier, Matisse later remarked: "It's even a way of speaking, to say that I brought back some drawings"; Matisse/Couturier/Rayssiguier 1993, p. 290, as quoted by Labrusse 1998. However, the recent uncovering of numerous Tahitian drawings of a very high quality shows that Matisse was too modest on that score; see Le Cateau-Cambrésis 1998, passim.

117. See Jean Vidal, "On meurt d'ennui au Paradis terrestre, affirme le peintre Henri Matisse," *Pour Vous* (June 1931), clipping in the "Album Georges Petit", a three-volume compendium documenting the composition and reception of the Matisse retrospective at the Galeries Georges Petit in 1932 (AHM). This little-known interview, conducted a year after Matisse's trip, is perhaps the most precise in its negative description of the Tahiti experience. It was only much later, while working on *Jazz* and other cutouts, that Matisse would be able to make use of his stock of Tahitian memories. On this issue, see Klein 1997, passim.

118. "Cent ans de peinture française," Galeries Georges Petit, June 15–30, 1930. The Matisse works exhibited were *Odalisque with Magnolias* of 1923 or 1924 (private collection; New York 1992, pl. 266); *The Open Window* of 1918 (private collection; Washington 1986, no. 30); and a pastel representing a reclining nude.

Of course, Picasso too was treated as an Old Master in the exhibition (he was represented by three works as well, including *The Greek Woman*, painted in 1923 or 1924; Z. V, 249). But given his "eclecticism," highly publicized (and most often criticized) at the time, such an accolade had far less significance for him.

119. The exhibition was organized by Pierre Loeb, who had bought most of the works on display, and Marguerite Duthuit. According to the chronology established by Ernst Goldschmidt, the show opened on June 12 (the closing date is uncertain, but it seems to have run through July); see *L'Aventure de Pierre Loeb: La Galerie Pierre. Paris 1924–1964*, exh. cat. (Paris: Musée d'Art Moderne de la Ville de Paris, 1979), p. 119.

120. See pl. 28 in Matisse's *Poésies de Stéphane Mallarmé*, illustrating the poem "Quelle soie aux baumes de temps" (Duthuit II, p. 25, bottom left).

121. "This year it was Matisse's turn to award the prize," notes *Time* in its October 20, 1930 issue. See also Henry McBride, "Matisse in America," *Cahiers d'Art*, 6, nos. 5–6 (1931), special issue on Matisse, p. 296.

122. On these works, see Yve-Alain Bois and Rosalind Krauss, *Formless: A User's Guide* (New York: Zone Books, 1997), pp. 79–86.

123. Pierre Cabanne remarked, unfortunately without source, that Picasso was not satisfied at having been granted the award for such a tame painting. It seems, however, that the picture came from his collection, for no lender is listed, as would normally have been the case; see Cabanne, *Le Siècle de Picasso* (Paris: Denoël, 1975), I, p. 435.

124. On Matisse's meeting with Barnes and the chronology of the commission, see Flam 1993, pp. 17ff.

125. Most commentators have noted the relationship between *Bathers by a River* (fig. 24) and *Back III*, from 1916–17. Like the two preceding works in the series, *Back IV* is directly modeled—carved is more exact—onto the plaster cast of the previous version.

126. On Matisse and Mallarmé's revival around 1905–06, see Labrusse 1998, passim.

127. According to the legend, it is Pierre Matisse who suggested Ovid's text to Picasso. Picasso signed a contract with Skira in September 1930.

128. Christian Zervos, "Les 'Métamorphoses' d'Ovide illustrées par Picasso," *Cahiers d'Art*, 5, no. 10 (1930), pp. 511–18, with seven illustrations, six of them full-page, including *Tereus and Philomela* (fig. 43), and *The Death of Eurydice* (fig. 44).

129. André Salmon, "Letter from Paris," *Apollo*, 12, no. 68 (August 1930), p. 149. Pierre Loeb, who was trying to secure an exclusive contract for Matisse's sculpture, wanted the exhibition to be "as complete as possible"; Pierre Loeb to Marguerite Duthuit, December 16, 1929, AHM. To this end, he purchased works in 1929 and 1930, and kept purchasing them until the show was about to open (most of them had to be cast). Loeb's correspondence with Marguerite Duthuit, to whom Matisse had delegated his authority, alludes to the possible purchase of no less than twenty-eight sculptures. Furthermore, Loeb could have borrowed some works, since he was having difficulty paying for his acquisitions (two years later Matisse would have to take back a certain number of them, including the hard-to-sell 1908 *Seated Figure, Right Hand on Ground* [fig. 40]).

In fact, it seems that Loeb did borrow *The Serf* (from Paul Guillaume), just as he might have borrowed some of the *Jeannettes*.

130. Four lists of works (in the correspondence between Marguerite Duthuit and Pierre Loeb) combine to give us a fairly clear idea of the holdings of the Galerie Pierre at the moment of the show. The first list, typed by Pierre Loeb, accompanies a letter of May 24, 1929. The second, giving prices, reference numbers, and titles, was compiled by Marguerite Duthuit for Loeb shortly thereafter. The third, in Loeb's handwriting, dates from October 1929 and acknowledges works already delivered. The last list, compiled by Loeb and dating from July 29, 1930, indicates what he has sold. The following articles were illustrated: Zervos' less than enthusiastic review in *Cahiers d'Art*, 5, no. 5 (1930), pp. 275–76; Tériade's short notice in *L'Intransigeant*, June 23, 1930, p. 5; and Waldemar George's review (repeating Zervos' stance according to which Matisse's work in sculpture has lost its "spontaneity" over the years) in the journal *Formes*, 1, no. 7 (July 1930), p. 19. A few months later, in the same journal, Gaston Poulain published a more elaborate article illustrated with five works labeled "Pierre collection." He also reproduced *The Serf* but attributed it to the Paul Guillaume collection. Finally, his comments seem to allude to *Head with Necklace* of 1907; *Formes*, 1, no. 9 (November 1930), p. 10. Using the numbering of the catalogue raisonné of Matisse's sculpture (Duthuit III), we can conclude from all this data that:

1) nos. 15, 34, 42, and 71, later bought back by Matisse and nos. 6, 22, 23, 36, 46, 61 and 62 (reproduced in the press, as was 71) were definitely in the show;

2) nos. 30, 49, 63, 64, and 70, marked as sold in the fourth list (made at the end of the show) were most certainly included; and

3) nos. 51 and 58, also bought by Loeb according to Duthuit's catalogue raisonné, were also probably included.

131. In her entry on *Jeannette V*, for Paris 1975 (no. 208, p. 226), Nicole Barbier indicates that it appeared in the Galerie Pierre exhibition, but she does not give any evidence.

132. The sketchbook filled between February 25, 1929 and January 1930 reveals that Picasso had first imagined *Seated Woman* as assembled/welded before visualizing her as modeled, and it is obvious that he later revisited his first round of sketches in order to develop *Woman in the Garden*. On the complex chronology of these works, see FitzGerald 1987, pp. 244–67. For the 1929–30 sketchbook, see Léal, II, no. 38, pp. 107–09, fols. 2r–19r.

133. See the sketchbook from July 1930 in the Musée Picasso; Léal, II, no. 39, pp. 119–21, fols. 15r–31r.

134. Julio González, "Picasso sculpteur et les cathédrales" (c. 1931), posthumously published in

Josephine Withers, *Julio González: Sculpture in Iron* (New York: New York University Press, 1978), p. 135, as quoted by Marilyn McCully in "Julio González and Pablo Picasso: A Documentary Chronology of a Working Relationship," in London 1994, p. 217.

135. Léal, II, no. 39, pp. 121–24, fols. 33r–48r.

136. The illustrated *Chef-d'œuvre inconnu* was already in the works (it would be released in December 1931), but this is hardly a book by Picasso: Vollard put it together with a group of etchings he had bought a few years before, supplemented with woodprints made by a craftsman after Picasso sketches dating as far back as 1924, and having no connection whatsoever with Balzac's text. On this odd potpourri, see the excellent study by Thierry Chabanne, "Picasso illustre. . .Illustre Picasso," in Chabanne, ed., *Autour du Chef-d'œuvre inconnu de Balzac* (Paris: École Nationale Supérieure des Arts Décoratifs, 1985), pp. 99–127. Let us note in passing that one of the etchings, *Painter Picking Up His Brush, and His Model with Turban*, alludes to Matisse's odalisques (Geiser/Baer, I, 129).

137. On this point and on Picasso's Ovid in general, see Florman 2000. This splendid study, which Lisa Florman had kindly made available to me in manuscript, appeared after the first edition of the present book. The passages quoted here appear between pages 15 and 33 of Florman's chapter on Ovid.

138. Christian Zervos, "À propos de la dernière exposition Picasso," *Cahiers d'Art*, 6, nos. 7–8 (1931), p. 325, with the reproduction of Z. VII, 322. Pierre Guéguen's "Picasso et le métapicassisme," published in the same issue, is not rigorously a review, but it alludes to the exhibition and discusses several works that were included. Guéguen also mentions the presence of *Three Musicians* (using the title this painting was given at the time, *The Three Masks*) and refers to "the more cubists canvases on the theme of 'The Studio,'" though his brief description matches best the 1928 *Painter and Model*, which was still owned by Rosenberg and often exhibited by him. The reviewer of *Beaux-Arts* (8 [July 1931], p. 22) speaks about a *Painter and His Model* dating from 1930. Tériade, in *L'Intransigeant*, July 6, 1931, speaks of "five or six large most recent compositions" surrounding *Three Musicians* of 1921, as well as "several plates" of the Ovid (the text of this review is reprinted in Tériade 1996, pp. 354–55).

139. This kamikaze assault was accompanied by a mini-retrospective of Picasso's work at the Galerie Percier, directed by his friend André Level, from June 23 to July 11: small canvases ranging from an "impressionist" cityscape of Paris dating from his early career to pictures of the late twenties.

140. Guéguen, "Picasso et le métapicassisme," p. 328.

141. As far as I know, Alfred H. Barr, Jr. was the last to relate paintings such as *Pitcher, Bowl of Fruit, and Leaves* to Matisse, albeit only in passing and with regard to one of its motifs; Barr 1951, p. 224. Writing about *The Conservatory* (fig. 107) in his great monograph on Matisse, he mentions the "philodendron, the palmate leaves of which had held Picasso's interest in several of his large paintings of 1932." The only "large painting" of 1932 representing a plant whose foliage resembles that of the Matisse is *Nude on a Black Couch* (Z. VII, 377): it is thus quite probable that Barr thought also of this canvas, even larger, from 1931.

142. *Courrier de la IVe République*, July 30, 1931, clipping MPP.

143. See Schneider 1984, p. 655 n. 48.

144. These publications aptly supplement the catalogue of the exhibition: they reproduce a good selection of early works that are conspicuously absent from the show, and relatively few works from the early Nice period. The texts in *Pour ou contre*, as the title indicates, are not unanimously reverential: the idea, with an eye on publicity, was to stir up public interest by rendering Matisse controversial. (Apart from some excerpts from earlier literature, the most damning remarks are to be found in Robert Rey's "Souvenirs d'un étudiant." The author reminisces about his visits to Matisse around 1908, then concludes by doubting that, after *Interior with Eggplant* of 1911, Matisse produced anything as strong or that he ever will.) *Cahiers d'Art* is more generous, more complete, and also more pedagogical. The journal published essays about the reception of Matisse's art in several countries, and Zervos' lengthy study, unusually historical, is quite detailed about Matisse's early work. Uncharacteristically, it expedites the whole 1917–29 Nice period in one single sentence. Christian Zervos, "Notes sur la formation et le développement de l'œuvre de Henri Matisse," *Cahiers d'Art*, 6, nos. 5-6 (1931), pp. 229-52.

145. Henry McBride, "The Museum of Modern Art Gives a Matisse Exhibition," *The New York Sun*, November 7, 1931, p. 12.

146. Tériade, "Une Grande Exposition: Henri Matisse," *L'Intransigeant*, June 22, 1931, reprinted in Tériade 1996, pp. 352–53. Tériade regretted the absence of *The Piano Lesson* (fig. 27), *The Joy of Life* (fig. 175), and of three works in Russia, *Dance*, *Music*, and *Harmony in Red*.

147. Matisse also added *Nude with Spanish Carpet* of 1919 (no. 38; Washington 1986, pl. 27), understandably misdated 1917 in the Georges Petit catalogue: the modeling is still quite abrupt, and the violently faceless figure is an oddity in the early Nice corpus. And he unsuccessfully tried, through Marguerite Duthuit, to secure the loan of the great 1917–18 *Interior with a Violin* from the Rump collection, because it had never been shown in Paris—the only time he seems to have intervened in the matter of loans.

148. He also added *Odalisque with a Turkish Chair* of 1928 (no. 134; Washington 1986, pl. 177) and the now lost 1929 *Odalisque with Tattoo*, another "crisis" work (reproduced in Alfred Barnes and Violette de Mazia, *The Art of Henri Matisse* [Merion, Pennsylvania: The Barnes Foundation Press, 1933], p. 343, no. 175).

149. L.C., "Henri Matisse," *Le Coopérateur de France*, June 27, 1931, clipping AHM.

150. See François Fosca, "Matisse," *Je Suis Partout*, June 27, 1931, clipping MPP.

151. Henry McBride, "The Palette Knife," *Creative Art*, 9, no. 4 (October 1931), p. 270.

152. See FitzGerald 1995, p. 213.

153. See London 1994, p. 269, nos. 77–78.

154. On metaphor in Matisse's sculpture, see my preface to Duthuit III, pp. XIX–XXI. It should be noted that is unlikely that Picasso had seen *Tiaré* at this point, unless he went to the foundry—which is not implausible, since Valsuani, Matisse's primary founder, also worked for Picasso, although probably somewhat later.

155. For further discussion of the relationship between these canvases and Matisse's work, see Monod-Fontaine 1989B, pp. 28ff.

156. Z.VII, 377. The picture is reproduced in color in Judi Freeman, *Picasso and the Weeping Women: The Years of Marie-Thérèse Walter & Dora Maar* (New York: Rizzoli, 1994), p. 148.

157. On this aspect of Matisse's art, see Krauss 1998, pp. 183–86.

158. Picasso, interview with Tériade, *L'Intransigeant*, June 15, 1932, reprinted in *Verve*, 5, nos. 19–20 (1948), n.p.

159. On this point, see Steinberg 1972, pp. 180–81.

160. Curiously, Picasso remained shy about his new modeled sculptures: the only recent sculptures exhibited were of the welded/assembled kind, dating from 1929–30 (*Head of a Woman*, made of two colanders [Spies 81], the original iron version of *Woman in the Garden* [Spies 72], and its duplicate in bronze [Spies 72.II]).

161. Among the missing: *The Family of*

Saltimbanques of 1905, *Portrait of Gertrude Stein,* the *Demoiselles d'Avignon,* and of course the paintings in Russian museums, including *Three Women* of 1908 and *Portrait of Vollard.*

162. For a thorough discussion of the composition and politics of the show, see FitzGerald 1995, pp. 190–204.

163. In fact, the Kunsthaus Zürich "borrowed" the Georges Petit show for its own retrospective exhibition of Picasso three months later (September 11–October 30, 1932), emphasizing this fact by scrupulously noting in the catalogue which works had been in Paris. The situation had been very different with Matisse's show at the same gallery the previous year, which had been considerably transformed for its venue at the Kunsthalle Basel (August 9–September 15, 1931)—numerous Nice paintings were deleted and replaced by early works from Swiss and German collections. Note the symmetry, however: just as a version of the Matisse show went to Basel, a version of the Picasso show opened in Zurich.

164. Jacques Guenne, "1832–1932: L'exposition Picasso, l'exposition Manet, le Salon des Tuileries," *L'Art Vivant* (juillet 1932), p. 343–344; Charles [Claude?] Roger-Marx, "Le mistère Picasso" [sic], *L'Indépendance Roumaine,* 9 juillet 1932; Roger Lesbats, "Le Cas étrange de Picasso," *Le Populaire,* July 12, 1932; clippings MPP.

165. Germain Bazin, "Un Bilan: L'exposition Picasso," *L'Amour de l'Art,* 13, no. 7 (July–August 1932), p. 247.

166. Matisse certainly felt that this was the case. Almost a year later, in August 1933, as his son Pierre proposed to organize an exhibition in New York of a "very noble and high standard, which would not be bad after Picasso's," Matisse replied that he had nothing new to show (he has not yet painted anything since finishing *The Dance*). "Furthermore," he continued, "I do not have to respond to Picasso's exhibition, since it had been made in response to mine"; Henri Matisse to Pierre Matisse, August 10, 1933, PML.

Chapter 4

167. Mallarmé: "I am for—no illustration, everything that a book evokes must happen in the mind of the reader"; "Sur le livre illustré" (1898), reprinted in Henri Mondor and G. Jean-Aubry, eds., *Œuvres complètes* (Paris: Bibliothèque de la Pléiade, Gallimard, 1945), p. 878.

168. Matisse, "Statement to Tériade," *L'Intransigeant,* June 16, 1931, translated in Flam 1995, p. 96. Matisse warns: "So that the artist can really give himself to it entirely, he must be very careful to guard against following the text word for word." Was this an allusion to Picasso's Ovid? Picasso had not exactly followed the text "word for word," but he had stayed close to the text, as Zervos had noted immediately.

169. Mallarmé's statement appears in a letter to Henri Cazalis (undated, but from 1864), in *Stéphane Mallarmé, Correspondance 1862–1871,* Henri Mondor, ed. (Paris: Gallimard, 1959), p. 137. Matisse's statement is taken from his 1912 interview with Clara T. MacChesney, in Flam 1995, p. 66. Beginning with the 1908 "Notes of a Painter," Matisse repeated over and over during his pre-Nice years that "there are two ways of expressing things; one is to show them crudely, the other is to evoke them with art"; translated in Flam 1995, p. 39. This is a direct echo of the celebrated dichotomy Mallarmé set up between the language of daily use and the language of poetry, and of his distinction between naming and suggesting.
For further reading on Matisse and Mallarmé, see Labrusse 1998, passim and Labrusse 1999, pp. 145–179. I am also indebted to an unpublished paper on this topic by Joseph Branden, delivered in my seminar on Matisse at Harvard in 1992.

170. This statement was actually made by Raymond Escholier (1956, p. 153), with Matisse's approval; quoted in Fourcade 1972, pp. 214–15.

171. Matisse, "How I Made My Books" (1946), in Flam 1995, pp. 166–67.

172. Perhaps it is because they are endowed with more details than most other images in the book and are thus conceived in a smaller scale.
In any case, the "illustrations" for "L'Après-midi d'un faune" are those Matisse ended up liking the least. Matisse to André Rouveyre, c. 1943–44; quoted in Duthuit II, p. 18.

173. For the Barnes commission, see Flam 1993, passim and my essay "The Shift," in Brisbane 1995, pp. 97–109.

174. "Interview with Dorothy Dudley" (1933), in Flam 1995, p. 110.

175. Matisse to Alexander Romm, March 17, 1934, in Flam 1995, p. 117.

176. Matisse to Alexander Romm, February 14, 1934, in Flam 1995, p. 115 (translation slightly modified).

177. Anne Baldassari was the first, to my knowledge, to have made this point. See her entry on a related drawing in Monod-Fontaine 1989A, pp. 218–25. Picasso's paintings of acrobats, it must be recalled, were reproduced in *Documents* while Matisse had left for Tahiti. But it is quite probable that Matisse became cognizant of this issue of the journal somewhat later, through André Masson for example, who was a very close associate of Georges Bataille, the editor of *Documents.* (Matisse's friendship with Masson developed precisely while he was working at *The Dance.*)

178. Matisse, quoted in Escholier 1937, p. 141. In the rest of the quotation, Matisse clearly differentiates between his working process and the use of traditional cartoons and squaring.

179. Tériade, "Edouard Manet vu par Henri Matisse," *L'Intransigeant,* January 25, 1932, reprinted in Tériade 1996, p. 383.

180. In making this remark, Picasso was surely aware that Matisse often blindfolded himself when working, notably in many engravings done in 1929. Matisse had mentioned this habit in a statement published in Florent Fels' 1929 monograph, and Picasso was acquainted with the writer, who interviewed him several times.

181. Matisse, "Statement to Tériade: On Creativity," in Flam 1995, pp. 106–07.

182. This phrase appears in an interview conducted in 1941 by Francis Carco, at the time Matisse was engaged in the preparation of *Thèmes et variations;* Flam 1995, p. 135 (translation slightly altered). But from 1933 on, Matisse often referred to the "unconscious." See the entry *"inconscient"* in the index of Fourcade 1972.

183. The surrealists, flooding the publication with their works, gradually pushed Tériade out. He resigned just after the ninth number, whose cover was designed by Matisse and which contained a long article on the painter (October 1936). He soon began to publish his own luxurious journal, *Verve,* whose first issue also had a cover by Matisse (December 1937).

184. Walter Benjamin, "Some Motifs in Baudelaire" (1939), translated in Harry Zohn, in *Charles Baudelaire: A Lyric Poet in the Era of High Capitalism* (London: New Left Books, 1973), p. 115, n. 9.

185. Picasso owned a copy of the Mallarmé book, but he may have bought it later (copy no. 105). There is little doubt, however, that through Skira he was shown a copy of the book as soon as it appeared.

186. On this point, see Steinberg 1995, pp. 108–11.

187. The drawings were simply dated 1933 when recently exhibited by the Pace Gallery in New York ("Picasso and Drawing," April 28–June 2, 1995, nos. 52–60). They are made on the same blue stationery paper, very unusual in Picasso's oeuvre, as many studies for *Lysistrata*, done between November 1933 and January 1934; Geiser/Baer, II, p. 234. Louis Gillet's article, "'La Danse' d'Henri Matisse à Pittsburgh" (*sic*), appeared in *Beaux-Arts*, 10 (May 26, 1933), pp. 1 and 6.

188. There is no evidence that *Tiaré* had been exhibited by then (although, given the general paucity or mediocrity of gallery exhibition catalogues at that time, we cannot exclude the possibility). It had been reproduced in *Henri Matisse: Retrospective Exhibition*, exh. cat. (The Museum of Modern Art, New York, 1931), pl. 161.

189. Leo Steinberg is the first, as far as I know, to have shown that this interpretation is erroneous; Steinberg 1972, pp. 411–12, n. 36.

190. Pierre Matisse underlined this fact when advocating the project in his correspondence with his father, urging him to choose *Ulysses* among various possibilities proposed by Macy. See Pierre Matisse to Henri Matisse, February 10, 1934, PML.

191. Matisse to Simon Bussy, June 25 and August 11, 1934; quoted in Duthuit II, p. 37.

192. See Delectorskaya 1986, p. 89.

193. They participated in an event commemorating Paul Guillaume at the Musée d'Ethnographie on December 7, 1934; Miró is often mentioned in Matisse's correspondence with his son Pierre; Stein's book is discussed in Matisse's correspondence with Simon Bussy and Picasso's anger alluded to in a letter dated September 23, 1934 (Bibliothèque du Musée du Louvre, Paris).

194. Jane Simone Bussy, "Henri Matisse: A Great Man" (1986), reprinted in Flam 1988, p. 320.

195. Laurie Monahan, discussing these images in their relation to André Masson's *Massacres*, convincingly argues for a political reading in direct connection with contemporary events; see "A Knife Halfway into Dreams: André Masson, Massacres and Surrealism of the 1930s," Ph.D. diss. (Cambridge, Massachusetts: Harvard University, 1997), pp.141–56.

196. Steinberg 1972, p. 175.

197. For another "Matissean" analysis of this painting, see Monod-Fontaine 1989B, pp. 32ff. Robert Rosenblum (1996, p. 361) convincingly invokes Ingres' odalisques in reference to this painting (noting in particular the orientalizing pillow) as well as several other Picasso pictures after Marie-Thérèse Walter. This does not contradict an allusion to Matisse, for Picasso would be using Ingres to scold Matisse, as it were, for his "lack of sensuality."

198. On Rosenberg's refusal to exhibit this painting, see FitzGerald 1995, p. 301, n. 93 (quoting Daix quoting Penrose).

199. See Léal, II, no. 40, fols. 31r–37r, to which must be added a few sheets torn from the sketchbook, Z. VIII, 202 and 207 (the Pygmalion solution to the riddle).

200. The connection between these two paintings was established by Jean Sutherland Boggs in Cleveland 1992, p. 234.

201. Picasso's recent encounter with *Marguerite Reading* and the *Interior with Eggplant* may also have played a role. Both works were exhibited in a Paris show of the masterpieces of the Musée de Grenoble, which had opened on January 30. We know that by February 16 Picasso had visited this exhibition, for that day, he mentioned the Zurbaráns to Kahnweiler; Kahnweiler 1952, p. 26.

202. On Matisse's uses of mirror up to 1928, see Stewart Buettner, "The 'Mirrored Interiors' of Henri Matisse," *Apollo*, 117, no. 252, new series (February 1983), pp. 126–29. Buettner also notes Picasso's fondness for non-reflexive mirrors, notably in his *Studios* of 1927–28.

203. Z. VIII, 250 (Musée Picasso, Paris) and 248. In a third drawing the mirror has been replaced by a painting; Z. VIII, 252.

204. Z. VIII, 249 *and* 255 (Musée Picasso, Paris), 251, 254.

205. Z. VIII, 253, 261, 262. The last drawing belongs to the Musée Picasso, Paris.

206. See Rubin 1972, p. 146.

207. Henri Matisse to Pierre Matisse, March 22 and April 26, PML. The show's confusion about what cubism was and who were its masters was standard at the time: mediocrities like Le Fauconnier, Georges Valmier, De la Fresnaye, and André Lhote were included, the last two much more praised in the press than Braque or Picasso. Picasso was appalled. On March 9 he told Kahnweiler: "There is no cubism whatsoever in all that. Everything disgusts me, my own things first"; Kahnweiler 1956, p. 74. Kahnweiler tried to defend the recent pictures, but to no avail. Picasso, having just helped put together another exhibition, this one entirely devoted to his cubist *papiers collés* and extremely well selected ("Papiers collés 1912–1914 de Picasso," Galerie Pierre, February 20–March 20, 1935), was not to be consoled. Two months later, he stopped painting for almost a whole year.

208. For an insightful reading of this picture, including a inquiry about the context of the 1930s and the general fate of the "sleeping beauty" theme in this period, see Monod-Fontaine 1989B, passim.

209. Even though Matisse's paper-cut technique in the elaboration of *The Pink Nude* has often been associated with cubism, including by Matisse himself, we should note that his use of collage has very little to do with Picasso's combinatory mode of thinking. For Matisse at this point the paper cutout was only a shortcut that allowed him to see the effect of a mass of color, and the general silhouette of a body, without having to paint it each time anew.

210. Photographs of eight states were published in the second edition of Roger Fry's monograph, *Henri Matisse* (London and Paris: Zwemmer and Weyhe, 1935), pl. 57, as noted by Barr, who also published some of the photographs; Barr 1952, p. 247, n. 2. All of the photographs are reproduced in Delectorskaya 1986, pp. 58, 63–66.

211. Christian Zervos, "Conversation avec Picasso," *Cahiers d'Art*, 10, nos. 7–10 (1935), pp. 173–78. Among the rare occasions when Picasso had his works in progress photographed, one can count the first state of the 1935 *Interior with a Girl Drawing* (Z. VIII, 263; The Museum of Modern Art, New York), published in this very issue of *Cahiers d'Art* and two years later the famous suite of photographs of *Guernica* in progress, made by Dora Maar. The facsimile reproduction of the studies for the *Ulysses* prints represented Matisse's first attempt to disclose his working process. Then came the 1935 edition of Fry's book, with its photographs of *The Pink Nude*, and countless published photographs of works in progress after that.

212. The issue only appeared in October 1936, after much delay, and as usual also came out as a book, with an exuberant cover designed by Matisse in paper cutouts.

213. There were twenty-one paintings and eight gouaches in the show. In addition to the three paintings just mentioned, there were many others with a Matisse overtone, including *Girl Reading* of 1934 (Z. VIII, 246; The Museum of Modern Art, New York) and *Woman with a Red Hat* of the same year (Z. VIII, 238). Then there were all the "sleeping beauties" of 1932, many of them small (Z. VII, 382, 383, 385, 407, 409), the larger ones being *The Dream* (Z. VII, 364) the (not sleeping) *Woman in a Red Armchair* (Z. VII, 395) and *Woman with a Book* (Z. VIII, 70), a painting where there seems to be a Matissean mirror/painting-within-a-painting.

Only a minority of canvases were definitely not Matissean: one of the tiny "sleeping beauties" (Z. VII, 403, very angular); a 1932 still life (Z. VII, 375); two "surrealist" still lifes of 1934 (Z. VIII, 195, 196); and three corrida scenes of that same year (Z. VIII, 230, 232, 228, the latter a "goring of a horse"). For the politics of this exhibition, see FitzGerald 1995, pp. 232–43.

214. The precise date of the exhibition is not known, but reviews begin to appear on February 21, 1936. At that date André Warmod, in *Le Figaro*, speaks about "the brutal amours of Pasiphaë"; clipping MPP.

215. The exhibition went through March. There were eleven Picassos, from the 1902 *Portrait of Gustave Coquiot* to a 1927 *Harlequin*. Emphasis was not placed on cubism (the only work dating from this period was an unidentifiable *Fenêtre ouverte* from 1909), but on the neoclassic works of the early twenties.

216. Clive Bell, "Picasso," *The New Statesman and Nation*, May 30, 1936, p. 857.

217. Matisse was the vice-president of this committee founded on June 17, 1936. He always felt disappointed not to have been solicited, as so many of his colleagues had been (foremost among them Picasso with *Guernica*), for the 1937 Exposition. Among the celebrations of the Front Populaire was the state-financed performance of *14 Juillet*, a play by Romain Rolland, its famous stage curtain by Picasso, its clear antifascist message celebrated in the press. For the occasion, the Maison de la Culture organized a collective exhibition in the hall of the theater (Alhambra), which Matisse and Picasso both helped install; see Boris Taslitzky, "Souvenirs du Front Populaire," *La Nouvelle Critique*, December 1955, reprinted in *Paris-Paris*, exh. cat. (Paris: Musée National d'Art Moderne, 1981), p. 52. In his daybook entry for July 13, 1936, Matisse noted "Les Marocains à l'Alhambra"; AHM. The loan of his 1915–16 *Moroccans*, then still in his possession, would be a clear indication that he wanted his support to be conspicuous.

218. For the sad story of the way *The Dance* was left in storage until 1977, and its recent (1993) reinstallation, see Jacqueline Munck, "La Danse de Paris," *Autour d'un chef-d'œuvre de Matisse: Les trois versions de* La Danse *Barnes (1930–1933)*, exh. cat. (Paris: Musée d'Art Moderne de la Ville de Paris, 1993), pp. 154–59.

219. On the politics of these exhibitions, see James Herbert, *Paris 1937: World on Exhibition* (Ithaca: Cornell University Press, 1998) and *Paris 1937: L'Art indépendant*, exh. cat. (Paris: Musée d'Art Moderne de la Ville de Paris, 1987).

220. Paul Rosenberg to Picasso, March 20, 1937, MPP.

221. In a lengthy review published in two installments of the arch-traditional *Revue des Deux Mondes*, the academician Louis Gillet considered "the famous rivalry between Matisse and Picasso" (p. 322) and structured the evolution of French art of the past thirty years along this dividing axis. The essay represents the first serious attempt to analyze the formation of the "School of Paris," and was much commented on in the press at the time; Louis Gillet "Trente ans de peinture au Petit Palais (1895–1925)," *Revue des Deux Mondes*, 107 (July 15, 1937), pp. 319–39; (August 1, 1937), pp. 562–84.

222. Matisse may also have seen the painting in progress, for he visited Picasso in his studio the day his own exhibition opened; indications in Matisse's daybook, AHM. Matisse again visited Picasso's studio on June 25 and July 3.

223. Christian Zervos, "Exposition Braque, Laurens, Matisse, Picasso à Oslo, Stockholm, Copenhague," *Cahiers d'Art*, 12, nos. 6–7 (1937), pp. 222–23.

224. Picasso to Matisse, February 10, 1938; AHM. The letter begins with the very formal "Cher maître," but ends with the familiar "salut."

225. Oddly, it is when speaking about sculpture, especially about Rodin's uses of anatomic fragments, that Matisse expressed his most adamant views on the subject; see "Notes of a Painter," in Flam 1995, p. 40.

226. Unless he took a quick, unrecorded trip to Paris (a possibility, since he was in the middle of legal complications involved with the separation from his wife), Matisse remained in Nice for the whole winter of 1938–39, arriving in Paris only around May 20 (he did not return to the south until October). Certainly intrigued by the press the show received, full of comparisons between Picasso's art and his own, he could very well have asked Rosenberg to privately show him some of these paintings. On the Picasso exhibition, see FitzGerald 1995, pp. 241–43.

227. Mary Callery to Matisse, July 31, 1939.

Chapter 5

228. Léal, II, nos. 44–45.

229. Ibid., no. 45, fols. 2r–5r.

230. Picasso might have been prompted to such a revision while perusing the special issue of *Cahiers d'Art* devoted to these Matisse drawings. At the time, he was having an exhibition of works on paper at the Galerie MAJ, run by Zervos' wife (April 19–May 18, 1940), his last show before the Occupation, and it is more than probable that idle moments during the installation were spent looking at old issues of the journal.

231. See Leo Steinberg, "Picasso's Sleepwatchers" (1968), in Steinberg 1972, pp. 93–114.

232. In the spring of 1944, Matisse showed his copy to Albert Flament, along with *Pablo Picasso: Seize peintures 1939–1943*, published in December 1943. See Albert Flament, "Le Sourire d'Henri Matisse," *La Revue des Deux Mondes*, 114 (July 1–15, 1944), p. 300.

233. Things became rather frightening after Maurice de Vlaminck denounced him in a collaborationist journal for having ruined the tradition of French painting, and Fritz René Vanderpyl, a sycophant of the new regime, "exposed" him as a Jew. See Vlaminck, "Opinions libres . . . sur la peinture," *Comoedia*, June 6, 1942, pp. 1, 6, much discussed in the collaborationist press and reprinted in Vlaminck, *Portraits avant décès* (Paris: Flammarion, 1943). Vanderpyl's book, *L'Art sans patrie, un mensonge: Le pinceau d'Israel*, appeared in November 1942 (Paris: Mercure de France). See Goggin 1985, pp. 192–93, 230–34; on Vlaminck in particular, see Dorléac 1993, pp. 187–90.

234. The best firsthand testimony is Brassaï 1966. Another valuable source of information is Jean Cocteau's *Journal 1942–1945* (Paris: Gallimard, 1989) and the beginning of Gilot/Lake 1964. For secondary literature, see Goggin 1985 and Dorléac 1993.

235. On this infamous trip, see Dorléac 1993, pp. 74–83. Matisse only privately expressed his disgust (in letters to his family and friends) but, after the war, Picasso would be indefatigable in his denunciation of the artists who had made the trip, Derain in particular.

236. Jean-Eugène Bersier, member of the Salon committee, to Matisse, August 9, 1943, AHM.

237. AHM for the guestbook.

238. Enough copies of *Thèmes et variations* were printed (950) so that the book could be purchased by all major French libraries and museums, thus giving students access to it. This, to some extent, makes it a public production.

239. As documented in the inventory of the Picasso estate, MPP.

240. Henri Matisse to Pierre Matisse, June 6, 1942, PML. The letter continues with an allusion to the trip to Weimar by his old friends.

241. Henri Matisse to Pierre Matisse, September 1, 1940, PML.

242. Matisse may have written to Picasso before the war, but with the exception of one little note slipped under the door at the rue des Grand-Augustins studio in 1938, no prewar letter survives.

243. AHM. That very same day, February 7, 1944, Picasso was drawing the pruned trees of the little square of the Vert-Galant (Z. XIII, 213). Save for the botanical species, his cityscape matches Matisse's description. Did Matisse call Picasso to let him know about his thought?

244. Matisse to Charles Camoin, August 12, 1941, published in Claudine Grammont, ed., *Correspondance entre Charles Camoin et Henri Matisse*, (Lausanne: La Bibliothèque des Arts, 1997), p. 161. Matisse's query was probably prompted by the fact that he was at that time working on *Bavardages*, the book of interviews with Courthion that was, in the end, not published. Camoin replied with a hideous attack (tainted with anti-Semitism) against Picasso, which Matisse ignored.

245. It is touching to read Matisse's letter from June 12, 1944: "How do you endure Paris at the moment? I don't ask you to reply to me, knowing how much you hate to write. But still ask someone else to write for you in case this letter reaches you"; MPP.

246. The frontispiece Picasso drew on the manuscript of *Le Désir attrapé par la queue* (written between January 14 and 17, 1941) represents himself drawing or writing, as if seen from above. It can be read as a commentary on Matisse's *mise-en-abîme* drawings—once again Picasso refused to trap the viewer in an impossible space. This rare representation may have been prompted by a "thank you" postcard from Matisse (dated January 14, 1941), probably acknowledging Picasso's help with his vault at the Banque de France.

247. Brassaï 1966, p. 143. See also p. 49, where Brassaï asserts that Matisse's still life is "the first picture" one sees "in the opening door leading to the studio."

248. Pierre Courthion, *Le Visage de Matisse* (Lausanne: Marguerat, 1942), p. 89.

249. Matisse noted the gift in his daybook on the date of October 11, 1941. The drawing was dedicated "À mon ami Picasso" on October 9.

250. Matisse to Max Pellequer, undated but in reply to the letter dated June 24, 1943, quoted above p. 136; Archives Pellequer, Paris. This hyperbolic appreciation is written in response to Pellequer's description of Picasso's delight in front of a painting Matisse had just given to him. To Picasso he wrote more soberly a few months later, when dealing with the next exchange. Alluding to the grisaille palette of the Dora Maar portrait, he said: "I already have from you a very beautiful severe canvas that still interests me"; Matisse to Picasso, June 12, 1944, MPP. On the other hand, in April 1949 he spoke about his admiration for the painting to Brother Rayssiguier, who was surprised to see such a work in Matisse's apartment. A few months later, he comments again on the picture: "Matisse says that the head that is there is very powerful, that he has owned it for a long time: it is the 'Abandon hope' of the gate of Dante's Hell"; Matisse/Couturier/Rayssiguier 1993, pp. 165, 247.

There is a small enigma here. On June 6, 1942, Matisse (who was then writing weekly to his son) sent this news to Pierre: "Picasso sent me a quite important painting on paper that he brought to Max at the train station like a madman. He still says that we are the only two painters"; PML. But the *Portrait of Dora Maar* is not on paper. Furthermore, a year later, Matisse seemed to imply that he has just received the portrait from Pellequer's hands: on June 15, 1943, in a note accompanying his own gift of a painting to Picasso, he wrote to Pellequer that he finds the portrait "very beautiful, very grave," but that he will take advantage of Pellequer's proposition, on Picasso's behalf, to bring another painting ("with extraordinary colors") to Nice so that Matisse could choose between the two. It is in his response to Pellequer's letter of June 24, 1943 that Matisse wrote enthusiastically about *Portrait of Dora Maar* and made the allusion to Dante. Pellequer had remained in Paris the whole time and thus could not have brought to Matisse another painting. Did Matisse change his mind about the portrait after receiving Pellequer's warm letter of June 24? Or were there two paintings, one given by Picasso in June 1942, on paper (of which there is no trace), and the *Portrait of Dora Maar* in June 1943? On Picasso's collection of Matisses (on the various exchanges and purchases), see the excellent entry on Matisse in Seckel 1998, pp. 160–79.

251. Most probably the large *Gosol Landscape* (Z. VI, 732). All the information concerning *Basket of Oranges* derives from Seckel 1998, pp. 166–70.

252. Archives Pellequer, Paris; quoted in Seckel 1998, p. 172. Unfortunately, nothing permits to identify which picture Matisse sent.

253. *Picasso: Seize peintures 1939–1943*, with a preface by Robert Desnos, was printed a month after the title on Matisse, a few weeks before the poet's arrest and deportation.

254. The oversized plates, the raison d'être of these books, represented the state of the art in color reproduction. Among the pictures reproduced in the Picasso album are two pictures of a seated woman discussed below (figs. 149 and 154) and the *Still Life with a Steer's Skull* (fig. 159).

255. Max Pellequer to Matisse, June 24, 1943, AHM; partially quoted in Seckel 1998, p. 172.

256. Matisse to Max Pellequer, undated but shortly after June 24, 1943. At the end of the letter, Matisse added: "The promise of a beautiful rooster by Picasso enchants me"; Archives Pellequer, Paris.

257. Matisse to Picasso, November 13, 1943; quoted in Seckel 1998, p. 172.

258. On June 12, 1944, Matisse writes again to Picasso in order to remind him that the painting was waiting for him. Picasso had picked it up by May 12, 1945, for at that date Matisse asked him if he would lend "the big still life [*Basket of Oranges*] or else the two [still life and seated woman] that you got recently" to the joint exhibition that was being prepared for the Victoria and Albert Museum in London; MPP.

259. In any event, it was not until after the famous 1944 Salon d'Automne, for it hung there together with other pictures from the same series. The present whereabouts of this picture is unknown, but if it was in the same league as its neighbors on the walls of the Salon (for example Z. XIII, 289, at the Musée d'Art Moderne de Saint-Étienne), it would have certainly fulfilled Matisse's desire to obtain a colorful work.

260. See the famous photograph by Robert Capa, showing Matisse drawing in bed, reproduced in Seckel 1998, p. 173.

261. Jean Clair ed., *Bonnard/Matisse: Letters Between Friends*, trans. Richard Howard (New York: Harry N. Abrams, 1992), p. 58 (translation slightly altered).

262. See, for example, *Young Woman in Yellow Armchair, Lilac Bunch, Blue Floor*, reproduced in Delectorskaya 1996, p. 71, completed the day before his letter to Bonnard.

263. *The Dream* was indeed signed in March. For the dates concerning these two paintings, see Delectorskaya 1996, pp. 69, 90. It is in May 1940 that the famous chance encounter of

Matisse and Picasso took place. Picasso stumbled upon an elated Matisse who had just gotten his ticket for a cruise to Brazil (it would have been his first major trip since Tahiti). "Seeing my face reddened with pleasure," recalled Matisse, "[Picasso] asked me: 'What's with you? Don't you know that the Germans are in Rheims?' 'No,' I answer. 'And our army? And our generals?' 'It's the École des Beaux Arts,' Picasso answers. He was perfectly right"; Henri Matisse to Pierre Matisse, September 1941, PML. Matisse was struck by Picasso's laconic remark about the bankruptcy of the French military establishment and often recounted it, sometimes adding: "If everyone was doing his job like Picasso and I do ours, all this [the French defeat] would have never happened"; Henri Matisse to Pierre Matisse, September 1, 1940, PML.

264. Matisse was particularly proud of the evolution of *The Rumanian Blouse*. He exhibited eleven photographs of its successive stages in December 1945 at the Galerie Maeght (the exhibition is discussed above, pp. 183–184); he showed even more stages in the film on him made by François Campeaux (*Henri Matisse*, released in 1946); and ten stages were reproduced in Gaston Diehl's monograph, published in March 1954, *Henri Matisse* (Paris: Éditions Pierre Tisné, 1954), pp. 63–64; see Monod-Fontaine 1989A, pp. 93–99.

265. The quotations within the quotations are not fictional but taken from a letter Matisse wrote to his Rumanian friend, Théodore Pallady, quoted in Delectorskaya 1996, p. 115. The date of this letter is unclear (see Fourcade 1972, p. 185, n. 40).

266. Margit Rowell compared Matisse's "collage" version of *Still Life with Shell* and Picasso's *Still Life with Three Apples and a Glass* of 1945 for their similarities. But it is fundamental differences that the comparison reveals. Picasso's elements are made of fragments locked in space by shadows and other markers of three-dimensionality. His table is tangible, with its dangling cloth functioning as a repoussoir. See Rowell, *Objects of Desire: The Modern Still Life*, exh. cat. (New York: The Museum of Modern Art, 1997), nos. 71, 72.

267. Matisse to Théodore Pallady; quoted in Delectorskaya 1996, p. 128.

268. Henri Matisse to Pierre Matisse, November 28, 1940, PML.

269. See Monod-Fontaine 1989A, pp. 104–07. Matisse exhibited photographs of the work in progress in 1945, and had these shown in Campeaux's film of 1946. He also exhibited sixty-eight sketches for the painting in London, in 1953.

270. Matisse to André Rouveyre, early 1942;

excerpted in Fourcade 1972, p. 189.

271. On this aspect of Picasso's picture, see Leo Steinberg 1988, pp. 12–15. On *Music* in relation to the *Demoiselles*, and the psychoanalytic interpretation of the myth of Medusa, see Bois 1994, pp. 109–12.

272. See Matisse's letters to Louis Aragon, dated August 24 and September 1, 1942; quoted in Delectorskaya 1996, pp. 373, 378.

273. Though Matisse had almost entirely finished his work on Ronsard's *Les Amours* and on Charles d'Orléans' *Poèmes* by the end of 1943, the two books only appeared in 1948 and 1950. *Jazz* appeared in 1947.

274. See Matisse, "How I Made My Books" (1946), in Flam 1995, pp. 167–68. On the long history of the *Pasiphaé* book, which actually begins in 1937, see Duthuit II, pp. 53–55, and Delectorskaya 1996, pp. 129–32, 156–57, 162–63.

275. All the linocuts Matisse prepared for the Montherlant book, but chose not to include, were printed, according to his wish, in a posthumous edition; see Duthuit II, pp. 304–317.

276. Henri Matisse to Pierre Matisse, September 1941, PML.

277. Matisse, "Interview with Francis Carco" (1941), in Flam 1995, p. 135.

278. Delectorskaya 1996, p. 202.

279. Ibid., p. 203. See also Jack Flam, "Matisse's *Dessins: Thèmes et variations*: A Book and A Method," in *Henri Matisse: Zeichnungen und Gouaches Découpées*, exh. cat. (Stuttgart: Staatsgalerie, 1993), pp. 121–32.

280. Even in his prints, Matisse was reluctant to reveal the existence of various states (unlike Picasso, for whom this was sheer pleasure). Two versions of a lithographic study for the St. Dominic of the Vence chapel are particularly telling: the second one has been made by erasing the facial features of the saint in the first, but Matisse made sure that there was no visible trace of this transformation: his "states" are in fact different versions; see Duthuit I, 656, 658. I thank David Drogin for bringing this point to my attention.

281. Picasso, as it turns out, missed the point altogether. Shortly after the publication of *Dessins: Thèmes et variations*, he told Brassaï: "Matisse makes a drawing, then he makes a copy of it. He recopies it five times, ten times, always clarifying the line. He's convinced that the last, the most stripped down, is the best, the purest, the definitive one; and in fact, most of the time, it was the first"; Brassaï 1966, p. 56.

282. Quoted in Delectorskaya 1996, n.d., p. 283.

283. Henri Matisse to Pierre Matisse, April 3, 1942, PML.

284. Marie-Laure Bernadac and Christine Piot, eds., *Picasso: Écrits* (Paris: Réunion des Musées Nationaux and Gallimard, 1989), p. 372. The fragment is undated, but the editors place it in 1951. The pun on chapelle/chapellerie (chapel/hat shop) is untranslatable. The tone matches Picasso's disparaging remarks about Matisse as a producer of "perfumes of handkerchiefs"; Joseph Barry, "The Two Picassos: Politician and Painter," *The New York Times Magazine*, May 6, 1951, p. 17.

285. See Goggin 1985, pp. 78–80, 91–92, 173–79.

286. See Brassaï 1966, p. 56.

287. Picasso used this device in several subsequent pictures; see Steinberg 1972, pp. 207ff.

288. Picasso had already explored this possibility in July; ibid., pp. 206–07.

289. Krauss, 1993, pp. 229ff.

290. Zervos published three sketches for the painting, the first of them dated September 15 (Z. XI, 282). The last, undated (Z. XI, 281), is without the pattern of rings, and with indications of color that do not match the definitive state of the canvas.

291. "It isn't any old object that is chosen to receive the honor of becoming an object in a painting by Matisse. They're all things that are most unusual in themselves. The objects that go into my paintings are not that at all. They're common objects from anywhere"; quoted in Gilot/Lake 1964, p. 74.

292. On this painting, see the entry in *The Collection of Victor and Sally Ganz* (New York: Christies, 1997), pp. 184–87.

293. The painting (Z. XIII, 48) is dated by Zervos June 19, 1943, just a few days after Max Pellequer's visit to Nice.

294. The exact date is not in Zervos, but given in Goggin 1985, p. 295.

295. See Delectorskaya 1996, pp. 314–15.

296. Picasso, quoted in Gilot 1990, p. 14.

297. Gilot 1990, p. 29, notes that when looking at Matisse's *Seated Young Woman in a Persian Dress*, which he had picked up at Lejard's, Picasso wondered "if he would be able to match such a mauve with such a green." She then says of the use of violet and green in *Still Life with Steer's Skull*: "Since they were separated by masses of black and white, he was still dubious about his ability to use such colors directly next to each other." The description is not entirely accurate (violet and green do abut in Picasso's canvas), but one can certainly assume that Picasso particularly liked this Matisse canvas because he could proudly relate it to his own coloristic achievement.

Chapter 6

298. Picasso's fate after the Liberation has been described many times: the journalists (many of them American) coming to interview him; the studio filled with GIs, and even groups of the Red Cross; his sudden transformation by the press into a "hero of the Resistance"; his participation in the "epuration committees," etc. For an excellent summary, and all the appropriate bibliographic references, see Utley 2000, pp. 39ff.

299. See Utley 2000, p. 3.

300. The scandal took the Communist officials by surprise and during the next few weeks they published many defenses of the painter in *L'Humanité* and the cultural weekly *Les Lettres Françaises*, edited by the arch-Stalinist Louis Aragon. These defenses grew more and more nationalistic by asserting the Frenchness of Picasso—which turned his critics in the press more and more xenophobic, even racist, surprisingly so in the immediate postwar context. This escalation went on for at least two years; see Utley 2000, pp. 90ff.

301. Matisse to Charles Camoin, November 16, 1944, in Camoin/Matisse 1977, p. 211.

302. Henri Matisse to Pierre Matisse, February 1, 1945. Matisse's *Basket of Oranges* might indeed be no. 62 in Picasso's exhibition—a *Nature morte aux oranges* whose title does not correspond to anything painted by Picasso during the war, at least to my knowledge.

303. Matisse had always denied that art should directly express political ideas. During the heyday of the Front Populaire, for example, fearing misunderstanding, he had remarked that the closed fist of his illustration for Mallarmé's *Le Guignon* (fig. 63) contained "no political allusion"; Matisse to René Blum, April 25, 1937, AHM. The letter was written less than a week before Picasso started painting *Guernica*. On the other hand, when asked by Picasso to donate a work of art to some charity, Matisse would always comply, especially during the immediate postwar period. Both artists supplied works to benefit auctions, and the press made much of the competitive nature of these gifts. Journalists were quick to report who, of the two most famous painters in France, raised the most money, whether for orphans or for Soviet war prisoners.

304. Matisse's daybook reveals that he came to Paris on April 19, met Picasso on the 21st, and returned to Nice on May 3; AHM.

305. "The Skulls of Picasso" (1971), in Steinberg 1972, p. 116.

306. Quoted in Brassaï 1966, p. 173. On this series of paintings, see also Jean Sutherland Boggs, in Cleveland 1992, nos. 119–21, pp. 290–95.

307. Boggs suggests (in Cleveland 1992, p. 294), and I concur, that these three paintings, sharing the same helmetlike form for the skull, must have been painted at the same time. The two other paintings are Z. XIV, 94 and 98.

308. We know from a letter Matisse wrote to Picasso, dated May 12, 1945, MPP, that the canvas was in Picasso's possession by then.

309. The catalogue provides a date and dimensions for each canvas. Moreover, Brassaï made a complete photographic record of the exhibition for Skira's new journal, *Labyrinthe*. Only two installation shots were published (no. 13, October 15, 1945), but copies of the photographs are kept in the Matisse archives.

310. Not in the catalogue, these works were obviously last-minute additions. The other paintings of this period are *Woman on a High Stool* of c. 1914 (The Museum of Modern Art, New York) and *The Painter in His Studio* of 1916 (Musée National d'Art Moderne, Paris).

311. The most remarkable paintings of the forties were *The Rumanian Blouse*, *The Dream* (fig. 128), and *Still Life with Shell* (fig. 129) of 1940; *Still Life with a Magnolia* of 1941 (fig. 134); and from 1942 *Dancer in Repose* (fig. 157), *Dancer and Rocaille Armchair on a Black Background* (fig. 136), and *Woman with Pearl Necklace* (fig. 131), added at the eleventh hour.

312. Léon Degand, "Matisse à Paris," *Les Lettres Françaises*, October 6, 1945, in Flam 1995, pp. 159–65.

313. Matisse to Picasso, May 12, 1945, MPP.

314. AHM. This extraordinary statement—in which Matisse in turn fears to be outmoded, reminisces about his youth, congratulates himself about his own courage, and finally doubts about his work in general—takes on a supplementary meaning (mimetic identification?) when one recalls that "epileptic" is a word Matisse had used to characterize his own production at the very beginning of his career as a modernist painter, in the spring of 1898. See Pierre Schneider, "Une Saison décisive," in "Matisse: Ajaccio-Toulouse, une saison de peinture," *Cahiers Henri Matisse*, no. 4 (1986), p. 14.

315. Some of the pictures Matisse had shown at the Salon were unavailable, and he had to make room for the canvases recently bought by the Musée National d'Art Moderne, all of which he insisted on including.

316. Picasso's selection formed a very coherent ensemble, with strong works such as *L'Aubade* (fig. 150), the large 1942 *Reclining Nude*

(fig. 155), *The Rocking Chair* (fig. 158), *Still Life with Steer's Skull* (Z. XII, 35; a different version of fig. 159), and the famously grimacing *Woman Dressing Her Hair*, painted in Royan in 1940, now at The Museum of Modern Art (Z. X, 302).

317. "The large number of otherwise cultured and intelligent people who fall victims to Señor Picasso are not posers. They are genuinely 'sent,'" and so on; Evelyn Waugh, letter to the editor, *The* [London] *Times*, December 20, 1945. On the whole, however, professional art critics were far less condescending or hysterical than the general public, and several articles seriously addressed Picasso's art without being signed by sycophants, as was often the case in Paris.

318. See Utley 2000, pp. 92–93 and p. 230, note 55.

319. *The Dream* (fig. 128) was adorned by no less than fourteen photographs; *The Rumanian Blouse* came next, with eleven; *La France*, of 1940, had eight; *Still Life with a Magnolia* (fig. 134) had four; *Still Life with Shell* (fig. 129), three. Matisse insisted, against the advice of the dealer Aimé Maegth, that this exhibition should not be advertised as comprising "new works." He wanted it to be seen, as his friend Marie Dormoy wrote to him, as "an 'explanation' or rather a 'commentary' of the exhibition at the Salon d'Automne"; Marie Dormoy to Matisse, January 5, 1945, AHM. The exhibition also included a large selection of drawings (mostly for the illustrations of Baudelaire's *Fleurs du Mal*, on which Matisse was currently working).

320. See Camoin/Matisse 1997, p. 219. Camoin's letter is mistakenly dated December 20, 1946, instead of 1945.

321. See Irving Lavin, "Picasso's Bull(s): Art History in Reverse," *Art in America*, 81, no. 4 (March 1993), p. 78, and passim.

322. Isabelle Monod-Fontaine in conversation with the author. Although Lavin ("Picasso's Bull[s]," p. 79) discusses Matisse's "state photographs," he denies any connection between them and Picasso's lithographs. Lavin seems to be considering Matisse's photographs as documents made for a purely private use, unaware that some of them were published as early as 1935, and very often after that.

323. See Utley 2000, pp. 77–80.

324. See the review by Pierre Descargues in *Arts et Lettres* (March 1946), p. 185, clipping MPP.

325. For the pro and con arguments concerning Matisse's art, see *La liberté de Nice et du Sud-Est*, March 6, 1946, clipping AHM.

326. Henri Matisse to Pierre Matisse, March 10, 1946, PML.

327. Isabelle Dufossez, "Matisse = Picasso," *Vrai*,

May 11, 1946, clipping MPP.

328. Gilot/Lake 1964, pp. 99–100; Gilot 1990, pp. 19–25.

329. Quoted in Gilot 1964, p. 117.

330. Gilot 1990, p. 151.

331. Ibid., pp. 72–76.

332. Gilot/Lake 1964, p. 117.

333. Reproduced in the catalogue of the exhibition, *Rape of Europa* is dated June 5, 1946 (that is, only nine days before the opening of the show), and Picasso quickly became dissatisfied with it, for he painted it over.

334. It should be noted, however, that the titles of these two works are only identical in English. The original title of Matisse's work is *Le Bonheur de vivre*, that of Picasso's, *La Joie de vivre*.

335. Matisse notes in his daybook for June 12, "Taxi (chez Picasso)," AHM.

336. On August 17, 1947, Matisse thanked Picasso for offering to bring him dishes that he could decorate at home. He declined the offer, arguing that he'd prefer to go work at the workshop when his health permitted, so that he could freely experiment and destroy the ugly pieces; MPP.

337. Matisse to Picasso, September 8, 1947, MPP.

338. Henri Matisse to Pierre Matisse, April 14, 1948, PML. A letter to Gilot dated April 22 (Gilot 1990, p. 105) also confirms the event.

339. Henri Matisse to Pierre Matisse, April 29, 1948, MPP.

340. Gilot 1990, p. 107. This feature of Picasso's art is extensively discussed in Steinberg 1972, pp. 175ff.

341. For the iconographic identification of the elements of this painting, see Gilot/Fréchuret 1996, pp. 12–14.

342. Matisse to André Rouveyre, June 3, 1947, in Fourcade 1972, pp. 193–94.

343. Conversation with the author, June 1995.

344. Henri Matisse to Pierre Matisse, January 18, 1948, PML.

345. The exhibition comprised thirteen canvases from 1947–48, twenty-two of the large brush drawings he had been concurrently making, among them some of his greatest contributions to graphic art, twenty one paper cutouts, tapestries, and decorative panels such as *Oceania, the Sky* (fig. 195), and most of his postwar illustrated books, plus several plates from the forthcoming *Charles d'Orléans*.

346. Matisse/Couturier/Rayssiguier 1993, pp. 209–10; also quoted in Schneider 1984, p. 733.

347. There was no catalogue of the exhibition, only a checklist, but *Cahiers d'Art* reproduced half the works; see Christian Zervos, "Œuvres récentes de Picasso exposées à la Maison de la Pensée Française," *Cahiers d'Art*, 24, no. 2 (1949), pp. 237–72. The others are easily identified by the dates given in the checklist.

348. In a letter of March 11, 1949 to Brother Rayssiguier, Matisse conceded that Picasso's illustrations for Reverdy's poems were related to *Jazz*, explaining that "it is normal that similar works appear in the same epochs." But he also could have related Picasso's red vignettes to his *Pasiphaé*. Matisse went on: "I already looked at [the book] three times and, the more I do it, the more I see that it is remarkably composed and that everything is in its right place, that all the pages are very well in balance. Only Picasso could do that; just as only I could do this. [He points at the models for stained-glass windows in front of his bed.] Picasso sees everything"; quoted in Matisse/Couturier/Rayssiguier 1993, p. 159.

349. Gilot/Lake 1964, p. 119.

350. Ibid., p. 122.

351. Matisse was impressed by *Carmen*, particularly by the speed with which Picasso had completed it (in half an hour, according to him); see Matisse/Couturier/Rayssiguier 1993, p. 247.

352. Hearing that Picasso was offended that he did not come to see him while in Vallauris, Matisse wrote a letter of apology (postmarked July 20, 1949, MPP), explaining how standing for long hours had become very difficult. He concluded: "My dear Picasso, come and scold me if this will relieve you—between old acquaintances, what does it matter—we know each other well"; see also Matisse/Couturier/Rayssiguier 1993, p. 216.

353. Pierre Cabanne, *Pablo Picasso: His Life and Times* (New York: William Morrow & Co., 1977), p. 430; also quoted in Forest 1998, p. 49.

354. See Matisse, radio interview with Georges Charbonnier, taped in August 1950, translated in Flam 1995, p. 192.

355. Matisse/Couturier/Rayssiguier 1993, p. 229.

356. See Matisse/Couturier/Rayssiguier 1993, pp. 298, 302, 308. In the end, Matisse abandoned this idea, for he rather optimistically thought that the chapel would be inaugurated during the exhibition (in fact, it took another year); ibid., p. 339. The exhibition, a mini-retrospective held from July 5 to September 24, 1950, comprised thirty-two drawings, half of them from 1950; twenty-seven paintings dating from 1896 to 1948 (including *The Basket of Oranges* [fig. 117], *Young Woman in a Persian Dress* [fig. 124], and *Tulips and Oysters* [fig. 125], lent by Picasso at Matisse's request); three paper cutouts (including *Zulma*); and fifty-one sculptures, the most complete installation of Matisse's sculpture assembled to that point (it was the first time that the five *Jeannettes* were displayed together). Matisse's emphasis on sculpture prompted Picasso a few months later to show forty-three of his own sculptures in the same space, all dating from 1931 to 1944, together with forty-three drawings; see *Picasso: Sculptures, dessins,* exh. cat. (Paris, Maison de la Pensée Française, 1950). The exhibition was held from November 1950 to January 1951.

357. Picasso was always mandated by the Party to get Matisse's signature. Utley reports that "during the Peace Movement's first campaign against the atomic bomb he insisted on visiting Matisse before anyone else because he wanted the old master's signature to be the first under his own name"; Utley 2000, p. 113.

358. For the poster of the first Congrés Mondial des Partisans de la Paix, Aragon picked a drawing Picasso had made after one of the long-feathered pigeons Matisse had given to Picasso; see Gilot 1990, pp. 114–19. For a full account of the myriad images of the peace dove produced by Picasso over the years, see Utley 2000, pp. 117–128.

359. Matisse would have also been intrigued by Picasso's paper cutout version of the dove, dated October 23, 1952, which was turned down by the Communist bureaucracy: although it is made of fragments floating on a rainbow background, it comes closer to Matisse's cutouts than anything Picasso ever did; Utley 2000, p. 125, fig. 97.

360. Matisse/Couturier/Rayssiguier 1993, p. 402.

361. Writing to Father Couturier on February 27, 1950, Matisse designated the crucified Christ as the center; ibid., p. 309. But as Graham Bader suggested, Veronica's veil, which displays the only facial features in the whole composition, and is represented frontally and at a much larger scale than any other element, is an obvious point of entry; unpublished paper for my seminar on Matisse and Picasso, Harvard University, Fall 1997.

362. Matisse/Couturier/Rayssiguier 1993, p. 309.

363. Ibid., pp. 165, 167.

364. Ibid., p. 308.

365. On Matisse and *Winter Landscape*, there are two contradictory accounts. That of Françoise Gilot (Gilot 1990, pp. 219–29), which testifies to Matisse's desire to possess this painting and Picasso's subsequent growing interest in it, and Father Couturier's diary, according to which Matisse found the "ten landscapes" that Picasso had brought to him so mediocre that he cried about it; Matisse/Couturier/Rayssiguier, p. 398.

It is hard to imagine that Matisse would have allowed Hélène Adant to photograph Picasso's painting enthroned among his chasubles if he had thought so little of it.

366. Forest 1998, p. 42 n. 9. In an interview published by Forest, Françoise Gilot notes that Picasso himself did not use this expression. ("He always said *War and Peace*, that was more dialectic"; ibid, p. 58).

367. See Utley 2000, p. 152, and Forest 1998, p. 42.

368. See Utley 2000, pp. 137–139 and 145. Fougeron's mediocre painting was eulogized at the time by Aragon, who did not cease pestering Picasso until he went to see it.

369. René Batigne's diary, excerpt published in Vallauris 1998, pp. 122–23. I am grateful to Dominique Forest for having brought this document to my attention.

370. Jean Cocteau to Matisse, September 19, 1952, AHM. A similar account is given by Cocteau in his diary, *Le Passé indéfini* (Paris: Gallimard, 1983), I, p. 343.

371. Claude Roy, *Picasso: La Guerre et La Paix* (Paris: Éditions du Cercle d'Art, 1954), p. 21; quoted in Forest 1998, p. 52.

372. Ibid, p. 42; quoted in Forest 1998, p. 46. It is not accidental that Matisse's beard, when he was a young man, was red.

373. The title *Human Comedy* is borrowed from that of Michel Leiris' introduction to the *Verve* issue that reproduced the whole series, "Picasso et la Comédie Humaine ou les avatars de Gros Pied," *Verve*, VIII, nos. 29–30 (1954), n.p.

374. See, among others, Karen L. Kleinfelder, *The Artist, His Model, Her Image, His Gaze: Picasso's Pursuit of the Model* (Chicago and London: Chicago University Press, 1992), pp. 134–37.

375. My thanks to Mark Pejcha for bringing this to my attention.

376. On these works, see Denis Hollier, "Portrait de l'artiste en son absence (le peintre sans son modèle)," *Les Cahiers du Musée National d'Art Moderne*, no. 30 (Winter 1989), pp. 5–22.

Coda

377. Brassaï 1966, p. 253.

378. Gilot/Lake 1964, p. 155. This particular sentence is lifted from a passage which does not concern Matisse, but Gilot and others give plenty of evidence that it could have referred to him.

379. Roland Penrose, *Picasso: His Life and Work* (New York: Harper & Row, 1973), p. 406.

380. Gilot/Lake 1964, p. 203.

381. "The Algerian Woman and Picasso at Large," in Steinberg 1972, pp. 125–34.

382. Ibid., p. 151.

383. Ibid., p. 142.

384. The Picasso painting closest to *Egyptian Curtain* has recently been acquired by The Tate Gallery, London (Z. XVI, 497). The sky in the window is bright yellow with spots of blue, the palm tree black and green: these four colors are exactly those of the outburst in the window of Matisse's canvas. There is one supplementary canvas, in horizontal format, dated November 12 (Z. XVI, 496).

It is very different in tone: the vertical canvases, even when extremely busy, breathe like a Matisse painting, while this one expresses a *horror vacui*. Picasso did not pursue this vein.

Chronology

Late 1920s:
While Matisse is going through an inspirational crisis and paints less and less, Picasso alludes to his work in pictures representing acrobats (figs. 31, 32, 173), odalisques (fig. 10) and the painter's studio (fig. 25).

1930

February (end): Matisse leaves for Tahiti (via New York). He will stay there three months, coming back with a few drawings and only one small painting.
June–July: Exhibition of Matisse's sculptures at the Galerie Pierre, Paris, which deeply impresses Picasso.
September: Matisse returns to the US where he takes part in the jury of the Carnegie International (the grand prize goes to Picasso); upon his visit to the Barnes Foundation (Merion, Pennsylvania), he is commissioned a large mural by Albert C. Barnes. Picasso starts working on the illustration of Ovid's *Metamorphoses* for Albert Skira.
December: Matisse goes a third time to the US and spends Christmas at Merion, where he produces the first sketches for *The Dance*. He will devote most of his time and energy to this work until its completion in April 1933.

1931

June: In Boisgeloup, Picasso begins a series of modeled sculptures (figs. 49, 50), which he continues in the late summer and fall (figs. 53, 58, 59). Matisse starts working on the illustration of Mallarmé's *Poésies*, commissioned by Skira.
June 16–July 25: Matisse retrospective at the Galeries Georges Petit, Paris (141 paintings, one sculpture and about

one hundred drawings). A reduced version of the exhibition goes to the Basel Kunsthalle in August.

July 1–21: Picasso exhibition at the Galerie Paul Rosenberg, Paris: recent still lifes (figs. 48 and possibly 47) and plates of the Ovid book.

October: Publication of Picasso's illustrated Ovid (figs. 43–46).

December: Picasso begins a series of paintings after Marie-Thérèse Walter on the theme of the "sleeping beauty." He will work at it until April 1932 and will present most of these pictures at his retrospective at the Galeries Georges Petit (figs. 62, 60, 39, 127).

1932

June 16–July 30: Picasso retrospective at the Galeries Georges Petit, Paris (225 paintings, seven sculptures, and six illustrated books). An enlarged version of the exhibition goes to the Zürich Kunsthaus in September.

October: Publication of the first volume of the catalogue raisonné of Picasso's work by Christian Zervos, and of Mallarmé's *Poésies*, illustrated by Matisse (figs. 63–67).

November: Picasso paints *Games and Rescue on the Beach* (fig. 74).

1933

February 3–10: Exhibition of Matisse's illustrated Mallarmé, with all the sketches and discarded plates, at the Galerie Pierre Colle, Paris.

March–June: Picasso works intensely on the etchings of the *Suite Vollard*, realizing more than half of them (figs. 78, 79).

May 17: Matisse installs *The Dance* at the Barnes Foundation, Merion (fig. 70).

June: Publication of the first issue of *Minotaure* (with a cover by Picasso and a photographic essay by Brassaï on his sculpture). Picasso draws violent scenes with the minotaur (fig. 80).

1934

February–March: The Limited Edition Club, New York, commissions Picasso to illustrate *Lysistrata* (Aristophanes) and Matisse that of Joyce's *Ulysses*. *Lysistrata* will appear in the fall (fig. 82), but *Ulysses* (which comprises the most violent images Matisse ever produced) only in 1935 (figs. 84–86).

May: Picasso paints *Nude with Bouquet of Irises and Mirror* (fig. 90).

August: Picasso paints *Nude in a Garden* (fig. 91).

1935

March–April: Exhibition "Les Createurs du Cubisme" at the Galerie des Beaux Arts, Paris, which Matisse comes especially to see from Nice. Among recent works, Picasso exhibits *The Muse* (fig. 93).

May: Matisse paints *The Dream* (fig. 94) and begins working on *Large Reclining Nude (The Pink Nude)* (fig. 92), which will be finished in October. Picasso stops painting until February 1936.

July: Matisse begins *La Verdure (Nymph in the Forest)*. He will intermittently work on this painting until 1942, leaving it unfinished (fig. 89).

Fall: Matisse begins a series of drawings of a reclining nude model, sometimes including reflections of himself and of the model in a mirror. Several are published by *Cahiers d'Art* in 1936 (figs. 95–98).

November: Exhibition of Matisse's drawings at the Galerie Renou et Colle, Paris.

December: Publication of a special issue of *Cahiers d'Art* on Picasso's work since 1932.

1936

February–March: Exhibition of Picasso's drawings (including erotic scenes with the minotaur) at the Galerie Renou et Colle, Paris.

March 3–31: Exhibition of Picasso's works from 1931–34 at the Galerie Paul Rosenberg, Paris.

May 2–30: First Matisse exhibition at the Galerie Paul Rosenberg, Paris.

May: Picasso begins to work on his illustration of Buffon's *Histoire Naturelle*, which will appear in 1942 (fig. 145).

1937

February–March: Picasso paints *Seated Woman in Front of a Mirror* (fig. 103) and begins a series of very colorful still lifes (figs. 110, 115).

May 1: Picasso begins *Guernica* (finished in early June).

June 1–29: Exhibition of Matisse's works from 1936–37 at the Galerie Paul Rosenberg, Paris, including *Woman in a Purple Robe with Ranunculi* and *Ochre Head* (figs. 113, 102).

June 17–November: Exhibition "Les Maîtres de l'art indépendant," at the Petit Palais, Paris (sixty-one pictures by Matisse, thirty-two by Picasso).

June–October: Exhibition "Origines et développement de l'art indépendant" at the Jeu de Paume, Paris (eleven pictures by Picasso, six by Matisse).

July 12: Inauguration of the Spanish Pavilion (with Picasso's *Guernica*), at the Paris World Fair.

November: Matisse begins *The Conservatory*, which will be finished in May 1938 (fig. 107).

1938

January: Matisse begins *The Arm*, finished in June and exhibited in October (fig. 108).

October 24–November 12: Matisse exhibition at the Galerie Paul Rosenberg, Paris (works from 1917 on). Picasso paints *Reclining Nude in a Brown Landscape* (fig. 111).

1939

January 17–February 18: Exhibition of recent works by Picasso, mostly still lifes, and mostly from 1937, at the Galerie Paul Rosenberg, Paris (works from 1917 on). Picasso paints *Reclining Woman with a Book* (fig. 112).

May: Matisse is in Paris for several months; paints *Daisies* in July (fig. 116). Picasso admires his new works during a short trip to Paris (from Antibes) at the end of July.

August: Picasso paints *Night Fishing at Antibes*. At the end of the month, a few days before the outbreak of the war, he leaves for Royan which remains his primary residence for a year.

October: Back in Nice, Matisse works on *La Verdure* (fig. 89).

1940

January: Matisse starts working on *The Dream* (fig. 126) and Picasso on a drawing series of a nude after Delacroix's *Women of Algiers* (fig. 118).

March: Picasso begins *Woman Combing Her Hair*, then leaves for Paris, where Matisse arrives a month later.

May: Last meeting of Matisse and Picasso until 1945. Panic of the French population as the German troops begin their invasion.

August: Picasso settles in Paris, Matisse in Nice. Neither move until the end of the German occupation. While Picasso produces very little art until May 1941, Matisse finishes *The Dream* (fig. 128) and paints *Still Life with Shell* (fig. 129) in the fall.

1941

January: Matisse is in Lyons for surgery, and remains there, convalescing, until May.

May: Picasso's first drawing related to *L'Aubade*.

August: Matisse begins the illustration of Montherlant's *Pasiphaé* (figs. 137, 140, 141, 143) and drawings that will lead to *Still Life with a Magnolia* (one of which, fig. 123, is inscribed to Picasso). The painting is finished in October (fig. 134).

September: Matisse starts working on *Dessins: Thèmes et variations* (figs. 147 f1-f10). Picasso works again at drawings for *L'Aubade* (figs. 151a–q, 152a–b) and starts a series of paintings on the theme of "Seated woman in an armchair", which he pursues during the next two months (figs. 149, 154).

November 10–30: Exhibition of Matisse's recent drawings at the Galerie Louis Carré, Paris.

November: Matisse begins his work on the illustration of Ronsard's *Les Amours* (figs. 138, 142, 144, 139). A group of French artists make a trip to Weimar under Nazi tutelage, including Matisse's ex-fauve acolytes Vlaminck, Friesz, and Derain.

1942

February: Matisse paints *Woman with Pearl Necklace* (fig. 131).

April: Picasso paints *Still Life with Steer's Skull* (fig. 159)

May: Picasso finishes *L'Aubade* (fig. 150) and Matisse *Dessins: Thèmes et variations*. Picasso's illustrated Buffon appears (fig. 145).

June: Vlaminck attacks Picasso in the collaborationist press. Picasso sends a painting to Matisse (possibly *Portrait of Dora Maar*, fig. 121).

August–September: Matisse paints a series of canvases of a dancer in an armchair (figs. 136, 157).

September: Picasso paints *Reclining Nude* (fig. 155).

October: Matisse begins working on the illustration for Charles d'Orléans' poems.

November: Picasso acquires Matisse's *Basket of Oranges* of 1912 (fig. 117).

December: Matisse paints *Seated Young Woman in a Persian Dress* (fig. 124) which he will give to Picasso in June 1943.

1943

February: Matisse paints a series of still lifes, among them *Tulips and Oysters on a Black Background* (fig. 125).

June: Publication of *Dessins: Thèmes et variations*. Picasso sees a group of recent Matisse paintings; Matisse offers him the choice of one of them in exchange for *Portrait of Dora Maar* (fig. 121). Picasso picks *Seated Young Woman in a Persian Dress* (fig. 124).

August: Picasso paints *The Rocking Chair* (fig. 158).

September–October: Matisse exhibits four paintings at the Salon d'Automne, Paris, including *Still Life with Shell* (fig. 129), *Still Life with a Magnolia* (fig. 134), and *Tulips and Oysters* (fig. 125). At the close of the show, he offers this last painting to Picasso.

November: Matisse begins working on *Jazz*. He paints very little until the end of the war, concentrating on his projects

of illustrated books.

1944

January–July: Picasso paints several series of still lifes, among them *Still Life with Pitcher, Glass and Orange*, which he will give to Matisse in the fall (fig. 1).

May: Publication of Montherlant's *Pasiphaé*, with illustrations by Matisse (figs. 137, 140, 141, 143).

August 26, 1944: Paris and Nice are liberated.

October 4: Picasso becomes a member of the Communist Party.

October 6–November 5: At the Salon d'Automne, Paris, special exhibition of seventy-three paintings and five sculptures by Picasso (mostly from the war), which creates a scandal.

1945

For several years, both painters donate numerous works to charity shows.

April: Matisse visits Picasso during a short trip to Paris.

June 20–July 13: Exhibition of recent works by Picasso at the Galerie Louis Carré, Paris. Matisse is in Paris from the end of June until November, and meets several times with Picasso.

September 28–October 29: At the Salon d'Automne, Paris, mini-retrospective of works by Matisse (thirty-seven pictures, more than half from the war years).

December 5–January 15, 1946: Exhibition of Matisse and Picasso at the Victoria and Albert Museum, London. The exhibition travels until May 1946 to Manchester, Glasgow, Amsterdam and Brussels.

December 7–29: Matisse exhibition at the Galerie Maeght, Paris, with photographs of the paintings in progress (figs. 167). The exhibition travels

to Nice in February 1946.

1946

February–March: Picasso and Matisse participate in the exhibition "Art et Résistance." Matisse paints *L'Asie (Asia)* and begins the series of Vence interiors (figs. 170, 171). Picasso visits Matisse in Vence with Françoise Gilot.

June: Matisse goes to Paris, where he stays until April 1947. He mainly works on his illustrated books but also on decorative panels with cutouts (fig. 195).

June 14–July 14: Picasso exhibition at the Galerie Louis Carré, Paris. Picasso leaves for the Riviera which he favors from now on, with occasional trips to Paris, as well as to various European capitals at the request of the Communist Party.

October–November: Picasso works in the Palais Grimaldi, Antibes (*The Joy of Life* and other works of the "Antipolis" series, figs. 174, 177–182, 187, 191).

1947

June: Matisse visits Picasso at Cap d'Antibes shortly after his return to Vence. He will remain on the Riviera until June 1948, and the two artists will see each other frequently.

August: Picasso becomes involved in ceramics, realizing close to two thousand objects in a few months.

December: Matisse begins working on the Vence chapel project.

1948

January: Matisse paints *The Pineapple* (fig. 196) and, during the next few months, works on the series of Vence interiors (figs. 164, 197).

April: Matisse draws sketches after Picasso's works at the Palais Grimaldi in Antibes (figs. 183, 184, 186, 188–190).

May: Matisse gives pigeons to Picasso, the origin of the "peace dove" imagery. Picasso begins the illustration for *Carmen* (fig. 199), which appears in March 1949.

June: Matisse in Paris, where he will remain until mid-October.

October 5–20: Recent works of Picasso at the Galerie Louis Leiris, Paris. Matisse returns to the south where he remains until July 1950.

November: Publication of Ronsard's *Les Amours*, illustrated by Matisse. Picasso paints *The Kitchen* (fig. 194).

1949

April: Working on *The Stations of the Cross* for the Vence chapel (figs. 203–205), Matisse again visits Picasso's display at the Palais Grimaldi.

June 9–September 25: Exhibition of recent works by Matisse at the Musée National d'Art Moderne, Paris (thirteen Vence interiors, twenty-five paper cut outs, and twenty-two brush and ink drawings).

July: Exhibition of sixty-four recent works by Picasso at the Maison de la Pensée Française, Paris.

1950

January–March: Matisse retrospective exhibition at the Galerie des Ponchettes, Nice.

June 8–October 15: Venice Biennale; Matisse is awarded the Grand Prize.

July 5–24: Matisse exhibition at the Maison de la Pensée Française, Paris; 115 works, including fifty-one sculptures. Matisse goes to Paris where

November 29–January 1951: Exhibition of Picasso drawings at the Maison de la Pensée Française.
December: Picasso paints *Winter Landscape* (fig. 207)

1951

May: Picasso shows *Massacre in Korea* at the Salon de Mai, Paris, where it is badly received. Begins speaking about his *War* and *Peace* project in Vallauris.
June 25: Inauguration of Matisse's Vence chapel.
December 7–29: Exhibition of Matisse drawings at the Galerie Mourlot, Marseilles.

1952

February: Picasso lends Matisse *Winter Landscape* (fig. 208).
Spring: Matisse works on the cutout series of the *Blue Nude* (figs. 213–217).
April: Picasso begins to sketch *War* and *Peace* and will continue throughout the summer. The panels themselves will be finished by the end of the year, and will be whisked away to Picasso's retrospective in Italy (May–December 1953), without being seen by Matisse (figs. 209, 210).
May: Exhibition of Matisse drawings at the Galerie Maeght, Paris.

1953

February 27–March 28: First exhibition exclusively dedicated to Matisse's cutouts at the Galerie Berggruen, Paris. Picasso paints *The Chinese Chest of Drawers* (fig. 219).
July: Picasso paints *Seated Woman* (fig. 218).
December: Picasso starts a series of caricatural drawings on the theme of the artist and his studio, later published in *Verve*. Paints *Child Playing with a Toy Truck* (fig. 221), *Claude Drawing, Françoise and Paloma* (fig. 222), and *The Shadow*.

1954

November 3: Matisse dies.
December 13: Picasso begins the *Women of Algiers* series, finished in February (figs. 223–226).

1955

October: Picasso paints the first *Studio at "La Californie"* series (figs. 227, 228).

1956

March: Picasso paints *Woman in a Rocking Chair* (fig. 229) and begins the second series of *Studio at "La Californie"* paintings, finished in May (figs. 230, 231).

Bibliography

ARCHIVES

AHM
Archives Henri Matisse, Paris

MPP
Documentation of the Musée Picasso, Paris

PML
Pierre Matisse Archives, The Pierpont Morgan Library, New York

CATALOGUES RAISONNÉS

BAER
Baer, Brigitte. *Picasso peintre graveur: catalogue raisonné de l'œuvre gravé et lithographié et des monotypes.* Vols. III–IV. Bern: Éditions Kornfeld, 1985–88.

CARRA
Carra, Massimo. *Tout l'œuvre peint de Matisse.* Rev. ed. Paris, Flammarion, 1982.

DAIX
Daix, Pierre, and Joan Rosselet. *Picasso: The Cubist Years, 1907–1916. A Catalogue Raisonné of the Paintings and Related Works.* London: Thames and Hudson, 1979.

DUTHUIT I
Duthuit, Claude, and Marguerite Duthuit-Matisse, with the collaboration of Françoise Garnaud. *Henri Matisse: Catalogue raisonné de l'œuvre gravé.* 2 vols. Paris 1983.

DUTHUIT II
Duthuit, Claude, with the collaboration of Françoise Garnaud. *Henri Matisse: Catalogue raisonné des ouvrages illustrés.* Paris 1987.

DUTHUIT III
Duthuit, Claude, with the collaboration of Wanda de Guébriant. *Henri Matisse: Catalogue raisonné de l'œuvre sculpté.* Paris 1997.

GEISER/BAER
Geiser, Bernard, and Brigitte Baer. *Picasso peintre graveur: catalogue raisonné de l'œuvre gravé et lithographié et des monotypes.* Vols. I–II. Bern: Éditions Kornfeld, 1990–92.

LÉAL
Léal, Brigitte. *Musée Picasso: Carnets. Catalogue des dessins.* 2 vols. Paris: Réunion des Musées Nationaux, 1996.

SPIES
Spies, Werner, with the collaboration of Christine Piot. *Das Plastische Werk.* Stuttgart: Gerd Hatje, 1983.

Z.
Zervos, Christian. *Pablo Picasso.* Paris: Cahiers d'Art, 33 vols., 1932–78.

BOOKS, ARTICLES, and EXHIBITION CATALOGUES

ARAGON 1972
Aragon, Louis. *Henri Matisse: A Novel.* Trans. Jean Stewart. 2 vols. New York: Harcourt Brace Jovanovich, 1972.

BAKHTIN 1986
Bakhtin, Mikhail. "The Problem of Speech Genres." In Mikhail Bakhtin, *Speech Genres and Other Late Essays.* Trans. Vern W. McGee. Austin, Texas: University of Texas Press, 1986.

BARR 1951
Barr, Jr. Alfred H. *Matisse: His Art and His Public.* New York: The Museum of Modern Art, 1951.

BENJAMIN 1987
Benjamin, Roger. *Matisse's "Notes of a Painter."* Ann Arbor, Michigan: UMI Research Press, 1987.

BLOOM 1973
Bloom, Harold. *The Anxiety of Influence: A Theory of Poetry.* London, Oxford, New York: Oxford University Press, 1973.

BOIS 1990
Bois, Yve-Alain. *Painting as Model.* Cambridge, Massachusetts: MIT Press, 1990.

BOIS 1994
Bois, Yve-Alain. "On Matisse: The Blinding." *October,* no. 68 (Spring 1994), pp. 61–121.

BRASSAÏ 1966
Brassaï. *Picasso and Company.* Trans. Francis Price. Garden City and New York: Doubleday & Company, 1966.

BRISBANE 1995
Matisse (exhibition catalogue).
Brisbane, Australia:
Queensland Art Gallery, 1995.

CAMOIN/MATISSE 1997
Camoin, Charles, and Henri Matisse.
Correspondance. Claudine Grammont, ed.
Lausanne: Bibliothèque des Arts, 1997.

CLEVELAND 1992
Picasso & Things (exhibition catalogue).
Cleveland: The Cleveland Museum
of Art, 1992.

COWLING 1985
Cowling, Elizabeth. "'Proudly We Claim
Him As One Of Us': Breton, Picasso,
and the Surrealist Movement."
Art History, VIII, no. 1 (March 1985),
pp. 82–104.

DAIX 1987
Daix, Pierre. *Picasso: Life and Art.*
Trans. Olivia Emmet. New York:
HarperCollins, 1987.

DAIX 1996
Daix, Pierre. *Picasso/Matisse.*
Neuchâtel: Ides et Calendes, 1996.

DAMISCH 1997
Damisch, Hubert. *Moves: Playing Chess
and Cards with the Museum.* Rotterdam:
Museum Boijmans Van Beuningen,
1997.

DAMISCH 2000
Damisch, Hubert. *L'Amour m'expose.*
Gand: Yves Gevaert Editeur, 2000.

DELECTORSKAYA 1986
Delectorskaya, Lydia. *Henri Matisse:
L'apparente facilité....*
Paris: Adrien Maeght Éditeur, 1986.

DELECTORSKAYA 1996
Delectorskaya, Lydia. *Henri Matisse,
contre vents et marées: Peinture et livres
illustrés de 1939 à 1943.* Paris:
Éditions Irus et Vincent Hansma, 1996.

DORLÉAC 1993
Dorléac, Laurence Bertrand.
L'Art de la défaite 1940–1944.
Paris: Éditions du Seuil, 1993.

DUTHUIT 1992
Duthuit, Georges. *Écrits sur Matisse.*
Rémi Labrusse, ed. Paris: École Nationale
Supérieure des Beaux-Arts, 1992.

ELDERFIELD 1978
Elderfield, John. *Matisse in the Collection
of The Museum of Modern Art.* New York:
The Museum of Modern Art, 1978.

ELDERFIELD 1992
Elderfield, John. "Describing Matisse."
In *Henri Matisse: A Retrospective*
(exhibition catalogue). New York: The
Museum of Modern Art, 1992.

ESCHOLIER 1937
Escholier, Raymond. *Henri Matisse.*
Paris: Librairie Floury, 1937.

ESCHOLIER 1956
Escholier, Raymond. *Matisse, ce vivant.*
Paris: Librairie Arthème Fayard, 1956.

FITZGERALD 1987
FitzGerald, Michael C. "Pablo Picasso's
Monument to Guillaume Apollinaire:
Surrealism and Monumental Sculpture
in France 1918–1959." Ph.D. diss.
New York: Columbia University, 1987.

FITZGERALD 1995
FitzGerald, Michael C. *Making
Modernism: Picasso and the Creation
of the Market for Twentieth-Century Art.*
New York: Farrar, Straus and Giroux,
1995.

FLAM 1986
Flam, Jack. *Matisse: The Man and
his Art, 1869–1918.* Ithaca and London:
Cornell University Press, 1986.

FLAM 1988
Flam, Jack, ed. *Matisse, A Retrospective.*
New York: Hugh Lauter Levin
Associates, 1988.

FLAM 1993
Flam, Jack. *Matisse: The Dance.*
Washington: The National Gallery
of Art, 1993.

FLAM 1995
Flam, Jack, ed. *Matisse on Art.* Rev.
ed. Berkeley and Los Angeles:
University of California Press, 1995.

FLORMAN 2000
Florman, Lisa. *Myth and
Metamorphosis: Picasso's 'Classical'
Prints of the 1930s.* Cambridge,
Massachusetts: The MIT Press, 2000

FOREST 1998
Forest, Dominique.

"Revoir *La Guerre* et *La Paix*."
In *Vallauris* La Guerre *et* La Paix
Picasso (exhibition catalogue).
Paris and Vallauris: Réunion des Musées
Nationaux, 1998, pp. 41–55.

FOURCADE 1972
Fourcade, Dominique, ed. *Henri
Matisse: Écrits et propos sur l'art.*
Paris: Hermann, 1972.

FOURCADE 1976
Fourcade, Dominique. "Autres propos
de Henri Matisse." *Macula*, no. 1 (1976),
pp. 92–115.

GALASSI 1996
Galassi, Susan Grace.
Picasso's Variations on the Masters.
New York: Harry N. Abrams, 1996.

GILOT/LAKE 1964
Gilot, Françoise and Carlton Lake.
Life with Picasso. New York, Toronto,
London: McGraw-Hill Book Co., 1964.

GILOT 1990
Gilot, Françoise. *Matisse and Picasso:
A Friendship in Art.* New York:
Doubleday, 1990.

GILOT/FRÉCHURET 1996
Gilot, Françoise and Maurice Fréchuret.
*1946, Picasso et la Méditérranée
retrouvée.* Nice: Grégoire Gardette
Éditions, 1996.

GIRARD 1966
Girard, René. *Deceit, Desire and the
Novel.* Trans. Yvonne Freccero.
Baltimore: John Hopkins University
Press, 1966.

GOGGIN 1985
Goggin, Mary-Margaret. "Picasso
and His Art During the German
Occupation." Ph.D. diss., Palo Alto,
California: Stanford University, 1985.

KAHNWEILER 1952
Kahnweiler, Daniel-Henry. "Huit
entretiens avec Picasso," *Le Point*, 7,
no. 42 (October 1952), pp. 22–30.

KAHNWEILER 1956
Kahnweiler, Daniel-Henry. "Entretiens
avec Picasso," *Quadrum*, no. 2
(November 1956), pp. 73–76.

KLEIN 1997
Klein, John. "Matisse After Tahiti:

The Domestication of Exotic Memory."
Zeitschrift für Kunstgeschichte, 60,
no. 1 (1997), pp. 44–89.

KRAUSS 1993
Rosalind Krauss, *The Optical
Unconscious.* Cambridge, Massachusetts:
The MIT Press, 1993.

KRAUSS 1998
Krauss, Rosalind. *The Picasso Papers.*
New York: Farrar, Straus and Giroux,
1998.

LABRUSSE 1996
Labrusse, Rémi. *Esthétique décorative
et expérience critique: Matisse,
Byzance et la notion d'Orient.* Ph.D. diss.
Paris: University of Paris 1,
Panthéon-Sorbonne, 3 vols. 1996.

LABRUSSE 1998
Labrusse, Rémi. "Un 'ensemble
concertant'? Matisse et Mallarmé
(1931–1932)." In Corinne Belle, ed.
*L'Atelier des signes: Esthétiques croisées
de poètes et de peintres au XXᵉ siècle.*
Paris: Presses de l'École Normale
Supérieure de Fontenay/Saint Cloud, 1998.

LABRUSSE 1999
Labrusse, Rémi. *Matisse. La Condition
de l'Image.* Paris: Gallimard, 1999.

LE CATEAU-CAMBRÉSIS 1998
Matisse et l'Océanie: Le Voyage à Tahiti
(exhibition catalogue). Le Cateau-
Cambrésis: Musée Matisse, 1998.

LONDON 1994
Picasso: Sculptor/Painter (exhibition
catalogue). London: Tate Gallery, 1994.

LOS ANGELES 1966
Henri Matisse (exhibition catalogue).
Los Angeles: UCLA Art Galleries, 1966.

**MATISSE/COUTURIER/
RAYSSIGUIER 1993**
Matisse, Henri, Marie-Alain Couturier,
and Louis-Bertrand Rayssiguier.
Marcel Billot, ed. *La Chapelle de Vence:
Journal d'une création.* Paris: Éditions
du Cerf, 1993.

MONAHAN 1995
Monahan, Laurie J. "Taming Violence:
Europa, Matisse and Myth."
In *Matisse* (exhibition catatalogue).
Brisbane, Australia: Queensland
Art Gallery, 1995.

MONOD-FONTAINE 1989A
Monod-Fontaine, Isabelle, Anne Baldassari and Claude Laugier. *Matisse: Collections du Musée National d'Art Moderne*. Paris: Musée National d'Art Moderne, Centre Georges Pompidou, 1989.

MONOD-FONTAINE 1989B
Monod-Fontaine, Isabelle. *Matisse: Le Rêve ou les belles endormies*. Paris: Adam Biro, 1989.

NEW YORK 1984
"Primitivism" in 20th Century Art: Affinity of the Tribal and the Modern (exhibition catatalogue). 2 vols. New York: The Museum of Modern Art, 1984.

NEW YORK 1992
Henri Matisse: A Retrospective (exhibition catatalogue). New York: The Museum of Modern Art, 1992.

NOCHLIN 1980
Nochlin, Linda. "Picasso's Color: Schemes and Gambit." *Art in America*, 68, no. 10 (December 1980), pp. 105–23 and 177–83.

OLIVIER 1965
Olivier, Fernande. *Picasso and His Friends*. Trans. Jane Miller. New York: Appleton-Century-Crofts, 1965.

PARIS 1975
Henri Matisse: Dessins et sculpture (exhibition catatalogue). Paris: Musée National d'Art Moderne, 1975.

PARIS 1993
Henri Matisse 1904–1917 (exhibition catatalogue). Paris: Musée National d'Art Moderne, Centre Georges Pompidou, 1993.

ROSENBLUM 1996
Rosenblum, Robert. "The Reign of Marie-Thérèse Walter." In Rubin 1996, pp. 337–83.

RUBIN 1972
Rubin, William. *Picasso in the Collection of The Museum of Modern Art*. New York: The Museum of Modern Art, 1972.

RUBIN 1989
Rubin, William. *Picasso and Braque:*

Pioneering Cubism. New York: The Museum of Modern Art, 1989.

RUBIN 1996
Rubin, William, ed. *Picasso and Portraiture: Representation and Transformation*. New York: The Museum of Modern Art, 1996.

SCHNEIDER 1984
Schneider, Pierre. *Matisse*. Trans. Michael Taylor and Bridget Stevens Romer. New York: Rizzoli, 1984.

SECKEL 1994
Seckel, Hélène, with the collaboration of Emmanuelle Chevrière and Hélène Henry. *Max Jacob et Picasso*. Paris: Réunion des Musées Nationaux, 1994.

SECKEL 1998
Seckel, Hélène, with the collaboration of Emmanuelle Chevrière. *Picasso collectionneur*. Paris: Réunion des Musées Nationaux, 1998.

SPIES 1995
Spies, Werner. *Pablo Picasso on the Path of Sculpture*. Munich and New York: Prestel, 1995.

STEINBERG 1972
Steinberg, Leo. *Other Criteria: Confrontations with Twentieth-Century Art*. London, Oxford, New York: Oxford University Press, 1972.

STEINBERG 1988
Steinberg, Leo. "The Philosophical Brothel" (1972). Rev. ed. *October*, no. 44 (Spring 1988), pp. 17–74.

STEINBERG 1995
Steinberg, Leo. "Picasso's Endgame." *October*, no. 74 (Fall 1995), pp. 105–22.

TÉRIADE 1996
Tériade [Efstratias Elestheriades]. *Écrits sur l'art*. Alice Tériade, ed. Paris: Adam Biro, 1996.

UTLEY 2000
Utley, Gertje. *Picasso: The Communist Years*. New Haven and London: Yale University Press, 2000.

VALLAURIS 1998
Vallauris La Guerre *et* La Paix *Picasso*

(exhibition catatalogue). Vallauris, Musée Magnelli-Musée de la Céramique; Paris, Musée Picasso, 1998.

VOLOSINOV 1986
Volosinov, V.N. *Marxism and the Philosophy of Language*. Trans. L. Latejka and I. R. Titunik. Cambridge, Massachusetts: Harvard University Press, 1986.

WASHINGTON 1986
Henri Matisse: The Early Years in Nice 1916–1930 (exhibition catatalogue). Washington, D.C.: National Gallery of Art, 1986.

ZELEVANSKY 1992
Zelevansky, Lynn, ed. *Picasso and Braque: A Symposium*. New York: The Museum of Modern Art, 1992.

LENDERS TO THE EXHIBITION

AUSTRALIA
The Art Gallery of New South Wales, Sydney

FRANCE
Musée Matisse, Nice
Musée National d'Art Moderne, Centre National d'Art
 et de Culture Georges Pompidou, Paris
Musée Picasso, Antibes
Musée Picasso, Paris

GERMANY
Kunstsammlung Nordrhein-Westfalen, Düsseldorf

RUSSIA
State Pushkin Museum of Fine Arts, Moscow

UNITED STATES OF AMERICA
The Art Institute of Chicago
The Baltimore Museum of Art
Cincinnati Art Museum
The Currier Gallery of Art, Manchester, New Hampshire
The Elkon Gallery, Inc., New York
Kimbell Art Museum, Fort Worth, Texas
The Phillips Collection, Washington, D.C.
The Saint Louis Art Museum
Solomon R. Guggenheim Museum, New York
Washington University Gallery of Art, Saint Louis
Yale University Art Gallery, New Haven, Connecticut

PRIVATE COLLECTORS
The Alex Hillman Family Foundation
Roger and Brook Berlind
Daros Collection, Switzerland
Collection of Kate Ganz
Collection Linda and Morton Janklow, New York
Collection of Linda and Harry Macklowe, New York
Marina Picasso Collection, Courtesy Galerie Jan Krugier,
 Ditesheim & Cie, Geneva
Patsy R. and Raymond D. Nasher Collection
Susan and Alan Patricof
Anonymous Lenders

INDEX

Works are listed under the names of the artists. All works are italicized. Page numbers printed in bold type refer to illustrations. Numbers preceded by an 'n' refer to notes.

Acknowledgements

―――

This book, which first appeared in English, originally functioned as the catalogue of the exhibition "Matisse & Picasso: A Gentle Rivalry" which I curated at the Kimbell Art Museum in Fort Worth, Texas (January 31–May 9, 1999). Without the invitation made to me by Joachim Pissarro and Edmund P. Pillsbury, then respectively curator and director of the Kimbell, and without the administrative support provided by the museum's staff, it is doubtful that I would have attempted a task as complex as this exhibition—I must also admit that the prospect of seeing the works of Matisse and Picasso hung side by side on the walls of Louis Kahn's splendid building played a major role in my acceptation of Pissarro's and Pillsbury's offer. From the outset, however, I conceived of this book as being independent from the exhibition. Would I have written it without the show? Nothing is less certain, and I shall be forever grateful to Pissarro and Pillsbury for having forced my hand.

Many people—private collectors, museum curators and directors, dealers, scholars—made the exhibition possible, and their precious help was dutifully acknowledged in the first edition of this volume. Writing is a solitary enterprise, and the friends and colleagues whose patience and generosity I taxed in order to complete this book are far fewer. But since the project of the exhibition provided the initial impetus for the book, I would like to pay special tribute to those who, apart from my friends at the Kimbell, encouraged me from the very start.

There is always a moment in launching a project of this nature when its feasibility is put to the test. I was fortunate enough that a positive answer to the test came very early on. In the spring of 1995, while in Australia for the opening of the first Matisse retrospective there, I broached the subject with Barbara and Claude Duthuit, who were representing the Matisse heirs, and with Isabelle Monod-Fontaine, chief curator at the Musée National d'Art Moderne in Paris: they responded enthusiastically, and their support has been invaluable ever since. The same enthusiasm was professed very soon thereafter by Gérard Regnier and Anne Baldessari, respectively director and curator of the Musée Picasso in Paris, and Claude Picasso, director of Picasso Administration. Serious work could then begin.

I also depended on the help of many colleagues and friends for the research that resulted in this book. For the support I received in Paris, I wish to extend my thanks to Barbara and Claude Duthuit, Wanda de Guébriant, and Georges Matisse in the Matisse Archives, and to Hélène Seckel, Anne Baldassari, Brigitte Léal, Emmanuelle Chevrière and Jeanne-Yvette Sudour in the Musée Picasso. I am particularly grateful to Wanda de Guébriant, Hélène Seckel, and Paul Galvez, then my research assistant in Paris, for generously and efficiently accommodating many urgent requests. The support of the late Maria-Gaetana Matisse and Olive Bragazzi, from the Pierre Matisse Foundation, was invaluable. My special thanks also to Scott Rothkopf, who superbly assisted my research in Cambridge, along with the staff of the Fogg Art Museum Library. Many colleagues have shared with me their knowledge and provided key information. Among them, I particularly wish to thank

Catherine Bock-Weiss, Richard Brettell, Lisa Florman, Dominique Forest, Dominique Fourcade, John Klein, Rosalind Krauss, Rémi Labrusse, John O'Brian, William Rubin, Leo Steinberg and Gertje Utley. I also wish to thank Georges Pellequer, for making available to me the correspondence between his uncle and Matisse, and Yves de Fontbrune for allowing me to use reproductions of Picasso's works published in *Cahiers d'Art*.

Finally, I am grateful to all those who participated in the material production of this book, notably Suzanne Tise, at Flammarion Inc., and Alexandra Keens, who gathered all the illustrations and faced many crises with equanimity. Finally, the editors of my manuscript have to be commended for their patience and perseverance: Sheila Schwartz for allowing my prose to become English, Richard Rand, for courageously proposing dramatic cuts that gave the essay its final form, and Dave Tucker for the fine combing.

PHOTOGRAPHIC CREDITS

The Author

Yve-Alain Bois is the Joseph Pulitzer, Jr., Professor of Modern Art at Harvard University. He has written extensively on twentieth-century art, from Matisse and Picasso to post-war American art, particularly Minimal art. A collection of his essays, *Painting as a Model*, has been published by M.I.T. Press (1990). He co-organized the 1994–5 retrospective of Piet Mondrian in The Hague, Washington, and New York. In 1996, he curated the exhibition "L'informe, mode d'emploi" with Rosalind Krauss at the Centre Georges Pompidou in Paris. The book accompanying this exhibition has recently been published in English under the title *Formless: A User's Guide* (Zone Books, 1997). Among other projects, he is currently preparing the catalogue raisonné of Barnett Newman.

Editorial Director
Suzanne Tise-Isoré

Editorial coordination
Alexandra Keens

Copy-editing
Richard Rand, Dale Tucker

Design
Compagnie Bernard Baissait, Paris
Bernard Lagacé

Production
Bruno Bredoux, Murielle Vaux

Photoengraving
Welcrome, Paris

Printed and bound by
Milanostampa, Italy

Dépôt légal: December 1998
Printed in Italy